ALSO BY DEBORAH SOLOMON

Jackson Pollock: A Biography

UTOPIA
PARKWAY

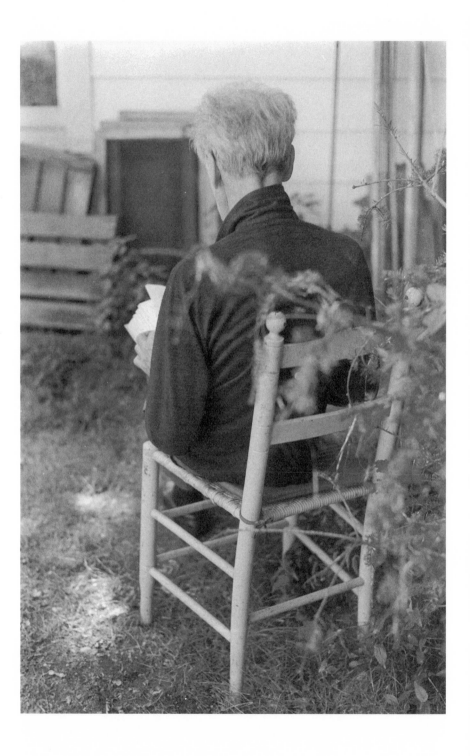

UTOPIA
PARKWAY

The Life and Work of
JOSEPH CORNELL

Deborah Solomon

Farrar, Straus and Giroux · New York

Farrar, Straus and Giroux
19 Union Square West, New York 10003

Copyright © 1997 by Deborah Solomon
All rights reserved
Published simultaneously in Canada by HarperCollins*CanadaLtd*
Printed in the United States of America
Designed by Jonathan D. Lippincott
First edition, 1997

Library of Congress Cataloging-in-Publication Data
Solomon, Deborah.
 Utopia Parkway : the life and work of Joseph Cornell / Deborah
Solomon.—1st ed.
 p. cm.
 Includes bibliographical references and index.
 ISBN 0-374-18012-1 (alk. paper)
 1. Cornell, Joseph. 2. Artists—United States—Biography.
I. Title.
N6537.C66S64 1996
709'.2—dc20
 [B] 95-18258

Photographs of works by Joseph Cornell © the Joseph and Robert Cornell Memorial Foundation
Photographs by Hans Namuth © Hans Namuth
Photographs by Harry Roseman © Harry Roseman

Frontispiece: Cornell reading in his yard at Utopia Parkway, September 1, 1971 (photograph
by Harry Roseman)

Third printing, 1997

For Kent Sepkowitz

Contents

Illustrations

Preface

On a typical afternoon, Joseph Cornell might stop in at his local Bickford's restaurant for a cup of tea and a slice of cherry pie. One can see him now, a thin, wraithlike man at his own table, bent over a book while enjoying his snack. He reads intently, absorbed in a biography of Chopin or Goethe or some other formidable figure, pausing only to scribble a note on his paper napkin or to gaze with birdlike keenness at a waitress. Cornell was a great reader of biographies; his library included dozens of books on poets, musicians, and scientists, among others, and they attest at least partly to the difficulty he had in sustaining friendships. He fared better with the deceased. He loved to immerse himself in the lives of the illustrious dead, with whom his identification was intense, and who became his most valued coffee-shop companions as they sprang to life inside his bony box of a head.

One suspects it never occurred to Cornell that one day he himself would become the subject of a biography and that someone, somewhere, would perhaps sit down at a table in a coffee-shop and open a book about *him*. The idea would have struck him as ludicrous, for his life was less a story than a strange situation. For most of his years, he resided with his mother and handicapped brother in their small frame house on Utopia Parkway in Queens. Cornell was no bohemian, just a gaunt man in drab clothes whose days were spent mainly in his basement workshop, where he arranged marbles, metal rings, and other frugally poetic objects in small shadow boxes —and transported five-and-dime reality into his own brand of unreality, which to him was as real as the objects in his boxes.

A reticent existence, a series of unrequited crushes on women, numberless days passed in his basement dreaming of long-gone Romantic ballerinas— his was hardly a life in the grand sense. It was different, at any rate, from

the lives Cornell read about, and modesty would have led him to protest that his life could not compete for greatness with the historical figures who filled his daydreams. His insomniac nights and long days of frustration were conspicuously short on plot; day in and day out, it sometimes seemed to him, he did little more than bicker with his mother, feed peanuts to the blue jays in the yard, and listen for the sound of the mailman on the front steps.

His biography, if such an entity were imaginable to him, could have seemed only a grim joke, an assemblage of remarkably unremarkable moments. A biography needs a hero, a Picasso or a Jackson Pollock, someone to get drunk, smash up cars, and bed women. Cornell didn't drink, never learned to drive, and, to his regret, died a virgin. On the other hand, Cornell was no stranger to desire. For women he felt a deep reverence as well as a nearly breathless longing. In his sixties, he finally relented and had his first physical relationships. But up until then he was unable to permit himself anything as impulsive as a love affair. An art monk, Cornell was determined to repent, for what sin he was not quite sure. Of one thing, however, he was sure: he was drawn to a vision of chasteness for himself, a vision that governed the arc of his life as well as his work. Paradoxically, the same impulse that condemned him to a lacerating aloneness would lead to romantic rapture in his art.

If Cornell didn't view himself as a major figure, the appraisal offered by his contemporaries was scarcely more generous. During his lifetime, he typically was dismissed as an odd-duck figure lost in the distant and irrelevant past. His shadow boxes, with their intimate scale and nostalgic spirit, seemed to go against what Ezra Pound called the "make it new" spirit of twentieth-century art, an impression reinforced by Cornell's timid and apprehensive behavior among his many art-world acquaintances.

Today, however, no one could accuse Cornell of artistic inconsequentiality. Though out of step with his own time, Cornell is certainly in step with ours. He was not the first artist to work in assemblage, but he was the first of any note to devote his entire career to that medium, keeping it alive during the heyday of Abstract Expressionism. He needs to be acknowledged as a leading forerunner of the junk-into-art aesthetic that has dominated the American art scene since the 1960s, and he can fairly be described as the most undervalued of valued American artists.

Even as an art-world personality, Cornell, in truth, defined his era as fully as did Picasso or Pollock. His life was a genuine New York story.

Cornell loved to wander the metropolis, a gray shadow of a man making the rounds of bookshops, record shops, and the city's handful of avant-garde galleries. From a bench in the airless waiting room of Grand Central Terminal, he would watch the crowds stream by; from his post in Union Square Park, he would observe flocks of pigeons with equal fascination. His urban rambles were made in a New York that no longer exists—a city of fedoras, Automats, and ten-cent cups of coffee, a city where the El still ran along Third Avenue and everyone smoked, a city with secrets on every block. Cornell was the quintessential New Yorker: the loner who couldn't stand to be alone, and who looked to the city as a place in which to live out his dream of connectedness.

Still, none of this exactly amounts to high adventure, as Cornell would have been the first to concede. If one imagines him bristling at the notion of a biography of him, he would have, in all fairness, grounds for complaint: he was a private man, and no one person ever knew much about him. Although he kept a diary for more than three decades, his journals are a compendium of fragments and seemingly unconnected details whose gaps speak more loudly than anything he wrote. Cornell placed a silence around him like a bell jar.

What, one might reasonably ask, can be gained from disturbing that silence with a biography? Some might say nothing. Nowadays, biography is an unpopular genre, at least among art historians. Formalists contend that an artist's life is irrelevant to his work and attach to the recording of day-to-day activities a suspicion of triviality. Leftist scholars, schooled in Marxism, are likely to view an individual life as the sum of social, political, and economic factors; artists, they say, are molded by forces far greater than themselves.

True, history creates us, but not as much as we create it. And Cornell, in spite of his own disavowals, certainly helped shape the art of the twentieth century. If a biography needs a hero, in Cornell we have one.

This biography was written not to ruffle the cloak of his privacy but, rather, for the reason that Cornell himself read—to better understand an interesting life. And perhaps this book was also written to widen our circle of acquaintances, at least by one. Bowed over a biography at a table in Bickford's, Cornell became all at once a reader, a traveler, and a lover. Like any biographer, Cornell understood that biography can be a form of true romance.

UTOPIA
PARKWAY

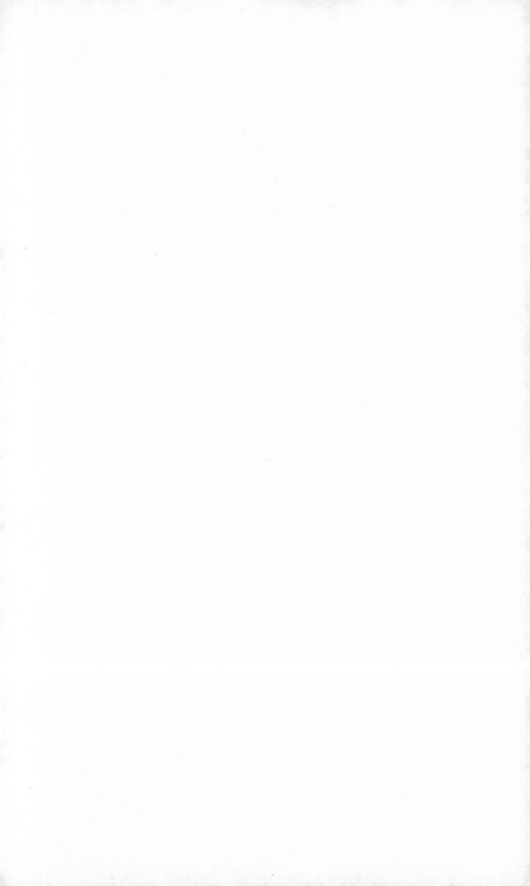

I

"Combination Ticket
Entitles Bearer To . . ."
1903-17

Why does anyone grow up to be an artist? There are many different routes to the artistic life, but in most cases a person turns to art for an almost disappointingly logical reason: he realizes in his youth that he possesses a talent for drawing. At some point he sits down with a pencil and a sheet of paper and discovers an ability to bring people and objects to life; he lays claim to a gift that sets him apart from other children.

This is not the route that Joseph Cornell took. As a child he had no interest in art, and his story is not the usual one of draftsmanly precocity followed by awards, prizes, and recognition. He was self-taught and did not make his first work of art until he was in his late twenties. It was neither a painting nor a sculpture but, rather, a collage composed from nineteenth-century engravings; a few years later he started making the fantasy-rich shadow boxes that secured his reputation.

If Cornell was a latecomer to art, however, it would be wrong to assume that he became an artist as a result of some miraculous overnight conversion. It's more fitting to say that Cornell was an artist—or at least an artful dreamer—long before he sat down to make his first work of art. To consider his early years is to find a boy in love with the shiny surfaces of popular culture and enthralled by tricks of magic and escape. Cornell's childhood did not teach him how to meet the challenges of life but, rather, how to avoid them; early on, he came to understand that if he was going to have a life at all, it would have to be through a profound act of imagination.

His parents had been married for just over a year when Joseph, their first child, was born on Christmas Eve, 1903, in South Nyack, New York, a picturesque village on the Hudson River about thirty miles north of New York City. Delivered at home, with a Dr. Toms in attendance, the healthy

newborn was the sixth in a line to bear the name Joseph I. Cornell. He would never know what his middle initial stood for, a comic and personal enigma.

Cornell grew up at a time when the movies had just come into existence but had not yet eclipsed live entertainment, and his earliest sense of culture was tied to his family's outings to the entertainment palaces of the day. On their trips to Manhattan, it never occurred to the Cornell family to visit the city's one art museum, the Metropolitan Museum of Art, which was regarded as a stuffy, moldering establishment, no place to take a family intent on having fun. Instead, like so many other American families, the Cornells were more likely to celebrate a holiday by seeing a vaudeville show, which was still the most popular form of theater in the country.

Cornell always retained the fondest memories of the theatrical extravaganzas of his youth. He was six years old when he saw Buffalo Bill in a Wild West spectacular at Madison Square Garden. When he was nine years old, the Palace Theatre opened on Seventh Avenue, turning Times Square into the heart of vaudeville almost overnight—and delighting the future artist with programs contrived from acrobats, tumblers, and dancing monkeys. The family also visited the Hippodrome, on Sixth Avenue at Forty-third Street, which was billed as the largest theatrical structure anywhere. A giant water tank was recessed into the stage, and Cornell, watching from the balcony, was fascinated to see as many as forty sirens swim in unison in an aquatic ballet.

It was at the Hippodrome that Cornell had the chance to see Harry Houdini, who escaped from chains and a locked safe, and made elephants vanish into thin air. Houdini's act turned out to be the most memorable performance of Cornell's youth; the magician would loom over his childhood as a symbol not only of inspired entertainment but of artistic possibility as well. For art, as much as a magic show, can be a disappearing act, and the notion of vanishing was central to the young Cornell's imagination. The metal rings and suspended chains that would later become common elements in his boxes refer at least partly to Houdini and the memory of a lonely boy who wished to vanish from the shackles of day-to-day reality. And the very form of the Box was already intriguing to Cornell; whereas Houdini escaped out of boxes, Cornell would one day escape into them.

As much as the young Cornell enjoyed the shows he saw at Manhattan theaters, perhaps nothing could compete for razzle-dazzle with the sights that lay outside them. Strolling Times Square with his family, Joseph felt

"entranced by the magic of the lights," as he later recalled in his journals. He remembered "lingering to gaze" before boarding the train that carried his family to Jersey City en route back to Nyack.

Cornell also had affectionate memories of trips to Coney Island. The famed amusements of Luna Park came into existence the year he was born, and it wasn't too long before he was skipping beneath the colorful half-moons adorning the park's entrance. Inside, you could travel to a lunar landing site where moon maidens pressed green cheese into your hand ("A Simulated Trip to the Moon") or whisk down a dramatic waterslide ("Shoot-the-Chutes" would later resurface in a title Cornell gave to one of his works). He was particularly fascinated by the penny arcades, where you could drop a copper penny into a slot and peep at pictures of model locomotives running in place or come away with a fortune-telling card.

On one of their trips to Coney Island, the Cornells ducked into a photographer's booth to pose for a family portrait. The charming black-and-white picture shows them in front of a (now faded) *faux*-Western backdrop, with little Joseph, a blond child of around five, sitting atop a fence in his cowboy hat. His mother is in white gloves and a flower-bedecked bonnet; his father in a three-piece suit. Mrs. Cornell is the only one who appears to be enjoying herself; Joseph, his father and his sister stare at the camera with a mix of boredom and impatience, perhaps because early photography required sitters to hold still for so long. Nonetheless, in later life, Cornell treasured this picture, and looked back on Coney Island as the enchanting setting where every family—for a day, anyway—became its own happily-ever-after fairy tale.

At home in Nyack, young Joseph was never too far from entertainment. The Cornell household was the type of place where there weren't many paintings or books but where one could find the latest records by Geraldine Farrar and Enrico Caruso; a stack of scratchy Red Seal albums survives among the family's heirlooms. The artist's parents were fond of opera and musical themselves, which gave them an aura of compatibility. Helen Cornell— short, vivacious, and not unpretty—liked to play the piano. Joe Cornell was musically more serious. An amateur singer and actor, he once appeared in a Nyack production of *H.M.S. Pinafore* and would walk around whistling tunes from all of Gilbert and Sullivan's light operas.

When his son was born, Joe identified himself on the birth certificate as a "commercial traveller," or traveling salesman. Commuting daily to New York City, he worked for a wool manufacturer called George E. Kun-

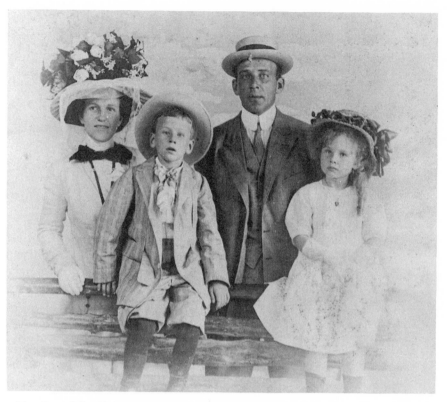

The Cornell family at Coney Island, c. 1908 (photograph courtesy Betty Benton)

hardt—an employer that would not vary in the course of his abbreviated life. He had joined the company in his early teens as a sample salesman and over the years rose to become a designer of fabrics. In photographs, he seems to be brooding, but his children remembered him as a stylish man who wore expensive Sulka suits and was full of mischievous charm. Little about his childhood might seem to point to the life of graceful ease he fashioned for himself. Born in Closter, New Jersey, on March 4, 1875, the youngest of three boys, Joe had grown up in straitened circumstances. His father (the artist's paternal grandfather) "caught cold walking up the hill to the train station" one day and died of typhoid fever when little Joe was just fourteen months old. His widowed mother, Harriet Bristol, settled in Nyack after living briefly in nearby Piermont, and her sons were raised burdened by worries about the family's welfare.

The artist's mother, Helen Ten Broeck Storms, was not nearly as attractive or poised as her husband, but came from a prominent family. Her maternal

grandfather, Commodore William R. Voorhis, had been one of Nyack's wealthiest citizens, and an avenue in the town still bears his name. Born in the Greenpoint section of Brooklyn on August 21, 1882, Helen had grown up in Nyack, an adored only child. In 1901, she graduated from Nyack High School, upon which occasion she received (according to her gift log) thirteen flower bouquets from as many people, as well as a gold chain, a purse, a lace collar, and some handkerchiefs.

It was only natural for her parents to assume that a young lady of Helen's advantages would go on to marry an eligible gentleman. To prepare her for this exalted fate, they saw to it that she was literate, could quote the Bible, and knew how to play bridge. Did she yearn for something wider than the life of utter idleness into which most women then routinely passed? Perhaps. In 1902, she enrolled in a training school for kindergarten teachers run by Miss Jenny Hunter—a handful of neatly folded origami squares survive among Helen's papers. Yet within a year she was engaged to Joe Cornell and had relinquished any interest in making her own way in the world.

Helen was twenty when they married, Joe seven years older. The service was held on November 12, 1902, at the First Reformed Church in Nyack, and news of it was carried on page 1 of the *Nyack Evening Star*. The article included a perhaps inadvertent jab at the disparity in the couple's social standing: "The popularity of Miss Storms with the entire community, and the respect of everyone for the groom, who is almost as well-known, was cordially attested."

The Cornells were comfortably upper-middle-class and had a good deal of hired help. Helen, a prima donna indisposed to cooking or cleaning, ran her household with a nanny, and soon would supplement her staff with a cook and a full-time handyman who doubled as a butler for her frequent parties. On a typical day, she might go into Manhattan to shop for a hat or see a play, or meet her girl friends for an afternoon bridge party at one of their homes. Unlike her parents, Emma and Howard Storms, who lived down the street on Piermont Avenue and were active in the Methodist Church, Helen, a child of the gay nineties, was drawn to worldly pleasures.

For the early part of his childhood, Joseph was one of a trio of children who were close in age. His sister Elizabeth, soon nicknamed Betty, arrived on February 4, 1905, when Joseph was barely a year old. A year later Helen was born, on February 15, 1906. It goes without saying that most firstborn children feel animosity toward their siblings, rivals for their mother's affection. Yet Joseph had little reason to harbor such resentment. His mother

treated him as her favorite and gave him attention the others did not share. "You have always had top place in my life," she informed him with characteristic bluntness in a letter written many years later.

Being the "chosen one" carries burdens all its own, and in Cornell's case they were considerable. He would live with his mother for nearly his entire life, bound to her by an inordinate sense of filial piety. They were one of the oddest mother-son couples in the history of art, which hardly lacks for instances of possessive mothers. Helen Cornell deserves to be viewed alongside art's most formidable mothers—Marie Vuillard, the widowed corset maker who shared her Paris dwelling with her son until her death; Adèle Toulouse-Lautrec, whose son dined with her nightly after drunken afternoons in Montmartre; and Anna Whistler in her little lace bonnet, gazing sternly from her son's portrait, an icon of chilly maternity.

Helen Cornell, too, would make a piercing impression, at least among her son's acquaintances, who, in later years, were invariably surprised by this short, plump matron living in noticeable discord with her son. Many would see her as a punitive presence, nagging her son about dusting the blinds or clearing the table as if he were a slovenly child. A critical woman, Helen bound Joseph to her not only with the attention she lavished on him but with the approval she just as capriciously withheld. While she claimed he had "top place" in her life, she left him feeling more diminished than fortified, and led him to believe that nothing he accomplished was enough to repay her devotion.

Joseph grew up longing for his mother's affection, which he tended to associate with the gifts she bestowed. In later life, Cornell recalled in his journals his "delight at the never-failing souvenirs" his mother used to bring back from the city, which he "received in bed in the dark." It was a potent image, his mother approaching him in bed to present him with little gifts from penny machines—"fortune-telling cards," "weighing-machine cards," "match boxes," and "miniature 'silver' charms," as he noted. That Cornell linked these trinkets with the recollection of bedside visits from his mother suggests that he attached a sensuality to inanimate objects, an interesting detail in the case of a boy who would grow up to prefer objects to people.

Cornell appears to have been no less fond of the souvenirs his father brought home. Later on, he often described his father to his friends as a "magician," adding that Joe would return from work pulling gifts out of his coat pockets—candy, charms, magazines, and new sheet music he had

picked up in the city. But if Joseph thought of his father as a magician, it may have also been for a less enchanting reason: Joe had a habit of disappearing. He was always boarding a train for somewhere else. In addition to his regular excursions to Lawrence, Massachusetts, where the Kunhardt company was based, he vacationed at the fashionable resorts of the day— Pinehurst, North Carolina, where he golfed, and Wanakena, a lodge in the Adirondack Mountains where he fished and hunted deer. Helen, in the meantime, stayed home. She had an affinity for the sea, and as Joe set off on his outings, she would tell the children, "Daddy likes the woods, but I like the ocean."

Their marriage was beset by larger differences as well. Joe was far more cultivated than his wife, and even at home found pleasure in interests she did not share. As someone who designed fabrics for a living, he was presumably a man of aesthetic sensitivity. His children thought he sang "like an angel," and were further impressed by his woodworking talents; in his leisure time he carved boats and built furniture. Clearly he had an artistic side, in addition to an innate sense of style, and Helen paled beside him. While he liked to spend her money, his frequent travels suggest that he was restless with their life together. One suspects that Helen felt disappointed by the unmet expectations of her marriage, which would partly explain the intensity of her emotional investment in her son.

Joseph's relationship with his father was distant compared to that with his mother. Once when his father took him on a trip to the Adirondacks, young Joseph jotted in a postcard to his sisters: "Dada," then crossed it out and wrote "Dad," then crossed that out, too, before finally settling on "Dady gave me this post-card to send to you." Joseph's difficulty in finding the appropriate moniker for his father hints at a fundamental unease in their relationship. Sometimes Joe would take him into the city and show off his "Boysie," as he nicknamed his son, to the men in his office. In later years, walking past his father's old work place at 25 Madison Avenue or a nearby wax museum they used to visit together, Cornell would grow nostalgic for the outgoing man with the slick hair and shiny shoes who in some ways remained a stranger to him.

When Cornell was growing up, his family lived in three different houses in Nyack. A modest white frame house at 288 Piermont Avenue today bears a plaque from the local historical society stating that Cornell was born there. When he was four, the family moved to a larger house on the same street, number 146, next door to Helen's parents. But Cornell's memories of his

childhood were invariably set against the backdrop of "the big house on the hill," purchased in December 1911, the day before Joseph's eighth birthday. Located at 137 South Broadway, the house was as grand as any in town: a rambling Gothic-revival mansion cluttered on the outside with chimneys, arches, gabled roofs, and a pointy tower.

The focal point of the house was the main hall, an oak-paneled room where Helen held her endless card parties. From the main hall, French doors opened onto the parlor, a candy box of a room decorated in high Victorian fashion with rose-colored wallpaper and polished brass trimmings everywhere. There, the family would gather on Sundays for a "sing" around the piano or to listen to records on the crank-up Victrola. At a time when most families with social or musical pretensions owned a piano, the Cornell family had two—one in the parlor, one in the main hall—as if to doubly affirm their musical cultivation.

The big house was up the hill from the Hudson, and a tiny balcony outside Joseph's bedroom afforded a view down the slope of Voorhis Avenue to the bank of the river. On clear days, he could see all the way to Tarrytown.

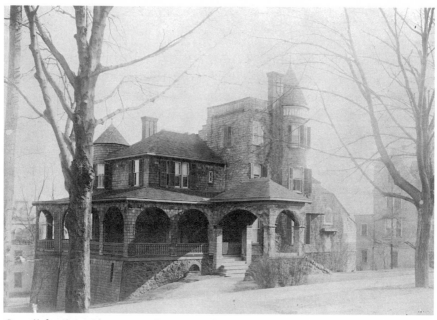

Cornell family residence, 137 South Broadway, Nyack, c. 1915 (Collection the Joseph Cornell Study Center, National Museum of American Art, Smithsonian Institution. Gift of Mr. and Mrs. John A. Benton)

At night he could watch lighted ferryboats gliding up and down the river. Nyack was a good town for dreaming. Built in the latter half of the nineteenth century, it gave off a quaint storybook charm; the peaks of its Victorian mansions, with their lacy woodwork, are still visible from the river's edge.

In Cornell's boyhood, Nyack's heyday had already come and gone. In the late 1870s, Nyack had been considered a healthful resort, and a dozen hotels and an opera house had sprung up to accommodate tourists. The depression of 1893 had brought a halt to downtown development. In the years when Cornell was growing up, the river was still lined with docks and hotels, but most were abandoned and served no use, except perhaps to a curious boy who could stroll the riverfront and imagine the days when the water was full of sails.

Joseph's connection to the history of Nyack was more than just a matter of idle reverie. At least one of his forebears—his Dutch ancestors in this country went all the way back to the days of the American Revolution— had played a large role in Nyack's development in the years following the Civil War. It was Commodore Voorhis, the artist's great-grandfather, who, in 1870, first persuaded the Erie Railroad to extend its tracks out to Nyack. An exemplary capitalist, rich by his adroitness and hard work, Voorhis designed and raced clipper ships, and made a killing in real estate. He founded the Nyack Water Works and came to own the local gas company as well. When he died in 1890, the *Nyack Evening Journal* elevated him to godly eminence in its page 1 banner headline: HE IS DEAD.

Commodore Voorhis had been dead thirteen years when Cornell was born. Cornell would come to prize the heirlooms he inherited from his great-grandfather, which included a silver pitcher won in an 1871 race, a set of monogrammed dinner plates commissioned from Tiffany's, and four or five paintings of his great clipper ships. One of them was done by James Bard, the distinguished boat painter, and showed a charming scene—the Commodore's *Tidal Wave* under full sail, its pennants waving in the breeze as two gentlemen in top hats converse on the deck.

Cornell always relished the notion that he was descended from voyagers, and though his own life would be externally static, he, too, was a kind of voyager. His little boxes are full of references to sea journeys—to moons, tides, globes, constellations, compasses, and longitudinal lines, all of which are evocations of his sailing ancestors, his own youth on the Hudson River, and a craving for transport in general.

• • •

It was believed that there was in fact a resident artist in the Cornell household: not Joseph, but his sister Elizabeth. Her mother thought she was uncommonly gifted and sent her to have lessons after spotting an ad an artist had placed in the local paper. The artist happened to be Edward Hopper. This was in the summer of 1915, and Hopper, at thirty-three, was eking out a living in illustration. In Nyack he was known mainly as the son of Garret Hopper, who owned a dry-goods store on South Broadway where Eddie had once worked after school. For some time now, Hopper had been living in New York City, but he would return to Nyack on Saturday mornings to teach classes in painting at his parents' house, where his hovering mother would serve lemonade to his students.

It would be nice to report that Joseph, too, studied with Hopper. It is appealing to imagine them as acquaintances, these two poets of yearning. For all the vast differences between their work, they shared a fascination with empty space and the melancholy feelings it can convey. Is it mere coincidence that both artists were obsessed with hotels? Hopper painted pictures set in hotel rooms, and Cornell would one day make a series of bare-looking Hotel boxes, a motif perhaps at least partly related to their boyhoods spent in the hotel town of Nyack.

Cornell was eleven the summer his sister studied with Hopper. Declining to join her in the class, Cornell chose to nurture his fantasy life through books. An avid reader, he would mystify and irk his parents with long disappearances into his bedroom. His favorite author was Hans Christian Andersen, whose "Ugly Duckling" and other fairy tales perhaps spoke to his sense of life's frustrations and the release offered by fantasy; his imaginative life was also peopled with the characters of the Grimm Brothers. Alone with his stories, Joseph would remain oblivious to the passing of time until his mother clambered up the stairs and burst into his room. "Get your nose out of that book," she would berate, "and go outside and get some fresh air."

Joseph was sent to Sunday school at St. Paul's Methodist Church in Nyack, probably as a concession to his grandparents. His grandfather Howard Storms was one of the church's directors, and his grandmother Emma never missed a church supper. While Joseph had been baptized six months after his birth at the First Presbyterian Church in Nyack (to which his father belonged), his parents soon switched to the Methodist Church, one of many matters in which his mother prevailed. While Cornell would later be consumed by

spiritual questions, nothing in his childhood might seem to have prepared him for the habits of devotion, except, perhaps, the void left by their very absence.

It was worldly experiences that counted now, none more so than holiday celebrations, which gave rise in the Cornell household to moods of almost unbearable excitement. If Helen had a forte, it was planning parties. She observed holidays with great fanfare, carefully plotting menus and guest lists and crafting imaginative party favors. One of her specialties was a Jack Horner pie, which wasn't really a pie at all but a sheet of cardboard rolled into the shape of a hat box and filled with tissue-wrapped favors. A colorful ribbon led from each plate to the gift-filled "pie," so that everyone at the table could become the Jack Horner of the age-old nursery rhyme, pulling out a plum.

At Christmastime, a candlelit tree was set up in the parlor, and the children would help their mother decorate it with everything from bits of imported hand-blown glass to plain paper snowflakes that Helen made herself. For Joseph, whose birthday fell on Christmas Eve, December 24 was always a truly royal day. His spirits would swell noticeably as his family gathered for a formal roast beef dinner. He would barely touch his food; instead, he would hop around the table, consorting merrily with his sisters as his parents scolded him to sit down and eat. In his adulthood, Cornell would look back on the Christmases of his youth as a magical time, and he always scheduled exhibitions of his work in December.

For all Joseph's love of childhood pleasures, his sisters recall him as a hypersensitive and moody boy who tended to stay around the house. He developed nervous ailments—stomachaches, especially—and did not hesitate to complain about them, if only because they brought attention from his mother. He once noted in his journals that "one of my most cherished, precious memories" was of lying in bed with a case of the croup as his mother administered a menthol treatment, "a vapor lamp lit to pervade the atmosphere." With the room aglow, he felt a keen sense of "mother-presence and mother-care."

From the time he was five, Cornell attended the Liberty Street School, a red-brick public school within walking distance of his house. While he was a top student—his grades hovered at around 90 percent—his attendance was less impressive. According to school records, he missed five weeks of kindergarten, four weeks of first grade, and six weeks of second grade.

In 1912, in the third grade, Joseph reformed his ways. That year the

number of "days absent" on his report card abruptly dropped to zero, and from then on he rarely missed a day of school. How does one explain the sudden change in the behavior of the nine-year-old? The answer, one suspects, is related to a tragedy that had recently befallen the Cornell family and made it increasingly unpleasant to be at home.

Robert Cornell was born on June 6, 1910, and it soon became evident that he was not like other children. To his parents' dismay, he was noticeably uncoordinated. He had trouble reaching and turning over, and suffered from tremors in his arms and legs. Specialists were consulted, opinions proffered. One doctor diagnosed Robert's difficulty in sitting up as "summer complaint," a euphemism for polio. Another doctor convinced Helen to spend a summer in Sharon, Connecticut, where in 1912 she dragged her four children—her husband stayed behind—to board in a farmhouse while subjecting her baby son to a predictably unsuccessful physical-therapy program.

The doctors did not realize that Robert was suffering from an incurable disease. As the family was to learn some years later, he was born with cerebral palsy, a disorder affecting muscular control and coordination. Cerebral palsy is usually caused by brain damage occurring before or during birth, and it seems likely that in Robert's case the damage occurred during delivery. He was the first of the Cornell children to be born outside his home—he was born in a hospital in East Orange, New Jersey, presumably because there were complications during labor that made it necessary to rush Helen to the nearest hospital.

In many cases of cerebral palsy, the effects are mild, but Robert's case was severe. From infancy he was almost completely disabled. While relatives recall him "crawling everywhere" as a baby, he was unable to raise himself up on his legs—he never walked and would spend his life in a wheelchair. He lacked the breath control necessary to speak in measured rhythms and instead blurted out words that sounded like grunts to those meeting him for the first time. In spite of his physical deformity, he was not mentally retarded (as many victims of cerebral palsy are) and so was fully conscious of his fate.

It never occurred to the Cornell family to shut Robert away in an institution. As the years progressed, he remained at home, with private tutors arriving daily to provide him with the equivalent of a school education. For Helen, who had never faced real difficulty before, the experience of having

Joseph (left) and Robert pose beside a little bird in Nyack, c. 1915 (photograph courtesy Helen Batcheller)

a disabled child was overwhelming, and she leaned on her other children for help. They were raised to understand that sacrifices would be expected of them. Betty later recalled once asking her mother whether she could have a dog, only to be told that a pet would pose a hazard to the nurses and maids as they carried Robert up and down the stairs in their floor-length dresses. And that was the end of that.

While all the members of the Cornell family felt protective of Robert, no one was more attached to him than his older brother. Joseph was six when Robert was born and felt great sympathy for the little boy with the "mysterious" disease who could not walk or play like other children. Robert was a good-natured child who laughed easily, and Joseph made every effort to amuse him. He played checkers and Parcheesi with him. He teased and joked with him. He nicknamed him Snicker, short for snickerdoodle, a kind of cookie their grandmother made.

Medical research has found that the siblings of a handicapped child are often encouraged to act as surrogate parents and are unable to express any negative feelings toward the child, a condition that developed to the extreme in the Cornell household: Joseph felt completely responsible for his brother's welfare, and their mother insisted he should. "She expected him to do everything for Robert, as if he were a girl," their sister Betty later remarked.

Already, it seems, the basic triangle of relations in Cornell's life was firmly in place. He believed it was his mission to care for Robert, a vision conceived out of loyalty to his brother but also to his implacable mother. The three would be inseparable for life, though it would be wrong to assume that the arrangement was particularly rewarding for any one of them. The sacrifices that Joseph made on Robert's behalf were certainly valiant, yet the self he inhabited was so diminished he could not afford to think of his deeds in such generous terms. The truth is that his mother made him feel that his own needs were unimportant beside Robert's—that he should be ashamed for having needs in the first place. Joseph would grow up believing that Robert was virtuous compared to himself and that nothing he did for his brother was ever enough to erase the stigma of unworthiness with which his mother seemed to have marked him.

It is difficult to exaggerate the intensity of Joseph's attachment to Robert and the degree to which he would tailor his life to meet his brother's needs. In later years, people who saw them together were invariably impressed by their closeness, though they often observed with surprise that Robert was the outgoing brother and Joseph the silent and depressed one. Robert was

the one in a wheelchair, but in some ways Joseph was the more hampered and hobbled brother.

In 1912, two years after Robert was born, the Cornell family was struck by another medical misfortune. Joe was diagnosed as having "pernicious anemia," a disease of the red blood cells that resembles leukemia. At first the illness assumed a mild form. As late as 1916, Joe was still commuting to work daily and was able to take a summer vacation with the family on Lake Mooselookmeguntic in Maine. In a snapshot from their trip, Joe stands rigidly beside his twelve-year-old son, who looks a bit tense as he leans against his father's body. The future artist looks more relaxed in a second snapshot taken moments later, in which he poses beside his smiling mother.

Within a few months, Joe had become a different person. His continual fatigue, his short temper, his almost complete withdrawal from family life left the children frightened. Helen couldn't conceal his condition from them; entering their parents' bedroom, they found their father "unable to lift himself, his skin tinted yellow." As Joe grew more and more debilitated, Helen decided she must have help. Though she had never considered institutionalizing her handicapped son, she apparently had less patience for her husband. She entrusted him to the care of a nurse named Valentine Peake, who ran a small hospice out of her townhouse on West End Avenue in New York City. There were brief periods when the disease seemed to be in remission, and Joe would be sent home from Miss Peake's for a buoyant reunion with his wife and children.

One April morning, Helen woke up the children especially early and told them their father was returning to New York immediately. If they hurried they could say goodbye to him. "Go and look out the window," she told them with her customary brusqueness, "because that's the last time you'll ever see him." Clustering around the large bay window in the living room, the children watched as their father was carried to an ambulance.

He died that night, April 30, 1917. "Joseph I. Cornell, a well known resident of S. Nyack, died yesterday at a sanitarium in New York City after a long illness," the local newspaper reported in a brief obituary. "He was engaged in the woolen business in the metropolis and was in his 42nd year. A wife and two sons and two daughters survive."

His body was promptly returned home and laid out for display in the parlor. Friends and relatives stopped by the house to pay their respects, and

the Cornell children were led into the parlor one by one to see the forbidding sight of their father in a casket. The funeral took place that Wednesday, at three in the afternoon, and more than a hundred people turned out for it, squeezing into the small pink room that had been the setting of so many Christmases and other happy celebrations.

With his father's death, Joseph lost the "magician" who had made his childhood a relatively comfortable and protected one. At age thirteen, he was suddenly the male head of his family, a sensitive youth trying to console his widowed mother and his three younger siblings.

In his abbreviated life, Joe Cornell had instilled in his son a love of vaudeville, music, and magic. Yet he made his greatest point about the rewards of escapism not by living but by dying. His death pushed his rattled son that much deeper toward a place where reality—threatening loss and disappointment at every turn—was something to be denied.

Already Joseph had ideas about how that could be done. In August 1917, just four months after his father's death, he tried to distract the family for at least an afternoon by putting on a show in the old barn on their property. According to his sisters, the show centered on a metal safe that contained a chained loaf of bread, in all likelihood inspired by Houdini and the death-defying escapes Joseph had seen him perform. Price of admission: one pin. A surviving ticket—which Joseph typed up and probably modeled on some real ticket stub he had squirreled away after a day in Manhattan—alerts the lucky holder:

COMBINATION TICKET ENTITLES BEARER TO:
"The Professional Burglar"
Relic Museum
Candy
Shadow Plays

It's a startling program. As a young impresario, Joseph was already focused on "relics" and tricks of escape, which together define the essential traits of his art. Cornell, of course, was hardly the only child of his era with a keen appreciation of vaudeville and penny arcades, or, for that matter, toys and candy. What set him apart from other people is not that he loved the amusements of childhood but that he would never outgrow them.

Cornell and his father in Maine, 1916 (photograph courtesy Betty Benton)

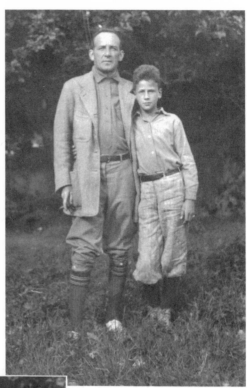

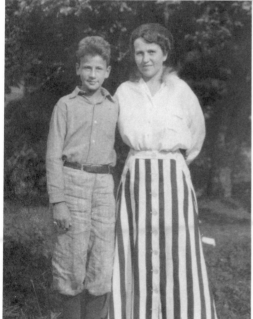

Cornell and his mother (photograph courtesy Betty Benton)

To the end of his life, Cornell retained an exalted vision of childhood. He regarded children as the royalty of the universe, and in his work they would one day surface as literal aristocrats. His Medici Slot Machines, perhaps his best-known series of boxes, each feature a child prince or a princess transported from an Old Master painting into a simulated penny machine. Cornell had virtually nothing in common with these little Medicis—he wasn't Italian, he wasn't blue-blooded, and obviously he didn't grow up during the Renaissance. Yet it isn't surprising that he would be drawn to these patrician children, for he believed more than anything in the nobility of childhood. And he believed it with the conviction of one whose own youth had been deeply unhappy.

The task of biography traditionally has been to find correlations between art and life and demonstrate how day-to-day events shape an artist's work. Yet while "real life" influences an artist's work, it cannot fully explain it, and the truth is that art and the dreams underlying it can shape a life as much as the other way around. In other words, artists are governed by ideas and ideals that determine the arc not only of their work but of their everyday lives. By age thirteen, Cornell had endured a good deal of disappointment, but the events of his childhood—his father's death, his brother's impairment, and the feelings of helplessness they engendered in him—perhaps matter less than the dream he was spinning in response. Already he had taken refuge in what might be called a fantasy of eternal innocence, imagining a world untouched by time or adult experience.

2

Dreaming of Houdini

1917-21

In September 1917, Joseph Cornell, accompanied by his ever-vigilant mother, traveled by train to Andover, Massachusetts, just north of Boston. It is surprising, perhaps, that a boy from a family with no academic ambitions—neither parent had attended college—ended up at Phillips Academy, one of the most prestigious preparatory schools in the country. However, the idea of sending Joseph to Andover didn't originate with his family. Rather, it was his late father's employer, George E. Kunhardt, who proposed that young Joseph be sent to boarding school. He felt that the experience would do him good, providing him with masculine guidance and direction. And the boisterous presence of boys his own age, he pointed out to Mrs. Cornell, would help coax Joseph out of his mourning. If she had any doubts about sending her thirteen-year-old son away from home, Kunhardt managed to quell them. An affluent businessman who had made a fortune in New England woolen mills, he happened to live just three miles from the school, in a newly built mansion in North Andover, and he promised to look in on Joseph from time to time. Moreover, he assured Mrs. Cornell that he would be happy to help on the financial end should money be an issue.

Cornell's four years at Andover were his first and last extended departure from the cocoon of his family. In later years he talked little about his time there, perhaps because it proved to be a frustrating one for him. He did poorly at his studies and was no good at sports. Painful stomachaches and other nervous ailments continued to be a problem. Four months after Joseph started school, a nurse informed Mrs. Cornell that her son had been confined to the campus infirmary with "an attack of German measles." In a second letter, written on January 28, 1918, the nurse dutifully reported: "This is

to advise you that your son's illness proved to be not German measles, but merely a rash caused by indigestion"—an unlikely diagnosis.

In later life, Cornell felt that his experiences at Andover had nothing to do with the development of his art; he was barely aware of what art was when he began and the school did nothing to change that. In 1969, after Cornell had become famous, Andover asked him to lend some of his boxes to an exhibition of work of alumni artists, who also included Frank Stella and Cleve Gray. Cornell obliged, though when asked to describe his "outlook on the arts" during his student days, he replied curtly: "Feelings at Andover at age 13–17 on this subject NIL." He went on to say that the "connection between Andover and subsequent development of my art work is a very, very remote one, if any."

Nonetheless, Cornell remained kindly disposed toward the school and, in the 1960s, considered donating some of his boxes to the Addison Gallery of American Art, the campus museum. He hoped that "the boxes might find a 'home' of extended duration as a memorial to my parents, especially my mother; memories of her taking me up [to Andover] in '17, an enormous debt to her." Clearly this memory loomed large in his imagination, though there is something inflated and even preposterous about his gratitude. For all the richness of his years at Andover, no experience left a stronger impression than the train ride that separated him from his mother.

Andover, the oldest preparatory school in the country, prides itself on a constitution predating the United States. In Cornell's time, the school was all-male and groomed boys for an Ivy League education and hence a future in what used to be called polite society. Cornell's fellow students included Benjamin Spock, Walker Evans, and a plethora of young men destined for careers in their fathers' law firms and businesses. Art in those days was virtually nonexistent, so far as the students knew. The school had no art museum—one was opened in 1931—and the closest thing to art instruction was a course in the T-square tasks of mechanical drawing.

A typical day at Andover began with the boys straggling from the dormitories for 7:45 chapel, where they'd say religious prayers and listen to Principal Alfred E. Stearns's summary of the daily war news. Then came morning classes. After lunch, the boys would converge at Brothers' Field for sports, until classes resumed again at four. Tremendous emphasis was placed on sports, and friendships could be made or broken on the basis of whether a student competed as a Gaul, a Saxon, a Greek, or a Roman.

Cornell ended up as a Gaul, a designation assigned by the school; one imagines it pleased the future Francophile.

If Cornell was interested in any one sport, it was track. A smattering of items in *The Phillipian*, the school newspaper, attest to his modest success in "club track," which was not the track team but the intramural version of the sport. Cornell once came in first in the 120-yard hurdle (time: 16⅓ seconds). On another occasion, Cornell finished third in the high jump, leaping 5 feet 2 inches off the ground—an appealing notion for an artist who would later make elevated ballerinas and flying birds motifs of his work.

While most Andover students lived in modern brick dormitories, Cornell ended up in more intimate, old-fashioned lodgings. His first year at the school he was installed at the Pease House, a five-room clapboard building whose residents were supervised by a live-in faculty member; in subsequent years he stayed at the similarly cozy Abbot House and Hardy House. The homelike accommodations had been chosen by Mrs. Cornell to help put Joseph at ease among his fellow students, and indeed it is clear that the lineaments of his shy, halting personality were already in place.

His classmates recall him as a nondescript youngster who failed to be much of a presence in the competitive fray of campus life. He formed no close friendships, and no one thought he was destined for greatness; in fact, very few people took note of him at all. "He was an inconspicuous loner who kept to himself," recalled a classmate, Dr. Alexander Preston. James Bunting, Jr., concurred: "He was just a quiet Joe who obviously must have had a tremendous imaginative mind."

Students at Andover were given the choice between two courses of study: the classical program and the scientific program. Cornell chose the latter, perhaps because it seemed more practical than the humanities. And who could blame him for eschewing the humanities, which was hardly the medley of "relevant" courses that dominate academia today? Instead, it was filled with dusty language requirements. Latin was considered the one subject of paramount importance to the humanistic mind, and students were expected to perform dreaded feats of memorization in which Virgil had to be absorbed by the page. Roughly half the 150 youngsters in Cornell's class chose (as he did) the science program, although that did not exempt them from having to study classical languages. Cornell took four years of Latin, muddling through with Cs and Ds. Among the other subjects he studied at

Andover were algebra, physics, plane geometry, English, and the Bible, and he received consistently poor grades in each. His transcript is an unimpressive alphabet soup of Cs, Ds, Es, and Fs.

If there was one subject Cornell seemed to favor, it was French, which he studied every semester. In the beginning, overwhelmed by irregular verbs and the principles of pronunciation, Cornell received his usual lackluster grades. But by his third or "upper" year, when his French class left behind grammar in favor of a consideration of literary works such as Hugo's *Les Misérables* and the stories of Daudet, his grades showed a genuine improvement. He managed to sustain Bs, the best he ever did at Andover, and good enough to qualify him for the school honor roll, which was issued three times a year and published in *The Phillipian* for everyone to see. Students could receive up to six honors, but Cornell was listed thus: "One honor: French." During his senior year, he studied Spanish, and the school newspaper carried a double citation: "Two honors: French and Spanish."

Cornell's letters home from his Andover years—his earliest extant correspondence—suggest that he was too consumed with his family's well-being and finances to concentrate on his studies. A typical letter to his mother, penned in a neat, round script on stationery with a small American flag waving in the upper left corner, begins: "More good news! I got a job in the library, but only two days a week. I am sort of an office boy, putting around the books, carrying messages, etc. I get about 25 cents an hour in the library and I can only work there two days a week. Dawgonit." It makes sense that the future bibliophile found his first job in a library.

In another undated letter to his mother, Cornell again focused on money: "I want to thank you for the dollar. It was very kind of you to send it. Please don't send it if you need it. I have plenty. Did I tell you that I have a job in the library?"

Joseph also corresponded with his brother, Robert, enclosing money and striking a note of mature concern. "Dear Robbie," reads an undated letter. "I got your two nice letters and I loved them. They were very cute. I am so sorry that you are sick and have a cold. I have something for you and will mail it tomorrow . . . Tell sister to buy you something with this 25 cents. Something to play with in bed if you still have a cold."

In the meantime, Cornell made his own effort to amuse his brother. His letter to Robert came decorated with his first surviving effort at art. In the margins he drew a picture of those comic-strip favorites Mutt and Jeff, talking to one another with word balloons. Mutt is saying: "Here's a quarter.

Go buy yourself a Ford, Robbie. I hope you get well." Jeff, dressed loudly in polka-dot pants, joins in: "Yep, save your pennies and buy a Ford, Robbie." It's interesting that Cornell would be fond of Bud Fisher's Mutt and Jeff—like himself and Robert, a close-knit odd couple whose sense of dignity was constantly undermined by the world's indignities.

If Joseph thought about anything besides ministering to his family, he did not say so in his correspondence. Was he making friends? How was the food? Were there any teachers he liked or disliked? He did not comment on the everyday effluvia of boarding-school life. Instead, he offered obsessive broodings on his family's welfare, on Thrift Stamps and War Saving Stamps and Liberty Bonds, which the boys of Andover could purchase through the student council, paying in weekly installments. Cornell's letters ("Please don't spend your money on Thrift Stamps for me. Keep them for yourself") might suggest that he was trying to live up to the ideal of manly service and self-sacrifice fostered by the war. Joseph's cause was not his country, though; it was his mother. His loyalty to her was so extreme that he could not even send a get-well card to Robert without guiltily informing her: "I am sending him a letter addressed to him. I didn't think you'd mind."

Most mothers make demands on their children, and most children learn in short order to resist them. But what chance did Joseph have of cultivating a life apart from his family? Mrs. Cornell's possessive behavior might not have cut so deeply in a less damaged household, but as a widow with a handicapped child, she inculcated in her older son an almost overwhelming sense of obligation. Moreover, the Victorian notions that prevailed during Joseph's childhood—sunny ideas about goodness in children—only reinforced his already exaggerated indebtedness to his mother. While other boys at Andover were moving beyond childhood to meet the challenges of adolescence, Joseph seems to have stopped somewhere short on the road to emotional independence.

If Joseph's letters from school tended to harp on finances, he had legitimate reason for concern. His family had fallen on hard times after his father's death, losing nearly all their money. With his parvenu's tastes and indulgent ways, Joe Cornell turned out to be a greater burden in death than in life: to his wife's dismay, he died with large debts she had known nothing about. Then, Mrs. Cornell was no wizard at business, either. When Mr. Lindsay, a local attorney, stepped forward after her husband's death to volunteer investment advice, she naïvely entrusted him with a few thousand dollars. Her daughters remember him telephoning the house every two weeks to

report on her earnings, but when Mrs. Cornell tried to recoup her investment—she met him once at Grand Central Terminal, another time at Delmonico's—all he could offer were promises of a future windfall. She never saw the money again, and Mr. Lindsay eventually went to jail for swindling eight widows out of their inheritances.

Within a year of her husband's death, Mrs. Cornell had laid off the help and was sending notes to the administrators at Andover to request information on financial aid. "Dear Mr. Bancroft," she wrote to the school registrar on August 9, 1918, "I would like to enter Joe as a scholarship student this September. Will you please tell me what steps to take." For further help, she turned to her late husband's longtime employer. She apparently let him pay for tuition and board, at the time about $600 a year. On Joseph's school records, beside the space reserved for "Guardian's Name," it says "Bills to Mr. George E. Kunhardt."

In a more dramatic concession to her reduced finances, Mrs. Cornell decided to sell the family house. Her plan was to rent it out for a spell as she tried living in New York City. It is hard to know why a widow who had four school-age children and whose parents lived a few blocks away would want to leave the comfort and familiarity of her longtime residence for the inevitable hardships of the city. Was she selling the house to pay off debts? Or did she feel an urge for something—anything—new? Indeed, her children cite her "spirit of adventure" as well as a restlessness with small-town life. They say she wanted something more than days filled with gossip and bridge parties.

Yet it seems more likely that Mrs. Cornell left Nyack not so much to pursue a new life as to escape her present one; undoubtedly she felt embarrassed by the family's fall from propertied eminence. No one on Montauk Avenue in Bayside, Queens—where she proceeded to rent a modest house in September 1918, while Joseph was off at school—need know about her husband's careless finances. And no one in Queens would raise an eyebrow at the sight of the Cornell family living in a small, plain, two-story house they did not even own.

For Joseph, the sale of his childhood home in Nyack was one more reminder of life's transience. A father dies, a house is sold, a family moves away without a trace. Yet whatever his feelings about the summary loss of his house, his immediate anxieties were tethered to nickel-and-dime concerns about supporting himself at school. He began his second year at Andover classified as a scholarship student, which obligated him to assume a new

part-time job. "He spent a lot of time working for his scholarship," recalled his classmate Edward Skillin, later the editor of *Commonweal* magazine. "What I remember is seeing him in the dining hall, waiting on tables, and how he seemed to be an energetic type." Busing dinner trays in the campus refectory obviously didn't enhance Joseph's social standing at Andover. Yet, as with his previous job shelving library books, he appears to have welcomed the task as a justification of his continued presence at school.

If Joseph had a hero at Andover, it wasn't a teacher or a favorite friend or anyone whom he knew personally. Rather, it was Harry Houdini. The memory of seeing him at the Hippodrome burned brightly in his mind. Assigned to prepare a short talk for a public-speaking class, Cornell wrote a report entitled "The Greatest Magician in the World"—the one paper that survives from his school days. Houdini, born Erik Weisz, the son of a Hungarian rabbi who eventually emigrated to Appleton, Wisconsin, was then touring Europe and America and astonishing audiences with his amazing repertory of escapes and mysteries. He could pull rabbits from hats and do a thousand card tricks. Locks would fall open at his fingertips, and he could extricate himself from ropes and chains and cabinets and coffins. Joseph relished the idea, as he reported in his paper, of "Houdini before seventy thousand people, hanging in midair, escap[ing] from very special constructed shackles and handcuffs."

Children everywhere were wonderstruck by Houdini, but for Cornell he held an unusually personal appeal. To be able to escape all physical constraints—the notion was understandably irresistible to a youngster who wanted nothing more than to see his crippled brother get up from his wheelchair and overcome his physical disabilities. If only Robert could walk. Joseph's interest in Houdini was perhaps also a way of finding a connection with his dead father, whom he had thought of as a magician in his own right.

Then again, Joseph's identification with Houdini grew out of a larger and more basic yearning—the desire to shed his own skin, to shake off his sense of limitation as a marginal student just barely scraping through school. He wanted to disappear from life just as he apparently "disappeared" in the classroom, not only by daydreaming but by vanishing behind that mental wall which everyone who knew him eventually ran up against. Cornell, too, was a kind of escape artist; he would one day free himself from his shackled existence through his art.

For now, however, reality continued to present him with so many obstacles

that he never even got to talk about Houdini. After boasting to his mother, "I am going to give a speech on Houdini if I get called on in English class," he confessed with his customary docility soon after: "I was all ready to give a speech on Houdini, but was not called on. I will save it for another time."

During his Andover years, Cornell remained in steady contact with his father's former employer, George Kunhardt, who had four young children and thought nothing of having Joseph join the family for Thanksgiving dinner or other special occasions. His fifty-acre estate in North Andover was a *nouveau riche* extravaganza; his house, though supposedly modeled after a French château, included a swimming pool lined with Italian tiles and hand-carved marble sheep frolicking in the living room on a fireplace mantel, a testimony to his success in the wool trade. Joseph once described the Kunhardt family as "rugged, German types" whom he liked enormously, and he was grateful for their help.

One summer Mr. Kunhardt gave Joseph a job in the company textile mills in Lawrence, Massachusetts. It was Joseph's first job outside of school, and not surprising perhaps that he followed his father into the wool trade. His best experiences that summer, though, were unrelated to work. He had a chance to make several trips to Sandwich, an old settlement on Cape Cod famous for its colored glass. Wandering the village, with its little streets and cottages, its ancient duck pond and crumbling mills, Joseph was able to imagine an earlier era. And he never forgot the feeling. In 1939, he wrote a friend: "Your card brought back the dunes of Sandwich and browsing amid the old glass ruins—you can enter the past so easily up there."

It was on his outings to Sandwich that Joseph first discovered the pleasures of antique shops and secondhand things. He liked to scout the local shops for Sandwich glass, the prized variety of cut-and-blown glass that had been discontinued in 1888. Already he knew that everyday objects could provide a route into the past that was almost as direct as memory itself, and it is worth noting that the dusty glass jars and saucers that constituted his first collectibles dated from the time of his father's youth. Joseph's early assemblage of glassware might be understood as both an affectionate remembrance of his father and an artistic rumination on how the dead can speak to the living.

Back at school, as Joseph's grades stayed low, George Kunhardt wondered if anything could be done. At one point he contacted Principal Stearns to ask whether Joseph might stay on for a fifth year, in order to complete his required courses with less pressure. But Andover's way of dealing with the

poorly adjusted student was to make him adjust. As the principal politely explained in a letter of September 18, 1919: "At your suggestion I brought to the attention of the faculty recently the case of the young Cornell and raised the question as to the desirability of extending the boy's course another year . . . The instructors who have met the lad in the past all seem to be pretty well agreed that it would be unwise to lighten his schedule to any considerable extent at this time. They feel that he can carry the full number of hours and that he will probably do his best work under such an arrangement." And so Cs and Ds continued to accrue on Joseph's report cards.

His family was well aware of the problems he was having at school, which extended beyond low grades. Visiting her son at Andover one year, Mrs. Cornell was informed by the principal that Joseph was an "unusually sensitive" youth who suffered from nightmares and was prone to anxious behavior. Word had gotten back to the principal about one occasion when Joseph alarmed his roommates by jumping up from bed in the middle of the night and tearing some U.S. war posters from the walls in what appeared to be an uncontrollable fit.

At home for Christmas recess during his eleventh or "higher" year, Joseph aroused his sister Betty's concern with his intractable self-doubts and apprehensions. She recalls a night when she awoke to find her brother in her bedroom, trembling violently and asking if he could talk to her. He walked to the window, gazed into the darkness, and explained that he had been studying the concept of infinity in his astronomy class. To this diffident youngster who was given to restrained, inhibited behavior, the idea of a universe without limits or boundaries was intensely vivid, and he quivered before visions of it.

A photograph from his Andover yearbook—the 1921 *Potpourri*—shows Joseph as a willowy young man with handsome features who is looking at the camera in a calm, cautious manner. He is wearing a tie and a jacket. The seniors who share the page with him appear to have enjoyed more active stays at the school, and their photographs are accompanied by testimony to their enterprise; their participation in the Gaul Wrestling Team, Club Football, the Harvard Club, the Winter Police Force, and other lofty pursuits is duly noted. Joseph I. Cornell, by contrast, has no extracurricular activities listed beneath his name. The only information provided is "JOE," his colorless nickname.

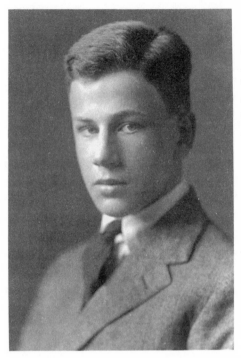

Cornell's yearbook picture, Phillips Academy, 1921 (Collection the Joseph Cornell Study Center, National Museum of American Art, Smithsonian Institution. Gift of Mr. and Mrs. John A. Benton)

While Joseph left Andover after four years, he did not in fact graduate. He lacked credits in history and mathematics, and thus was not awarded a diploma. During his junior year, nearly all his classmates had filled out applications to Ivy League schools and taken their college qualifying exams. But Joseph never did. Consumed as ever by his family's situation, he felt it was inappropriate for him to consider college. "He didn't go to college because he couldn't afford it," his sister Betty later explained. "He felt he should never have gone to Andover. He felt he should be home being the man of the house." While other boys were bent on secret plans of their own, Joseph did not feel entitled to harbor grand plans or to envision a future beyond the life of familial loyalty he felt awaited him.

Joseph was thirteen years old when he entered Andover, seventeen when he left—four years that spanned a crucial period in his life. That he claimed these years had no influence on his art is not a true gauge of their significance. At the very least, he came away from Andover with a favorite author: Thomas De Quincey, whose *Joan of Arc* and *The English Mail Coach* remain among Cornell's surviving books. It makes sense that Cornell would be drawn to De Quincey, an eccentric English essayist and critic whose childhood ex-

periences were not completely dissimilar from his own. As De Quincey recounted in his *Confessions*, his early years were shattered by a family death (his sister's), which led him to retreat deep into an imaginary world. De Quincey was probably not assigned in a course; Cornell most likely discovered his books through his job as a library clerk. Andover has a good dreaming library, and it is easy to imagine Cornell exploring the stacks.

But Joseph's experiences at Andover were hardly confined to books. Andover was a world of its own—rivalrous, demanding, unforgiving of failure. And for Joseph, a tense adolescent who remained in danger of flunking out his entire time at school, it was a world that offered very few rewards. Whatever he learned there had less to do with his exposure to the French subjunctive mood or the properties of "pi" than with his awareness of the outside world—a world, he now knew, that could only sharpen his already intense feelings of isolation.

3

Life of a Salesman

1921-28

After leaving Andover in June 1921, Cornell joined his family in Queens. Few Manhattanites in those days crossed the East River to make the trek into Queens, a mix of small businesses and former dairy farms that had recently been divided into residential building lots. The Cornells settled in Bayside, a picturesque town of about 7,000 people that combined the charms of a village and a seaside escape. They lived just a block from Bell Boulevard, the hub of town, where you could order an ice-cream soda at Voss's pharmacy, buy a stogie at Heichert's cigar store, or see the latest Western at the Bayside Motion Picture Theatre. When people went shopping on Bell Boulevard, they said they were going to the "village," the women in gloves, the men in vests, everyone in a hat. The trolley, with its clanging bells, carried riders to neighboring Flushing.

Bayside was located on Little Neck Bay, and the air had a salty smell. The town's shoreline was fringed with mansions and villas, many of which in Cornell's time were owned by famous actors and actresses. Hollywood then consisted of little more than orange groves, and a good deal of moviemaking was being done in new studios in Astoria. Gloria Swanson, W. C. Fields, Norma Talmadge, and Buster Keaton were among the "Baysiders" who lived within walking distance of the Cornell family's house, albeit sequestered in their imposing and princely waterside digs.

During the decade they spent in Bayside, the Cornells lived in three different rented homes. At first (when Joseph was still at Andover), they lived on Montauk Avenue, in a comfortable house next door to an Episcopal church; they had to vacate it when the estate to which it belonged was sold. Next they moved to First Street (now 214th Place), where Joseph joined them after finishing boarding school. The shingled house was small and

uninteresting; it was one in a line of eight virtually identical houses, with eight others just like it across the street. The strip was known as Bridal Row—its residents consisted mostly of hard-pressed newlyweds—and was owned by a spinster named Annie B. Storm, who was descended from one of the town's founding families and came around personally on the first of each month to collect the rent.

Cornell's first priority after leaving school was finding a job, which he was able to do with little difficulty. In the fall of 1921 he began work as a salesman for the William Whitman Company, a Boston-based textile wholesaler with a division in New York City. The company occupied two floors of an office building at 25 Madison Avenue, near Twenty-fourth Street, in the middle of the insurance district. As was true of his summer jobs, Cornell obtained his first permanent job through family connections, this time an old friend of his father's from Nyack named Frank Leahycraft. Leahycraft had started his career at the Kunhardt company alongside Joseph's father, but had since switched to Whitman's and become head of the New York branch.

Hired as a "sample boy" at a starting salary of twelve dollars a week, Cornell was expected to sell as much cloth as was humanly possible. Day in and day out, he made the rounds of menswear manufacturers, most of which were located on the strip of Broadway just south of Madison Square; the area was once known as "Ladies Mile," because of the stylish clientele streaming through Wanamaker's and other department stores. Cornell was now eighteen years old, a lanky adolescent who stood five-foot-ten but who looked taller, with long limbs and a long face. He had amazing eyes—blue and piercing—yet in conversation usually averted them, staring at the ground. His jackets and slacks tended to be a bit large for him, hanging loosely on his frame, as if he wanted to disappear inside them. No one could mistake him for a happy salesman as he lugged his heavy sample trunk along the crowded sidewalks of Broadway. Withdrawn and socially uneasy, he was, by nature, anything but a salesman: it's hard to imagine that he ever convinced anyone to buy anything. He later remarked that he loathed his encounters with customers and lived in dread of his daily sojourns to "the nightmare alley of lower Broadway."

Cornell's job at Whitman's was not an intellectually demanding one and represented an abrupt anticlimax to his years at Andover: his knowledge of Virgil and the abstruse workings of French grammar, however elemental, did not count for much in the clamorous offices along Broadway where he

peddled his goods. While his father had started out as a sample boy and eventually risen to become a designer of fabrics, it is doubtful that Joseph hoped to do so. Unlike his father, he wasn't interested in designing clothes and saw his job mainly as a paycheck, a fulfillment of his family duties.

It isn't surprising that Joseph cared little for his job at Whitman's. What is surprising is that he kept it for nearly a decade, never looking elsewhere or preparing for another career. He seems to have been afraid of reaching beyond his web of family connections to secure something on his own. Rather, he took the job that was offered to him, the path of least resistance.

One consolation for Cornell was simply being in Manhattan. He later recalled the 1920s with affection, if only because they exposed him to "the teeming life of the metropolis." He had a passion for walking the city, walking anywhere, looking at whatever fell into his sight—the people, the pigeons, the reflections glimpsed in the windows of buildings, the new steel skyscrapers rising out of nowhere, the crumbling brick houses where the city's Dutch settlers had lived so many centuries earlier. Plying the streets as a salesman, he came to see Manhattan as the epitome of glamour, a large and faceless city that held secrets and mysteries on every block.

Among his favorite parts of town was Times Square, where theatergoers in top hats and tails shared the sidewalks with gangsters, bootleggers, and other sleazy types. At night Broadway was the Great White Way; by day it offered a grayer sight, but the crowds pouring into the Roxy, the Strand, and the other new moving-picture palaces made the area seem furiously alive. Cornell would soon be among them.

Lower Manhattan was another world altogether. While most artists were drawn to the cafés and cabarets of Greenwich Village, Cornell was more interested in the neighborhood's quieter spots. He loved visiting the secondhand bookshops up and down Fourth Avenue; they extended from Astor Place to Union Square and formed the longest row of bookstores in the city. With open-air bins lining the sidewalk, the avenue's bookshops were the New York equivalent of Paris's bookstalls, and Cornell could not have been any happier walking the banks of the Seine. Inside, the shops were shadowy, overstuffed places with narrow aisles and crooked floors; they had names like Biblio & Tannen, Schulte's, Aberdeen, and Green Books. There was always some owlish proprietor parked on a stool behind a wooden desk, though Cornell had no need to talk to anyone. Silently he browsed among mountains of books or riffled through bins filled with prints and postcards from distant eras and countries. Among his regular stops was Sign of the

Sparrow, which specialized in theatrical memorabilia; he once described the musty shop as "a sanctuary and retreat of infinite pleasures." On innumerable evenings he returned home to Bayside with a treasured secondhand or third-hand book, his topcoat glazed with dust.

The neighborhood where Cornell reported to work every day had its own rewards. He knew Madison Square from the days when his father had worked nearby and was not unhappy to be back among the urban landmarks of his childhood. In nice weather he would often have his lunch on a bench in the square, a large, unpretentious park starting at Twenty-third Street, where clerks, shop assistants, and office girls would sit and eat their frugal sandwiches. The park looked out on wonderful buildings, such as the Flatiron Building—our American Parthenon, as Alfred Stieglitz called it at the time of his famous photograph—and the Metropolitan Life Insurance Company Building, with its *faux*-Venetian tower. And then there was Stanford White's Madison Square Garden, at Madison Avenue and Twenty-sixth Street, the soon-to-be-demolished entertainment palace whose boxing matches and circuses made the area a hub of activity.

Joseph was one of a dozen salesmen at Whitman's, and a boyish camaraderie prevailed among them. The salesmen's desks were clustered toward the back of the fifth floor, and walking by the area one could hear a din of voices as the men took orders by telephone or shouted out numbers—information on sales—across the room. While Joseph got along with his fellow salesmen, he remained an essentially solitary young man who did not see anyone outside work or share his colleagues' inevitable interest in girls and dating. "He was just different that way," remarked his sister Helen, who began working at Whitman's two years after her brother, as a secretary in charge of the order books. "He was wrapped up with Robert. He was wrapped up in his own life."

The chasm that divided Joseph from other young men was not merely a function of his unusual living situation. Compared to his office mates, he was prone to exceedingly prudish behavior. One day in the office, the salesmen began exchanging ribald comments about a large, sleek sculpture of the Greek goddess Diana being dismantled outside their window (the famous gilded copper statue by Augustus Saint-Gaudens had towered above Madison Square Garden). Four decades later, the incident was still in Cornell's thoughts; he told the art critic Phyllis Tuchman that he never forgot his embarrassment and dismay over his office mates' bawdy comments.

Diana was a goddess: yet so were all women to Cornell. He brought an

almost worshipful respect to his relations with women, treating them as embodiments of a lofty ideal. While he was likely to admire women from afar on his jaunts around the city, he did not manage so much as a date or even an after-work cup of coffee during these years, according to his family.

At the end of his workday, Cornell would walk across town to Pennsylvania Station and take the Long Island Rail Road to Bayside, usually catching the 5:11. He enjoyed the thirty-minute commute; as he gazed out the window, the day's activities would wash away. His evenings were uneventful, but he seemed not to mind; he felt obligated to be with Robert, who remained in a wheelchair, with no more hope of walking now than he ever had had. On most nights, Robert and Joseph could be found in the living room listening to the radio or the record player. Joseph had a good ear, and music moved him profoundly. He would play new French recordings he had picked up in the city—the moody impressionism of Debussy, the deceptively simple piano arrangements of Erik Satie—as well as composers like Beethoven and Wagner whom the brothers had admired since their childhood.

Robert, almost sixteen, was still more or less homebound. When the family first moved to Bayside, a teacher from the public-school system came to the house several times a week to enable him to receive the equivalent of a high-school education. But then one day the teacher fell asleep out of boredom. Robert *"felt so* for him," his sister Helen later wrote, "he told the chap not to continue." The anecdote is believable in light of the family's general indifference to formal education.

Cornell's sisters were living at home, too. After graduating from high school, they had taken on the sort of menial jobs young women then assumed while waiting to find a husband. Helen tended to the order books at Whitman's—she and her brother often commuted together—and Betty was a secretary in a small real-estate office in Flushing. As for Mrs. Cornell, it did not occur to her to look for a job. Rather, she lived off the children's earnings, insisting that they contribute most of their salaries to household expenses. Every week she drew up budgets on little index cards, specifying how much everyone owed her for rent, food, the dentist, and any additional expenses she managed to concoct in her unending hours of leisure. She was, beyond doubt, the head of the household, as anyone would know who looked up the family in the Queens city directory and found them listed, somewhat lugubriously, under "CORNELL Helen (wid Jos I)."

Whatever domestic gaiety had been present during the family's years in

Nyack had largely evaporated by now. There were no more lavish dinner parties, no more family sing-alongs around the Victrola. Upon moving to Bayside, Mrs. Cornell had sold her two pianos and promptly abandoned her efforts at music, which suggests she had taken it up in the first place merely as a concession to her musically inclined husband. Since his death, she had become a less graceful personality, a middle-class widow focused on paying the rent and other practical concerns. Her two daughters were sympathetic to her situation but nonetheless hoped to move away from home as soon as they could. In the meantime, they didn't hesitate to take long vacations in the country upstate and send notice of their travels to the local newspaper, as when the *Flushing Evening Journal* reported: "The Misses Helen and Betty Cornell are spending three weeks with friends in Saratoga Springs." Perhaps because they had always believed that their mother far preferred Joseph to them, their sense of obligation to her was not nearly as great as his.

For Joseph there could be no chance of pulling away from his family's orbit. This was because he felt obligated to care for Robert. In a way Joseph, too, had received an injury, a kind of emotional equivalent to his brother's physical paralysis. He felt compelled to renounce virtually any pleasure that he could not share with Robert, willing himself into a life as monotonous as his brother's.

If Joseph traveled anywhere, it was to see relatives. In 1923 he returned to Nyack for the Independence Day weekend, making the trip by himself, by railroad, and staying with his grandparents Howard and Emma Storms. Joseph appreciated their company; he liked to hear their tales of bygone days and to see their Dutch collectibles. After Joseph returned to Bayside, his grandfather wrote to Mrs. Cornell: "I'm so glad Joe enjoyed his visit. Tell him there will be something more to show when he comes again—the old quilt from Holland." The letter continues on a bizarre note: "What time did he get home Sunday eve? He bought such nice bananas for us, and so many they are not eaten up yet. I wanted him to take some of them home with them, but he would not." It's a curious detail, this surfeit of bananas. One might say that Cornell was beset by worries about manhood; or, alternately, that sometimes a banana is just a banana.

Already, Cornell had a consuming interest in culture—both the visual and the performing arts. On Saturdays, after finishing up at Whitman's at noon (he worked five and a half days a week), he would often head uptown for

one of the few worldly pleasures he regularly allowed himself: a matinee performance at the Metropolitan Opera House. The opera company then occupied a notoriously ugly building, a "yellow brick brewery" at Broadway and Thirty-ninth Street, though its interior was suitably ornate, all red-and-gold-encrusted splendor, and renowned for its perfect acoustics. Joseph loved going to the opera. He knew all the music from his childhood, when he had played and replayed his father's many Red Seal recordings, but until he moved to New York he had never had the chance to actually sit through a staged opera other than the amateur productions in Nyack. His customary practice was to buy a standing-room-only ticket for fifty cents and watch the performance from the back of the crowded theater.

The world of grand opera was far removed from Joseph's day-to-day experiences. Up on the stage, anything could happen. People fell in love, fought duels, fled homelands. Joseph found all this overblown emotion liberating. One of his favorite opera singers was Geraldine Farrar—majestic, dark-haired, with large, soulful eyes—who in 1922 gave her farewell performance at the Metropolitan Opera House as the emotionally received "Zaza." Farrar was an acclaimed dramatic soprano, but for Joseph her appeal went beyond the seductions of her voice and acting. He was enchanted by her very being, and he dreamed of actually meeting her. One afternoon he got up the courage to approach her backstage. He told her how much he admired her work, and she received him graciously. To his amazement she gave him a glossy signed photograph of herself—the memento survives among his papers.

On most other occasions he returned home with a less personal souvenir, a libretto purchased in the lobby of the opera house for a few pennies. His father, too, had once brought home the texts of operas and plays, but Joseph had no intention of singing the words or having his family join in. Librettos were simply mementos to him, and one imagines he valued them as much for the way they looked—ruled, black-and-white, vaguely antique—as for the mist of memories they stirred in him long after the stage lights had dimmed.

Cornell was also seeing plays. For a dollar you could purchase a ticket to the best seats in the roughly eighty playhouses concentrated in the streets around Times Square. Cornell, always frugal, was more likely to stand through the shows. One of his favorite plays was the 1922 *Rain*, which was based on a story by W. Somerset Maugham about a minister who falls in love with a prostitute. The play starred Jeanne Eagels, a slender blonde who

was briefly one of the great actresses of the stage. Years later, after her death from a drug overdose, Cornell would make a series of collages in her memory.

Another of his favorites was Eleonora Duse, a small, dark performer with sad eyes and the leading Italian actress of her era. After admiring her one afternoon in Ibsen's *Lady from the Sea*—the story of a physician's wife whose placid life is interrupted when a former lover returns to take her away from her family—Cornell became a stage-door Johnny, hovering expectantly outside the theater until he caught a glimpse of her. Eventually Miss Duse did appear, and he never forgot the sight, recalling in a letter in 1953: "I have a treasured memory of her emerging from the Met stage door in the plainest of overcoats."

In 1924 Cornell made several trips to the Metropolitan Opera House to see the great ballerina Anna Pavlova, who was performing *Swan Lake* on her farewell tour. Two years later, he saw a considerably less ethereal performance when a Spanish singer named Raquel Meller, who had all of Europe at her feet with her Gypsy love songs, made her U.S. debut, an "event of purest joy" for Cornell. After taking his two sisters to see the performance, he carefully filed away his ticket stub and program notes, making them the first of the "dossiers" that would become so crucial to his creative activities in later years.

Before he ever became an artist, Cornell was an enraptured fan, and his stint as a fan might be said to constitute his artistic apprenticeship. Most artists go to art school and learn how to draw the human figure. Cornell, instead, haunted the back sections of theaters and opera houses and waited excitedly outside stage doors, turning female performers into icons. There was something voyeuristic about his activities. Nowadays, of course, theater and its more modern descendants—film and television—have made voyeurs of just about everyone. But when looking is a substitute for sexual relations, it acquires a pathological edge. Cornell was a trailblazer when it came to the act of not acting and settling instead on vicarious looking.

Not that he was unaware of the art world. He had many opportunities to learn about painting as a curious newcomer roaming the streets of New York. He made the rounds of the galleries and museums, where the emphasis was still on nineteenth-century French art. Walking along Fifth Avenue or Fifty-seventh Street, he would peer into gallery windows lit up with Impressionist pictures in curly gold-leaf frames.

In the 1920s, the New York art scene was still provincial, and aspiring painters headed straight to Paris. Yet a few true talents stayed behind in

Manhattan and managed to infuse the scene with some semblance of vitality. At the Daniel Gallery, among the places showing avant-garde painting, Cornell admired the work of Charles Demuth and Peter Blume. Cornell also frequented Alfred Stieglitz's gallery, linking it years later to "a vanished golden age of gallery trotting." In 1926 he saw John Quinn's great collection of modern paintings, which briefly went on public view before being auctioned off. "In a single room," Cornell recalled three decades later, "one glimpsed *The Sleeping Gypsy* of Rousseau, *Le Cirque* of Seurat, the largest Picasso *Mother and Child* I have ever seen."

Another place to see new art was the Whitney Studio Club (the precursor of the Whitney Museum of American Art), which occupied a townhouse at 10 West Eighth Street in Greenwich Village and was devoted to promoting the neighborhood avant-garde. There was a shop on the premises where wide shelves overflowed with stacks of drawings priced at next to nothing. Cornell liked to browse in the shop and came to know its manager, Alexander Brook. He purchased a drawing by Brook's wife, Peggy Bacon, as well as a watercolor by George Ault depicting the nearby Jefferson Market.

But Cornell's artistic education was mostly conducted not in galleries or museums but at the Fourth Avenue bookstalls. One of his most prized purchases was Marsden Hartley's *Adventures in the Arts* (1921), an undervalued classic in which the artist writes with great sensitivity about people as different as Paul Cézanne, Odilon Redon, Emily Dickinson, Walt Whitman, and vaudeville performers, comfortably mixing high culture and popular entertainment. Reading Hartley's book, the critic Paul Rosenfeld once noted, was like "having strolled with him, looked into shop windows, visited a gallery or two, taken a turn at a vaudeville house, stepped into a circus dressing room." Hartley was a great wanderer of the city, much like Cornell himself.

Browsing at the bookstalls, Cornell became acquainted with material published both here and abroad. He later recalled that "the superb folios of *Ganymede*"—a Munich yearbook with sumptuous illustrations and essays by the great art historian J. Meier-Greife—"opened up a world of wonder." Among Cornell's early acquisitions was the H. Floury deluxe edition of the work of Odilon Redon, a Hartley favorite and one of the few artists whom Cornell admitted to having been influenced by prior to his own debut as an artist. Redon may be best known for his glowing florals, but his earlier drawings and prints, with their floating eyeballs and smiling spiders, were the most vivid nightmares in art since Goya.

While Cornell was rapidly learning about artists, it's unlikely that he imagined becoming one himself. In the 1920s, art meant oil painting, and the notion of standing in front of an easel and using brushes and pigments to paint scenes of the teeming city—as well-known artists like John Sloan were doing—would have struck him as impossible. It wasn't simply that Cornell was untrained and didn't know how to draw. Anyone can learn how to draw or paint with some proficiency. Yet it requires more than proficiency to make paintings; it requires a belief that either your personal experiences or your sense of style should be recorded on a flat, uncovered surface for all to see, and Cornell was far too cautious to assume that of himself.

Besides, what did he have in common with the artists he met? The men who dominated the scene around the Whitney Studio Club lived in Greenwich Village and belonged to a bohemian world in which the life of art seemed nearly inseparable from radical politics and sexual freedom. Evenings, artists congregated at the cafés along MacDougal Street or the restaurant of the Brevoort Hotel, destinations so unlikely for Cornell they might as well have been in Montmartre. Rather, he conscientiously headed for the train station before dusk. Evenings were to be spent with his family.

Yet life in humble Bayside was not completely without diversions. At least there was the Bayside Motion Picture Theatre, a neighborhood movie house on Bell Boulevard run by an entrepreneur named A. J. Corn, whose family doubled as ushers, janitors, bill posters, and ticket takers. Cornell could often be found there on Sundays with his siblings. He far preferred movies to other forms of entertainment, which is no surprise, for movies are the ultimate fantasist's medium. In a movie house the performer is absent, allowing the viewer a kind of intimacy—a release of private wishes—that is safe and anonymous, and alien to the brightly lit public stage. His friend Donald Windham once said that Cornell didn't go to the theater too often because "it was too live," but the movies were pure illusion. In the dark cocoon of a picture house, Cornell could become the hero of his imaginings, the handsome suitor up on the screen who was loved by quivering, spotless maidens and was worthy of their outpourings.

Cornell thought of movies as cheap melodrama made transcendent, and he delighted in spotting famous faces around his neighborhood in Queens. In 1967, interviewed by David Bourdon of *Life*, he volunteered little information about his past beyond recollections of his star sightings, as if they constituted the only experience of his youth worth recounting. Once, he

related, he saw Francis X. Bushman—a romantic hero of the silent films who lived in Bayside—on the set of an Indian village. On another occasion he caught a glimpse of the "fearless and peerless" Pearl White, as she was known, a queen of the silent serials who was beguiling audiences in classics such as *The Perils of Pauline*. She, too, lived in Bayside and was often seen strolling Bell Boulevard with a tiny white pig on a leash.

Robert shared Joseph's love of the movies and at one point had a chance to meet the greatest director in the business. When D. W. Griffith set up headquarters in Bayside in 1925 to shoot *Sally of the Sawdust*—in which W. C. Fields plays a sideshow con-man—Joseph took Robert to see part of it being filmed. The movie's chase scene culminates in a bakery on Bell Boulevard, with Fields hiding in the oven. Robert, watching from his wheelchair, was ecstatic when Griffith took a break from the filming to walk over to him and personally explain the story line to him.

Cornell became a dedicated moviegoer virtually the moment he settled in the city. Movies were still silent then, and his early favorites were an eclectic lot, ranging from the smash hits of the day to obscure foreign imports. Did anyone then give serious thought to movies? At the neighborhood movie houses people paid to have their emotions stirred. They saw cops-and-robbers chases and slapstick comedies. They saw looming close-ups of a man and a woman moving nearer and nearer to an embrace, a rush of images with an inexplicable power. It didn't occur to viewers that any of this melodrama might be art, certainly not in the same way that a painting by Leonardo or Vermeer was "art," or even the way the work of a more local talent like John Sloan was art.

To Cornell, however, movies were far more than an evening's entertainment. From the beginning, he thought of film as a forceful visual medium, one with real artistic possibilities. What captured him was nothing less than "the profound and suggestive power of the silent film to evoke an ideal world of beauty, to release unsuspected floods of music from the gaze of a human countenance in its prison of silver light," as he wrote in 1942, by which time he had become an experimental moviemaker himself. His comment suggests that, like most artists, Cornell went to the movies largely for the pictures. And silent movies had a distinct visual magic, with their black-and-white images and giant faces and exaggerated gestures, their pearly mingling of dream and reality. When movies with sound finally came along in 1927, Cornell considered them vastly inferior to their silent predecessors. They represented, as he wrote in 1942, "barren wastes," an

"empty roar," celluloid fantasies utterly devoid of the "poetic and evocative language of the silent film."

Sometimes the romance of the motion pictures seemed to spill over into Cornell's own life. In what was perhaps the most poignant of his early attachments, he became interested in a young woman who worked as a cashier at the Bayside Motion Picture Theatre. Day after day she stood in a little booth in front of the theater selling tickets, and Cornell grew accustomed to admiring her from afar. It gave him pleasure just to walk by and see her encased in the quietude of the glass ticket booth, like a delicate instrument inside a bell jar. Did he ever talk to her beyond asking for a ticket? All that is known is that one afternoon Cornell showed up at the movie house with a bouquet of flowers, which he proceeded to present to her. But when he tried to say hello, he became tongue-tied, so he just hurled the flowers at her. Startled by his gesture as well as by his frightening intensity, the cashier mistook the flowers for a gun and screamed. The theater manager promptly rushed out and wrestled Cornell to the ground, holding him in place until he noticed the bouquet and realized that the suspected robber was merely the most hapless and awkward of suitors.

The details of this curious anecdote tend to vary, depending on who is telling it. In some versions the girl is blond, in others black-haired; sometimes the police show up and Cornell is hauled off to the station, sometimes not. Yet one suspects that the gist of the story is accurate. In later years, Cornell shared it with several friends, including Marcel Duchamp, and, his romantic defeat notwithstanding, seemed to cherish the memory of the prosaic cashier. One can speculate that seeing her in the ticket booth was like seeing life itself step onto the movie screen; she was a living embodiment of that cinematic device known as a freeze-frame, a silent image trapped for the viewer's perpetual gaze. What the story suggests, among other things, is that Cornell's ideal of beauty was not a vibrant and pulsing one; it was an apparition of glamour sealed inside a box.

During his decade as a salesman for Whitman's, Cornell suffered minor ailments. Morning after morning he woke with the same anxiety in the pit of his stomach, and with a sense of uncertainty about his life. In the course of his workday he often developed painful stomachaches. His sister Helen recalls several occasions when she stepped outside Whitman's and saw her brother doubled over on a bench in Madison Square Park moaning to himself.

It was assumed within the family that Joseph was suffering from a form of "dyspepsia," the old term for indigestion, and to help ease his discomfort Mrs. Cornell was constantly testing ever-milder recipes at the dinner table.

Cornell's eating habits did little to assuage his stomach problems. He loved sweets, so much so that, in later life, he was rumored to subsist on nothing but doughnuts. Already his craving for sugar was manifest. In one of his few surviving letters from this period, Cornell reported with great enthusiasm that his mother had set up a "luxury shelf" in the icebox reserved exclusively for heavy cream and other goodies. Furthermore, he noted, he "finished off [a] jelly roll from Sandwich this morning with best creamery butter." Cornell possessed the child's predilection for sweets, an indulgence for which his chronic dyspepsia was perhaps self-willed penance.

Yet his penance, of course, was not only for desiring butter-laden jelly rolls. Cornell's symptoms would persist over time and probably reflected less his diet than his disposition. Like a Victorian woman suffering from neurasthenia, Cornell had many mysterious nervous illnesses. Because he associated his body with sin and guilt and was intent on silencing its insistent demands, illness was the only way he could comfortably draw attention to it.

One day a fellow salesman at Whitman's quietly mentioned to Cornell that he knew of a "practitioner" who might be able to help him. He was referring not to a doctor but to a believer in Christian Science, whose teachings emphasize physical healing. Christian Science had been founded by Mary Baker Eddy, a Boston housewife and religious zealot who in the 1860s underwent a "healing experience" after a fall on ice sent her to the Bible for relief and guidance. She recounted her experiences in *Science and Health with a Key to the Scriptures* (1875), the textbook and holy writ of the religion. With many parallels to New England Transcendentalism, Eddy's teachings declare that the material world—indeed, all of reality—is a virtual illusion with no connection to man's true spiritual status. So Eddy rejected drugs and traditional medicine in favor of "mind healing."

Cornell was about twenty-one years old when he became aware of Christian Science, and two years later he formally joined a Christian Science church. His commitment would not waver over the years. Up until his last days he studied the writings of Mary Baker Eddy and attended services fairly regularly. He subscribed to *The Christian Science Monitor*, the movement's reliable daily newspaper, and filled his personal files with poems, editorials, and inspirational messages clipped or torn from its pages. He even attended a

few church picnics in Queens with his fellow members, most of them middle-aged housewives. While Cornell was always reluctant to discuss his religious belief with his art-world friends, in private he didn't hesitate to acknowledge his gratitude to Christian Science and "the natural, wholesome, healing and beautiful thing that it is," as he once noted in his diary.

The mid-1920s, when Cornell joined Christian Science, were the movement's heyday. As technology began to play a greater role in American life, there was an apprehensive questioning of where the world was going, and the ranks of Christian Science swelled noticeably. Between 1910 and 1930, the number of its churches doubled from 1,213 to 2,400, a greater increase than that of any other American denomination during the period. Among the new churches was the First Church of Christ, Scientist in Great Neck, on Long Island, where Cornell regularly attended Sunday services. He selected the church, he wrote on his membership application in June 1926, because of its "accessibility from place of residence." Cornell was asked at the time to submit two letters of recommendation from members of the congregation. A man named Mr. Bliss confessed to not knowing him very well: "I only know Mr. Cornell from seeing him at church," he wrote guardedly. The second letter, from a Bayside woman named Jessie Pierson, perhaps a neighbor of the Cornell family, was more supportive: "Mr. Cornell is most sincere in his desire and is most worthy of your loving consideration."

It is not hard to understand Cornell's attraction to Christian Science. He would have agreed that the natural world is an illusion, or at least much less important than inner sight. Cornell's religious temperament had been apparent since his Andover days, when he took an elective course on the Bible. After leaving school and moving to Bayside, he had joined the local Methodist Episcopal church. It may be revealing that he applied for membership in Mary Baker Eddy's Mother Church in Boston in September 1926, a few weeks after a death in his family. Emma Storms, Mrs. Cornell's mother, had died in Nyack at the age of seventy-seven.

While nearly all branches of the Christian faith support the idea of eternal life, very few are modeled on the notion of Jesus Christ as a faith healer. This is the tradition to which Christian Science belongs, and one suspects it was largely the promise of miracles that led Cornell to convert (and give up the Methodism of his youth). Perhaps he saw Mary Baker Eddy as something like the religious equivalent of Houdini: instead of making elephants disappear, she made physical ailments disappear. Listening to the testimonials at church and reading brochures filled with triumphant tales

of people whom doctors had pronounced incurable, Cornell must have won-
dered whether Eddy's ideas could be of benefit not only to his dyspeptic
self but to his brother, Robert, as well.

At Joseph's urging, Robert in fact became a fellow convert around the
same time he did and over the years assiduously kept up with the weekly
lesson-sermons. Mrs. Cornell did not approve. Though a regular Bible reader
herself, she insisted to her sons that Eddy's interpretations were just so
much bunkum. According to her daughter Betty, "My mother was very
jealous of Joe's attachment to Mary Baker Eddy." It vexed Mrs. Cornell to
have the Boston matron intrude on the closeness and exclusivity of her
household, even though Eddy had died a generation earlier. Mrs. Cornell
would roll her eyes mockingly at the mention of the fanatic's name.

But perhaps she had good reason for envy. For Joseph's feelings for
M.B.E.—as he would refer to Mary Baker Eddy in his future diaries—were
tinged with filial loyalty. Eddy's life, by an odd coincidence, bore some
resemblance to Mrs. Cornell's. Widowed while she was still a young woman,
she was left alone with a son, and subsequently lost the family fortune.
Unlike Mrs. Cornell, however, Eddy didn't allow hardship to impede her
worldly self-advancement. She abandoned her son and married two more
times while founding the movement that gave her a status second only to
God Himself; acting with brilliant political savvy, she decided that there
would be no clergy in Christian Science, and so all but mandated that she
would remain its unrivaled central figure.

At any rate, in choosing Christian Science, Cornell chose one of the few
religions in the Western world to be founded by a woman. This seems
appropriate given his naturally reverential feelings toward women. The day-
to-day involvement Christian Science requires made Mary Baker Eddy an
integral presence in Cornell's life, and he welcomed the intrusion, not least
because he was drawn to the structure and order of the church. From here
on in, he could redeem his time with prayer and the regular practice of
devotion, and thereby hold his instincts in check.

In 1929, Cornell turned twenty-six. He had been in New York for nearly
a decade, yet outwardly his life had remained unchanged. There was little
to indicate that he was headed for artistic greatness. No miracles had hap-
pened. He was still working as a sample boy at Whitman's and hadn't
advanced in the company ranks since the day he started. While his head

was full of daydreams, he seems not to have imagined himself rising in the world or commanding a spotlight. Rather, he sought to lose himself in the diversions of the movie house and the disciplines of religion.

His family was still living in Bayside, though in 1925 they had moved a few blocks to a larger rented house at what was then 42–10 Fourth Street. A two-family house, it was across from the railroad station. To help make ends meet, Mrs. Cornell briefly took in a boarder. Such financial measures soon became unnecessary, for when her mother died in August 1926, she and the children inherited a good deal of money and property. Emma Storms—the well-to-do daughter of Commodore William Voorhis—left an estate valued at $24,500 (about $190,000 in 1996 dollars), to be divided among Mrs. Cornell, her father, Howard, and her son Robert (the only one of the Cornell children to be named in the will, receiving a bequest of $5,000 cash).

Mrs. Cornell's inheritance, valued by the court at $11,300, ranged from personal effects such as "6 Sterling ice cream forks (engraved)" and a "gold pearl lace pin" to shares of stock in Nyack's utility company and bonds purchased from the Grand Trunk Railroad, Seaboard Airline, and other companies. Mrs. Cornell also inherited half her mother's property in Nyack, which consisted of two small plots of undeveloped land and the house where her father was still living. In 1928, seventy-seven and feeble, he sold the house and moved in with his daughter's family in Bayside; he would spend his remaining six years with them.

Only two letters of Cornell's survive from the 1920s, and they suggest that he accepted the ordeals of family life without complaint. "Dear Sis," he wrote to his vacationing sister Helen on October 27, 1924, "I have just come back from the Catholic fair, so please excuse the brevity of this letter. I spent fifty cents (think of it!) and didn't win a penny"—it would be the last time he went so far astray. "Mrs. Snell and Mrs. Johnson were there, and all the other Catholics in Bayside. Yours luffingly, Choey."

The second surviving letter, from September 11, 1928, has a similarly jokey tone: "Dear Girls, Just a line to acknowledge your thoughtful letter and try to say a little something about nothing . . . Grandpa is up in my room tonight as his room will be papered tomorrow. I hope he behaves nicely."

To the people who knew him—his neighbors in Bayside, his colleagues at Whitman's, the members of the Christian Science Church in Great Neck—Cornell was just a nice young man, a bit on the quiet side, who

lived with his vivacious widowed mother and helped support the family.
Yet, unknown to anyone, really, Cornell had a rich interior life, and his
creative self was already well in evidence. Though he had not yet made a
work of art, he had become an urban hunter-gatherer, expressing his secret
self by collecting librettos, record albums, books, prints, souvenir photos,
theater memorabilia, and ticket stubs, and filing any pertinent material into
"dossiers."

There are many different reasons why people are moved to collect objects.
For some, collecting is a display of affluence. For others, it is a means to
affluence; they trust that the worth of their collectibles will appreciate with
time. For still others, collecting is not a material activity so much as an
emotional one, and this was certainly true of Cornell. "To collect is by
definition to collect the past," Susan Sontag has written, and Cornell's
collectibles offered him a route into the past, where he could repair an
unhappy reality. Moreover, his objects offered a promise of immortality by
virtue of their simple staying power. He could afford to become attached
to them because, unlike people, they would never vanish.

In the 1920s, as Cornell was combing through jumbles of objects in New
York City, across the world, in the streets of Paris, André Breton was
scouting flea markets for intriguing *trouvailles*. Breton, the founder of Sur-

Cornell with his sister Betty and their
mother on Fourth Street, Bayside, c.
1928–29 (Collection the Joseph Cor-
nell Study Center, National Museum
of American Art, Smithsonian Insti-
tution. Gift of Mr. and Mrs. John A.
Benton)

realism, once said that the most interesting thing artistically in Paris was the flea market, and in his autobiographical *L'Amour fou* (1936), he described his practice of "wandering in search of everything." Both he and Cornell understood that everyday objects can be unexpectedly poetic. Cornell came to this discovery on his own, amid feelings of loss and vulnerability. Soon he would learn of an entire art movement that glorified the so-called found object, and would start making art himself.

4

The Julien Levy Gallery
1929-32

On May 9, 1929, after a decade of living in rented houses, the Cornell family bought a house at 37–08 Utopia Parkway, in Flushing, just a few miles from their previous residence. The twenties had been a rosy time for the town. After plans were announced in 1923 to extend the subway line out to Flushing, enabling riders to get to and from Manhattan for a nickel, block after block of single-family homes sprang up on what had been open farmland. By the time the Cornell family moved to Flushing, the subway was a year old and Main Street, where the terminal was located, had shed the quaint wooden storefronts of its past and entered modern times. There was even a brand-new movie palace, Keith's.

The Cornells' new house, which cost $14,000 and had been built the previous year—it was Mrs. Cornell who held the deed—could not have been more ordinary. A two-and-a-half-story Dutch colonial whose shingles were painted white, it sat on a quarter-acre and was one in a row of four identical houses set closely together on the block. The façade was split down the middle by a red-brick chimney, making the house look narrower than it was. Out back was Cornell's "Arcadia," a tiny scrap of lawn squeezed between the high walls of the house's detached garage and the garage next door. Mrs. Cornell, who liked to garden, wasted no time in planting a quince tree in the yard; she had bought it, her son always liked to point out, as a sprig at the local Bloomingdale's "for seventy-nine cents." In coming years the tree would grow tall and strong, and provide Joseph with a favorite site for reading, daydreaming, and entertaining his many guests.

The house was cramped quarters for a family of six (including Cornell's grandfather). One entered through a glass-enclosed porch, which opened onto a small living room, just sixteen feet across and eleven feet deep; the

room was promptly assigned to Robert, since he couldn't use the stairs. Behind the living room was the dining room and, directly behind that, the tiny, shoebox-shaped kitchen. A flight of oak stairs in the living room led up to three bedrooms and the only bathroom in the house. Mrs. Cornell claimed the master bedroom for herself and decorated it with floral wallpaper, but Joseph's bedroom, which was down the hall from hers and overlooked the back yard, was as austere as a monk's. All through the house, furnishings left over from the family's brighter days in Nyack—heavy Edwardian chests, paintings of boats, fringed lampshades—lent the house an air of comfortable clutter.

Cornell would live in this house for the rest of his life. Over time, it would become a symbol of the very strangeness of his existence—strange because it was so resolutely middle-class. After Cornell became famous, visitors to his home would invariably remark on the oddness of finding him ensconced in one of the outer "boroughs," that harshly defining address that conjures up visions of beauticians and shoe salesmen barely scraping by. American artists were supposed to live in dilapidated cold-water flats in the city or way out in the countryside. True, Brooklyn, another outer borough of New York, had a leading museum, an artistic lineage, and a certain over-the-bridge charm. But none of this was true of Queens—a nowhere land, neither here nor there.

Still, Cornell's admirers always relished the aptness of his address: 37–08 Utopia Parkway, which seemed almost custom-made for this daydreamer who found his ideal dwelling place on the most ordinary of streets. It is tempting to imagine that Cornell and his mother selected the house, whether consciously or not, at least partly for its suggestive address. The irony is that Utopia Parkway—the name anyway—was conceived as a singularly commercial enterprise. In 1905, a group of investors calling themselves the Utopia Land Company purchased a fifty-acre tract near Flushing with the intention of establishing a Jewish colony that they envisioned as a second Lower East Side, complete with streets named Hester, Ludlow, and Essex. Yet neighborhoods cannot be duplicated like so many model homes, and the plan, unsurprisingly, never materialized. The only trace of it to survive is the road named Utopia Parkway, a seven-mile string of middle-class houses winding through northeastern Queens.

Cornell was as aware as anyone that Flushing was hardly Utopia. "These suburbs are dumps in the accepted sense," he once wrote. Yet from the outset he liked Flushing and relished his trips by bus to Main Street, where

over the years he enjoyed shopping at Woolworth's and Fischer-Beer's, or stopping for a piece of pie at Bickford's restaurant. Cocteau once wrote about "the good taste that sets yesterday's bad taste on a pedestal," but Cornell set today's bad taste on a pedestal as well, not as a joke, but because he had real affection for his bourgeois surroundings.

One of the oldest communities in the country, Flushing did not lack for picturesque sights. On his trips around town by bus, and later by bicycle, Cornell might admire the Quaker Meeting House, built on Broadway in 1694, or the aged Bowne house, the oldest in all of Queens, a squat salt-box edifice where a local hero named John Bowne had once harbored Quakers in defiance of the Dutch government. There were still a good many empty fields, and for Cornell they suggested a "sense of Americana at its purest."

Not long after the Cornells settled in Flushing, the family would come to seem incalculably smaller. Cornell's two sisters were about to marry and move away, disappearing into lives of their own. They both found husbands who were kind and dependable. Helen was married in June 1929 to Arch Jagger, a pilot who was working as a mechanic for an aviation company in Florida. She dutifully joined him in the South; a few months later the Depression hit, and they came back North to start a chicken farm on property owned by his family in Westhampton, Long Island. Betty was married two years later, in August 1931, to Jack Benton, who sold Buicks at a dealership in Great Neck. They, too, ended up in the poultry-farming business in Westhampton, about a two-hour train ride from New York.

Both sisters felt exceedingly guilty about the prospect of marriage, which they saw as a betrayal of Joseph. Now he was left alone with their mother to care for Robert, and what had once been a lively and boisterous family suddenly shrank into a weird and slightly grim trio—a widow and her two unmarried sons, one in a wheelchair, suffering from cerebral palsy; the other a withdrawn dreamer stuck in a job as a salesman.

Returning home from the city after work, Joseph could count on finding his brother awaiting him in the living room. Robert, now in his early twenties, was physically as helpless as ever. While Mrs. Cornell kept him company during the day, Joseph would take over in the evening, often feeding Robert, washing him, and shaving his face. He would sit by his side late at night reading him passages from the Bible and Mary Baker Eddy, believing that prayer could allay his brother's suffering. Joseph tended to these tasks with tender consideration, and Robert, in turn, relished the attention his brother lavished on him. He tried to have a sense of humor

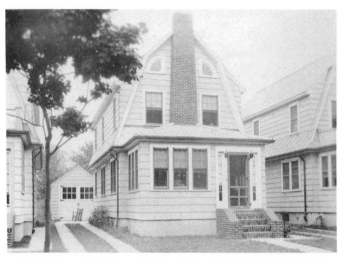

The house on Utopia Parkway, 1930 (photograph courtesy Betty Benton)

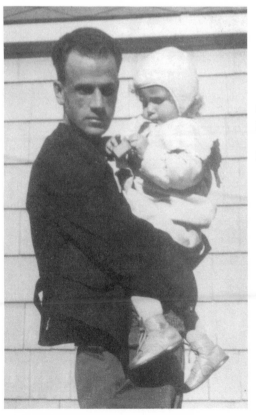

Cornell and his niece Helen (Jagger) Batcheller on Utopia Parkway, 1932 (photograph courtesy Helen Batcheller)

about his difficult life. Even when he had to relieve himself, he expressed himself in a coded joke. "I need the funny papers," he would say in his low, grunting voice, and Joseph would rush to assist him, helping him onto his commode, which was discreetly concealed behind a bookcase in the living room.

Robert had a passion for locomotives. With Joseph's help, he assembled a large collection of model trains, which took up most of the living room. The family lived near the Auburndale station of the Long Island Rail Road, and in nice weather Joseph would push Robert in his wheelchair to a section of Utopia Parkway where they could see a stretch of the tracks. "They'd sit and watch the train go by," their sister Betty once remembered. Believing that his brother was virtuous and deserving, Joseph kept any feelings of resentment hidden, so that they bothered no one other than himself.

With his mother, though, it was different. Joseph often complained to his sisters that she got on his nerves; his exchanges with her had an undercurrent of anger. To be sure, Joseph greatly admired his mother. He felt that she was good to her children, and in the moments when he thought of her planting her primroses on each side of the house, or shuttling back and forth to Bohack's for groceries, she struck him as noble and he wanted to please her. Yet Mrs. Cornell could not be pleased, and her inherently critical temperament only seemed to harden as the hopes of her girlhood grew more and more remote. In her youth, as one of Nyack's most eligible young ladies, she could not have imagined that her life would yield so few worldly rewards, that she would find herself, in her robust fifties, without the protecting wing of a husband, a widow in a little house in Queens with two undistinguished sons. She couldn't really blame Robert, but she could blame Joseph, and in helpless frustration, she faulted him for everything. Other men, she reminded him, earned more money. Other men had better jobs, more "get-up-and-go," and didn't waste their time with Mary Baker Eddy's Christian Science.

But mostly it was little things that provoked their arguments, like the birds in the yard. Cornell loved to stand out back tossing peanuts to the blue jays, which, to his mother's dismay, left the grass scattered with shells. As Cornell fed the birds his mother would scold from the kitchen, rapping indignantly on a window to try to shoo the birds away. As much as she irritated him, Cornell, inevitably, would later regret any harsh words that passed between them. "When he got to the city," his sister Betty noted, "he would call her up and everything would be all right."

In spite of his onerous domestic responsibilities, Cornell's life was not quite as circumscribed as it may have appeared, for within a few months he would make his way to the Julien Levy Gallery. Cornell was more than ready to commit himself to the world of art, which, unlike everything else he knew, held out the promise of flight.

The Julien Levy Gallery opened quietly in the fall of 1931 on the fourth floor of a brownstone at 602 Madison Avenue, right off Fifty-seventh Street. It consisted of two rooms decorated in traditional French style, with gray carpeting, Pompeian-red walls, and a general air of Old World elegance. Despite the staid decor, Julien Levy had no interest in purveying the kind of genteel pictures by minor Impressionists found in fashionable galleries around town. A Harvard dropout and photography buff who opened his gallery when he was just twenty-five, Levy was a precocious aesthete whose chief interest was vanguard art. Dark, attractive, and socially adept, he also liked vanguard people. His wife, Joella Loy, was the beautiful daughter of Mina Loy, the London-born poet. When Levy married Joella in Paris, he asked James Joyce and Constantin Brancusi to be witnesses. The latter actually accepted.

Growing up in New York, Levy had revered Alfred Stieglitz and his "291" gallery, where the latest modern painting was given serious treatment and photography was presented as high art. Levy, too, opened his gallery intending to concentrate on photographs, but instead made his mark as the art dealer who single-handedly imported French Surrealism to New York. It could be said of Levy that he was committed to avant-garde art with a fervor that only a scion of the establishment could afford. His father was a real-estate operator on a large scale, building apartments along Park Avenue. So secure was Levy's financial situation that he was able to open his gallery of avant-garde art in the darkest days of the Great Depression.

Did Cornell discover Surrealism at the Julien Levy Gallery? It seems more likely that he read about the movement before the gallery opened. The exact chronology of events may never be known, but it is clear that no "ism" would have as great and enduring an influence on Cornell as Surrealism, which provided the context in which he first started making art.

When we think back to Surrealism today, we think of images that we know from museums: Dali's melting watches, de Chirico's eerily emptied-out plazas, Magritte's floating men in bowler hats. Or else we think back

to art-history texts, where Surrealism is presented as the "ism" that follows Cubism and Dadaism. But no other art movement ever caused more of a stir. Surrealism was founded in Paris in the early 1920s by André Breton, an unsmiling poet with a large cranium and features that are invariably described as leonine. A former medical student who had treated the shell-shocked during World War I, Breton was familiar with psychiatry and drew heavily on Freud's ideas. In 1924, in his First Surrealist Manifesto, he coined the key phrase "psychic automatism," which refers to techniques for exploring the unconscious. Though Breton found his earliest following among poets—through the 1920s they gathered around him on the terrace of the Café de Flore to experiment with new methods for automatic writing—the movement would make its greatest mark among painters and sculptors.

Surrealism was hardly the first art movement dedicated to dreams and buried desires; art that explores the subconscious is as old as art itself. But only the Surrealists, with their knack for self-promotion, could have thought to present themselves as the first men in the history of art to understand the workings of the irrational mind. You would think that depressives from Bosch to Goya had never lived. No artists were ever more self-conscious about the subconscious than the Surrealists, and their work—which restored realism to avant-garde art—might be understood as an illustration of the literature of the subconscious. The authenticity of this content can be measured by Freud's supposed remark to Dali that he found himself more interested in Dali's conscious than his unconscious mind. Basically, the Surrealists used the word "unconscious" as a convenient justification for loading up their work with bizarre and erotic imagery calculated to offend. Their love of scandal was fully evident by the time Breton wrote, in his second manifesto (1928), that "the simplest Surrealist act consists of dashing down into the street, pistol in hand, and firing blindly, as fast as you can pull the trigger, into the crowd."

Was there ever an artist who was a less likely Surrealist sympathizer than Cornell, a mama's boy who spent his Sundays in church and quavered before visions of fleshly sin? Cornell's temperament was the very opposite of that of a subversive, and much about the Surrealists—their call for revolution, their hatred of the church, their furious loathing of the parental generation they blamed for World War I—made him a most improbable disciple. "I never had any real sympathy for the movement and what it stood for," Cornell noted in 1953. On another occasion, sounding like an optimistic schoolteacher, Cornell remarked that he felt Surrealism "has healthier pos-

sibilities than have been developed," a comment that betrays his diligent reading of Mary Baker Eddy's *Science and Health*.

In retrospect, it is easy to find similarities between Cornell and the Surrealists, from a love of dreaminess to an appreciation of the theatrical gesture. But what probably first caught Cornell's attention was the Surrealists' interest in humble non-art images and objects. The Surrealists believed that painting had lost the confident centrality that had characterized it at least since the nineteenth century, and envisaged their movement as a multimedia event. They were dedicated to collage and the *objet*, a decidedly minor art form based on the recycling of ordinary objects. The strategy was scarcely new and had a genealogy that went back to the Dadaists before them. Marcel Duchamp, Dada's poker-faced prankster, pioneered the "readymade" after World War I, when he took commonplace things like a shovel and a bottle rack and called them art. And Kurt Schwitters, Dada's melancholy poet, picked up oddments off the street to construct his walk-in *Merzbau* (1923) in his home in Hannover, Germany. Earlier still, Picasso and Braque had experimented with newsprint, pioneering the strain of modern art that attached the highest value to things of *no* value.

The curator and art historian William Rubin has pointed out that the readymade object allowed people who were neither painters nor sculptors to enter the realm of art. Cornell is certainly the most notable among them. When he finally made his first art object, he was twenty-seven years old— a latecomer to art. If his life had not intersected with the advent of collage and assemblage, one imagines that Cornell would not have become an artist at all but instead would have passed his life in virtual anonymity—just another loner in Queens who happened to have a lot of books and oddments lying around his house.

Cornell made his first work of art in 1931, after stumbling upon a piece by Max Ernst that was decidedly not a painting. *La Femme 100 têtes* was instead a book, a "collage-novel" published two years earlier in Paris, where Ernst was then living as a German expatriate. Ernst is perhaps best known for "collage," a word that in French simply means "to glue," and *La Femme* is the first of his famous glued-together novels. Using Victorian steel engravings from old catalogues, magazines, and pulp novels, he fastidiously cut and recombined them, mixing images that don't belong together. Turning the hundred-plus pages of *La Femme*, you see stern matrons sprouting wings, serpents writhing in parlors, and other examples of Surrealist madness.

On the surface, of course, *La Femme 100 têtes* might seem like a doubtful source of inspiration for Cornell, who would have been uncomfortable with the adventures of its naughty protagonist. One imagines him peering furtively at the pictures, both seduced and repelled by Ernst's fantasies. Cornell later remarked that *La Femme* was the immediate spur for his entry into art, presumably because it alerted him to the possibilities of collage—a medium that eliminated the need to paint or draw. Books could provide almost all the materials. Everything was ready-made and in reach of anyone who chose to put it together.

After seeing *La Femme*, Cornell returned home to Flushing and sat down at the dining-room table with a stack of old books and various supplies: glue, a pair of scissors, a few sheets of heavy cardboard upon which the cutouts would be pasted. Over the next several weeks, he fabricated his earliest works of art, a series of spartan black-and-white collages that owe a good deal to Ernst. Cornell had no qualms about cutting up old books for illustrations, proving to be an eager cannibalizer of his extensive library.

Mrs. Cornell was well aware of Joseph's undertakings and looked upon them with the bemused endorsement she might once have brought to one of his childhood science projects. She went about her own business as her son sat hunched at the kitchen table into the small hours of the night. Most of his work was done after his mother and brother had gone to sleep, when he could have the house to himself.

Cornell's first surviving collage is also one of his most memorable. This tiny, untitled work, which measures under 5 by 6 inches and is known as *Schooner*, shows an imaginary scene: a clipper ship aloft on calm waters, with a rose and a spider mysteriously sprouting from one of its sails. Dominating the composition is the ship, a likely reference to Cornell's own sailing great-grandfather. The ship, of course, bespeaks a desire for mobility, a yearning for a virile life of action. Yet the image of the spider inside its web suggests the very opposite—stasis, desiccation, all that is arid and inert. The rose has been strangely overtaken by the spider's expanding web, its remaining petals curled and ready to fall. Keenly attentive to visual detail, Cornell rhymed the ship's ropes with the threads of the web, so that the elements in this prim, carefully scissored collage are made to mingle poetically. For this viewer, the collage suggests a female invalid on a dream journey.

Cornell's earliest collages have traditionally been dismissed by art historians as a feebly derivative homage to Ernst. Yet in some ways they surpass

Untitled (Schooner), 1931; collage, 4½ × 5¾ in. (Collection June Schuster, Pasadena, California)

La Femme 100 têtes, in truth a rather monotonous book. *La Femme*, like so much Surrealist art, is essentially a one-liner; after you've been surprised and amused by its parade of erotic and absurd images, there is little else to extract from it. Cornell, from the start, was after something larger than shock effects. He had a more visual approach than Ernst, celebrating images for their own sake rather than for the sake of argument. Compared to Ernst's art of disputation, Cornell's was an art of distillation.

In November 1931, just a few weeks after the Julien Levy Gallery opened, Cornell stopped by one Saturday afternoon with a few of his new collages. The two men had never met, but Levy disliked him already. He had often glimpsed Cornell poring over old photos in the gallery's back room and had come to think of him as a nuisance—a drab young man who obviously had no money to spend on art. On this particular afternoon, Levy tried to get his straggler to leave by announcing that it was closing time. But Cornell had already clumsily taken two or three small collages from his overcoat pocket. Levy was startled when he saw them, thinking they were works by

Ernst he had carelessly misplaced. Cornell, intuiting his reaction, asked, "You wouldn't mistake one of mine for one by Max Ernst, would you?" He added pointedly, "Ernst disturbs me."

Or so Levy recounted in his autobiography, *Memoir of an Art Gallery* (1977), which remains the principal source of information on the early years of Cornell's career. The book is not always reliable, however, and there is good reason to doubt that Cornell made as bold an entrance into the art dealer's life as Levy recalled. In a later interview with *Life* magazine, Cornell himself mentioned dropping off a small package of collages at the gallery without bothering to introduce himself, which seems more plausible. And Joella Loy, the art dealer's wife and assistant at the gallery, believes that Cornell never approached Levy: "He was scared of Julien and left his first collages with me."

In any case, at some point Julien Levy got a look at Cornell's collages and met their creator as well. What was the art dealer to make of this twenty-seven-year-old aspiring artist who seemed to have come out of nowhere? He hadn't gone to art school, knew no one in the art world, and had no experience to speak of beyond a decade of selling wool.

As Levy tells it, a quick look at Cornell's collages convinced him they were purely imitative, so he suggested to Cornell that he try experimenting with shadow boxes instead. Presto, his story went, Cornell arrived at the gallery a week later with some finished boxes. In reality, it would be almost five years before Cornell started producing the Box upon which his reputation rests—though he did make a leap now into the third dimension and began producing his first *objets*.

Cornell's first boxes were not shadow boxes. Rather, they were pill boxes—round cardboard containers that he purchased at the drugstore and that came with actual medicine inside. Some of the boxes were just two inches in diameter and printed with a commercial message: "Sure Cure—for that tired feeling." Did Cornell initially buy the pills to relieve himself of his chronic aches or, rather, for purely artistic reasons? Probably the latter: as a Christian Scientist, he was not permitted to take drugs, and the project he now conceived was wholly in keeping with the religion's reliance on spiritual healing rather than medical treatment. In making his boxes, Cornell took out the pills and replaced them with his own idea of a cure-all: tiny shells, sequins, red ground glass, rhinestones, beads, black thread, scraps of blue paper—a mix of natural and theatrical ephemera that hint at a very personal prescription for well-being.

Cornell made dozens of "pill boxes," yet even most aficionados of his work are unfamiliar with them. Not a single one is on permanent display in a museum; instead, they're tucked away on museum storage shelves or in private collections. Most of them are crazily small—palm-sized objects that could easily be misplaced in a desk drawer—and their size reveals how tentative Cornell felt about making art. Still, they're fascinating harbingers of Cornell's later work, in part because they're made from boxes and suggest his instinct for hiding, for concealing the evidence. Art is supposedly about seeing, but Cornell was more interested in the things you can't see, the inward experiences that can glitter as brightly as the sequins encased inside his very first boxes.

Cornell also undertook a "glass bell" series, in which he experimented with setting objects under tiny domes. This art form, if indeed it is one, harks back to the second half of the nineteenth century, when wax flowers and stuffed birds displayed inside a glass bell were a staple of American parlors. Women's magazines published tips on how a lady could add a fine

Untitled paperboard box, c. 1935; ½ × 1¼ in. (diameter) (Collection the Joseph Cornell Study Center, National Museum of American Art, Smithsonian Institution. Gift of The Joseph and Robert Cornell Memorial Foundation)

ornament to her home by making her own glass bell, complete with lobster claws decorated as faces, shells assembled into palaces, and other popular tableaux.

From this recipe for Victorian kitsch, Cornell managed to compose some unexpectedly compelling pieces. In one of his bell jars, a mannequin's hand graciously proffers a fan and a tiny rose-studded collage. In another, a tiny metal thimble balanced on an upright needle hovers in space with an almost cinematic intensity. Like the pill boxes, Cornell's glass domes are a cross between the Surrealist *objet* and Victorian bric-a-brac.

It was as if Surrealism gave Cornell permission to draw on the art forms favored by Victorian women. Instead of taking up painting, Cornell turned to the minor media in which women had specialized in the days before they were allowed to study at the academy and become professional painters. From the beginning, Cornell's artistic persona was bound to women and the marginal media they had once called their own, perhaps because he felt marginal himself and unable to face the world, the art world especially, in a masculine way.

Later it would be said that Cornell started making art mainly to amuse his brother, Robert, with homemade toys and objects. There is nothing to justify this claim. And yet there is no question that Robert's influence on Cornell was profound—indeed, Robert might be viewed as the key person in Joseph's creative life as well as his domestic one. As Henry Geldzahler, the writer and curator, observed on one occasion: "Joseph had a total identification with Robert. Whereas Robert was wounded physically, Joseph was wounded in the emotional realm." Cornell's earliest creations—pill boxes and glass bells—together conspire to suggest something sickly, airless, and confined: the life of an invalid. That life was his own as much as it was Robert's, and by avoiding the manly tradition of painting in favor of more female art forms, Cornell managed to make his entry into the great arena of modernism with singular meekness.

When Cornell met Julien Levy, the art dealer had just organized an unforgettable exhibition. Surrealism was still so new that even its name was subject to debate, and Levy settled on "The Newer Super-realism" for the title of the first survey of the movement in America. The show opened on November 16, 1931, at the Wadsworth Atheneum in Hartford, Connecticut, the oldest museum in America and, at the time, the most progressive.

Its stylish young director, A. Everett Austin, Jr. ("Chick" to his friends), had already startled conservative Hartford with a show of works by Giorgio de Chirico. Now Levy and Austin, who had met while students at Harvard, would import the whole Surrealist group to America and beat the two-year-old Museum of Modern Art to the punch.

Levy and Austin were well acquainted with MoMA's director, Alfred H. Barr, Jr., whom they knew from college. During their student days, Levy had hung authentic prints by Chagall and Klee in his dormitory room rather than the usual cheap posters, and Barr once borrowed them for a campus exhibit at the Fogg Museum. Their future dealings, however, were less cordial. Barr, Levy noted defensively in his memoirs, "resented a gallery that had more mobility than his museum . . . He wanted to give novelty shows, but a gallery like mine took the novelty out of his hands by giving shows before he did." Old college rivalries probably played a larger part in the rush to bring Surrealism to this country than anyone realizes; one suspects that Levy was determined to upstage Barr as a champion of the latest art. He and Austin decided that "The Newer Super-realism" would open in Hartford before traveling to the Levy Gallery in New York—a savvy maneuver on Levy's part that would lend the paintings, all of which were for sale, the historical legitimacy only a museum can confer.

It was Cornell's good fortune to meet Julien Levy right before the show was mounted at his gallery, where it was retitled "Surrealisme." The new name wasn't the only thing that set the show at the Levy Gallery apart from its predecessor at the Wadsworth Atheneum. Levy decided to add works by a few new artists, most of them Americans: George Platt Lynes, Man Ray, and, undaunted by the distinguished company, himself; Levy stuck in a collage he had recently made from a cut-up tabloid. His revisions to the show were presumably intended to get an American version of Surrealism off the ground, and Levy's last addition actually would: he added Joseph I. Cornell, inviting the artist to contribute a couple of collages as well as one of his glass bells.

Moreover, Levy asked Cornell to design the show's announcement—an honor that befell him surely because none of the Surrealists was available in New York. Cornell gladly obliged, furnishing a playful collage composed from old steel engravings. It shows a boy from the back, trumpeting the word "Surrealisme" so that its eleven letters are made to float upward like a string of notes. But instead of a trumpet, the boy is blowing into a twirling swatch of fabric that Cornell later identified as a "cake decorator's tube," a

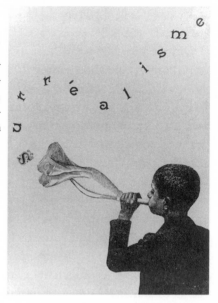

Cornell's announcement for "Surréalisme" exhibition at Julien Levy Gallery in 1932 (Collection the Joseph Cornell Study Center, National Museum of American Art, Smithsonian Institution. Gift of Mr. and Mrs. John A. Benton)

reminder all at once of his love of sweets, his mother's predilection for baking, and his eagerness to hide behind her petticoats. And so it was that the Surrealists, that pack of scandalmongers, were introduced to New York with an image that seems more fitting for a book of children's fairy tales.

Cornell had just turned twenty-eight when "Surrealisme" opened in January 1932. The first exhibition to survey the Surrealist movement in New York, it turned out to be a landmark show, one of those events that would later receive quick but unequivocal mention in virtually every official history of the art of the period. The eighteen artists beside whom Cornell made his debut were an illustrious lot. They included Ernst, Man Ray, Pierre Roy, Picasso (no matter that he had already abandoned his Surrealist phase), Marcel Duchamp (who had never had a Surrealist phase in the first place), and Jean Cocteau (secretly an enemy of the movement). Salvador Dali contributed his just-finished *Persistence of Memory*, later to attain inordinate fame as the "melting watch" painting. While "Surrealisme" was by no means a comprehensive show and in fact omitted the movement's most interesting talents (namely Joan Miró, Jean Arp, and Giacometti), it did establish the Levy Gallery as "probably the only civilized place in New York," as Ernst put it. From then on, Levy's gallery would be known as the one place outside Europe where the Surrealists' work could regularly be seen.

Not that any Surrealists could be found on the premises. During the

1930s, when the movement experienced success abroad and dissension within, it continued to be headquartered in Paris. Levy's epic show did nothing to change that. As hundreds of visitors climbed the four flights to his gallery in hope of being pleasantly startled by the objects on display, the Surrealists remained in the cafés of Montmartre, drinking their Mandarin-curaçaos. They gave little thought to cultural happenings in America, a country they felt had produced virtually nothing of interest, with the exception, perhaps, of Hollywood movies and the macabre fiction of Edgar Allan Poe.

Cornell's debut at the Levy Gallery changed his life very little. His collages and glass bell failed to sell, and he received no mention in the reviews of the show, beyond a passing reference to one of his collages ("a ship that is mostly cobweb") in *The New York Times*. The critics instead directed their comments at his famous and flamboyant co-exhibitors. If Cornell shared the occasion with anyone, it was only with his mother. Mrs. Cornell took great delight in her son's debut, and did not hesitate to ride the train into Manhattan to see the exhibition at least twice. As she noted proudly in 1966, "I always *re-visited* every show of Joseph's way back to the Julien Levy days."

But did anyone else know what he was up to? Other artists in New York would have been indifferent to his art; most of them were working in the prevailing Depression-era styles. On the right were the Regionalists, such as Grant Wood and Thomas Hart Benton, whose work was all farmers and flag-waving optimism. On the left were the Social Realists, like Ben Shahn and William Gropper, who took up the downtrodden as their cause. Both these movements depended on a form of realism that wasn't very far from illustration, and today their work looks dated. Cornell, by contrast, bypassed the native styles of the thirties in favor of foreign adventure. In doing so, he became as advanced as any artist anywhere, repudiating the provincial American scene a whole decade before the future Abstract Expressionists learned the lessons of Surrealism.

Soon after his debut at the Levy Gallery, Cornell was offered his own one-man show there. It would open in November 1932, just ten months after the "Surrealisme" show came down. In spite of this honor, Cornell continued at his full-time job and worked on his art only at night, as if relegating it to the least valuable hours. But this routine did not last long. Early in 1932, at the height of the Great Depression, Cornell lost his job at the William Whitman Company after eleven years of steady employment.

The company, which had first prospered selling woolen blankets during World War I, was about to go into bankruptcy. Cornell was predictably upset by his dismissal. As much as he had disliked his job, he felt obligated to bring his family a weekly paycheck.

According to his sisters, Cornell soon after managed to get hired selling refrigerators door-to-door in Queens, a job so uncongenial to his temperament that it brought on severe headaches. He quit after a few months, but his ailments only intensified. He was stricken with a case of eye inflammation, as if the mere sight of the world caused him pain. His sister Betty recalls a few months when his eyes swelled up into "wells of blood." His vision, normally 20–20, became sufficiently compromised to require that he walk with a cane.

Only two brief letters of Cornell's survive from this period, and they can be disconcerting to read. Writing to his sisters just a month before his first one-man show, Cornell sounds less like an up-and-coming artist than a simplehearted child whose main concern is cake and candy. He offers none of the thoughts one might expect of an artist who is about to make his solo debut: no boasts of an upcoming exhibition or musings on how it will go, no hints of the tense excitement it inevitably engendered. Instead, he adopts a juvenile tone. Writing to his sisters on October 14, 1932, Cornell reported on a neighborhood birthday party he had recently attended for a girl named Ginger, where he rapturously consumed "a swell piece of my own cake and half pieces from the girls' plates after the party. A swell piece of ice cream, too."

Cornell's love of sweets was matched in its compulsiveness by a preoccupation with physical cleanliness. The letter continues: "We got the bathroom all washed this morning, windows, walls, ceiling, floor, etc., etc. It looks like some other place when you look out the window"—he liked peering through a spotless pane of glass. His only other letter to survive from this period similarly alludes to hygiene. "You should have been with me yesterday morning in the subway, one stop past Woodside," he notes to his sisters, when "two Scotchmen with kilts and carrying bagpipes got on. Full regalia, wing collars, diamond buckles and about the 'cleanest' looking individuals I have ever seen; they actually seemed to shine." Cornell recognized in this skirt-wearing twosome what some part of him felt he ought to be: a happy creature purged of the grubbiness of male sexuality.

Who would believe that this twenty-eight-year-old man who dwelled

obsessively on birthday cake and sparkling bathrooms was about to have his first one-man show at New York's most progressive gallery? To be sure, "The Objects of Joseph Cornell" (November 26–December 30, 1932) was a modest affair. No checklist of the exhibition survives, but we do know, on the basis of reviews, that the artist's diminutive bell jars and pill boxes were consigned to the gallery's small back room. The larger room was reserved for thirteen etchings by Picasso, published in Paris the previous year as illustrations for an edition of Balzac's *The Unknown Masterpiece*. While Levy had hoped that the double billing would guarantee a wide audience for Cornell, it didn't work to Cornell's advantage. Beside the volcanic energy of Picasso, Cornell's tiny creations seemed doubly fragile, and few viewers took them seriously.

It didn't help that Levy advertised the objects as "toys for adults," describing them as such in a press release and sprinting from his office whenever visitors arrived to natter on about their suitability as Christmas gifts. It was as if the art dealer was not at all certain that Cornell's work could be included within the category of Surrealism, or even that of modern art. And the December scheduling only further diminished Cornell's already minuscule creations, making them seem as innocuous as any holiday gift. This was all fine with Cornell, who had no discernible self-confidence and whose objects, tiny as they were, practically demanded to be overlooked.

Reviews of the show were patronizing. Edward Alden Jewell, writing in *The New York Times* on December 1, 1932, devoted several respectful paragraphs to Picasso's etchings, then remarked that the Levy Gallery was also showing some "amusingly clever bibelots for the Christmas season—'toys for adults'—and also, maybe, for children of the present day, who, it may be supposed, are growing up with an intimate appreciation of surrealisme." The New York *Herald Tribune*'s reviewer could have been describing tree decorations when he summed up Cornell's objects as "glittering ornaments for the Christmas season."

A more sensitive review came from Henry McBride, the forward-looking critic of *The Sun*. Writing with his usual mix of astute observation and chatty informality, McBride devoted an upbeat paragraph to Cornell in his Saturday column of December 3, 1932. Cornell's "toys for adults," McBride noted, "are very simple, very strange and very chic. Mr. Cornell puts one or two small objects under glass globes and contrives to give them a mesmeric air. They are almost perfect ornaments for a small table in the waiting-room

of an astrologist, a palmist or a mind-reader. The only objection is that they are so attractive that some of the clients would be sure to inadvertently make off with them."

Within a week of the show's opening, the critics for the major dailies had all weighed in—and, sadly, the notion that Cornell fabricated "toys for adults" was firmly in place. It would persist for many years, fostering a distorted view of Cornell as an inspired amateur whose work existed outside the boundaries of modern art. We cannot, of course, take this notion seriously if we are to take Cornell seriously. To see him as a glorified toy maker is to miss the astounding artistry of his work—its sureness of taste, its spare and exacting sense of form.

Besides disfiguring Cornell's work, the "toys for adult" idea also created a false impression of Cornell himself. It made him sound like a marveling elf who found wonder and magic everywhere he looked. In fact, he was a tense and often depressed man, conscious of all the romance of art and of his own fragility and suffering.

5

The Persistent Memory

of Salvador Dali

1933-36

Consumed as he was by his artistic activities, Cornell still found time to be an active member of the Christian Science Church. On Sunday mornings he traveled by train to the Great Neck church he had joined in 1926, the year it was founded. It occupied a new building, a red-brick edifice with two white pillars on a grassy slope at 46 South Middle Neck Road, within walking distance of the train station. In addition to attending services, Cornell was eager to do volunteer work and lent his time to various committees. At first he was an usher, according to church records, and during the same period, for about five years, he worked on the "literature distribution committee," leaving little pamphlets in banks and laundromats and hotels throughout the city, probably during his daily salesman's rounds for the William Whitman Company.

Early in 1932, however, after being laid off from his job at Whitman's, Cornell took on a far more substantial responsibility with the church. He arranged to be an attendant in the Reading Room, which was located not far from the church in a storefront on Grace Avenue in downtown Great Neck. Christian Science makes a ritual of reading, and each of its churches maintains its own Reading Room. As an attendant, Cornell worked part-time and was paid a nominal fee. A couple of afternoons a week, he would sit at a counter in the Reading Room, patiently answering questions from church members and assisting them in the study of the weekly "Bible lesson-sermon," which was devoted to any one of twenty-six rotating subjects: "Mortals and Immortals," "Are Sin, Disease and Death Real?" "Probation After Death," and the like. Cornell was also responsible for selling books, namely Bibles and Mary Baker Eddy's *Science and Health*. Most of the members of the church's congregation were local housewives, few of whom, one

imagines, had any idea that the helpful young man they met in the Reading Room was making his name in Manhattan, at a place called the Julien Levy Gallery and in an art movement called Surrealism.

Following his first show, which closed on December 30, 1932, Cornell became a regular visitor to the gallery. The artists he met there knew no more of his church activities than his church acquaintances knew of his art work. The different aspects of his life existed as if in separate chambers, or boxes. Not that many people at the Levy Gallery expressed a strong interest in his activities, anyway. On his Saturday visits, Cornell was hardly noticed as he combed through the bins of photographs in the back room—the old daguerreotypes, with their ancient faces, or Eugène Atget's shots of turn-of-the-century Paris. So, too, Cornell would look at the latest Surrealist paintings out of Europe, while milling quietly as he overheard gossip. Allen Porter, Levy's assistant, remembers Cornell as a singularly undramatic presence. "He was so embarrassingly shy, everything he said was monosyllables," Porter noted. "He would ask questions mostly about what the artists he admired like Dali or Ernst were like."

Cornell also admired Marcel Duchamp, one of the original (and most original) figures in the Dada movement. At forty-six, Duchamp, a charismatic and handsome Frenchman, had already led several artistic lives. While his *Nude Descending a Staircase, No. 2* was the *succès de scandale* of the Armory Show in 1913, Duchamp soon after gave up painting for readymades, elevating commonplace objects like a bottle rack and a snow shovel into art. Then, in 1923, as if pulling the ultimate Dada prank, he claimed to have stopped making art altogether and to be spending all his time playing chess. It wasn't quite true, but the artfulness of his anti-art antics endeared him to his many friends and followers. When he and Cornell were first introduced at the Levy Gallery, Cornell nearly fainted with excitement. As Allen Porter said: "He made for the WC, where he stayed for an hour." It would be a decade before Cornell fully recovered and his friendship with Duchamp began in earnest.

In the meantime, Cornell's fascination with the European avant-garde was not to be doubted. In November 1933, when Levy gave Salvador Dali his first one-man show in America, Cornell, astoundingly, was already a collector of Dali. He had purchased a work from the Surrealist group exhibition held at the gallery the previous year. Accounts differ as to which piece he acquired. Robert Motherwell later recalled that Cornell "told me once he made the first surrealist purchase in America, a drawing by Dali for $75." Other reports indicate that Cornell's acquisition was instead a

Dali painting, *Myself at the Age of Ten When I Was the Grasshopper Child*. Whichever work he purchased, Cornell left it at the gallery, asking Levy to store it for him indefinitely. Apparently he was concerned that its spicy imagery would offend his mother. As his future dealer Rose Fried explained: "He never took the painting home because he was scared of what she would say."

Mrs. Cornell might have been startled by her son's new life among the Surrealists. He certainly did relish their company. While Dali, living in Paris, had not yet visited New York, Cornell befriended the few Surrealists who did. Among the arrivals was Lee Miller, an American expatriate who had a show of photographs at the Levy Gallery immediately following Cornell's exhibition. Few would describe her as a memorable artist, but she was certainly a memorable woman. A noted beauty, her blond hair cut short to just below the ear, she won fame while still in her teens as a top model for *Vogue*. Living in Paris in the late twenties, she became a glittering adjunct to the Surrealist circle. Her entrée was provided by Man Ray, who was known for his innovative Surrealist photographs (but who, in fact, was just a kid from Brooklyn, né Manuel Radnitsky). He hired Miller as his darkroom assistant, had a suitably unhappy love affair with her, and helped her establish a thriving career as a portrait photographer.

Among the paradoxes of the Surrealist movement is that what began as an assault on bourgeois morals had become, by the 1930s, a complaisant appendage of the *beau monde*, and surely no one was more *beau monde* than Lee Miller. For her debut exhibition at the Levy Gallery, Frank Crownin-shield, the editor of *Vanity Fair*, was enlisted to write the catalogue essay. He praised her work as a brazen exploration of the "theories of Surrealism"—no matter that ideas were nowhere inscribed in her photographs of Gene Tunney, Clare Boothe Luce, Charlie Chaplin, and other celebrities.

Like so many men who crossed her path, Cornell was instantly taken by Miller, whom he probably met at the Levy Gallery. She was unlike anyone he had ever known, her blue eyes sparkling as she related stories about the Surrealists. Cornell was no match for her many high-powered suitors, the most recent of whom, an affluent Egyptian named Aziz Eloui Bey, she married after jilting Man Ray (and divorced with equal swiftness). Yet Miller was flattered by the attention Cornell paid her and treated him appreciatively. He would visit her often at the photography studio she set up at Madison Avenue and Forty-eighth Street, and his admiration was obvious. One day she gave him a photograph of herself in Jean Cocteau's

movie *Blood of a Poet*, in which she had a starring role as a Greek statue, and Cornell squirreled it away with his numberless glossies of singers and Hollywood starlets. Later on, he would incorporate her photograph into a collage, *Portrait of Lee Miller* (1948–49).

Like most art photographers in the thirties, Miller supported herself with commercial work. Her specialty was society portraiture, and her studio in New York was a bustling place patronized by the most fashionable people in the city. While Miller rarely photographed those who could not afford her high fee, she made an exception for her admirer from Flushing. From time to time, Cornell appeared at her studio carrying some of his recent *objets* so that she could photograph them, and she gladly indulged him; one of her odder photos shows a doll's head glowing inside a darkened glass bell. Miller's unceasing patience for Cornell confounded at least one person. When Antony Penrose, Miller's son, wrote a monograph on her work, he described Cornell as "a pitiful little lunatic from Brooklyn"—an assessment that stings only more sharply because of the carelessly mistaken borough.

Cornell was always quick to assert that he never joined up with the Surrealist movement, as if fearful of being linked with its naughty activities. Yet secretly, it seems, he was fascinated by the movement, and in general his feelings for Surrealism echoed the ambivalent nature of many of his other attachments. He had a passionate desire to be part of the art scene, and an alternating desire to pull back, to be insular and private and alone. His conflicted feelings extended to his work as well: he emulated the latest developments out of Paris, but in his own furtive way.

As much as the French Surrealists provided the context in which Cornell made his earliest collages and *objets*, they were also the impetus behind the various cinematic projects Cornell now undertook. Virtually overnight, Cornell began collecting old movies, writing scenarios, amassing movie stills, and actually making motion pictures.

Cornell had always loved movies. He had grown up along with the new medium, following its every development and keeping track of every new starlet. One of his crushes was Fay Wray, the girl who, in 1933, was screaming and thrashing in the hairy clutches of King Kong. Cornell sent her a fan letter, and she took the time to answer him. "Thank you so much for your cordial letter," she replied in a handwritten note that survives

Untitled (Portrait of Lee Miller), c. 1948–49; collage, 11 × 9¼ in. (Collection Vivian Horan, New York)

among his papers. "Yes, I read my fan mail, and enjoy it tremendously."

Julien Levy played a key role in Cornell's transition from movie buff to moviemaker. Levy had once aspired to make movies himself, and got as far as convincing Max Ernst and Brancusi to be in them. Once a week, Levy would have friends and collectors squeeze into the gallery to watch experimental movies. While his first program, featuring Léger's *Ballet mécanique* and Duchamp's *Anemic Cinema*, left his audience "bewildered and unconvinced," as he recalled in his memoirs, he persisted in showing the avant-garde films of the Dadaists and the Surrealists, who had embraced moviemaking with the subversive's love of new—and preferably disreputable—art forms.

Levy's gallery screenings laid the groundwork for the official-sounding New York Film Society, which he founded in 1933 with Iris Barry, an English film critic who had just moved to Manhattan to work at the Museum of Modern Art. (She had been fired from her previous job as the critic for *The Daily Mail* in London after writing an uncomplimentary review of a film starring Marion Davies, a love of the paper's publisher, William Randolph Hearst.) She and Levy were hoping to set up a projector, a screen, and a few dozen folding chairs at various locales, none of them theaters, and show old movies, which at the time couldn't be seen in New York. Movies were still so new an art form that it had not yet occurred to anyone to be nostalgic about them.

Levy's film society, which also showed foreign films, was the first of its kind in America. It was Iris Barry who assembled the movies, retrieving them from the warehouses of American Biograph or Edison or whatever company had made them. This experience would prove most helpful in 1935, when she founded the Film Library at the Museum of Modern Art (now the Department of Film) and proceeded to collect nearly every movie in existence for the purpose of making them available to the public.

From Levy's fledgling New York Film Society, Cornell realized that it was possible to acquire movies and watch them somewhere other than a crowded theater. He could even watch them at home, alone. And so Cornell began buying movies, himself becoming part of a circle of collectors who purchased their material mostly through correspondence. He concentrated on comedies and lighthearted entertainments, the kinds of movies that make children laugh. His collection focused on the "primitive" era of cinema and included some of the earliest shorts. He eventually accumulated about a hundred movies or fragments from movies, some anonymous, some by the

legends of early filmmaking. There were industrial documentaries. There was footage from the great D. W. Griffith and his celebrated cameraman G. W. "Billy" Bitzer. There were fast slapstick comedies by Mack Sennett, whose Keystone Kops made policemen look ridiculous, and pantomime and pathos from Charlie Chaplin, a favorite of the Surrealists. Most important, there was *Voyage to the Moon* (1902) by Cornell's beloved Georges Méliès, a French magician who in 1897 organized the Star Film company and constructed a small glass-enclosed studio in his house in Montreuil; there, in more than 500 films, he explored the capacities of cinema to do the impossible and resemble dreams.

Cornell acquired his own 16-millimeter projector and often set it up in the living room for a night of motion pictures. In coming years, while other families settled in to watch home movies featuring themselves mugging and waving at the camera, the Cornells gathered around Griffith and Méliès. Cornell's home screenings were intended as more than just fun. Most of his films dated from the turn of the century, as did the artistic project he was already envisaging in connection with them. He took his cue from the nickelodeon, where children paid a nickel to sit on a bench in a converted storefront and watch images flicker on a taut white curtain. By the early 1930s, nickelodeons were a thing of the past; movie palaces had replaced them. Yet as the movie industry advanced, Cornell slipped back in time, giving much thought to the itinerant projectionists who had flourished during film's "novelty" period; he would soon be traveling to different galleries with his projector and films from his collection.

Besides collecting movies, Cornell also wrote one. In 1933 he produced a movie scenario (now we call them screenplays) inspired by the ones he had read in Surrealist magazines. *Monsieur Phot* (1933) is his first completed cinematic work, and film historians have praised it as a daring project in which "one can readily see the influence of French avant-garde cinema," as P. Adams Sitney has observed. You don't have to be a cineaste to appreciate reading *Monsieur Phot* (it's about ten typed pages long), which, despite its disjunctive modern structure, is a rather sentimental tale. With four scenes and an epilogue, it dramatizes the experiences of a nineteenth-century New York photographer, a man who resembles a camera in that he's always on the outside, always looking in, yet who's so sensitive he feels overwhelmed by everything he sees.

We first meet Monsieur Phot in a park on a winter day as he's training his camera on a group of street urchins, his head and shoulders concealed

beneath a black focusing cloth, his top hat resting beside him. His manner, we are told, "is one of excessive politeness." One of the street urchins is holding a basket of clean laundry, and the photographer feels inexplicably moved by him. All of a sudden we read: "Close up of the head and shoulders of the photographer looking down upon the urchin in tenderest compassion, tears streaming down his cheeks and spotting his immaculate white wing collar." (The little boy with the wicker basket suggests Robert and the wicker wheelchair of his childhood.)

It seems fitting that Cornell cast himself as a photographer in *Monsieur Phot*. Although he never owned a camera, it is easy enough to imagine him as a photographer, lingering on streetcorners in pursuit of fleeting visions, a voyeur taking refuge behind the camera lens. Cornell once explained that he didn't have a camera because he disliked machinery. More to the point, he preferred collecting photographs to snapping his own. By nature he was drawn to the secondhand, the "found," and by the early thirties his basement collection had expanded to include photographs.

This isn't to say he became a collector of fine-art photographs. Instead, he concentrated on movie stills, those cheery, stagy, often saccharine photos that studios send to newspapers and magazines to help promote a new film. Very few people in America were then collecting stills; even the studios discarded them after a movie closed. Cornell quickly assembled one of the largest collections in individual hands, some 2,500 pictures by the mid-1930s. Librarians at public archives became as aware of him as he was of them. When the picture collection department of the New York Public Library put on an exhibit in May 1933 tracing the history of cinema, the library borrowed some Western stills from Cornell. Already, his house was its own lending library.

Probably no one outside his family realized that this artist who was among the earliest worshippers at the shrine of the moving image was equally serious about formal religion, his passions divided between the screening room and the Christian Science Reading Room. While Cornell's dual allegiances hint at his fundamental conflict between spiritual aspirations and sensual compulsions, what made him singular is that he could reconcile them through the experience of art. For Cornell, movies were not wholly dissimilar from religion. While plays, operas, and ballets held a veritable magic for him, their thrill was short-lived; an opera or a theatrical production is necessarily transitory, since each performance lasts only as long as the hour or two it takes to perform it. A movie, by contrast, is more like a

Bible: it's an enduring work that can be experienced and re-experienced over time, with everything about it staying exactly the same. For Cornell, who had lost so much in his boyhood and felt overwhelmed by life's precariousness, movies represented a reassuring world in which people and places were immune to age and decay, in which no one and no thing was ever lost from view. In the luminous flicker of moving pictures, he found the promise of eternal life.

In the fall of 1933, a few months before his thirtieth birthday, Cornell felt privileged when he was offered a new position by the Christian Science Church in Great Neck. He was asked to teach a Sunday-school class, an honor bestowed on outstanding members of the church. The class met for an hour on Sunday mornings, in a ground-floor classroom of the church, where Cornell was charged with instructing children and teenagers in the Bible and *Science and Health* and, more generally, with "guiding, protecting and directing" his students. Cornell taught his own class for three years, and in 1935 was also made librarian of the Sunday school, a fitting position for this most bookish of men.

As her son discussed difficult questions about guilt and salvation with his students, the literal-minded Mrs. Cornell wondered when he would find a real job again. His Sunday-school job paid nothing—it was volunteer work—and his other job in the Reading Room was hardly lucrative. Much as she liked to decorate a Christmas tree, to put on a hat and see her friends at the local Methodist church, Mrs. Cornell was not the sort of woman to give much thought to the state of her soul, and the recent loss of her father, Howard Storms—who died on July 14, 1934, at age eighty-three—led her to be newly focused not on the afterlife but on this life, and to further burden her older son with her clamorous needs.

In the fall of 1934, with the Depression finally over, Mrs. Cornell found her son a new nine-to-five job, requiring him to leave his position as a Reading Room attendant and of course to curtail his art-world peregrinations. She learned of the job from a friend of hers named Ethel Traphagen, who had graduated from Nyack High School in the same class as Mrs. Cornell. In 1923, she founded the Traphagen School of Fashion, reportedly the first design school in the country. It was located in an office building at 1680 Broadway, on the edge of the city's garment district, which had moved uptown since the days when Cornell and his father before him had

peddled cloth along the former Ladies Mile. Miss Traphagen, as Cornell would always call her, was a large-boned woman with plain Dutch features and white hair cut in a flapper bob. On a trip out West to study the costumes of American Indians, she met her husband, William Robinson Leigh, an explorer, author, and noted painter of cowboys and Indians.

Cornell was hired to work at the Traphagen Commercial Textile Studio, an offshoot of the school that sold designs to manufacturers. His salary was paltry, just fifteen dollars a week, exactly a quarter of what he had been earning at Whitman's. His title was more impressive, though. As his father had been, Cornell was now a "textile designer," and one imagines his mother pushed him into the job because she herself was eager to regain some of the prestige her designer-husband had once brought her. Yet Cornell had little interest in a career in design, and his mother's fierce hopes could not change that. At Traphagen's, he worked in the home-furnishings division, and the job consisted mostly of "hack work," according to his sister. Much of his time was spent assisting Miss Traphagen with design research—consulting books from her large art library and tracing patterns in pencil or tempera that could be used for home products like bedspreads, curtains, or carpets. There is something appropriate about the idea of Cornell tracing other people's designs rather than conceiving his own. Even as a so-called designer, he stuck with the ready-made.

Cornell would work at Traphagen's for the next six years without complaint. True, the job was tedious and "countless days seemed like eternities," as he later noted in a letter to a friend. Still, he felt it was his responsibility to be the wage earner in his family, and it did not occur to him to challenge his mother and the self-serving hopes she harbored for his career. Rather, he tried to make the best of the situation. Writing to his sisters at his desk one day, he observed in the forced, cheery tone he often used in his letters to them: "This gray morning marks a milestone in my life, maybe. Over the weekend the studio gets shunted from spacious quarters on the second floor to a corner (horrible light) on the fifth floor. Such cozy recollections of the old quarters . . . place by myself looking at traffic at Broadway and 52nd Street, etc. etc. So nice . . . Just as I am writing Miss T. appears and I help her measure another department back on the second floor."

As Cornell was attending to Miss Traphagen, other artists in New York were earning a living on the WPA Federal Art Project, one of the more successful of the New Deal efforts to create jobs. Cornell once said that he didn't apply for a job with the Project because he didn't believe in accepting

handouts. One suspects as well that he would have felt anxious presenting himself as a professional artist worthy of the standard rate of pay, since his artwork was so unconventional by American standards. Obviously he couldn't climb up on scaffolding and paint a mural, as many of the future Abstract Expressionists did, or produce three or four pictures a month that could be hung in a post office or some other government building.

So day after day, Cornell repaired to the Traphagen studio, a thirty-three-year-old dreamer stuck behind a desk. Yet his life was not without rewards. At night he could be found at the kitchen table on Utopia Parkway, where his artwork continued to develop. It had been about five years since Cornell first started making art, and so far he had produced little more than cardboard pill boxes, glass domes, and other *objets* notable for their miniature size and tentative feeling. Now, however, he left all that behind and moved on to something more substantial. In the summer of 1936, Cornell crafted his first Box—which is to say, his very first glass-fronted shadow box, the medium in which he would specialize for the rest of his life.

In searching for explanations for Cornell's discovery of the Box, various factors must be considered, but perhaps the most persuasive is also the most simple: Alfred H. Barr, Jr., the director of the seven-year-old Museum of Modern Art, was then gathering works for his landmark survey of "Fantastic Art, Dada and Surrealism," and Cornell needed a work to submit—a work that could hold its own at the museum, a work that established his talent not only to the public but to his own doubting self.

In preparation for his show, Barr ransacked the studios of Europe. He also conferred with his rival, Julien Levy, who remained the only art dealer in New York with a serious commitment to Surrealism. After Barr asked him to recommend some works by Cornell, Levy replied in an undated letter: "I don't find any Cornell about for the moment that would be good enough. Am dropping him a card tonight." Was Levy merely strutting his insider knowledge? Or did he really think Cornell could do better? Probably the latter, for the work which Cornell would end up exhibiting—his *Untitled (Soap Bubble Set)*—was far more ambitious than anything he had done before, and there can be little doubt that it was made in anticipation of Barr's epic show.

One practical problem for Cornell was his lack of a studio. The kitchen table was small—an enamel rectangle seating four—and on countless mornings before he left for work, his mother would scold him about the mess he had made the night before. He had no special place to store his art

supplies or his growing collection of books, papers, and assorted objects, and Mrs. Cornell, who kept the house tidy, was vexed by the ever-growing mounds of material she found in the kitchen and the dining room. Robert had the living room to himself, and Mrs. Cornell, too, had her own area of the house. Besides the master bedroom, she took over the glass-enclosed front porch, where, at a big Edwardian desk, she would pay bills, talk on the phone to her girl friends, and screen any calls for her sons that came into FLushing 7–7653. Cornell, however, had no such room of his own, as if reluctant to have his art intrude on the family's domesticity. When his mother told him to put his things away, he would move them into the detached garage, getting them out of the house.

For all his mother's complaints, the small-scale work Cornell had produced so far made less of a mess than painting or sculpting might have. His supplies were ready-made: cardboard boxes, pine boxes, glass bells, fabric, and engravings to cut up and put inside them. Snipping and pasting, he used little more than scissors and glue. Now, however, in the summer of 1936, as he prepared for the MoMA show, Cornell wanted to build a glass-fronted shadow box, which would require, among other things, a carpenter's tools. He didn't own a power saw and had no idea how to use one. His next-door neighbor, Carl Backman, was interested in woodworking and had a modest shop in his basement. When Cornell asked him one afternoon to cut some pieces of pine for him, Backman obliged and wondered what Cornell was planning to do with them.

Taking the planks home, Cornell constructed his "real first-born," as he once called his *Untitled (Soap Bubble Set)*, the first in a long series of the same name and one of his most satisfying works. It makes sense that Cornell, who lived in a bubble, would seize on the theme of soap bubbles for his very first shadow box. A small vertical work about 16 inches high and painted bright white inside ("I applied at least six coats of the best enamel obtainable"), the *Soap Bubble Set* at first might seem to recall the child's pastime of blowing bubbles, though bubbles, as in seventeenth-century "Vanitas" still lifes, are also a symbol of the brevity of life.

These two associations nicely coalesce in Cornell's first *Soap Bubble Set* (now owned by the Wadsworth Atheneum, Hartford), which might be viewed as a symbolic family portrait. A narrow compartment on the left contains a shapely wineglass implanted with an egg, perhaps a symbol of motherhood. To the right a tiny doll's head is displayed on a pedestal, a stand-in for the artist himself. Four cylindrical blocks are arranged in a neat

Soap Bubble Set, 1936; construction, 15¾ × 14¼ in. (Collection Wadsworth Atheneum, Hartford, Connecticut. The Henry and Walter Keney Fund)

row at the top and suggest the orbit of the four children in the Cornell family. A white clay pipe resting on a shelf evokes the artist's Dutch ancestors, as well as his dead father.

The soap bubbles of the work's title exist only by implication, their round shape suggested by the map of the moon that hovers above the pipe. However delicately evoked, they remind us of the healing power of daydreams—and art itself—in the face of death. Cornell's *Soap Bubble Set* offers up an immortal family, an assemblage of fragments that gain their identity only in relation to one another, and whose graceful bonds time can neither separate nor destroy.

What led Cornell, with this one work of art, to come up with the idea of the Box? Cornell himself offered different explanations on different occasions, none of them completely convincing. At times he referred art historians to *Illumined Pleasures*, a well-known Dali painting from 1929 that eventually passed into the Museum of Modern Art's collection. *Illumined Pleasures* shows boxes—three boxy "paintings-within-a-painting" inserted into a landscape to suggest the secret thoughts and Oedipal anxieties of the naked boy whose eye bulges through a peephole.

On other occasions, Cornell insisted that the idea of the Box had more populist origins: it came to him on one of his walks through Manhattan. Passing an antique shop, he noticed a pile of compasses in the window. "I thought, everything can be used in a lifetime, can't it, and went on walking," Cornell told David Bourdon of *Life* magazine in 1967. "I'd scarcely gone two blocks when I came on another shop window full of boxes, all different kinds . . . Halfway home on the train that night, I thought again of the compasses and the boxes. It occurred to me to put the two together."

However Cornell chose to explain his breakthrough, it is incontestable that assembling objects in a glass-fronted box was a popular pastime in the Victorian era. Like the bell jars and little pill boxes that were among Cornell's earliest creations, the shadow box was a staple of home decoration in the decades following the Civil War. This period marked the heyday of genteel recreations for ladies, or "parlour pastimes," which were spurred by an increase in leisure time as well as restrictive customs that denied women entry to art schools and official academies. Unable to become professional painters or sculptors, Victorian women busied themselves with shellwork, feather-made flowers, seaweed pictures, and other pseudo-arts.

Chief among them was the shadow box, essentially a three-dimensional frame lined with silk or satin or black velvet and containing a medley of

objects that passed for artistic arrangement. Like Victorian ladies who believed it was undesirable to parade their talent, Cornell found in the form of the shadow box a safe place to hide his ambition.

Cornell had the good fortune to first display his *Untitled (Soap Bubble Set)* in what turned out to be the most discussed exhibition in New York since the Armory Show of 1913. "Fantastic Art, Dada and Surrealism" opened at the Museum of Modern Art—located in a five-story limestone townhouse at 11 West Fifty-third Street—on December 9, 1936, and brought together some 700 works that traced Dada and Surrealism all the way back to their irrational roots in the fifteenth century. Half a century before "high-low" became a hot topic in the art world, Alfred Barr hung the Renaissance masterworks of Leonardo da Vinci and Giovanni di Paolo alongside the cartoons of Rube Goldberg and Walt Disney. It was an unknown and modest entry, however, that ended up attracting the most attention: a teacup, saucer, and spoon, all covered with real fur. Swiss Surrealist Meret Oppenheim's *Fur-lined Teacup*, as the work came to be called (its actual title is *Le Déjeuner en fourrure*), seemed to unhinge people who just glanced at it.

Installation photos by George Platt Lynes reveal that Cornell ended up exhibiting his *Soap Bubble Set* alongside a few earlier objects inside a big glass vitrine—a box for his boxes. He set up the display himself, reminding Barr in advance that he was available for the task. In a typed letter to Barr's secretary, Cornell offered his phone number at Miss Traphagen's and remarked in his usual guarded manner: "Although this is an emergency number for me the few calls that would come in preparatory to the Surrealist exhibition would be perfectly all right."

More than any other exhibition, MoMA's homage to Surrealism truly brought the movement to America. The fanfare surrounding the show began before it opened. In November, as Barr was still rushing last-minute selections into his exhibition, *Harper's Bazaar* announced with only slight exaggeration: "One sure thing, you aren't going to find a solitary place to hide from surrealism this winter." Surrealism was the sensation of the moment, as marketable in its way as the skin cream and razor blades touted in the ads that ran alongside the article ("Astound him with your womanly intuition. Give him a Rolls Razor"). The article devoted considerable attention to Cornell, "who is, according to Mr. Levy, one of the few Americans who fully and creatively understands the Surrealist viewpoint."

Although Cornell had never received such attention in the press, he was displeased by the article. It bothered him to be grouped with the Surrealists, as if their company somehow reflected poorly on his character. After reading the article, he wrote a complaining letter to Barr. He wrote another a week later, on November 13: "In the event that you are saying a word or two about my work in the catalogue," Cornell told Barr, "I would appreciate your saying that I do not share in the subconscious and dream theories of the Surrealists. While fervently admiring much of their work I have never been an official Surrealist, and I believe that Surrealism has healthier possibilities than have been developed. The constructions of Marcel Duchamp who the surrealists themselves acknowledge bear this out, I believe."

The statement is Cornell's own Surrealist manifesto—or, rather, his anti-manifesto, an attempt to distance himself from the Surrealist movement and its "unhealthy" focus on sexuality. In spite of Cornell's fears, Barr had neither the space nor the inclination to acknowledge them in the catalogue, where Cornell was grouped with the Surrealists though labeled an "American constructivist"—a brilliantly noncommittal assessment that got Barr off the hook for the moment.

The show, though a flop with the critics—"Farewell to Art's Greatness" read the headline above Henry Bride's review in *The Sun*—was an undisputed hit with the public. A new magazine, *Time*, put the mustachioed face of Salvador Dali on its cover, and its article gushed: "Surrealism would never have attracted its present attention in the U.S. were it [not] for the handsome 32-year-old Catalan." For years to come, Dali's melting watches and lobster-telephones would define Surrealism to most Americans, even though Dali himself was about to be officially expelled from the Surrealist movement. His publicity stunts in New York, which culminated in his smashing Bonwit Teller's Fifth Avenue display window after the store made some changes to two windows he had designed, distressed his colleagues and led André Breton to give him the anagrammatic nickname "Avida Dollars." ("That's the only truly brilliant intuition Breton ever had in his life," Dali sniped back.) None of this diminished the interest that Dali held for Cornell, whose life was about to be changed by their first meeting.

As record crowds descended on the Museum of Modern Art and were greeted at the entrance by Man Ray's *Observatory Time–The Lovers*—in which a six-

foot-long pair of red lips (Lee Miller's) float in the sky—art dealers capitalized on the excitement by staging their own Surrealist shows. New oil paintings by de Chirico and Miró popped up in the windows along Fifty-seventh Street. Julien Levy mounted an exhibition of Dali's latest paintings—and published *Surrealism*, a book Levy himself had written. Conceived as a challenge to the scholarly catalogue Barr had prepared for his own Surrealism show, Levy's *Surrealism* remains the most valuable early chronicle of the movement in English and a great souvenir of the 1930s. It was modeled after the avant-garde anthologies of Europe, with their long, obscure excerpts from the writings of artists and poets, and is packed with such rarities as the unabridged version of Cornell's scenario *Monsieur Phot*.

By now Cornell's film activities included more than writing scenarios. He was also making movies, which might seem a little surprising. At first, it is hard to imagine him presiding over auditions, casting, costumes, sets, over lavish budgets and sizable egos—over action. Yet Cornell's movie work, like all his creative doings, was rooted in the concept of the readymade, and he in fact produced his early movies amid the quietude of his home. He may be the only moviemaker ever who had no idea how to operate a movie camera.

Cornell's first movie is also his best known, and is now considered a classic of experimental cinema. *Rose Hobart* is essentially a celluloid collage—a re-edited version of a cheap Hollywood melodrama. Until then it had never occurred to anyone to make a movie by "appropriating" an earlier movie (not counting documentaries), and it is a measure of Cornell's originality that he saw that something interesting could be salvaged from the most mundane reel of found footage.

His raw material was a print of *East of Borneo*, a grade-B jungle flick from 1931, which he'd found in a rubble heap. As Julien Levy recounts in his memoirs, one day Cornell discovered a warehouse in New Jersey where scraps of discarded film were being sold by the pound, their only presumed value residing in their silver nitrate. For a ridiculously low price Cornell bought a batch of old footage that included *East of Borneo*. The movie had been made five years earlier by the relatively unknown director George Melford and released by Columbia Pictures as one of its first talkies. Starring the now-forgotten actress Rose Hobart, the movie chronicles her adventures in the fictional Indonesian kingdom of Marudu. Its story line is not too subtle: the heroine, who of course is virtuous and valiant, travels to Marudu

to reclaim her estranged husband, and ends up defending herself against a sinister prince as well as an array of tropical hazards (a panther, a python, an erupting volcano)—all courtesy of stock footage.

How did Cornell conceive the movie-collage form? Perhaps the idea came to him at home, after innumerable evenings of running strips of celluloid through a viewer. Maybe he realized, as he rewound a reel or tried to fix a warped frame or puzzled over a missing sequence, that there was something to be gained from visual dislocations. As P. Adams Sitney has written: "When one owns a print of a film and shows it repeatedly, accidents happen in the projection and rewinding; passages are damaged and strange ellipses occur in their repair." While such slip-ups are usually a source of frustration, to Cornell they offered an inadvertent model of formal boldness. Of course, one need not strain for explanations of his montage technique, since it's essentially the cinematic equivalent of his boxes: it's based on his sense that anything can be transformed by juxtaposing it with something else, something unexpected.

Having acquired a 16-millimeter print of *East of Borneo*, Cornell worked at home revamping it. His method was almost comically primitive. With a pair of scissors and a roll of tape, he cut the film into loose frames and segments which he then pieced together out of sequence. As a result of his splicing and editing, a 77-minute feature film was compressed into nineteen and a half plotless minutes. "If you love watching movies from the middle on," the poet Charles Simic once wryly observed, "Cornell is your director."

Cornell's basic strategy was to delete the most dramatic sequences—the perilous voyage upriver to Marudu, the final volcanic eruption that devastates the town—and concentrate on shots of Rose Hobart. The narrative is collapsed into "mismatched" images of her pensively bewitching face. We see her framed by jungle foliage, wandering dreamily through the rooms of the palace, reclining in her cabin, looking up, looking down, her countenance always retaining the same cool allure, her actions rhythmically echoing one another. There's also footage from a second movie: documentary shots of an eclipse are intercut with frames of Rose Hobart, allowing her gaze to encompass the heavens.

Despite the crudeness of Cornell's technique, his finished product is remarkably coherent. A standard melodrama undergoes a sea change and becomes a film whose every frame is somehow imbued with Cornell's vision. In one scene the actress studies a parrot, presaging Cornell's later Aviary boxes. In other scenes she holds a wine goblet, an object he had already

used in his *Soap Bubble Set*. And like much of Cornell's future work, the movie is an idealized portrait of a female performer. It makes us feel the emotions that come with being a fan: Rose Hobart looms before us as an icon. Yet her appeal is not purely feminine. With her short hair and slender, flat frame, Rose Hobart is a study in androgyny, the first of many boyish girls to surface in Cornell's work. We first see her dressed in a man's jacket and tie; later she appears in a silky evening dress—her masculine and feminine costumes blurring the boundaries of gender.

Even her name connotes sexual uncertainty, at least to followers of modern art. Rose, after all, was the name of Duchamp's female alter-ego, Rrose Selavy, the appellation he gave to photos of himself dressed in women's clothing. It is not farfetched to see Cornell's *Rose Hobart* as a valentine to Duchamp, who, though certainly not the first artist to be sexually confused, was the first artist to make "modified readymades," the category into which the movie falls. In *Rose Hobart*, Cornell extended the technique of the modified readymade into film.

Cornell mustered the courage to approach Levy with several reels of his homemade movies, and the dealer was sufficiently impressed to schedule a matinee program at the gallery. "Goofy Newsreels," as Cornell called the program, included *Rose Hobart* as well as several shorts from cinema's earliest days; it was the first of many screenings in which he would share his dream of the nickelodeon with his fellow artists. The program was held in December 1936, just a few days after the Surrealist exhibition opened at MoMA. Many of the Parisian Surrealists were in town for the show, and so, it turned out, Cornell's first audience would include Salvador Dali as well as other members of the European avant-garde.

Cornell operated the projector himself at the screening. While doing so, he further transformed *Rose Hobart* by projecting it through a piece of tinted blue glass and slowing it down to the speed of a silent movie (one-third slower than sound speed). He also suppressed the original sound track in favor of a selection from a reject-bin record called "Holiday in Brazil." And so his *Rose Hobart* became a slow-creeping blue creation, its grainy black-and-white images bathed in a rich cerulean light and backed by jagged musical rhythms intended to echo the baroque visual rhythms.

Most of the audience found *Rose Hobart* unintelligible, and even the ever-tolerant Levy dismissed it as an "incomplete experiment in a new direction." Dali, however, was beside himself with envy. He had always been prone to jealous rages, and *Rose Hobart* provoked his full malevolence. Halfway

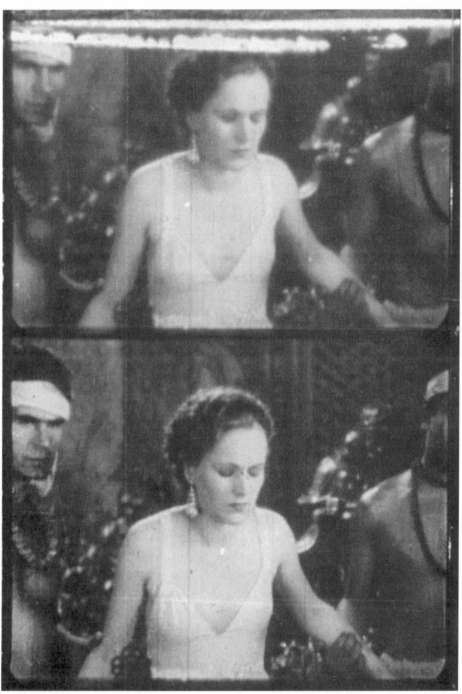

A scene from the movie *Rose Hobart* (Collection Anthology Film Archives, New York)

through the movie, there was a loud crash as the projector was overturned. "Salaud!" came from Dali, which was tantamount to calling Cornell a skunk. Levy yelled for lights. Dali's wife, Gala, pushed her way toward him and pleaded, *"Calme-toi."* But Dali could not be placated. "Salaud and encore salaud," he shouted again and again, while members of the audience rose from their seats to restrain him.

Dali had good reason for envy. As critics would later remark, *Rose Hobart* ranks with *Un Chien Andalou* as a masterwork of Surrealism—and in some ways it is a more radical work, forcing the idea of the "found object" into film and thus bringing a key Surrealist concept to its logical conclusion. Cornell's movie-collage was so innovative that not for thirty years would there be anything like it: *Rose Hobart* initiates a genre of film—the so-called compilation film—that flourished among experimental filmmakers in the late 1960s. Dali himself had given thought to the very same innovation, or so he claimed at the time. After his anger had subsided, he lamented to Julien Levy: "My idea for a film is exactly that, and I was going to propose it to someone who would pay to have it made . . . I never wrote it or told anyone, but it is as *if* he had stolen it."

Cornell was deeply aggrieved by the incident. It had never occurred to him that someone as marginal as he could excite the envy of a world-famous Surrealist. "Why, why," he fretted to Levy, "when he is such a great man and I am nobody at all?" Thus Cornell was instructed firsthand in the unkindness of fellow artists. Dali soon forgot the contretemps, but Cornell would always remember it. To the end of his life, he would recount the story whenever he was asked to screen his films, usually as a way of explaining why he must decline.

6

Introducing the Neo-Romantics
1937-39

In January 1937, "Fantastic Art, Dada and Surrealism" closed at the Museum of Modern Art. However prestigious it may have been to exhibit his work in Barr's landmark show, Cornell hardly felt like an art-world success. Uncertain as ever of his talent, he was still working nine-to-five at the Traphagen textile studio, as his mother insisted he should. She felt he was fortunate to have a fifteen-dollar-a-week job, which, she didn't hesitate to remind him, was certainly more lucrative than making art. While Cornell was able to devote late-night hours to his boxes, by the time he sat down at the kitchen table he often felt too discouraged to achieve anything and would chastise himself for his dilettantish manner of working.

Sometimes Cornell simply gave up and spent the night reading instead, turning on the oven for heat and moving his chair beside it. His taste in literature, like his work, was shaped at least partly by the Surrealists. His favorite author was Gérard de Nerval, the nineteenth-century poet and writer who used to stroll the streets of Paris with a lobster on a leash. In his own writings, Breton urged people to read Nerval as if he were some compelling new author published just last week. Nerval, a forerunner of both the French Surrealists and the Symbolist poets who had flourished in Paris a half century before them, lived during the heyday of French Realism, but resisted the literal in favor of dreams and fantasies. He was in his twenties when he fell in love with a young actress named Jenny Colon, who married someone else and who became in his writings a symbol of the unattainable. His years of destitution and mental illness ended in 1855, when he was found hanging from a lamppost in the rue de la Vieille Lanterne in Paris.

Cornell read and reread everything Nerval ever wrote, from *Aurélia* and *Les Filles du feu* to the "supernaturalist" sonnets collected in *Les Chimères*.

So, too, Cornell became intimately familiar with the stirring details of Nerval's life, and a decade later would start a transatlantic correspondence with Nerval's biographer, Albert Béguin. While Nerval's writings gave Cornell license to trust his own inner visions, they probably left his greatest mark on Cornell by alerting him to the artistic dimensions of a stroll through the city. Venturing out from Utopia Parkway to explore the streets of Manhattan, Cornell came to regard 1930s New York in much the same way that Nerval had seen Paris a century earlier, never knowing what random sight might suddenly prompt the flow of the dream into everyday life. He could never be sure what awaited him as he turned a corner, what rare book or photograph he might find in a shop, what pretty young girl espied from a distance might provide him with yet another collectible—a mental picture to be filed away in his inner archive.

After Nerval, Cornell's favorite writer was the Symbolist poet Stéphane Mallarmé, whose life story also provided much that Cornell could identify with. Plagued by rheumatism, insomnia, and creative blocks, Mallarmé led a relatively uneventful life, toiling as a schoolmaster in the provinces to support his family. Once when Cornell was at the Flushing Library reading Edmund Gosse's *French Profiles*, he came across a description of Mallarmé that he decided to copy down: "I have a vision of him now, the little, brown, gentle person, trotting about in Bloomsbury . . . It was strange that Mallarmé never saw, or never chose to recognize, that he was attempting the impossible. He went on giving us intimations of what he meant, never the thing itself."

In Gosse's description of Mallarmé, Cornell perhaps recognized himself, another wistful dreamer trotting about town. Like the Symbolists, Cornell believed that experience must be invoked in a subtle and indirect way. A symbolist by temperament, he had always preferred night to day, shadows over legible sights; he prized echoes over blurted truths. Moreover, Cornell heard those echoes everywhere. He saw connections where others saw only fragments. A compulsive cross-indexer, Cornell linked life to books, contemporary Manhattan to a vanished Paris, city pigeons to long-gone performers.

Cornell's penchant for time-hopping reflected not only his artistic principles but his anxieties as well, his fear of the empty everyday moments that stand for nothing, except the threat of dissolution and loss. Even before he read Mallarmé, the disappointments of his childhood had led him to envision an imaginative universe in which the past and the present are

forever linked, and where nothing is ever permanently lost. His idea of "complete happiness," Cornell later noted in his journals, was of "quickly being plunged into a world in which every triviality becomes imbued with significance."

Could that experience ever be conveyed through his art? Following the big Surrealism show at MoMA, Cornell remained unsure not only of his boxes but of whether he wanted to make boxes at all. At times he wondered whether it wasn't cinema that was in fact the new language of poets. And so he tinkered with his home movies, staying up late at his kitchen table and pasting his celluloid scraps together. His latest project was *The Children's Party*, *Cotillion*, and *The Midnight Party*—an entertaining trilogy of black-and-white films in which Cornell recycled reels of found footage into a kind of dream party for children, complete with vaudeville acts, constellations in a night sky, and a sequence of dancing kids swiped from an *Our Gang* comedy. The longest of the three films is only seven minutes.

Whom could Cornell count on for support in this endeavor? "I have just completed a rough (very rough, in fact) draft of the children's party film and you've probably since forgotten that I ever started one," Cornell wrote with touching modesty on November 15, 1938, to Jay Leyda, a film historian then working at the Museum of Modern Art. "I was wondering if I could come over to the museum and run it off with you on the sidelines to throw in a little encouragement—if it deserves it."

Despite Cornell's awkwardness in finding supporters for his work, his reputation appeared to be advancing. In January 1938, he made his European debut when his work was tapped for another now-legendary show, the International Exposition of Surrealism at the Galerie Beaux-Arts in Paris. Surrealism by then had lost its creative edge, but did any other artists ever have so much *fun*? The International Exposition featured a fake street assembled outside the main exhibition hall—the rue Surréaliste, with seventeen female mannequins transformed by as many artists to cry crystal tears (Man Ray), sport bird cages on their heads (André Masson), grow a mustache (Miró), and generally revel in the fraternity-house humor into which Surrealism had descended. Of the sixty artists in the show, Cornell was the sole American to contribute pieces from abroad (though two Americans based in Paris, Man Ray and Roberto Matta's wife, Ann Clark, also participated). For Cornell's entry, Julien Levy had sent over some works identified on the exhibition checklist only as *Objets*. Their French title reminds

us that Cornell was a Francophile who had never been to Paris and whose work was already more widely traveled than he was.

Closer to home, Cornell was enjoying the interest of Chick Austin, the director of the Wadsworth Atheneum and the college friend of Julien Levy who had mounted the pioneering "Surrealism" show in Hartford in 1931. Now, in January 1938, the Atheneum exhibited Cornell's *Untitled (Soap Bubble Set)* in a show called "The Painters of Still Life"—a category that at first might seem to exclude Cornell. Yet it was, in truth, a stroke of inspired curatorial vision that led Austin to link Cornell's work to the line of realism that began with seventeenth-century Dutch still lifes, a genre Cornell happened to admire. For while Cornell's little boxes have the dreamy extravagance of Surrealism, the humble, homely objects from which they're constructed tie them at least partly to the tradition of realism, in particular the *trompe l'oeil* still lifes of his American predecessors John F. Peto and William Harnett, who, like Cornell, found a spare poetry in discarded objects.

The following May, Austin expressed his support for Cornell more pointedly. He acquired *Soap Bubble Set*—the artist's very first shadow box—for the permanent collection of the Atheneum, purchasing the piece for the respectable price of sixty dollars. The sale was Cornell's first to a museum, and possibly to anyone at all. As such it might seem to have been a cause for happiness. Yet Cornell was always reluctant to part with his work; as much as he longed for recognition, the prospect of a sale was likely to make him cranky and anxious. In this case he tried inflating the price for the express purpose of thwarting the sale. As Julien Levy cautioned Chick Austin in a letter: "Cornell is very cut up about selling the 'Soap Bubble Set' which he says took him a summer to make, etc. He originally asked about $300 as he is a madman."

The story of the New York art scene in the 1940s tends to be presented as an all-star production featuring Jackson Pollock, Willem de Kooning, Mark Rothko, and other ascending Abstract Expressionists—and no one else. The truth, of course, is that the scene was a more messy and crowded affair including innumerable minor characters, each with his own dramatic and convoluted plot. To fully understand the period, we must divest ourselves of the textbook version of art history, or at least shine the spotlight on a

darkened corner of the stage—on a group known as the Neo-Romantics, who were vastly famous in their own time but would later disappear from view or, rather, find their following, which once consisted of the monied bohemia of Paris and New York, reduced to a small group of loyalists interested mainly in the Neo-Romantics' cultivation of what we now call a gay sensibility.

The most prominent of the Neo-Romantics was Pavel Tchelitchew, who in his lifetime was—amazing as it may now seem—placed in the same league as Picasso and lionized as the greatest living painter. If he is known today, it is mainly as the man who painted *Hide and Seek* (*Cache-Cache*), a large, gaudy, congested picture showing babies' heads tucked between the gnarled roots and branches of a tree. The Museum of Modern Art purchased the painting in 1942, the same year Tchelitchew completed it, and a few months later honored him with a full-scale retrospective. While the painting has since been taken off MoMA's walls and consigned to storage, for years *Hide and Seek* hung by the entranceway to the museum's third-floor galleries. To those of us who grew up entranced by its acid colors and outrageous subject matter—our young eyes eagerly scoured its branches to find the hidden heads, with their translucent veins and capillaries—the painting practically defined what we perceived as the exacting strangeness of modern art. Never mind that Tchelitchew was a facile draftsman who "confused the aim of painting with puzzle-making," as Jean Cocteau once noted.

Tchelitchew, a volatile and high-strung homosexual, was well known in his time in society circles. His specialty was the society portrait, and internationally famous ladies rushed to sit for him. They were charmed by the polyglot patter of this Russian émigré who was so well-bred he was "almost overbred," as Julien Levy once remarked. Tchelitchew (pronounced Chelly-cheff) was the product of an aristocratic upbringing that ended with the Russian Revolution. After escaping his homeland on a French battleship, he commuted between the cosmopolitan centers of the West: he exhibited his early pictures in Paris, designed sets for Diaghilev in Monte Carlo, and painted a famous portrait in London of Dame Edith Sitwell, a publicity-ravenous poet who fell madly in love with him. It was a well-known bit of gossip that when Miss Sitwell "took Pavel up," his earlier patron Gertrude Stein, who could be possessive about her geniuses, let him down just as emphatically.

After moving to New York in 1934, Tchelitchew exhibited his work almost annually at the Julien Levy Gallery. Although Levy remains best known as a promoter of Surrealism, he was equally committed to his clique

of NeoRomantics, who failed to attain similar prominence. Besides Tchel-
itchew, the Neo-Romantics included Eugene Berman and his brother Léo-
nid, Christian "Bebe" Berard, and Kristians Tonny—figurative painters
who had first come together in Paris in 1926, after deciding that Cubism
was an unfortunate trend which had to be stopped. In other words, they
were violently opposed to abstract painting. Today, Tchelitchew is often
classified alongside the Surrealists, but in his lifetime he spoke dismissively
of them, perhaps because he was envious of the attention they received.
When Tchelitchew's retrospective opened at the Museum of Modern Art—
a year after Dali's—he reported gleefully to Edith Sitwell that a thousand
people descended the first day, "three hundred more than Dali last year."

On the surface, there might seem to have been little place for a man like
Cornell in Tchelitchew's social calendar—with its ongoing swirl of Park
Avenue dinners, gala costume balls, and gatherings bright with chatter and
laughter. Yet in the next few years Tchelitchew would become a key person
in Cornell's life, providing him with a sense of community and direction.
Cornell came to know him only gradually, and at first was more friendly
with the clan around him than with Tchelitchew himself, perhaps because
he felt a bit awed by the glamorous émigré.

Cornell initially befriended Tchelitchew through the painter's longtime
lover, Charles Henri Ford. A skinny, blue-eyed poet from Mississippi, Ford
would soon achieve something significant by founding *View*, the avant-garde
magazine in which many of the French Surrealist poets published their
work. Ford's own poetry was, at best, a heavy-handed approximation of
Surrealism. If Ford was ahead of his time in anything, it was in his penchant
for uninhibited self-disclosure; in 1933, along with Parker Tyler, he co-
authored a novel called *The Young and Evil*, described at the time by the
critic Louis Kronenberger as "the first candid, gloves-off account of more
or less professional young homosexuals."

Ford became aware of Cornell's work before he actually met him; they
were brought together in 1939, after Ford wrote to Cornell to propose that
they collaborate on a volume of poems and collages. Flattered, Cornell began
a steady correspondence with him—even though he saw little possibility of
an artistic partnership with a writer of Ford's flagrantly libidinous bent.
"One thing that might make it hard for me to offer you material for
collaboration," Cornell wrote defensively that July, "would be my total lack
of interest in psycho-analysis and the current preoccupation with sex."

At thirty-six, Cornell held a certain cracked interest in the eyes of his

new acquaintances. He was unlike any other artist they knew, with his alarming prudery, his shyness and silences, his fantastic knowledge of nineteenth-century literature and music. Charles Henri Ford was genuinely appreciative of Cornell's mysterious ways and became an invaluable friend. When Ford gave him a copy of Isak Dinesen's *Seven Gothic Tales*, he inscribed the book: "Joseph, these were written for you."

Not least among Cornell's idiosyncrasies was his boringly middle-class address in Flushing—which, to his delight, he shared with the 1939 World's Fair. "I have been going by the old garbage dumping grounds for twenty years," he wrote to Charles Ford, "and thought it just a plaisanterie [he invented this word] when I read in the papers that the Fair site would be established there." Cornell made several trips to the fairgrounds with Robert and their mother, and came away with a trove of Dutch clay pipes, many of which were later used in his Soap Bubble Set series of boxes. Dali had his own display at the fair, a sleazy sideshow of bare-chested mermaids in a giant fish tank, but by now Cornell had tired of his consumer-friendly art. He accused Dali of favoring the cheap thrills of "black magic" over the "white magic" of Houdini—for Cornell, an unpardonable sin.

The comment was made to Charles Ford, with whom Cornell enjoyed corresponding. He felt relieved to have found someone who understood his intense interests. In his letters to the poet, Cornell emerges as a guarded but affectionate figure, eagerly reporting on the books and illustrations he had picked up on his forays in Greenwich Village. "I found something last week," Cornell noted in a typical moment, "that I think would enchant you, a set of two paper bound German children's books from 1854, in pristine condition . . . That, along with a rare set of coloured plates of the Grandville 'Metamorphoses,' has given a little zest to the sometimes weary business of scrutinizing the Fourth Avenue bookstalls." Cornell's letters to Ford were generally typed, a single-spaced surge of arcane cultural references. They seem designed to bolster Cornell's image as an artist as much for himself as for the poet who received them.

In spite of their extensive correspondence, Cornell was cautious about socializing with Ford, who lived on Christopher Street in Greenwich Village. Cornell's job at the Traphagen textile studio left him with little time to see people except for his lunch hour; and during lunch, he claimed, he couldn't relax enough to be much in the way of company. He routinely declined any evening invitations, excusing himself on the basis of his "family obligations" and the long trip home to Queens. "He was a day prowler,

not a party boy," Charles Ford later noted. "He wasn't an aggressive person; he didn't promote himself. We thought of him as a monk."

Indeed, what was an uptight man like Cornell doing with Ford and his Neo-Romantic cronies, who flaunted their bohemian homosexuality and surely qualified as the most openly gay artists of their era? The Surrealists, by contrast, were aggressively heterosexual, the one obvious exception being René Crevel (who had committed suicide in 1934). While Surrealist paintings were full of ominous eroticism, André Breton, betraying his true bourgeois soul, declared that male homosexuality "completely disgusted him." He upheld heterosexuality as well as monogamy as the province of the proper Surrealist.

Was Cornell a repressed homosexual? Some of his contemporaries thought so, albeit for superficial reasons: he never married, lived with his mother, and loved opera. But it would be some time before anyone thought to make the claim in writing. Wayne Koestenbaum, in his cult classic *The Queen's Throat: Opera, Homosexuality and the Mystery of Desire* (1993), lists Cornell in a group of "gay artists" that also includes Robert Mapplethorpe and Andy Warhol, the first assertion in print that Cornell was homosexual.

Yet there is no evidence to suggest that Cornell was gay, and ample evidence to suggest otherwise. To judge from his journals and experiences, he felt nothing for the bodies of men. To the contrary, as we will see, Cornell's libidinous nature was focused on the bodies of women, though he could not permit himself to satisfy his erotic curiosity through the normal means. He could allow himself only what might be called "visual possession," taking hold of women not in the flesh but rather through the tool of his eyes. For Cornell, the act of looking—whether at photos of long-gone performers or at anonymous girls he happened to notice on the street—was itself an erotic activity, and he was capable of little beyond such spectator gratification.

If Cornell's sexuality was a riddle to his friends, it was also a mystery to himself, one that he preferred not to think about. His comment to Ford earlier that year about his "total lack of interest in psycho-analysis and the current preoccupation with sex" hints at a refusal to acknowledge his desires not only to the poet but to himself as well. Perhaps it is not wholly surprising that a boy who entered adolescence and became aware of his sexual urges at a moment when his family was collapsing—his father dying, his brother disabled, his mother desperately attached to him—should pass his adulthood denying he had urges at all.

There is a tendency nowadays to "out" any individual whose sexuality is confused or ambiguous, who chooses to not choose. Yet not everyone who refrains from a life of active heterosexuality is clandestinely gay. Cornell's great secret was this: In spite of his celibate ways and the cloaked spirit of his art, he yearned for intimacy with women. Still, he lived in fear of his longings to an extreme degree. While one can blame a good deal on Cornell's overly possessive mother, who kept him under close guard and demanded his loyalty, there is no theory sufficient to explain how one person could turn out so strangely. He was more affectionate toward objects than people, preferred little girls and actresses to available women, suffered from migraines, and talked to pigeons.

On the other hand, Cornell did exhibit certain tendencies that are often associated with homosexuality. To some extent, he identified with women; in coming years, he would often imagine himself the double of female artists and performers and would fantasize about women's clothing. At times it was unclear whether the objects of his longing were women he worshipped or women he wanted to be. A strong identification with women, though common among homosexuals, is not synonymous with being gay. To my mind, Cornell was not homosexual, but he was strongly female-identified.

In light of the contemporary trend for interpreting art according to issues of gender, Cornell seems likely to be deified as a quintessentially postmodern artist—a pioneer of sexual ambiguity, androgyny, and gender reversal. Cornell, of course, never actively sought to blur the boundaries between masculinity and femininity in either his art or his life. Rather, he was a wounded man who felt excluded from the province of sexual fulfillment and was determined to ignore his longings, at least until the last decade of his life. In his mind and in his awkward, rangy body, desires were something to be buried deep and never exhumed. For most of his life, Cornell was "in denial," and his art demonstrates, among other things, that denial can do wonders for an artist's work.

In 1939, if Cornell became part of the gay art-world clique in which Tchelitchew was the sovereign member, his new friendships might best be viewed as a reflection of his desire for artistic camaraderie. Through Charles Ford, Cornell met a man who now became his closest friend. Parker Tyler was one of the few true talents among the hangers-on who constituted the Tchelitchew crowd. A descendant of Presidents William Henry Harrison and John Tyler, he early on broke from family tradition. After leaving his native New Orleans, he settled in Greenwich Village in the 1920s and in

the next two decades became a prolific poet, movie critic, and art critic. He was also a biographer; his *Divine Comedy of Pavel Tchelitchew*, 504 pages of graceful prose, is a much better book than Tchelitchew deserved. "If his name had been easier to pronounce, it might have had more currency," Tyler announces at the outset of his witty biography, in which he never veers from his inexplicable admiration for Tchelitchew's art.

It was as a movie critic that Tyler was best known, although he published his commentary as collections of essays rather than as newspaper or magazine reviews. When Cornell met him, he was working on essays for his first film book, *The Hollywood Hallucination* (1944). His criticism was unlike anyone else's, eschewing the usual thumbs-up, thumbs-down verdicts and instead concentrating on individual performers. He once described Mae West as "an impersonator of a female impersonator," a comment that hints at his pioneering interest in the campy side of movies.

A flamboyant figure, Tyler had naturally striking features, which he enhanced with eyebrow pencil and mascara. His Victorian clothing was hand-picked from Lower East Side thrift shops to create the image of a dandy. Yet, for all his dramatic self-presentation, Tyler is probably most familiar today as a character in Gore Vidal's novel *Myra Breckinridge*. He appears in the novel as himself, a brilliant film critic whom Myra hopes to write a book about. Why? "Because Tyler's vision (films are the unconscious expression of the age-old human myths) is perhaps the only crucial insight this century has produced," she gushes. The success of the novel, published in 1968, prompted the reissue of several of Tyler's early books on the movies, leading Vidal to quip: "I did for Parker Tyler what Edward Albee did for Virginia Woolf."

While his film criticism was overtly Freudian, Tyler tended toward the puritanical in his personal relationships, which was reassuring to Cornell and allowed their friendship to develop unimpeded by the threat of intimacy. They were two men in love with fantasy, and their bond was a deep one based in large measure on their shared sense of the magic invested in strips of celluloid. Tyler was probably the first person to genuinely admire Cornell's movies—*Rose Hobart*, as well as the children's-party trilogy Cornell had since begun—and would occasionally ride the train out to Queens to sit and watch the artist's homespun productions in the company of the whole Cornell clan. Mrs. Cornell enjoyed the visits of this amusing dandy; on several occasions, with her permission, Tyler stayed the night in the guest bedroom. He appreciated Cornell in all his splendid peculiarity, and once

inscribed a book to him: To "the Benvenuto Cellini of Flotsam and Jetsam"—recognizing Cornell's genius for recycling junk as autobiography.

Tyler often had Cornell to his home in the East Village, invitations Cornell cherished. One winter weekend, after fantasizing about a cream-filled jelly roll, Cornell reminisced in a letter to Tyler about "my first visit to you—over on Sixth Street in the room with the 'white' decor where you regaled me with a similar confection at tea time—jelly roll, I believe."

Parker Tyler's main heartthrob was not someone he knew but an image looming on a screen: the actor Carlyle Blackwell, who was among the earliest he-man stars of the American screen. Tyler had first developed an interest in the actor as a child and duly began to model his appearance after him; for the rest of his life, he would wear his long black hair the same way Blackwell wore his. On one of his visits to Queens, Tyler was thumbing through Cornell's scrapbooks of movie stills when he discovered several photos of his beloved. A few months later ("Cornell's reflexes were always slow," Tyler explains), Cornell presented him with assorted strips of film featuring Blackwell.

Among Cornell's creations from this period is a small collage in which Carlyle Blackwell is shown skiing through a fantasy landscape of snow maidens, owls, and parrots—this whimsical scene overlooked by the glazed eyes of a doll. Cornell gave the collage to Parker Tyler in June 1939. "By a rather curious coincidence," Cornell wrote his friend at the time, "I got all the material for it from a picture magazine I picked up for you with a resume of C.B.'s life to date."

Cornell and Tyler also shared a fondness for Carmen Miranda, the Brazilian musical-comedy star who embodied camp before the term was invented. The thirty-one-year-old actress had just been brought to New York by the Broadway impresario Lee Shubert to star in a musical, *The Streets of Paris*. She could be heard singing her pop-samba numbers on the *Vallee Hour*, a radio program that Cornell tuned into. He believed that all other stars faded beside Miranda. As he put it in a typed postcard to Tyler: "At present writing Garbo and Dietrich are somnambulists compared to CM."

Charles Henri Ford was off in Europe for the summer, and Cornell wrote him, too, about his new favorite performer: "There is a miracle going on in our midst over here, and it happens every evening and at a matinee or two every week. The name of the miracle is Carmen Miranda . . . It must be very cool in those there Alps, as you say . . . But I don't envy you with Carmen Miranda on our side."

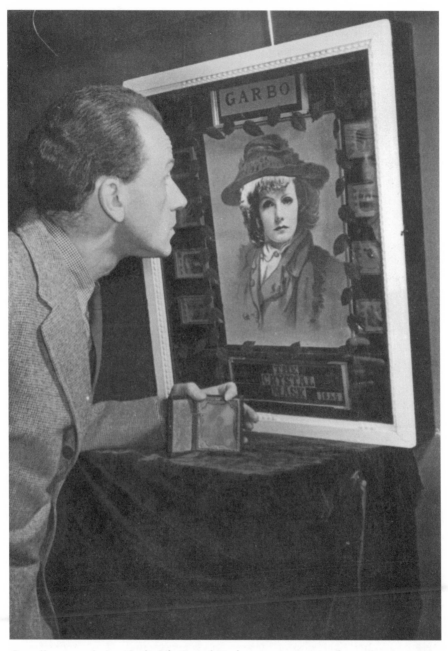

Cornell contemplating *Garbo: The Crystal Mask*, c. 1939–40; one of several constructions he made in honor of the actress (Collection the Joseph Cornell Study Center, National Museum of American Art, Smithsonian Institution. Gift of Mr. and Mrs. John A. Benton)

Cornell was then preparing for his December 1939 show at the Levy Gallery—his first one-man show in seven years. It's entirely plausible that it was Parker Tyler who gave Cornell the impetus to exhibit his work again after such a long hiatus. Their friendship appears to have enabled Cornell to muster renewed confidence in his art, to believe he should be doing something more than commuting daily to the Traphagen textile studio and appeasing his mother with his job. No one before Tyler had ever seemed so genuinely appreciative of his artwork. True, there was Julien Levy, but dealers have a vested interest in an artist's career. Levy, besides, was preoccupied by the gallery's more prominent artists. He had recently moved the gallery from Madison Avenue to larger quarters at 15 East Fifty-seventh Street, noting in his memoirs that his new address "was a step up—as was the monthly rent." He was counting on such salable stuff as Tchelitchew's society portraits to help him recoup his investment.

In Tyler, Cornell found a much-needed source of support—and an artistic model as well. Cornell was more receptive to his contemporaries than most people realize, and much of his work from this period betrays his keen interest in Tyler's writerly celebrations of stage and screen icons. Departing from the childhood-focused spirit of his early Soap Bubble Sets, Cornell began experimenting with boxes conceived in tribute to actresses. As he informed Tyler that summer, "I am trying to finish a fortune telling parrot cage dedicated to Carmen Miranda (did you hear her again last night or have you seen her?)." Cornell was apparently referring to his *Fortune Telling Parrot*, which is notable for its stuffed gray bird (and for being the first of his many bird-related boxes); the piece, though dedicated to Miranda, lacks the least trace of irony. Unlike Parker Tyler and his other friends, who promoted what we now call a camp sensibility, Cornell was too fervent a worshipper of female performers to have any sense of humor about it. That which so amused his friends instead filled Cornell with the ache of yearning.

Significantly, Cornell was also working on a boxed tribute to Greta Garbo. The Swedish-born beauty had just turned thirty-four and revealed a surprising gift for comedy in the brand-new *Ninotchka*. Cornell kept an extensive file on her, squirreling away publicity shots from MGM as well as newspaper clippings, and together they amounted to a kind of visual journal of his feelings for her. The photos became the basis for his *Legendary Portrait of Greta Garbo*, which, unfortunately, no longer survives. While Cornell considered the box "one of my favorite objects," he dismantled it in the mid-1940s, after word got back to him that Garbo herself had seen it at a gallery

and actively disliked it, blurting in her deep voice, "It looks nothing like me." Cornell was crushed by her appraisal, though the work lives on at least in memory. Had any other serious artist ever made a work of art in tribute to a movie star? Possibly not. Cornell's portrait of Garbo reflected his early and radical insight that modern art could afford to become less insular and reach out to the popular realm of film.

If Cornell was already using publicity shots of movie stars in his boxes, he was also swiping material from art history. His marvelous *Dressing Room for Gilles*, which he made in 1939, features not a glamorous actress but, rather, an actor who is famous for being a nebbish—Gilles, the hero of Watteau's famous painting in the Louvre. Cornell was not the first artist to create a work of art by recycling a photo reproduction of a masterpiece; that distinction belongs to Marcel Duchamp, who had already committed the pioneering sin of drawing a mustache on the *Mona Lisa*. Yet whereas Duchamp recycled art history as a joke, Cornell discerned in the art of the past the same thing he saw in the movie stills of the present: secret bonds and connections. It makes sense that Cornell found a kindred spirit in the figure of Gilles, a stock character in the *commedia dell'arte* who, as depicted by Watteau (around 1721), is memorable mainly for his awkwardness; his pants are too short and his expression is painfully self-conscious. (Significantly or not, he bears some resemblance to the young Cornell as seen in the Coney Island photograph [page 6], a pale face ringed by a halo-like hat.) In *Dressing Room for Gilles*, Cornell transports the actor from the French countryside to a backstage dressing room, where he looks chalky white, casts a tall shadow, and is literally more isolated than ever. He might be seen as a stand-in for Cornell—the most thwarted of actors on the stage of life, incapable of any romantic attachments besides those he imagined with actresses.

It should be noted that Cornell never saw Watteau's picture of Gilles in the Louvre; the reproductions that surface in his work were of paintings he had not seen. In using a reproduction, Cornell wasn't trying to recapture the experience of seeing the original; rather, he was recognizing that reproductions have their own potent qualities. Like his boxes, reproductions are suffused with desire: they make us long for originals we can never possess or perhaps even see.

Moreover the works of art in Cornell's boxes were photostats—that is, copies of copies. At a camera shop in downtown Flushing, he would have the proprietor make him photostats of the reproductions he tore out of

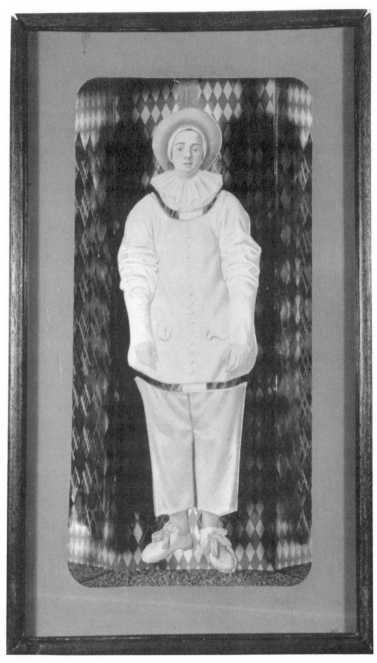

A Dressing Room for Gilles, 1939; construction, 15 × 8⅝ × 5¹¹⁄₁₆ in.
(Collection Richard L. Feigen, New York)

books. A photostat in those days could look as crisp as a black-and-white photograph and was similarly made with a camera, but could be obtained more quickly and less expensively than a regular photograph, since it didn't require the intermediary step of a negative. Rather, it was done on special paper and came straight out of the camera, somewhat like the Polaroid snapshots of today. From the beginning, Cornell made extensive use of "stats," as they are called. Much later on, art historians would cite Cornell as a proto-postmodernist whose use of photo reproductions—not to mention reproductions of reproductions—was startling and profound, raising important questions about the meaning of originality. Yet Cornell's use of stats was conceived as a gesture less of artistic novelty than of anxious parsimony: by using photostats, he guaranteed that the material in his "source files" would never be depleted. The most stubborn of hoarders, he didn't like parting with his paper collectibles, even for something as worthy as his boxes. Another advantage of photostats is that he could provide himself with multiple copies of any one picture, a virtual infinity of images.

Cornell's second one-man show opened at the Julien Levy Gallery on December 6, 1939. Visitors might have easily mistaken it for so much Christmastide glitter. The main room of the gallery was given over to Léonid (Berman), a Neo-Romantic decorator, while Cornell's objects were relegated to a small sitting room designed by the artist to resemble a walk-in fairy tale. The lights were turned down, and thimbles, dolls, and bits of broken glass could be found both in and out of shadow boxes. In other words, the room itself was a work of art—a box in its own right—and remains an unsung forerunner of installation art. In this, as in much else, Cornell was taking his cue at least partly from the Surrealists, who favored theatrical settings for their work.

A note of professionalism was lent by Parker Tyler, who volunteered to write a short appreciation in a brochure accompanying the show. (It was Tyler's first piece of art criticism, though he would soon become the regular art critic for *The Nation*.) Tyler's comments, beautifully written as they are, don't really penetrate Cornell's artistic veils. He presents Cornell as a maker of "creative toys," much as other critics had done. Yet his essay remains valuable in its evocation of his personal feelings for the artist, whom he seemed to regard as a helpless child overwhelmed by everything around him. Referring to an unidentified work by Cornell, presumably a collage, whose imagery includes a trapped and frightened mouse, Tyler mused: "Is

it not a symbol of the adult shackled by a world too big and difficult for him?"

Tyler overlooked what was probably Cornell's most genuinely child-like quality: his capacity for fantasy. Symbolism may be best known as a nineteenth-century literary movement, but it is also a trademark of child-hood. When a kid sees a stuffed animal, he sees not a piece of brown plush with two buttons for eyes but a companion who makes him feel safe and protected. Cornell, like most children, saw the world in symbolist terms, investing common objects with rich meaning and importance, which in turn gave him entry to a self-contained kingdom free of the threats of adult experience. This is not to say that his work was childlike but, rather, that his instinct for fantasy was, and of course it would have counted for nothing if he hadn't been moved to express his fantasies in the knowing language of the modern artist.

In addition to Parker Tyler's brochure, Julien Levy issued a press release for the show that included a blurb from Salvador Dali: "The only truly surrealist work to be found in America," he trumpeted about Cornell's boxes. And it was true, more or less: Cornell was America's one home-grown Surrealist.

It had been so long since Cornell's last show, and his reputation had advanced so little in the intervening years, that at least one reviewer mistook his second show for his first. In a review in *The Sun* on December 9, 1939, Henry McBride introduced the "new" artist enthusiastically. "It appears that only dreamers are acceptable at the Julien Levy Galleries," he wrote, "and the new artist now making a debut there, Joseph Cornell, not only dreams well but has the approval of the great Salvador Dali, who says that Mr. Cornell does the only truly Surrealist work in America. Mr. Dali ought to know, of course. Mr. Cornell's star production is an evocative early presentiment of Greta Garbo framed dreamily with 'shots' from some of her famous roles. It is a curious work, with significance that will strike only the most subtle of movie fans."

McBride, whose column ran in *The Sun* on Saturdays (the paper didn't publish on Sundays), was certainly the best art critic on the scene. A native of West Chester, Pennsylvania, he had grown up in a Quaker family, studied painting at the Art Students League, and arrived at art criticism surprisingly late in his career. When he started writing for *The Sun* in 1913, just in time to review the Armory Show, he was already in his forties. Now, in 1939, he was an elderly gentleman of seventy-two, tall and distinguished,

with a white mustache and goatee, and the obligatory round wire-rimmed spectacles. Fortunately for Cornell, McBride would live well into his eighties and never hear of the word retirement; he continued writing almost until the end of his life. His reviews of Cornell's shows in coming years, though no longer than a paragraph apiece, were literate, interesting, and thoroughly upbeat—just what an artist wanted.

In those days, there were three big New York dailies in which an artist could anticipate (or dread) having a show reviewed. Besides *The Sun*, reviews ran regularly in *The New York Times* and the New York *Herald Tribune*, where Royal Cortissoz, master of the nasty adjective, remained implacably hostile to every strain of modern art. Two trade magazines—*Art News* and the now-defunct *Art Digest*—could usually be counted on to say something friendly.

The press received Cornell's latest exhibition with mild amusement. He dodged a bullet at the *Herald Tribune*, where Cortissoz passed on the show and let someone else review it. "It is impossible to describe the show in a few words," Carlyle Burrows wrote approvingly on December 10, 1939, "or even the exotic setting which has been created for it, except to say that it is a holiday toy shop of art for sophisticated enjoyment." That same Sunday, Howard Devree observed noncommittally in the *Times* that the show should please "the more exotically minded." A short unsigned notice in *Art Digest* referred readers to the wisdom of Julien Levy, who, as if offering a sound bite, described Cornell as "more surrealist than the surrealists themselves."

And so, with the passing of Christmas, Cornell's objects came and went under the catch-all label of Surrealism, and the public remained blind to all that was not *surreal* but *real* in his work—all that concerned itself with his dreams of love and romance, and his frustrated inability to satisfy them.

7

A Night at the Ballet

1940-41

In 1940, the Romantic ballet became a key theme in Cornell's work, not simply as a matter of nostalgia or as the isolated gesture of a lonely man searching for beautiful visions. Ballet was then coming into its own in America, and Cornell was well acquainted with the scene around it. It was Pavel Tchelitchew who provided him with his entrée. Tchelitchew, who had designed sets and costumes for various ballets, was himself something of a dance-world figure. His most ardent champion was Lincoln Kirstein, an affluent New Yorker who was widely influential as a writer, balletomane, and patron of the arts. Kirstein would soon value Cornell as "an extremely gifted and subtle artist," as he noted on one occasion, and Cornell, in turn, would be quite appreciative of this generous, witty, and solemn-looking aesthete who dressed in black suits and reminded many people of a clergyman.

Kirstein, a native of Rochester, New York, had grown up in Boston, the son of a cultivated German-Jewish father who earned his fortune as a partner in Filene's department store. During his undergraduate days at Harvard, Kirstein had co-founded the literary quarterly *Hound & Horn*. He was still a young man when he single-handedly reinvented dance in this country. In 1933 he brought the Russian dancer and choreographer George Balanchine to the United States and started the School of American Ballet in partnership with him; the following year they founded The American Ballet, which led (in 1948) to the founding of the New York City Ballet.

Kirstein also had strong views on modern painting. He turned against Picasso and Matisse (whom he called "a clumsy decorator") in favor of figurative artists such as Tchelitchew, Paul Cadmus, and George Tooker. He was a key force in the founding of the Museum of Modern Art, yet, as

a trustee of the museum, caused harm to the modern movement when he persuaded Alfred Barr to endorse the Neo-Romanticism that dominated the museum's official taste in the years before World War II. As the director of The American Ballet, Kirstein had many opportunities to popularize his taste in art: his dance company made extensive use of artists and was a strange hybrid of balletic prowess and painterly fiasco.

To be sure, it was an act of idealism that led Kirstein to envision The American Ballet as a collaborative effort, a Wagnerian *Gesamtkunstwerk* with sets and costumes designed by leading artists. He was not the first impresario to believe that the visual arts were of crucial importance in the creation of new ballets. A generation earlier, all over Europe, the ballet stage had been a place where artists had tested daring new ideas. Picasso, the best stage designer of them all, had set the standards for ballet decoration with his *Three-Cornered Hat*, a Diaghilev production of 1918. Diaghilev's designers had also included Matisse, Derain, Braque, Utrillo, and de Chirico. Their sets were serious works of art, like the works of baroque designers, though with Diaghilev's death in 1929 the era of great ballet collaborations came to an end.

Could that moment now be revived in New York? Trying to be the new Diaghilev, Kirstein enlisted Balanchine, who had been one of Diaghilev's choreographers. He also turned to Pavel Tchelitchew, who he believed was the new Picasso. Yet no artist was more miscast; the designs Tchelitchew produced would add nothing but a lugubrious footnote to the illustrious history of The American Ballet. In 1940, for instance, invited to collaborate on Balanchine's new *Balustrade*, Tchelitchew made plans to attire the dancers as fanciful insectlike apparitions; they would barely be visible in a nighttime gloom. Tchelitchew's designs, "not for the first time, ruined a ballet," as Balanchine biographer Richard Buckle later noted. It was for good reason that many future Balanchine ballets were dressed only in leotards or plain tunics.

For all his shortcomings as a ballet designer, Tchelitchew was a well-known figure on the international dance scene, and as such he acquainted Cornell with that world. Cornell was fascinated by his friend's dance-related work, and during his lunch break liked to stop by the rehearsal studios of The American Ballet. He could count on finding interesting people around, Balanchine and Kirstein among them. He looked forward to seeing Parker Tyler and to hearing "Tchelitchew's tchit-tchat," as he noted in a rare moment of relaxed wit. "If I don't see you at the rehearsals of the American

Ballet this week I'd like to drop you another line very shortly for another note-comparing session," Cornell wrote to Tyler in May 1941. "Or would you like to come out some evening, and enjoy the calm and green of our modest back-yard villa?"

Cornell's lunch-hour peregrinations also included trips to the Dance Archives of the Museum of Modern Art, which Kirstein had founded in 1939, the same year the museum moved out of a townhouse and into a new building on the same site designed by Philip Goodwin and Edward Durell Stone. Kirstein had donated some 5,000 books, photos, and slides to the newly expanded museum, making it the best place in the country to research the history of dance. Nonetheless, Cornell usually ended up enlightening the librarians rather than the other way around. "He was always full of fascinating tips on where to find extraordinary odds and ends of everything," noted Paul Magriel, the archives' first curator. As his acquaintances knew, Cornell had his own trove of dance memorabilia. He often glued cut-out photos of leaping ballerinas along the borders of his letters, displaying a monkish gift for marginalia.

One of the distortions of Cornell scholarship is that it has tended to view Cornell in relation to the Surrealist movement, as if no other art movements existed at the time. Excellent as much of the writing on Cornell is, it makes little reference to the artist's Neo-Romantic contemporaries, who in fact defined his artistic milieu for much of the 1940s. While Cornell is inevitably described as an artist who seized on Surrealism's main strategy (i.e., incongruous juxtaposition) while renouncing its spirit of provocation, he didn't come out of the blue. His work is related to the soft, nostalgic fantasies perpetuated by the Neo-Romantics, and particularly by Tchelitchew, with his love of ballet and his adulation of glamorous women. It does not diminish Cornell's work to say that his ballet-related boxes from the 1940s had kitsch counterparts in Tchelitchew's ballet designs.

Cornell first demonstrated a serious interest in dance through Fanny Cerrito—a nineteenth-century Neapolitan ballerina who remains best known for her 1843 performance in *Ondine*, which was based on a fairy tale about a knight who falls in love with a magical water sprite. The ballet is more renowned than the dancer who first starred in it: in the 1940s, only the most committed balletomanes knew who Fanny Cerrito was. Yet it's not surprising that Cornell was aware of her. In 1939, in what turned out to be his greatest theatrical triumph, Tchelitchew had sailed to Paris to design an elaborate stage set for Jean Giraudoux's adaptation of *Ondine*.

In choosing *Ondine* as a subject for his own work, Cornell provided himself with a convenient excuse to stay in touch with Tchelitchew, who he hoped would furnish him with material pertaining to the ballet. In a letter written in July 1940, Cornell wondered whether the Russian artist would be interested in a "little proposition"—drawing a picture of Fanny Cerrito and swapping it for an unnamed object Cornell had created expressly for him. "If it is a question of my raising the ante with another object I'd be more than glad," Cornell volunteered.

As much as Cornell adored the ballet, he was more interested in the lore surrounding his favorite ballerinas than in the development of dance as a whole. He disliked modern dance and instead was drawn to the Romantic era. The dancers Cornell loved most were ballerinas whom he had never seen dance and whom no one would ever see dance again. They had lived a century earlier, in an era when the cult of the ballerina had replaced that of the male dancer. Almost overnight, dazzling female stars had stepped forth: the ethereal Marie Taglioni (the most celebrated of her era), Fanny Elssler (her voluptuous rival), Cerrito (the lesser known of the two Fannys), and Carlotta Grisi (creator of the title role of *Giselle*).

The Romantic ballet, which flourished abroad between 1830 and 1850, marked the era when everything in dance changed. For the first time, dancers rose on their toes, as if yearning to draw nearer to the ideal. Through his reading, Cornell imbibed every last detail about Taglioni and her peers. Hunched over books at the kitchen table, he spent sleepless nights immersing himself in their vanished world. His thoughts roamed freely to the Paris Opera House, the Vienna Hoftheater, and the St. Petersburg Imperial Theatre as he read the ballerinas' life stories and eyewitness accounts of their performances.

Of all the dancers of the Romantic era, Cornell's favorite was always Cerrito, in part because she was less famous than the others and seemingly in need of his saving gaze. He liked to imagine her in his midst. Twice in the summer of 1940 he had fantasies of the dead ballerina appearing out of nowhere amid the workaday bustle of Manhattan—events which acquired in his mind the stature of religious visitations. His first "sighting" occurred as he was making the rounds of the Fourth Avenue bookstalls and chanced upon an old portrait of Cerrito by Josef Kriehuber: "The figure of the young danseuse stepped forth as completely contemporaneous as the skyscrapers surrounding her." Later that summer, he was sitting at his desk at Traphagen's at five o'clock one evening when he glanced out the window at

the Manhattan Storage Warehouse, a red-brick building across the street. Fanny Cerrito seemed to materialize before his eyes in the form of a uniformed guard closing a window. In later years, Cornell's friends never knew whether or not he was joking when he referred to these brief flares of vision.

He probably wasn't. Like a child protecting himself with a comforting daydream, Cornell felt fortified by his thoughts about Cerrito. He wrote up his sightings of her as if they had actually happened. The photos and prints that passed into his Cerrito scrapbook pertained not only to her life but also to the history of his own felicitous "relationship" with her. The scrapbook—later displayed as a work of art in its own right—brought together such unlikely artifacts as an 1843 souvenir print of the ballerina and a photo of pigeons from 1940, significant because it marked the year when Cornell experienced the first of his Cerrito revelations. "The gracious and elusive figure of Fanny Cerrito was very alive then," Cornell wrote to Parker Tyler two years later. "Much more so than now, as I realized this afternoon trying to recapture some of that spirit."

Did any other artist ever devote so much time to dreaming about the ballet? One thinks, perhaps, of Edgar Degas, who, like Cornell, never married, had no mistresses, and was enthralled by dancing women. Degas's pastels and paintings of ballerinas are the work of a man who relished catching ballerinas off-guard as they rehearsed in their pink tulle skirts. He celebrated their animal awkwardness, their thrusting limbs and writhing flesh. Cornell, by contrast, found something altogether different in the experience of ballet: a vision of female purity. Ballerinas, particularly dead ones, were safe sexual objects, posing no threat to the celibacy Cornell demanded of himself and the exclusivity of his relationship with his mother.

Cornell's most intense experience of the ballet occurred not in rehearsal studios or in darkened theaters but at home on Utopia Parkway. Besides reading about long-gone performers, he took great pleasure in collecting related material for his work, which would come to include sequins and crystal, velvet and chiffon, among other evocations of a ballerina's exhibitionism. Clothing and costumes excited Cornell, a natural development for an artist whose father had been a textile designer and who himself had sold fabric for a decade.

Most of Cornell's ballet-related pieces belong to a long series of *Homages to the Romantic Ballet*, in which he packaged tulle and glitter into tiny velvet-lined boxes made from wood. The boxes are too treacly to qualify as sub-

stantial works of art and remind us that Cornell's ballet-related pieces are probably the most uneven of his career. Looking at his many *Homages*, some as small as 4 inches square, we do not doubt his fondness for ballerinas and the erotic charge their costumes held for him; he had a fetish for fabric scraps. Nor do we doubt Cornell's own uncertainty about making art. It's as if he felt small and unworthy next to the subjects of his homages, incapable of any gesture besides one of worship. When Cornell faltered in his work, it was not because he was insincere. Rather, it was because he was *too* sincere. With every new work, he risked lapsing into the sentimental.

There is only one ballet-related box from this period which, for this viewer anyway, classifies as a masterwork: *Taglioni's Jewel Casket* of 1940 (it's now part of the collection of the Museum of Modern Art). The title refers to Marie Taglioni, the quintessential ballerina of the Romantic era. The daughter of a well-known Italian choreographer, she achieved her greatest fame as a winged creature of the air when she danced the title role in *La Sylphide* in Paris in 1832. Cornell was fascinated to read in a book that the ballerina traveled with her very own "jewel casket," in which she stored the gems that had been showered on her by appreciative kings and tsars.

This quaint object became the inspiration for *Taglioni's Jewel Casket*, which departs from Cornell's usual glass-fronted shadow boxes and instead is modeled after a jewelry box. Starting with a medium-sized wooden chest, a foot long and 8 inches deep, Cornell lined it with rich brown velvet. In place of Taglioni's precious jewels, the artist substituted a dimestore item—glass cubes, a dozen in all, arranged in three neat rows. A string of fake diamonds is pinned to the inside of the box top and dangles gracefully below a sheet of blue glass inscribed with the story of an adventure Taglioni had at the end of her St. Petersburg tour. "On a moonlight night in the winter of 1835, the carriage of Marie Taglioni was halted by a Russian highwayman," the inscription begins. It goes on to explain how she danced beneath the stars for the Russian robber and thus was allowed to keep her box of jewels.

A story as elaborate as this might seem to lend *Taglioni's Jewel Casket* (of which Cornell later made many variations) a built-in obscurity, or at least a layer of weirdly arcane detail that few could unravel. Of course, that's just what he wanted. In much the same way that he was frugal with money, Cornell was retentive with meaning, refusing to give anything away. In his art, he resisted instant communication with the viewer much as he resisted

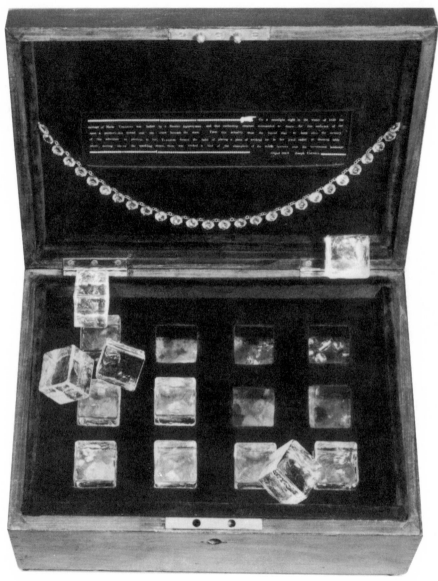

Taglioni's Jewel Casket, 1940; box construction, 4¾ × 11⅞ × 8¼ in. (Collection Museum of Modern Art, New York. Gift of James Thrall Soby)

easy intimacy with the people in his life. The objects inside his boxes were not just random assortments of material but souvenirs of a quest, a chronicle of infatuations whose meaning was as complicatedly inward as a private journal.

Fortunately, however, in spite of his mania for secrecy, Cornell also wanted to be a great modern artist, one whose work succeeded in purely visual terms. You don't have to be a balletomane to appreciate *Taglioni's Jewel Casket*, which is one of Cornell's most abstract and riveting works. Standing in front of the piece at MoMA, anyone would know it's a jewelry box, one that contains not rings and bracelets but a dreamlike assembly of glass ice cubes. The work hints at both a longing for romantic attachment and a kind of sexual frozenness that makes romance impossible. Put another way, the box contrasts the richness of the European past (as evoked by the ballerina) with the tawdriness of the American present (as conveyed by five-and-dime rhinestones). Nothing is more modern, it seems to say, than a yearning for the past.

Cornell's moments of confidence alternated unpredictably with dark, agitated spells when he could barely collect his thoughts. He frequently felt depressed and discouraged. Sitting at his kitchen table in the solitary hours after his family had gone to sleep, he had trouble mustering the energy to work. At the root of his problems, he felt, was his "dilettante manner of working," "the apathy and resentment that come of only being able to work at night, when I have no particular urge or inspiration . . . The routine job I'm at all day cramps my style too much, I am ashamed to say. How I ever get any objects finished, especially with the endless detail that goes into them, is always a mystery to me."

Cornell wrote this to Parker Tyler as a way of explaining why he didn't have time to contribute an article to *View*, a new magazine founded by Charles Henri Ford in September 1940. Initially a six-page tabloid modeled after the "little" literary magazines of the 1920s, *View* was dedicated to promoting the Surrealists and Neo-Romantics in New York. Today, it is often confused with another magazine of the same era, *VVV*, founded in 1942 by André Breton. While the two magazines shared writers, in its time *VVV* was resented by the *View* claque down to the V's in its title. (As Tyler comically observed, "Soon there appears a 100% Surrealist, rival magazine, short-lived though it be, *VVV*, or *Triple V* as it is called. We conclude that

obviously it is meant to be three times as good as *View*.") Tyler, a member of *View*'s editorial board, asked Cornell to submit collages and to consider writing a few words about his working method. Cornell, in his usual hesitating fashion, declined at first—which didn't prevent *View*'s editors from mentioning him affectionately in their second issue. Sounding less like an avant-garde tract than a small-town newspaper, *View* noted chirpily: "As we go to press . . . Joseph Cornell says he is working on some ballet items, inspired by his new interest in dance and ballet."

Not only dead ballerinas captured Cornell's fancy. Living ones, too, could make him feel happily transported. It was Pavel Tchelitchew who, in November 1940, introduced Cornell to his first real dancer, Tamara Toumanova—dark-haired, statuesque, twenty-one years old—who had just arrived in New York as a star dancer in Colonel de Basil's Original Ballet Russe. She traveled everywhere with her overprotective mother, the redoubtable Madame Eugenia Toumanova, perhaps the most famous mother in dance history. Tchelitchew had known the dancer since she was a "baby ballerina" of thirteen, and was currently designing her costume for *Balustrade*. His ridiculous decorations could not disguise Toumanova's talent. The critic Edwin Denby, enraptured by the ballerina's "large, handsome, deadly face," described her as "an actress who more than anyone could create a tragic isolation on the stage."

Cornell first met Toumanova at the 51st Street Theatre, where her troupe was performing. The theater was only a block away from the Traphagen textile studio, and on his lunch break Cornell liked to stop by and watch the rehearsals. Before they were formally introduced, Toumanova noticed him in the theater, hanging about "like a Pierrot" in the wings. She wondered who this strange interloper was, and her mother was similarly puzzled. The mystery was solved when Tchelitchew came to the ballerina's dressing room and graciously announced: "I want you to meet a genius. He's a magician and will be more important than any of us." And thus he introduced Cornell, who, startled by his first encounter with a real live ballerina, awkwardly "took five steps backwards," as she later recalled.

Cornell was almost thirty-seven when they met, a lean, handsome man with a high forehead and deep-set blue eyes. Yet his cautious manner made him seem older than his years. "He was already an elderly man, rarely smiling, never laughing out loud," Toumanova later said. "He was completely unaffected, but terribly reticent. We talked in an odd fashion, my broken and his shy English; everything came out in gasps." In spite of his

awkwardness, she liked him from the start, believing that Tchelitchew was correct in calling him a great artist. She told Cornell he was welcome to visit her again at the theater. A few days later Cornell returned, presenting her with the first of many gifts: three tiny hand-painted figurines depicting her in the famous ballets she had danced at the age of thirteen (Fokine's *Les Sylphides*, Massine's *Jeux d'enfants*, and Balanchine's *La Concurrence*), as if eager to imagine her as a child.

Cornell invited Toumanova to Utopia Parkway, and she kindly accepted. She arrived with Tchelitchew one afternoon to find their host in a state of extreme anxiety, his mother and brother hovering in the background. As the ballerina later remembered, "Tchelitchew had to order him to stop being nervous so that we could settle down comfortably." The kitchen table was set with nice dishes, but the only fare Cornell offered his Russian visitors was "water and tea bags."

Aside from that one visit to Queens, Cornell's contact with Toumanova was confined to brief backstage visits, hardly enough to sustain a great romance or even a real friendship. Yet it was enough to stir up a whirlwind of artistic inspiration. Cornell produced about two dozen homages to Toumanova, some of which seem less like finished works of art than untransformed souvenirs of a fantasy romance. They include a scrapbook filled with clippings and memorabilia, and a series of *Toumanova Snow Balls*, each a charming three-inch-high glass globe encasing a cut-out photo of the ballerina; spin it and Toumanova appears to be dancing amid a flurry of snowflakes. Though Cornell's feelings for Toumanova far exceeded her feelings for him, he seemed not to mind. Unrequited love was his very requirement. It was too disturbing to consider the alternative, an adult relationship with all its unknowable hazards. In his homages to Toumanova, Cornell variously imagined her as a child ballerina or as a sister of the Romantic ballerinas of the nineteenth century, ensuring that his living muse remain almost as inaccessible as the dead Cerrito. Conversely, as Toumanova noted, "Cerrito, Taglioni and Grisi all seemed to come alive to him when I danced."

In December 1940, just a year after his previous show at the Levy Gallery, and a little more than a month after meeting Toumanova, Cornell had another exhibition. Levy again saddled it with that noxious phrase "toys for adults," though the show was in fact devoted to the theme of the Romantic ballet. No checklist was prepared, so it is hard to know exactly which of Cornell's works were included beyond his new *Taglioni's Jewel Casket* and a

second, somewhat related wooden casket-box, *L'Egypte de Mlle Cléo de Mérode: cours elementaire d'histoire naturelle*, which contains in the place of a dozen glass cubes twelve specimen bottles holding pearl beads, sequins, plastic rose petals, a photo of Cléo de Mérode's head, and so on—a trove of dimestore souvenirs gallantly presented by Cornell to the nineteenth-century ballerina-courtesan of the work's title. As he knew from his reading, Cléo had once been offered a vast sum to dance for the Khedive of Egypt. Might she have been enticed to perform for Cornell on the basis of his frugal offering? Cornell was no king; he had no great fortune to offer. But he had something better: the Cléo-specific souvenirs he encased inside his glass phials with a naturalist's passion for classification promise her everlasting life. The box is a virtual museum whose holdings time cannot touch.

In what had become standard practice for his shows, Cornell shared the gallery with other artists, including two who were distinguished in the popular arts. There was Ludwig Bemelmans, the great children's book author and illustrator who had just introduced a brave and naughty heroine in *Madeline* (1938); Milton Caniff, the creator of the comic strip *Terry and the Pirates*; and David Hare, a young sculptor then experimenting with a recent innovation, color photography. Levy billed the show as a "four-ring circus," though Cornell had no reason to concern himself with his co-exhibitors, since his work was consigned to the small sitting room, as it had been the previous Christmas. He sent out his own invitation, which remains a classic in itself—an ingeniously folded piece of paper on which the figure of Gilles, that poignant character Cornell swiped from Watteau, is transformed with a fold of the card into a master of ceremonies toting a sign that says "Objects."

The reviews were mostly favorable. Henry McBride of *The Sun* weighed in first, on December 14, 1940: "Joseph Cornell repeats his last year's showing of 'surrealist toys for adults' and improves upon it. His shadow boxes and other constructions are not only fanciful and witty but have more than a suggestion of elegance. They seem like the playthings of aristocrats from another world; and happily there is nothing shady about them." Carlyle Burrows, in the next day's *Herald Tribune*, was similarly approving: "Cornell's neatly boxed surrealist inventions, of which there is lively new variety this season, are fantastically amusing trifles"—did he need that last word? "The fabulous histories attached to some of the exhibits, including a miniature case of 'fairy costumes,' go far to show the maker's ingenuity and cleverness."

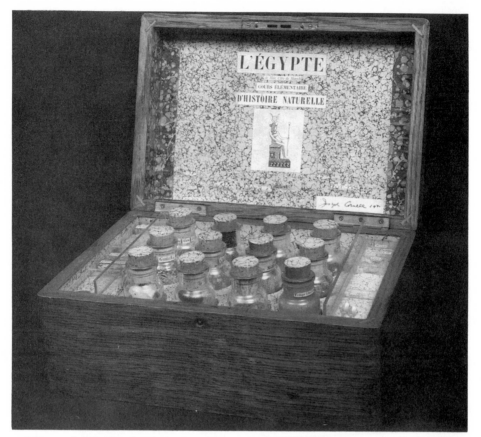

L'Egypte de Mlle Cléo de Mérode: Cours Elementaire d'Histoire Naturelle, 1940; construction, 10⅝ × 7¼ × 4¾ in. (Private collection; photograph courtesy Richard L. Feigen & Co.)

Edward Alden Jewell, in *The New York Times*, wasn't so sure. After summarizing the work of Cornell's co-exhibitors, Jewell patronizingly added: "In another room you enter Joseph Cornell's 'own little world' furnished with such 'toys for adults' as defy description. It is simply one of those 'worlds.' " And that was all the critic said. Jewell's lightly mocking review, which better captures a mental patient than a modern artist, was the first of several notices in which he carelessly mistook Cornell's self-involvement for artistic inconsequentiality.

At least Cornell could derive some contentment from a couple of sales—if not quite from a widening pool of collectors. Julien Levy purchased *L'Egypte de Mlle Cléo de Mérode* for about a hundred dollars. And the art

historian James Thrall Soby, an heir to a pay-telephone fortune who was briefly a partner in the gallery, bought *Taglioni's Jewel Casket*. For Cornell, however, the most rewarding response came not from the critics or his collectors but from his newfound Russian friends. He was delighted when Pavel Tchelitchew sauntered into the gallery one Saturday afternoon along with George Balanchine and Tamara Toumanova—and jokingly introduced the ballerina as the reincarnated Fanny Cerrito. Toumanova, a dazzling presence in her fur coat and her "round fur hat," as Cornell later noted, paused to admire *Taglioni's Jewel Casket*. Reaching inside it to pick up one of the glass cubes, she held up the *faux* gem for inspection and marveled at its wondrous "unworldly" quality, a comment Cornell would never forget.

In December 1940, while his show was up, Cornell took a dramatic step. He decided, after six tedious years, to finally leave his job at the Traphagen textile studio. It was, perhaps, the most daring decision he had ever made, not least because it marked a challenge to the life his mother had envisaged for him. For nearly twenty years, since leaving Andover, Cornell had worked for a living, supporting his family and shielding his mother from the indignities of widowhood. His jobs had reflected his mother's hopes far more than his own; it was she who wanted him to amount to something in the field of design.

For years Cornell had thought about pursuing his art full-time. While his mother was scornful of such a notion, finally Cornell had friends, and he felt emboldened by their support. Balanchine and Kirstein, Parker Tyler and Tchelitchew, the ravishing Tamara Toumanova—they had all seen his latest show and said kind things. Even his employer, Ethel Traphagen, a girlhood friend of his mother's, was sympathetic to his situation; and a turning point apparently came after she intervened on his behalf. Traphagen, according to Cornell's sister, "wrote a letter to my mother and said it was ridiculous for Joseph to continue at his job." While Mrs. Cornell was reluctant to heed advice from her son and still treated him as if he were an adolescent in need of direction, she was far more trusting of her old friend Ethel, whose comment led her to finally relent and honor her son's wishes.

Cornell worked out a compromise with his mother: He would become, he proposed, a "freelance commercial artist," staying home all day but managing to earn some money by obtaining assignments from editors who were aware of his collection of old photographs and other material. He had already received a few freelance assignments. In 1937, he had furnished the photos for the book *The Movies Come to America*, by Gilbert Seldes. When

the British photographer Cecil Beaton was preparing his book *Cecil Beaton's New York* (1938), he enlisted Cornell to help locate photographs of the city and design the layouts. Yet Cornell proved to be a difficult collaborator. He "never seemed content and he disappeared and could not be got hold of," Beaton later remarked, adding that Cornell was "unattractive." Wondering whether any money could be made circulating his collection of silent movies, Cornell optimistically wrote to Charles Henri Ford: "My collection of old films for use at parties, etc. is modest but hand picked . . . Can supply a professional projectionist for ten dollars."

And so in December 1940 Cornell at last extricated himself from the demands of a nine-to-five job. Yet the luxury of having his days to himself did not significantly alter his artistic habits. He continued to work on his art at night, when the house was quiet and he was better able to pitch himself into reverie. During the day, he concentrated on his freelance work, trying to obtain assignments from magazine editors. He went into the city once or twice a week, and always on Wednesdays, to attend a mid-week service at the Christian Science church. It was a relief for him to get out of the house, away from his quarrelsome mother. While they rarely sat down to meals together—Cornell subsisted on snacks—she was very much present during the day, nagging him to get his art materials off the dining-room table or out of the kitchen as she dusted the house. The only time her bossy chatter stopped and the house was quiet was when she went out grocery shopping or met friends for bridge. It occurred to Cornell that he could be more efficient if he had a studio, and he began to think about fixing up the basement so he could have some space and privacy in which to work. But the plan progressed slowly.

In a letter to Parker Tyler on February 3, 1941, Cornell provided a hint of his inveterate night-owl habits. He typed the letter at the kitchen table at around two in the morning, apparently not worrying that the sound of his typing could be heard beyond the kitchen. On this winter night Cornell seated himself beside the gas oven, turning it on while leaving the oven door open for heat. *Tap, tap, tap.* Did he smile as he sat over his typewriter and thought of Tyler? "I've just snapped out of it," Cornell reported, "enough to write another brief page for the album, with almost your lone inspiration, & that of Toumanova."

Tamara Toumanova was still very much on his mind, and he hoped she would come through on her promise to provide him with fragments from her costumes—invaluable raw material for his boxes. He told Tyler that he

hoped to make him his very own box contrived from ballet scraps, "like the fairy costume [box] in the show."

As inspired as Cornell was by the ballet, he invariably found less satisfaction in attending performances than in staying home and fantasizing about them. Going to a theater, he tended to feel overwhelmed. There was too much to see all at once. He lamented to Parker Tyler after one of his rare nights out at the ballet: "Unfortunately I wasn't near enough front to take in all the facial expressions of Toumanova, and when I had my glasses trained on her features I missed the movements of her steps." A month later, he was attending another performance by de Basil's Original Ballet Russe—this time a revival of *Aurora's Wedding*—when through his opera glasses he spotted Toumanova dressed in street clothes watching the ballet from the wings. For the rest of the performance, he "watched her watching instead of seeing out the ballet"—an extended bit of voyeurism that pleased him immensely.

Later that year, Cornell received an invitation from Tamara Toumanova to see her dance in *Swan Lake* at Lewisohn Stadium in the Bronx, a theater (now demolished) once known for its summertime concerts. The night he attended, July 17, the performance was rained out; but his spirits were lifted by the chance to visit the ballerina backstage, "radiant and buoyant in her Swan Queen costume," as he later noted. Cornell returned two nights later to see Toumanova in *Le Spectre de la rose*, and again it rained. "I got soaked," he reported to Pavel Tchelitchew, "but went backstage again and dried my head in the dressing room . . . I liked it more backstage than I did the dancing. It was fascinating to watch her make up." That night, Toumanova finally presented Cornell with the costume fragments he had sought since first meeting her—tokens such as hairpins, white tulle, and a piece of fabric from a ballet slipper, which would soon surface in his work.

Following his visits to Lewisohn Stadium, Cornell began work on a *Swan Lake* shadow box, the first in a series he would continue for about five years. Of the many objects Cornell made in tribute to Toumanova, the *Swan Lake* constructions are the most substantial. Most of them feature a solitary swan—sawed from wood and hand-painted—gliding on a lake with a forest in the background, rhinestones glittering everywhere. The boxes are based on Act II of the ballet, the opening moment when an evil magician, determined to keep the mortal Odette away from her lover, turns her into a swan. Later on, the magician's spell is broken and Odette gets her prince. In Cornell's *Swan Lake* boxes, however, the longing never ends. He dreamed

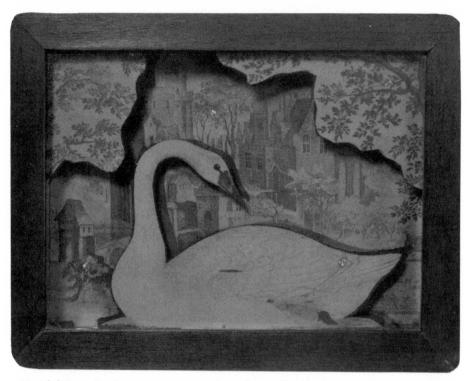

Untitled (Swan Box), c. 1945; construction, 4⅞ × 6⅜ × 1¼ in. (Collection Mr. and Mrs. Robert Lehrman, Washington, D.C.)

his way into a Romantic forest where the woman he loved lived on permanently as a bird.

Cornell's relations with Toumanova grew more tenuous in the fall of 1941, when de Basil's company moved into the Metropolitan Opera House, at Broadway and Thirty-ninth Street. Toumanova was dancing in a new ballet, *The Magic Swan*, which was resurrected from Act III of the Petipa-Tchaikovsky *Swan Lake*, and critics agreed that she had matured immeasurably since the previous spring. As Edwin Denby rhapsodized, "When she dances it is a matter of life and death. Dancing can be other things than this, but I don't see how it can be any greater."

For Cornell, however, Toumanova's growing popularity made it that much more difficult to spend time alone with her, and there was no hope of loitering in the wings of the opera house the way he had a year earlier during her rehearsals at the 51st Street Theatre. Suddenly her dressing room was crowded with movie stars and hangers-on. One night Cornell headed

backstage and plaintively asked her, "Who takes you home?" "Mama, Papa . . . friends," she replied evasively. "Yes," Cornell noted sadly, "too many friends."

In 1941, when his feelings for Toumanova were at their most intense, Cornell was also deeply interested in another performer from abroad: Hedy Lamarr, then a twenty-six-year-old actress who had recently moved to New York from her native Vienna, by way of Hollywood. She was starring in a new movie, *Come Live with Me*, a slight comedy in which she plays Johnny Jones (the male name is significant), a refugee girl who arranges a strictly platonic marriage with a writer in order to stay in America. It's an understatement to say that Cornell liked the movie. "I've seen 'Come Live With Me' five times through," he wrote to Parker Tyler in May 1941, "a fact I'd hate to have many of my friends in on." Tyler was then working on an essay on Lamarr for his forthcoming book *The Hollywood Hallucination* (1944), and he may have been responsible for directing Cornell's attention to the actress.

Lamarr was probably the most conspicuous sex symbol of her era. She was introduced to the world film public in the nude when she made her debut in *Ecstasy* (1933), a Czech-made *succès de scandale* as one of the very first "sex films." In it, Lamarr, nymphlike, is discovered undressing and then moving through the countryside to enter a stream and swim; her exposed breasts could be glimpsed for ten minutes through a tangle of tree branches. In 1938, after moving to Hollywood, Lamarr quickly became a top MGM star, though her renown rested less on her acting abilities than on her raven-black hair and exquisite beauty.

In his usual teen-fan manner, Cornell tried to befriend Lamarr by sending her admiring letters. She graciously took the time to answer him. He reported to his friends that he and Hedy were corresponding "about a story of stars, birds, and the deep shady forests of Carl Maria von Weber," the German Romantic composer. Or so Cornell wrote to Tchelitchew, adding that Hedy "sends regards." He went on to say that he had recently visited the Hayden Planetarium in Manhattan for the first time, and "the day I was there Hedy Lamarr was the lecturer and she spoke with a wonderful soft detachment that is her unique pictorial appeal." Returning home, Cornell was moved to undertake a collage tribute: "Yesterday I was trying to fit Hedy Lamarr into Dante Gabriel Rossetti's pre-Raphaelite garden, without success."

On the surface, there might seem to be little connection between a kittenish movie star like Hedy Lamarr and the lofty talent of Toumanova, with her *fouettés* and other technical feats. Yet to Cornell, these two European beauties both offered him a chance to indulge his love of costumes. We already know about Cornell's interest in watching Toumanova make herself up for her performances, which, by his own admission, was more satisfying than watching her actually perform. And we know as well about his cherished fantasy in which Fanny Cerrito appears before him in a guard's gray uniform. He had begun his movie *Rose Hobart* with a scene of the actress dressed in menswear.

Hedy Lamarr, too, offered a study in cross-dressing. Inspired by a scene in a movie in which she appears in pants, Cornell fantasized about seeing her in more elaborate menswear. One July morning he devoted an entire letter to Parker Tyler to relating a fantasy in which he glances out the window and sees Hedy on an antique bicycle, circa 1900, dressed up as a turn-of-the-century dandy, complete with "starched shirt with bow tie," "double breasted jacket," "beige bloomers, black stockings and patent leather shoes."

Cornell offered an artistic exploration of the theme of cross-dressing in a project that appeared in *View* in December 1941. On page 3 of that issue, a headline reads: ENCHANTED WANDERER: EXCERPT FROM A JOURNEY ALBUM FOR HEDY LAMARR. The single-page collage is dominated by a photo of Lamarr's sultry face—fastidiously inserted into a reproduction of a Giorgione portrait of a Renaissance boy. In mingling a publicity shot of an actress with a Renaissance masterwork, Cornell intuitively blended high and low art, an aesthetic split which in this case echoes the male-versus-female confusions of the collage's subject matter.

The text accompanying the collage, written by Cornell, suggests a deep identification with Lamarr. "She has carried a masculine name in one picture," he observes of the actress, "worn masculine garb in another, and with her hair worn shoulder length and gentle features like those of Renaissance youths she has slipped effortlessly into the role of a painter herself . . . le chasseur d'images." It's a peculiar statement, this tribute to Lamarr, in which Cornell views her as a male figure as well as an image-chasing artist like himself. For better or worse, this precious collage is undeniably in sync with postmodern interests: it seems to say that gender is a construction, and that you can change it simply by changing your clothes.

Cornell was obsessed with clothing. On his long walks in Manhattan, he

"ENCHANTED WANDERER"

★ Excerpt from a Journey Album for Hedy Lamarr ★

By
JOSEPH CORNELL

★

Among the barren wastes of the talking films there occasionally occur passages to remind one again of the profound and suggestive power of the silent film to evoke an ideal world of beauty, to release unsuspected floods of music from the gaze of a human countenance in its prison of silver light. But aside from evanescent fragments unexpectedly encountered, how often is there created a superb and magnificent imagery such as brought to life the portraits of Falconetti in "Joan of Arc," Lillian Gish in "Broken Blossoms," Sibirskaya in "Menilmontant," and Carola Nehrer in "Dreigroschenoper?"

And so we are grateful to Hedy Lamarr, the enchanted wanderer, who again speaks the poetic and evocative language of the silent film, if only in whispers at times, beside the empty roar of the sound track. Amongst screw-ball comedy and the most superficial brand of clap-trap drama she yet manages to retain a depth and dignity that enables her to enter this world of expressive silence.

Who has not observed in her magnified visage qualities of a gracious humility and spirituality that with circumstance of costume, scene, or plot conspire to identify her with realms of wonder, more absorbing than the artificial ones, and where we have already been invited by the gaze that she knew as a child.

Her least successful roles will reveal something unique and intriguing — a disarming candor, a naivete, an innocence, a desire to please, touching in its sincerity. In implicit trust she would follow in whatsoever direction the least humble of her audience would desire.

"She will walk only when not bid to, arising from her bed of nothing, her hair of time falling to the shoulder of space. If she speak, and she will only speak if not spoken to, she will have learned her words yesterday and she will forget them to-morrow, if to-morrow come, for it may not." *

(Or the contrasted and virile mood of "Comrade X" where she moves through the scenes

* Parker Tyler

like the wind with a storm-swept beauty fearful to behold).

* * * * * * *

At the end of "Come Live With Me" the picture suddenly becomes luminously beautiful and imaginative with its nocturnal atmosphere and incandescence of fireflies, flashlights, and an aura of tone as rich as the silver screen can yield. Her arms and shoulders always covered, our gaze is held to her features, where her eyes glow dark against the pale skin and

her earrings gleam white against the black hair. Her tenderness finds a counterpart in the summer night. In a world of shadow and subdued light she moves, clothed in a white silk robe trimmed with dark fur, against dim white walls. Through the window fireflies are seen in the distance twinkling in woods and pasture. There is a long shot (as in white covers, her eyes glisten from the ceiling) of her enfolded in the semi-darkness like the fireflies. The reclining form of Snow White was not protected more

lovingly by her crystal case than the gentle fabric of light that surrounds her. A closer shot shows her against the whiteness of the pillows, while a still closer one shows an expression of ineffable tenderness as, for purposes of plot, she presses and intermittently lights a flashlight against her cheek, as though her features were revealed by slow-motion lightning.

In these scenes it is as though the camera had been presided over by so many apprentices of Caravaggio and Georges de la Tour to create for her this benevolent chiaroscuro . . . the studio props fade out and there remains a drama of light of the *tenebroso* painters . . . the thick night of Caravaggio dissolves into a tenderer, more star-lit night of the Nativity . . . she will become enveloped in the warmer shadows of Rembrandt . . . a youth of Giorgione will move through a drama evolved from the musical images of "Also Sprach Zarathustra" of Strauss, from the opening sunburst of sound through the subterranean passages into the lyrical soaring of the theme (apotheosis of compassion) and into the mystical night . . . the thunderous procession of the festival clouds of Debussy passes . . . the crusader of "Comrade X" becomes the "Man in Armor" of Carpaccio . . . in the half lights of a prison dungeon she lies broken in spirit upon her improvised bed of straw, a hand guarding her tear-stained features . . . the bitter heartbreak gives place to a radiance of expression that lights up her gloomy surroundings . . . she has carried a masculine name in one picture, worn masculine garb in another, and with her hair worn shoulder length and gentle features like those portraits of Renaissance youths she has slipped effortlessly into the role of a painter herself . . . le chasseur d'images . . . out of the fullness of the heart the eyes speak . . . are alert as the eye of the camera to ensnare the subtleties and legendary loveliness of her world. . . .

[The title of this piece is borrowed from a biography of Carl Maria von Weber who wrote in the horn quartet of the overture to "Der Freischutz" a musical signature of the Enchanted Wanderer.]

"Enchanted Wanderer": Excerpt from a Journey Album for Hedy Lamarr," View, December 1941–January 1942 (Collection the Joseph Cornell Study Center, National Museum of American Art, Smithsonian Institution. Gift of Mr. and Mrs. John A. Benton)

was keenly attentive to what passersby were wearing; the people who later surfaced in his journals, from movie stars to anonymous children, are often described in terms of their garments. ("Saw Marlene Dietrich in polo coat & black beanie cap on back of hair waiting . . . for a taxi," reports a typical entry. "First time I'd seen her off screen.") Many of his boxes, with their cramped spaces and mirrored walls, suggest a backstage dressing room; one suspects that Cornell unconsciously yearned to be in such a place, exchanging the cut and shape of his identity for something else.

Yet, while sequins and scraps of tulle adorned his art and fantasies, Cornell was not a dandy. To judge from photographs, he dressed conservatively, putting on a jacket and tie when he went into the city. The only time he mentioned his own clothes in his diary he noted that he owned "a royal purple shirt that I wear in public sparingly." The key word here is "sparingly"—as if even a purple shirt represented an indulgence that needed to be kept in check.

Yet inside the dressing rooms of his boxes, he was considerably less guarded. In 1942 Tamara Toumanova moved to Hollywood to pursue a career in film, but she and Cornell kept up a correspondence; from time to time she sent along snippets of tulle and other costume fragments that he incorporated into his latest works. A couple of them would be exhibited that fall at the Wakefield Bookshop, on East Fifty-fifth Street, where Betty Parsons, who would soon emerge as a leading art dealer, organized a show devoted to the exploration of ballet in art. Cornell encouraged Parker Tyler to see it—"my Toumanovas I guarantee will lighten your spirit for a spell," he promised—even though he was moving beyond the ballet and the circle of Neo-Romantics who had been his main source of encouragement for the past three years. He was about to take up with another circle of artists, one that was both more "neo" and more "romantic" than the movement that went by that name. That movement was Surrealism, and its leading figures had just arrived in New York as refugees from World War II. Their presence would have a pronounced influence on Cornell, whose art was about to take a giant step forward.

8

Voices from Abroad

1942

Few years in American art were quite as lively as 1942, in part because its leading figures were not American at all. Rather, they were the Europeans who had recently arrived in New York amid the general exodus of artists and intellectuals after the fall of France. Some of them had visited earlier, including Marcel Duchamp and Salvador Dali. Now they were joined by André Breton, Surrealism's stern founder, who moved into a small walk-up on West Eleventh Street; he notoriously refused to learn even a few phrases of English for fear of dulling his intellectual edge. Fernand Léger could often be spotted herding groups of friends to restaurants in Chinatown. Piet Mondrian, a jazz buff, liked to visit the dance halls of Harlem. Max Ernst was living in a deluxe townhouse on East Fifty-first Street with the expatriate American heiress Peggy Guggenheim, who had helped him escape from occupied France and then demanded that he marry her ("I did not want to live in sin with an enemy alien," she explained in her chatty autobiography). Not everyone had sailed over; the big three—Picasso, Miró, and Matisse—had stayed in Europe, finding safety behind the walls of their reputations.

By the time the Surrealists arrived in New York, the creative period of the movement was essentially over. Moreover, the group activities of Paris, as it turned out, could not be duplicated in New York—the artists blamed the absence of cafés. They grumbled endlessly about the New World, deriding it as "a land without myth," as Breton once said. Left with nothing to do, the once-scandalous Surrealists visited galleries, sat through movie matinees, and strolled down Third Avenue as Breton pointed out surreal-like objects in the windows of the secondhand stores. If they attempted any radical breaks during their stay in America, it was only with their wives:

before heading back to Europe, many of them would switch partners. Other than Mondrian, who, at seventy, painted his great ode to the metropolis, *Broadway Boogie Woogie*, in his apartment on East Fifty-sixth Street, few of the artists seemed to find inspiration in New York.

However, as every first-year art-history student knows, the émigrés' presence would have a liberating effect on the local art scene. Much has been written about the Surrealist influence on the future Abstract Expressionists. With the arrival of the émigrés—or so the official story goes—Jackson Pollock and other Americans who had previously assumed that Surrealism went no deeper than the slick tricks of Dali took a second look and became aware of the movement's more experimental side. In the technique of "psychic automatism" and other spontaneous methods of art-making, they found an alternative to the rhetoric of social realism. Never mind that the Surrealists' forceful personalities probably had a greater influence on the Americans than did their artwork.

For Cornell, too, 1942 was a pivotal year. That may sound surprising, for unlike most other American artists, Cornell had absorbed the lessons of Surrealism in the 1930s and had virtually nothing to learn from the movement by the time its members sailed to New York. Nonetheless, 1942 was a time of unmatched creativity for Cornell, perhaps for a deceptively simple reason: the Surrealists were here, Cornell befriended them, and he wanted to prove himself in their eyes.

The arrival of the European avant-garde was naturally an event of great interest to Cornell. Although he had met Dali in the 1930s, most of the other Surrealists had never visited New York, and it was during the war years that Cornell became personally acquainted with them. On some days it seemed that a chapter of art history had sprung to life in the streets of Manhattan, where one could suddenly find Yves Tanguy riding the Madison Avenue bus, as Cornell did one summer morning, to his delight. Cornell, one imagines, initially made only the vaguest impression on the flamboyant personalities of Surrealism. As the art historian Meyer Schapiro once remarked, "His art was more memorable than he was."

For all their disdain for American culture, the Surrealists were aware of Cornell's work and spoke of him with respect. It is not an exaggeration to describe him as Surrealism's most accomplished American fellow-traveler. In an interview in *View* magazine in October 1941 intended to announce his arrival, Breton included two Americans—Cornell and David Hare—in a (predictably short) list of living artists he approved of. While Breton never

inducted Cornell into the official Surrealist group, he did acknowledge, in an essay in Peggy Guggenheim's *Art of This Century* (1968), that Cornell "had evolved an experiment that completely reverses the conventional usage to which objects are put"—high praise from Surrealism's high priest.

But the Surrealists' interest in Cornell went beyond his boxes. It did not take long for them to realize that Cornell himself was as exotic as any Surrealist creation—a passive autodidact who wandered the city with a brown shopping bag full of *trouvailles* and whose passions extended from Symbolist poetry to the dream of the nickelodeon. For all his impatience with America, Breton did concede that the country had produced one thing of significance: movies. And of course Breton was interested in Cornell's vast collection of moving images from cinema's earliest days. On at least one occasion, Cornell lugged his projector into the city to run off a selection of nickelodeon classics for Breton and his colleagues, probably at the Levy Gallery. "The session . . ." Cornell noted passingly in a letter in April 1942, "came off quite well."

Among the first of the newcomers to express interest in Cornell's work was Peggy Guggenheim, the maverick patron of the arts. Like her "copper king" uncle, Solomon R. Guggenheim, Peggy hoped to start her own museum; she had spent the 1930s on an extended shopping spree in the studios of Paris, and briefly ran a gallery in London called Guggenheim Jeune. Her goal was to buy a picture a day, and she more or less succeeded, amassing a large collection of European masterworks before the German advance forced her to flee. In 1941, returning to this country, she made plans to open a new gallery, Art of This Century, which would serve as the headquarters of the artists-in-exile (and to which the famously stingy heiress would initially charge 25 cents admission).

On the advice of Duchamp, whom she credited with educating her in modern art, Guggenheim wasted no time in contacting Cornell. Before she even opened her new gallery she snapped up three Cornell objects from the 1930s—*Thimble Box*, *Revolving Book with Red Ball*, and *Fortune Telling Parrot*, the box with the stuffed gray bird that he had dedicated to Carmen Miranda. For Cornell, the sale was a windfall, and he sent his new patron a gracious thank-you note on March 12, 1942: "Dear Mrs. Ernst, The check for the thimbles is acceptable, but no more so than your kind and sincere appreciation of the objects. I am glad that you like them well enough to keep a couple of them in your home. The box of thimbles has always been one of my special favorites, although not a best-seller . . ."

The Surrealist who interested Cornell most, perhaps, was Max Ernst, the best-known painter among the émigrés. It was Ernst's *Femme de 100 têtes* that had alerted Cornell to the possibilities of collage in the early 1930s, and Cornell felt indebted to him. When *View* magazine published a special issue that April devoted to welcoming Ernst to America, Cornell contributed *Story Without a Name—for Max Ernst*, a series of sixteen collages done a decade earlier. They tell an elusive tale about a young girl, swans, and a shipwreck, and represent an expurgated version of Ernst's sadistic collage novels.

Upon his arrival in this country, Ernst had a show of recent paintings at the Valentine Gallery. Cornell was invited to a party in his honor and agreed to attend, but was too nervous to enjoy himself as people around him drank cheap Scotch and spoke French. "I could hardly hear myself think when talking to you at the Ernst buffet supper," he wrote on April 7 to James Thrall Soby, a former partner of the Levy Gallery who had since become a curator at the Museum of Modern Art. Cornell's letter touchingly reveals not only his social unease but his discomfort about being an artist. During the party, Soby had made some encouraging comments on his behalf. "Really very comforting if only I can hold on to them," Cornell wrote in response. "I've had such a bewildering experience in the past ten years regarding [my] vocation and new artistic activities that I feel that only now am I beginning to realize what some of it is all about."

Cornell perhaps was referring to his long frustration over assigning his art a secondary status as he labored to support his family. A year and a half had passed since he left his job, during which he had expended much thought on setting up an atelier. He felt pleased, his letter to Soby continues, by the "establishment of my first real workshop in my cellar, which I am trying to make at once workshop, 'bulletin board,' repository and gallery . . . You would always be more than welcome to view the progress I am making." Turning the letter into a winsome collage, Cornell embellished the margins with cut-out engravings of ducks, three of them flying, three nesting below—trios that evoke Cornell's own household and his conflict between domesticity and artistic flight.

While Cornell spent most of his time on Utopia Parkway, he rode the train into Manhattan at least once a week to catch up with friends and scout for material for his work. On a typical day in the city, he might visit the Levy Gallery, browse in bookstores, and stop for a snack at an Automat, dropping a dime into a slot to retrieve a slice of pie from a glass box. His

wanderings regularly brought him to the "Reading Rooms" run by the Christian Science Church, where he could peruse that week's lesson-sermon and count on seeing people he knew: "Took some flowers to the Ninth Church Reading Room and had a chat with Mrs. Merrick the librarian," he noted on March 26, 1942. Also that day, in pursuit of more worldly articles of faith, he was delighted when he chanced upon "five *New Yorkers* with Toumanova picture," back issues of the magazine.

The comment is among the very first entries to survive from Cornell's copious diaries, but then "diary" may be too formal a word to describe the project he now conceived. As if taking his cue from Mallarmé, who once said that everything exists to be put in a book, Cornell began recording his day-to-day experiences on paper. It became his custom to scribble comments in the middle of the day on any available scrap and then type them up in a more coherent fashion at a later time. Yet the scraps proliferated with a speed that far surpassed his ability to keep up with their transcription, and his diaries in fact consist of thousands of loose scraps that he kept in folders. Some of the notes were made on the backs of used envelopes or in the corners of crumpled printers' bills. He wrote notes on discarded programs and gallery invitations, on empty cake boxes from Shelley's bakery ("Flushing's Leading Bake Shop," the box informs us) and its rival, the Victory Bakery ("Butter Makes It Better"), on creased paper bags from Woolworth's and Wanamaker's and Record Haven. He wrote notes in the margins of newspapers and books. He wrote notes everywhere. In much the same way that his art was made from everyday castoffs, so, too, were his diaries, and their fragmentary form says as much about his state of mind as any of the messages he wrote on them.

Cornell's diaries, extended selections from which were published in 1993 in *Joseph Cornell's Theater of the Mind* (edited by Mary Ann Caws), can be startling to read. They're a flood of consciousness in which people and places come into view as abruptly as visions half-recalled from a dream. Cornell shifts without warning from the present to the past, from lofty art to junk food, from the sublime experience of seeing a Constable landscape at the Metropolitan Museum of Art to that of eating a slice of pie at an Automat. Hundreds—no, thousands—of details float by, and nothing seems connected to anything else. Often it is unclear if a name refers to someone Cornell met or just read about in a book. Phrases far outnumber complete sentences. No themes are proclaimed, no totalities offered. When compared

to Cornell's diaries, with their profusion of nearly impenetrable detail, his boxes seem miracles of editing and restraint.

While the diaries may disappoint anyone seeking insights into the tensions of Cornell's daily life or family situation, their voids and unbridgeable gaps say much about his imagination and the powers of connection he found in it. Moreover, the diaries reflect his burgeoning self-confidence, his belief that his experiences might be of interest to someone other than himself. While his encounters in the city could not quite compete for literary color with the diaries he read—the famous "Mardis" of Mallarmé or those lively evenings at Magny's restaurant that the Goncourts recorded in their *Journals*—Cornell was now meeting some of the Surrealists, often stopping by their studios and apartments during his trips into the city. The compulsiveness with which he wrote up his encounters is reminiscent of the most prolific French diarists, as, perhaps, was his reverential desire to see, to witness, to compose an *hommage*.

Of all the Surrealists living in exile, Cornell was probably on easiest terms with Roberto Matta Echaurren, a charming and talkative architect-turned-painter who signed his work simply as Matta. He showed at the Levy Gallery, where Cornell presumably met him. Unlike the other Paris Surrealists, Matta, the youngest and newest convert to the group, spoke English fluently and was interested in getting to know American artists. He had real affection for Cornell, addressing him as "Jo-Jo," the French diminutive of his name, and relishing the sight of him arriving for a visit carrying "a suitcase filled with objects, old films, photos, etc." At Cornell's invitation, Matta once ventured out to Utopia Parkway for an overnight stay and was struck by the childlike gesture with which Cornell welcomed him to the house: "The first thing he showed me as a 'promise' of a *good* weekend," he said, "was the ice-box—it was packed with cake, ice cream and all sorts of sweets."

Through Matta, Cornell befriended Robert Motherwell, the future Abstract Expressionist. A slender blond painter in his late twenties, Motherwell had grown up in Aberdeen, Washington, and held a philosophy degree from Harvard. He was enamored of French culture and got along well with the Surrealists. In the presence of someone who shared his interests, Cornell could be suddenly and stunningly vocal, and Motherwell was glad to listen as Cornell held forth on "ballet, Mallarmé, small hotels, Berlioz, and Erik Satie, 'whiteness,' " as Motherwell once described their mutual passions.

Both artists were habitual browsers in secondhand bookshops, and at times they foraged among the Fourth Avenue bookstalls together.

Cornell would visit Motherwell at his apartment on Perry Street in Greenwich Village, but Motherwell didn't take this as a compliment, suspecting that Cornell was less interested in hearing him discourse on Symbolist poetry than in ogling his pretty wife, a Mexican actress named Maria Ferreira. "He just watched her and watched her and watched her with absolute delight," Motherwell remembered, adding that he always set out a bowl of sour balls when Cornell came by and was amazed to find that it had been completely emptied by the time he left.

Another new friend was Hedda Sterne, a Bucharest-born painter who arrived in New York in 1941 and first met Cornell at the home of Peggy Guggenheim. Sterne, too, knew of Cornell's predilection for sweets; she would prepare "a tall stack of Danish" in anticipation of his visits and recalls him eating "ten or twelve Danish" in a single sitting. In spite of his sweet tooth, Sterne thought of Cornell in antique terms. "I saw him as a Victorian old maid, a spinster stuck in an attic," she later said. "He lived in a halfdream, which he carried around with him. He was weighed down by his dreams and visions, and you could see that his life wasn't easy. I always had the feeling that if I shook him, he would pulverize into dust, like old paper."

Sterne was then married to Saul Steinberg, the erudite cartoonist-turnedartist, who was less taken with Cornell than his wife. For one thing, Steinberg found it difficult to talk with Cornell. "It was his desire to have a limited relationship," Steinberg noted. "He would rather talk about some French Symbolist than a day in the life of Queens. While I, too, like to talk about books, the one thing that interests me is direct experience, and spontaneous inventions of the moment were impossible with him."

Cornell fared much better with Marcel Duchamp. Since their first meeting at the Levy Gallery a decade earlier, Duchamp had spent much time abroad, and had returned to New York only recently amid the general influx of European artists. This time he settled permanently in Manhattan, moving into a studio apartment in a commercial building at 231 West Fourteenth Street and working on his art in a small room across the hall. Living austerely, he seldom went out, didn't drink, and purchased his clothes off pushcarts on Orchard Street. Duchamp invited few people to his apartment, and his refusal to get a telephone made him hard to reach, but Cornell didn't hesitate to include him in the group of artists whom he regularly visited.

Duchamp may not have realized how much his friendship meant to Cornell, for whom a little kindness went a long way. Duchamp had lived briefly with Peggy Guggenheim and Max Ernst upon his return to New York, and one morning "during a cloudburst," Cornell was pleasantly startled when he called the art dealer and Duchamp answered the phone instead. "It was at once one of the most delightful and strangest experiences I ever had," Cornell noted in his diary. "He is coming out Friday which should prove a much needed inspiration to get some of the objects finished."

Duchamp, a notary's son from a small village in Normandy, was well liked by other artists for his uncommon charisma and generosity, from which Cornell was to benefit as much as anyone. Duchamp had already introduced Cornell's work to Peggy Guggenheim and convinced her to buy a few of his pieces. One winter morning, Cornell stopped by Duchamp's apartment and was delighted to come away with a gift. "At Duchamp's 11 to 1," he noted in his diary in December 1942. "Gave me 'ready made' done on spot. A glue carton 'gimme strength.'" Presumably this work consisted of a cardboard box for a jar of glue that came with the slogan "gimme strength" printed on the outside. It was an amusing gesture on Duchamp's part—an exhortation of spiritual well-being retrieved from a common cardboard box.

If *Gimme Strength* (as one might title it) was a kind of box, it was not Duchamp's first. He had started making boxes before Cornell, though in his hands the box was a strictly conceptual object—dry and devoid of visual magic. His cardboard *Box of 1932* is full of notes for a treatise he wrote on chess. It served as a model for his *Green Box* of 1934, the title under which he gathered the notes and sketches for his famous *Large Glass*. That same year Duchamp began work on his best-known box, *The Box in a Valise*, a little pigskin suitcase whose sides open out to form a sort of personal museum for miniature reproductions of all the artist's key works. An edition of three hundred valises was planned; acting with his famous hands-off nonchalance, Duchamp had his friends assemble them instead of doing it himself.

Cornell was among the select who helped assemble the valises, which gave rise to a rumor among their friends that Duchamp had given Cornell the whole idea of making boxes in the first place. There is no truth to this assertion: Cornell was making boxes before he learned of Duchamp's boxed notes. Yet, through Duchamp, Cornell did discover the idea of the valise-as-art. To pack your life into a traveler's suitcase to take anywhere and everywhere—the fantasy appealed to Cornell. He soon began work on a

"suitcase for Fanny Cerrito," a project that would engage him for the rest of his life as he continued to add programs, photos, and his own notes pertaining to the ballerina to an ever-weightier attaché case, which he kept under his bed.

After a decade of working at the kitchen table, Cornell was happy to have a workshop at last. Though not spacious, it at least had a door and was a private place where he could be alone with his creations. A flight of stairs on one side of the kitchen led down to the small, cramped basement. The cinder-block walls and seven-foot-high ceiling made it feel as claustrophobic as a cave. To the right of the stairs was Cornell's work area, furnished with a wooden worktable and lit by a bare bulb. To the left, by the coal furnace, he established a storage space for finished boxes and boxes-in-progress, some of which he kept neatly stacked inside a black metal trunk—a box for his boxes. His carless garage provided him with additional storage space.

On a wall in the work area, Cornell built floor-to-ceiling shelves for his extensive collection of what he called "source material." Instead of file cabinets, he organized his holdings in brown cardboard cartons, labeled with headings such as "Stamps" or "Maps" or "Dürer." He also kept folders on motifs he hoped to pursue in his work, typically waiting several years before retrieving handwritten notes or a favorite reproduction from a folder and beginning work on a related box. Later on, many of Cornell's visitors would remark on the clutter of his workshop and the seeming haphazardness of his mounds of material—as well as their inevitable surprise upon seeing him locate, say, a yellowed newspaper clipping on Anna Pavlova's final performance with an archivist's efficiency. He knew exactly where everything was.

Cornell felt fortunate to have set up his workshop at a promising moment in his career. While Julien Levy had recently joined the U.S. Army and temporarily closed his gallery, the art dealer's absence worked to Cornell's advantage. Peggy Guggenheim would be opening her gallery that October, and Cornell would have a show there alongside Duchamp before the year was out. He recorded few comments about his work in his diaries in 1942, but the objects he made eloquently attest to his productivity. They mark a real departure from his work of the previous years, so much of which had consisted of trinkets and timid homages to ballerinas. His new pieces were not large by most artists' standards—16 inches tall, at most, not much

more than a shoe box—but they reveal an artist at the peak of his creative powers.

Still, making boxes was a slow, painstaking labor that took more time than even Cornell's admirers probably realized. He usually started a box by building what he called an outer "shell," using a power saw, a hammer, and planks of high-quality pine that he purchased at a local lumberyard. In the six years since Cornell asked his next-door neighbor, Carl Backman, to saw the wood for his very first boxes, he had learned the basics of woodworking. As Backman said, "As time went on and I realized what he was trying to do I offered my help in instructing him to use my circular saw and to design wooden boxes for his projects." Cornell was an adequate carpenter, but not a great one; the mitered corners of his boxes seldom meet perfectly.

After building a shell, Cornell tried to make it look antique. His usual practice was to stain the outside and then varnish it with multiple coats. Inside his boxes, he pursued more elaborate vintage effects. He might line a box with blue velvet, aged wallpaper, or torn-out pages from a nineteenth-century book. Or, using house paint, he might apply six or seven coats to the interior walls of a box, until the surface looked crusty and acquired a seeming patina of age.

Though Cornell's boxes resonate with the past, most of the material he used to make them was new. Cordial glasses, rubber balls, cutouts from 25-cent paperbacks like *Sea Shells of the World*—his extravagant fantasies were contrived from the most inexpensive five-and-dime finds. This approach was not a strategy to Cornell or a formula for clever provocation. Rather, it reflected his instinctive openness to popular culture. Fragile and death-haunted, Cornell appears to have felt as moved by dimestore objects as he was by Mozart and Michelangelo; pop culture spoke to his sense of life's evanescence, to feelings about his own slightness and vulnerability, to an aspect of experience that the shining radiance of museum trophies could not entirely convey.

Then again, did Cornell's boxes really begin as he sat and sawed planks of wood, sawdust flying everywhere? Or did they begin sometime earlier, outside his musty cellar atelier, in the midday moments when Cornell, roaming the city, chanced upon an old photo or print that aroused his imagination?

It was during one such Manhattan ramble that Cornell, or so he said, conceived the idea for his extraordinary *Medici Slot Machine*—his best box

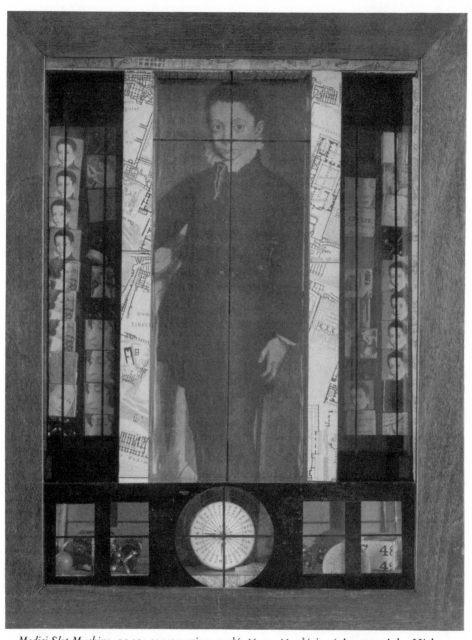

Medici Slot Machine, 1942; construction, 15½ × 12 × 4⅜ in. (photograph by Hickey & Robertson, Houston; private collection)

from 1942 and perhaps his greatest ever. He was making his rounds of the bookshops one day in the late 1930s when he chanced upon a stockpile of reproductions of a painting of a Renaissance prince—a willowy, wide-eyed adolescent whose face he found inexplicably arresting. If Cornell had any qualms about swiping the image for his own work, one imagines he might have felt emboldened by the thought of Duchamp's own raid on the Renaissance in his mustachioed Mona Lisa. Yet whereas Duchamp cracked jokes and made absurd machines, Cornell made dream machines, and never more powerfully than in his *Medici Slot Machine*—a funny title, half sixteenth-century Florence, half twentieth-century Coney Island, as is the piece itself, in which Cornell situated a photostat copy of the boy-prince inside a box modeled after a candy vending machine.

Penny-arcade machines, for Cornell, had always been synonymous with the enchantments of childhood. The little boy who once skipped through amusement parks, dropping pennies into machines and peering with fascination at the pictures inside, grew up to be a connoisseur of Manhattan's vending machines. There was a chewing-gum machine in the BMT subway station at Thirty-fourth Street that Cornell found particularly striking; it was this unlikely object that served as a model for his *Medici Slot Machine*, which he envisioned as a fantasy version of the original, something "that might be encountered in a penny arcade in a dream," as he once noted. In it, the prince's face appears in the space where a child would ordinarily find his own image reflected, and is flanked on both sides by vertical rows of Renaissance faces that suggest the spliced frames of a movie. Jacks, balls, and toy blocks are poised as if to provide the prince with a game to play when a penny is dropped into the machine.

The prince is Piero de' Medici, a delicate youth in a frilly lace collar and dark suit. The picture of him, *Portrait of a Boy with Sword, Gloves and Dog*, was painted by a little-known sixteenth-century artist, a woman named Sofonisba Anguissola, and is owned by the Walters Art Gallery in Baltimore. Cornell was always drawn to the sensitive portraiture of the Old Masters, and from his reading, he knew much about Sofonisba Anguissola. An extraordinary character, she was one among five sisters, all of them artists, though only Sofonisba had a career. She painted many family portraits in which she depicted herself with her siblings and her nurse in an age when women artists tended to restrict their subjects to the domestic sphere.

It has often been noted of *Medici Slot Machine* that it juxtaposes an Old Master painting with popular amusements, mingling high and low culture

in a way that breaks from the purist impulses of modern art and prefigures the vernacular content of Pop art. But what makes *Medici Slot Machine* so memorable is not merely the mixing of disparate elements but the potent new meanings they acquire in the process. A Renaissance princeling is made to seem part of the present, and a candy machine in a subway station becomes the vaulted palace in which he resides.

Why was Cornell so drawn to this princeling? One of the few portraits of an adolescent to survive from its era, it has often been viewed as "the artist's self-image," as the critic Harold Rosenberg once noted. Piero, however, so pale and tender, might instead be seen as a surrogate for Cornell's disabled brother—a prince in the artist's eyes, an aristocrat ennobled by years of suffering. Though utterly powerless, here he becomes empowered: he is rescued from his disappointing life and transported to a child's idea of paradise, a candy machine, with toys and movies within easy reach.

If Cornell identified with anyone, it was not Piero, one suspects, but Sofonisba Anguissola, a family-minded artist like himself. *Medici Slot Machine* was among the first pieces that Cornell completed in his basement workshop, and if we view the box as an idealized portrait of Robert, we come closer to understanding Cornell's sense of family reponsibility and the guilt he may have felt for neglecting his brother as he devoted his full attention to his career.

Some people might find such an interpretation overly literal. Cornell's boxes have the quality of coded entries in a diary, and it's not clear that he wanted them to be decoded. Perhaps he just wanted us to relish their aura of mystery, and many critics have been content to label them with words like "hermetic" and "enigmatic," and then sign off. Yet his boxes are not generic fairy tales. They have specific meanings that touch on the events and issues of the artist's day-to-day life, and it does not diminish Cornell to say that he was the most autobiographical of artists, obsessively relating his life story—or lack of one—in his work.

A second great box from 1942 is *Setting for a Fairy Tale*, which is less elaborate than *Medici Slot Machine*. It's dominated by a single image: a cut-out engraving of a Paris municipal building. Real twigs, which Cornell spattered with white paint, loom against a wintry sky, and tinsel snow glazes the ground. Cornell found the engraving of the building in Jacques Androvet du Cerceau's famous book on French edifices, *Les Plus excellents bastiments de France* (1576) and used a photostat in his box. He made some changes to the original image: he cut out the windowpanes, so that the

Setting for a Fairy Tale, 1942; construction, 11⁹⁄₁₆ inches high (Peggy Guggenheim Collection, Venice; photo by Carmello Guadagno and David Heald)

sixty-odd windows of the building remain open. What do we see when we peer inside? We see ourselves, since Cornell ingeniously glued the castle onto a mirror and guaranteed that the peeping viewer will be rewarded with nothing more than a reflection of his own prurience.

Cornell often used mirrors in his boxes, turning them into virtual dressing rooms in which we look at ourselves looking at art. Momentarily, the viewer becomes an actor or actress, an exhibitionist cloaked in art's sumptuous veils. Cornell's use of mirrors has generally gone unremarked on, perhaps because the mirrors don't show up in reproductions of his work. Yet mirrors are integral to a box such as *Setting for a Fairy Tale*. As we see our face reflected in the box's mirrors, a Renaissance building is brought into the present and made to seem part of that modern cityscape in which passersby glimpse their reflection in shop windows a thousand times a day, and in which every urban voyager is also a voyeur.

All in all, the box resembles a miniature theater, as does the work that

followed: *A Pantry Ballet (for Jacques Offenbach)*. Here, five bright red plastic crayfish—perhaps inspired by Dali's larksome *Lobster Telephone*—are decked out in tutus and beaded necklaces. Suspended from strings, they appear to be dancing a ballet to the music of metal teaspoons jingling above. The box, a spoof on the romantic ballet, is one of Cornell's rare attempts at humor.

Cornell left the stage altogether in *Untitled (Pharmacy)*, in which twenty-two apothecary jars containing different substances are neatly arrayed on four glass shelves, with mirrors behind them creating multiple reflections of glass-on-glass. The piece captivates through its coolness, and reminds us of Cornell's tendency to express the wildest fantasy with laboratory-precise detachment. The work owes something to Duchamp, who made his own *Pharmacy* in 1915 and whose recent gift to Cornell of the "gimme strength" readymade might have led Cornell to conceive his own work devoted to the theme of spiritual healing. The idea was one he had already explored in his early series of "pill boxes," and his *Pharmacy* box similarly respects the Christian Science ban on drugs; in place of medication it offers a symbolic opiate of seashells, confetti, scraps of tulle, and the like. One of the bottles contains something dry and crumbled, which led Pavel Tchelitchew to spread a diabolical rumor: he told his friends the jar contained "dog shit" and that Cornell himself had told him so—if he did, surely it was a joke.

Duchamp was more respectful of Cornell's new *Pharmacy* box. In this assemblage of glass bottles, Duchamp surely discerned the influence of his own great transparent masterpiece, *The Bride Stripped Bare by Her Bachelors, Even*, known as *The Large Glass*. Duchamp liked the *Pharmacy* box so much he wanted to own it, and Cornell was deeply flattered. The following year, just as Duchamp's *Large Glass* was loaned by Katherine Dreier to the Museum of Modern Art, where it went on public display for the first time since its debut in Brooklyn in 1926, Cornell made a second *Pharmacy* box that was similar to the original and which Duchamp purchased for his personal collection.

While Cornell's new boxes were accomplished works in and of themselves, they were also prototypes for future boxes. It was his custom to work in series, making variations on the original that could differ extensively or hardly at all. The boy-prince in his *Medici Slot Machine*, for instance, would later slip from view as other noble children took his place. *Setting for a Fairy Tale* was the first of thirteen *Palace* boxes that Cornell made between 1942 and 1951; and *Untitled (Pharmacy)* was the first in a series of six. The serial nature of Cornell's work, while harking back to Monet's variations on hay-

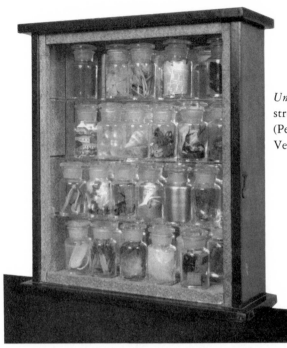

Untitled (Pharmacy), c. 1942; construction, 14 × 12¹⁄₁₆ × 4³⁄₈ (Peggy Guggenheim Collection, Venice)

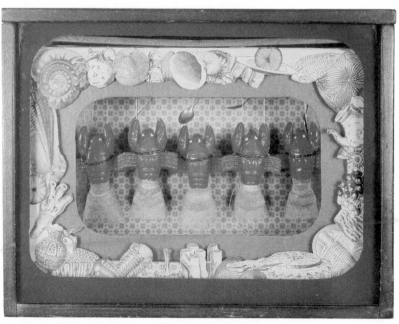

A Pantry Ballet (for Jacques Offenbach), December 1942 (Collection Donald Morris Gallery, New York)

stacks, also looks forward to postmodern tastes. From Cornell's use of repetitive imagery in individual boxes to the repetition of the boxes themselves, he went against the modernist idea of art as a one-of-a-kind masterpiece and laid the groundwork for the factory approach of Pop Art.

Yet in his serial practices, as in so much else, Cornell was driven as much by the need for emotional security as by the wish for artistic novelty. One imagines he made duplicates and triplicates of his boxes as a way of protecting himself from the threat of loss. He had always been reluctant to part with his boxes and this way could be sure to have another version—a sibling, a shadow, an effigy—of any box that left his workshop.

In December 1942, Cornell participated in a three-man show at Peggy Guggenheim's new gallery. Art of This Century had opened only two months earlier, seven flights above a grocery store at 30 West Fifty-seventh Street. Designed by the five-foot-tall Viennese architect Frederick Kiesler, the gallery was a Surrealist funhouse, complete with curving walls and lights that continuously switched between displays. Paintings taken out of their frames and off the walls leaped out at viewers on invisible arms, and sculptures appeared to float in midair. The recorded sound of a train was played at regular intervals. The critics, for the most part, could not help but be dazzled, even if they weren't sure exactly what it added up to. Covering all bases, *Newsweek*'s headline proclaimed when the gallery opened: ISMS RAMPANT.

For her Christmastime show, Guggenheim selected a trio of artists whose work she found especially amusing. Cornell contributed his three new masterworks: *Medici Slot Machine*, *Setting for a Fairy Tale*, and *Untitled (Pharmacy)*, which were shown alongside some earlier pieces purchased by Guggenheim before the gallery opened (*Thimble Box*, *Revolving Book with Red Ball*, and *Fortune Telling Parrot*). Duchamp lent his *Box in a Valise* in a limited edition, and Laurence Vail, Guggenheim's ex-husband, exhibited his "bottles"—modified readymades salvaged from his drinking bouts and decorated with cutouts from magazine advertisements. One of the advantages of having an independently wealthy art dealer is that she can purchase the work she exhibits. True, Guggenheim foolishly let Cornell's best box— *Medici Slot Machine*—slip away; it ended up with her accountant and his wife, Bernard and Becky Reis. But Guggenheim did purchase two other

pieces, *Setting for a Fairy Tale* and *Untitled (Pharmacy)*, for her personal collection.

Cornell must have been gratified as well by the notices accompanying the show. While the easily rattled Emily Genauer of *The World-Telegram* dismissed the exhibition as "surrealist, pretentious and silly in the extreme," a more penetrating review came from Clement Greenberg, who would soon emerge as the leading champion of Jackson Pollock and the Abstract Expressionists. In a short item in the December 26 issue of *The Nation*, Greenberg praised Cornell as "greatly gifted" and also noted: "The stuffed birds, thimbles, bells, cardboard cut-outs, and so forth which Cornell puts into boxes faced with glass please by their arrangement and the unspecified associations they call up, but mean or represent nothing not themselves. They . . . derive from modern painting, from Chirico and Ernst—and Kurt Schwitters's 'trash' objects. (Cornell's only unsuccessful compositions, those relying on thimbles, have an emptiness resembling the duller canvases of Chirico) . . . An infinite prospect lies ahead. Cornell could construct landscapes ten feet square inside his boxes. I am in dead earnest."

The review marked the first and last time the great critic ever wrote on Cornell. Asked in his later years to explain the fleeting nature of his interest, Greenberg replied with characteristic pithiness: "Other things took precedence." Indeed, Greenberg was then more interested in artists whose work seemed to break free of Europe and who might establish America as the rightful heir to the modern tradition. Like other critics of the time, he seems to have considered Cornell's work too French to advance the cause of the New York art scene.

If Cornell lacked an advocate among American critics, he didn't fare much better among the circle of European émigrés. One group slighted him because he was too French, the other because he wasn't French at all. To be sure, Peggy Guggenheim had lent him at least a token of support; and anyone who has visited the Peggy Guggenheim Collection in Venice, the remarkable museum she founded after the war in a palazzo on the banks of the Grand Canal, knows that only three Americans—Cornell, Pollock, and Alexander Calder—are represented in a serious way in the permanent collection.

Yet Guggenheim's interest in Cornell was erratic at best. She never offered him a one-man show at her gallery, and in her revised memoirs, *Out of This Century: Confessions of an Art Addict*, mentions Cornell only in passing.

Her most extended comment about his work crops up in connection with a British spy she was in love with: "I had sent him a beautiful Cornell object . . . as a birthday gift." Guggenheim appears to have thought of Cornell's boxes mainly as gifts for her friends and upscale toys for children. In later life, after settling in Venice, she once entertained a socialite named Maria Theresa Rubin, who brought along her five-year-old son, who later recalled her astonishment at Guggenheim's casual treatment of her collectibles. In an attempt to distract the little boy, Guggenheim handed him a Cornell box, suggesting he play with it.

But then Cornell, in the end, was no more devoted to Peggy Guggenheim and the Surrealists than they were to him. As involved as he was in that movement, he was still on friendly terms with their rivals, the Neo-Romantics, fluttering mothlike between different flames. In December 1942, when Cornell made his debut at Art of This Century, his work could also be seen in "Twentieth Century Portraits" at the Museum of Modern Art. The show was organized by Monroe Wheeler, a curator whom Cornell would eventually count as a valued friend. Wheeler was an avid supporter of Pavel Tchelitchew, and was viewed by his fellow Tchelitchevians as a figure of "ever-smiling, gentle, solid friendliness," as Parker Tyler once described him. For years he lived with his lifelong companion, the novelist Glenway Wescott, and the photographer George Platt Lynes in a homosexual *ménage à trois* that has been chronicled at length in Wescott's published diaries.

In a letter written on August 31, 1942, Cornell informed Wheeler: "Julien Levy suggested that I get in touch with you regarding my 'Legendary Portrait of Greta Garbo' for your coming portrait exhibition . . . This Garbo portrait is one of my favorite objects and was shown successfully at two exhibitions at the Levy Gallery." A week later Cornell wrote again, enclosing a photo of his Garbo box and dutifully reporting: "It is being refinished at the moment, but a week or so will see it in shape." A month later, after having delivered the box to the museum but not heard back, Cornell defensively requested that the box be returned to him. In response, Wheeler scribbled to his secretary: "Please phone him and ask whether I may put it in show. Tell him I found it irresistible."

And so Cornell was presented at the Museum of Modern Art as, of all things, a portraitist—a fitting turn of events for an artist who saw an endless flicker of faces in the soft close-ups of his imagination.

9

Bébé Marie,

or Visual Possession

1943-44

Cornell had always liked wandering in Central Park. It was a short walk from Peggy Guggenheim's Art of This Century and the other galleries on Fifty-seventh Street to the park's southern entrance, and he made the trek often, slipping from the din of Fifth Avenue into the park's twisting paths and grassy lawns. Sometimes he would head over to the carousel and watch the children riding up and down on the brightly painted horses, as gaudy music filled the air around them. He loved watching children and would inevitably project a shining radiance on them. Sitting on a park bench with his dog-eared copy of Nerval's *Les Filles du feu*, which includes the story "Sylvie," Cornell could well empathize with the writer's childhood love for a young girl who remained impossibly unapproachable.

Cornell's favorite spot in the park was the Central Park Zoo, where he would make the rounds of the caged displays or stop at the cafeteria for a cup of tea. He was fascinated by the seals and birds, particularly pigeons and starlings, which of course were not caged at all but congregated freely at the zoo to feed on food that other animals had left behind. Pigeons—gray, scavenging creatures though they are—struck Cornell as regal beings. They were a little like him: tireless haunters of the city in pursuit of cast-off scraps.

Jimmy Ernst, son of Max and a painter himself, often accompanied Cornell to the park, and he later recalled how strange the experience could be. "He would suddenly stop and look at a tree as if waiting for it to burst into bloom," Ernst noted in his memoirs. "We would huddle on a park bench in long silences, and I could swear that I was beginning to see the scene around me in slow motion. On the one occasion when I felt flush enough to treat both of us to tea in the zoo cafeteria, Cornell somehow transformed

it into a kind of ceremony just by the way in which he raised his cup and the way he sat."

Though he continued to visit the city, Cornell had begun to withdraw from the world of galleries and shows. Like the long silences in his social conversations, wide gaps habitually dropped into his exhibition history. He was always recoiling from something or someone: an art collector, a curator, the whole prospect of a career in art. And in 1943 he retreated from the art world, deciding to take yet another job: he signed up for defense work. Starting in April and continuing for eight months, he worked at the Allied Control Company, Inc., an electronics plant in Long Island City, a Queens industrial district across the East River from Manhattan. His job consisted of assembling and testing radio controls, for which he was paid 55 cents an hour, about twice the minimum wage and twice what he had earned at the Traphagen textile studio. As other men went off to war, Cornell went the way of Rosie the Riveter, dutifully joining the thousands of housewives and unmarried shop girls who worked in defense plants during the war years to compensate for the shortage of male labor.

Cornell had often complained in the past about having a nine-to-five job. He hated working—but he hated *not* working, as if still unable to reconcile himself to making art full-time. His triumphs of the previous year had changed his life not in the least. He was no Picasso, it seemed to him, just a man at a table in a basement in Queens, guiltily aware of his family's needs and how little he was contributing financially. The war only reminded him further of sacrifices he had failed to make. According to his sister Betty, Cornell went back to work because "he wanted some kind of involvement" after the U.S. draft board rejected him for medical reasons. By now he was forty-one, too old to serve anyway.

At the beginning, Cornell disliked his job at Allied Control. Summer was approaching and the plant was hot and airless. Sweating in his shirt sleeves, he sat at a worktable testing radio parts and counting the hours until it was time to leave. His fellow employees were mostly from Queens, working-class girls in long swirling skirts and bright lipstick. It's unlikely they knew of Peggy Guggenheim or a gallery called Art of This Century or a box that had recently been exhibited there entitled *Medici Slot Machine*. In their eyes, Cornell was a nice gentleman from Flushing, nothing more. By the end of his workday, he often felt "overwhelmed with mental fatigue," as he noted in his journals.

One June afternoon, however, Cornell chanced upon a "young girl" who gave sudden meaning to his routine. He first noticed her on June 4, standing in front of him on the time-card line. Studying her profile, he felt roused by her "sharp" features, "her pleasant expression after very hot working day. Black dress." She struck him as a noble creature, unfazed by the summer heat and utterly composed, possessing "such gracious qualities of serenity that I felt ashamed of any inner complaining." He managed to learn her name from her time card: Anne Hoysio. The next day, he arrived at work with a bouquet of flowers, left them on her worktable, and "spoke to her, noon, for the first time."

Over the next few months, Cornell dwelled obsessively on "Anne H.," as he referred to his working-girl muse in his journals. One day they had lunch together, and learning that her father had died two years earlier, Cornell felt moved by her vulnerability. Yet their relationship would progress no further. He could not, it seems, imagine anything as impulsive as a love affair, or even a date at the movies, preferring to think of his attachment to Anne in ideal or spiritual terms. A typical encounter occurred on August 10, when Cornell, after leaving work in the middle of a thunderstorm, was excited to spot Anne in her black raincoat at the train station. Across the platform she noticed him, and with her glance the "stress" he had felt throughout the day "lifted beautifully and completely." On September 4, he gave her a present, "a souvenir box," one of the tiny, velvet-lined, sequin-filled mementos he had made in tribute to Romantic ballerinas, as if she were somehow a living descendant of the European performers who filled his daydreams.

What did Anne H. make of this *objet* and the curious bachelor who had given it to her? Certainly she could not have realized how fully she preoccupied Cornell's thoughts and the flood of pleasure he felt just seeing her. She was probably some twenty years younger than he, and unaware that he regarded her as anything other than a workplace acquaintance. When Christmas came, she sent him a store-bought card and signed it: "Anne (tester) (Allied)." That was all she wrote, those three little words that say so much; she considered her friendship with Cornell so insignificant that she thought she had to remind him of who she was. Cornell kept the card for the rest of his life, filing it away in a manila folder thick with notes chronicling his feelings for her.

Anne H. might seem a poor cousin to the legendary ballerinas and actresses whose photos and engraved portraits filled Cornell's "source files." As she

sat at her worktable, there was no mistaking her for Garbo or Taglioni or Cléo de Mérode. Unlike them, Anne wasn't an inaccessible icon—an image retrieved from a daguerreotype or a movie screen—but a real woman punching a time clock and riding a train home from work. In Cornell's mind, however, Anne H. was a virtual twin of the others. As much as he invested photographs of female performers with a living presence, he pushed living women into some otherworldly realm, turning them into images. It seems that Anne, to Cornell, was primarily a vision, someone whose face and silent movements he liked to observe amid the vast spaces of the defense plant, in itself "a kind of theater," as he noted in his diary.

Cornell's behavior toward Anne captures at once his romantic desires and the furtive way in which he gratified them. Though he didn't give himself license to have relationships with women, his sexual curiosity apparently remained keen. He satisfied it through what might be called acts of "visual possession," staring at a woman and bringing an image of her into his inner museum, where he was free to contemplate it and manipulate it without any fear of harmful consequences. He didn't believe he could possess a woman in the flesh; his tools were strictly visual.

Cornell particularly liked observing Anne's clothing. A fetishist, by definition, derives erotic pleasure from objects or body parts such as a glove or a foot, and Cornell certainly had fetishistic tendencies. He was as focused on Anne H.'s dresses as he was on the costumes of Romantic ballerinas, carefully making note from one day to the next of little besides her "black dress," "black top coat," "blue dress," "yellow dress (marigold)," "green dress (white collar)," and so on. His diary sometimes reads like a couturier's note pad and suggests that Cornell was more excited by a woman's garments than the flesh they concealed. Within a few months, however, his obsession with Anne would end. As was often the case, his "ineffable" feelings seemed to be followed by a complete lack of feeling.

Among his art-world acquaintances, Cornell kept the news of his job fairly quiet. Writing to Frederick Kiesler, the architect who designed Art of This Century—in a letter that was amusingly typed in a vertical column a single word wide—Cornell was vague about his situation. "Have not forgotten you but work long hours these days," he remarked in August 1943, saying no more about his work and instead inquiring: "How is your niece?"—who, much to Cornell's delight, happened to be Hedy Lamarr.

Though weighed down with his new job, Cornell continued to work on his art, spending long nights in his basement workshop while his mother

and his brother slept upstairs. His latest project was interesting but slight, deliberately so, and revolved around what he variously referred to as his "monographs," "albums," or "dossiers"—boxed portfolios devoted to a single subject and consisting of photographs, prints, and other memorabilia he had amassed over the past decade, his Cerrito album being the most notable among them. It was as if the material he gathered on his urban excursions meant as much to him as anything he might do with it artistically—and he wondered if there was a way to share his albums with the public, to present his material outside the constraining walls of his boxes. For a few years already, he had been publishing material in "little" magazines, as if realizing that images reprinted in a magazine may find another life.

Cornell's most revealing work from this period was not a box but an excerpt from one of his albums—*The Crystal Cage (Portrait of Berenice)*. He published the piece in *View* in January 1943, in a special issue devoted to the theme of "Americana Fantastica." *The Crystal Cage* is a seven-page collage of photos and text culled from Cornell's extensive file of the same name. It's a kind of fan album devoted not to a movie star but to Cornell's ideal female: a child. Readers must have been a bit baffled by this spread of material, which weaves a nearly incomprehensible tale about a little girl named Berenice who presides over an abandoned tower. *The Crystal Cage* is too inward and sentimental to qualify as a major work of art, but it is a memorable expression of the fantasy of female innocence that shaped so much of Cornell's life and work.

In some ways, Cornell's inordinate fear of adult sexuality can seem archaic, or at least Victorian, harking back to an era when the cult of virginal innocence was evident in many men's lives. John Ruskin's fascination with Rose LaTouche, Lewis Carroll's fixation with Alice Liddell, Edgar Allan Poe's marriage to his cousin on her thirteenth birthday—these all drew on a larger cultural phenomenon that glorified young female purity, and Cornell's own tastes might seem to recall pre-Freudian sexual preferences. Even so, unlike so many of his Victorian predecessors, Cornell did not have actual liaisons with girls or young women. Unlike Poe, he didn't marry; and unlike C. L. Dodgson (a.k.a. Lewis Carroll), he did not leave behind a collection of photographs in which little girls are made to look like nymphets. Instead, Cornell admired children from afar and expressed more affection toward images and objects relating to them—i.e., photos and dolls—than toward any one child he knew.

Detail of *The Crystal Cage (Portrait of Berenice)* in *View*, January 1943 (Collection the Joseph Cornell Study Center, National Museum of American Art, Smithsonian Institution. Gift of Mr. and Mrs. John A. Benton)

Cornell's manner with women tended to be gentle, concerned, and reverential, more that of a devoted older brother than that of a lover. Surely it is relevant that he was reared with two younger sisters who were close to him in age and for whom he had intense feelings. Unlike his disapproving mother, his sisters represented dependable sources of affection. His sister Betty once remarked, "He had a hard time when I got married because I used to get him through his nightmares . . . There were different girls in his life who he thought were going to be his sister, but they didn't work out. He was looking for a sister to help him bear the burden of Robert; the sister he was looking for didn't exist." If Cornell regarded women as "sisters" of sorts, a word that would later surface frequently in his diary in his descriptions of his female friends, his art, too, often suggests a preference for a childlike sister rather than a mature woman.

Cornell's obsession with little girls would find its most memorable artistic expression in a box called *Bébé Marie* (now owned by the Museum of Modern Art in New York). *Bébé Marie* is a bewitching work that takes its name from the pretty, apple-cheeked Victorian doll—a real doll with blond tresses and a straw hat—who gazes solemnly at the viewer from behind a thick forest of silver-painted twigs. Cornell initially found the doll on one of his trips to Nyack. It belonged to his mother's first cousin, Ethel Storms, who had saved it for decades in an attic trunk. What did the doll—an expensive bisque import from France—represent to Cornell? A double metaphor for himself, perhaps: a figure of untouched, even girlish innocence before the fall of adulthood. And, too, the grown-up savior of girlish innocence in the abstract—exemplified by this one doll that was, fittingly, a family heirloom for this most family-minded of artists.

Bébé Marie is a bit too sentimental, and a bit too disturbing, to be completely satisfying as a work of art. Looking into this box, we feel we are also looking in on the troubled inner life of its creator, a grown man who is overly invested emotionally in a doll. A few years after completing the work, Cornell temporarily removed Bébé Marie from her box and had her photographed by his friend Ernst Beadle, with the intention of using the photos in future collages. "He wanted a picture of the doll the way some other man might want a picture of his girlfriend," Beadle recalled. "Bébé Marie was his ideal of a woman. He couldn't consider a woman in the flesh and blood." Indeed, Cornell expressed more emotion toward objects than women; and Bébé Marie—smooth and lacking body hair or breasts—surely helps explain what disconcerted him about the female sex.

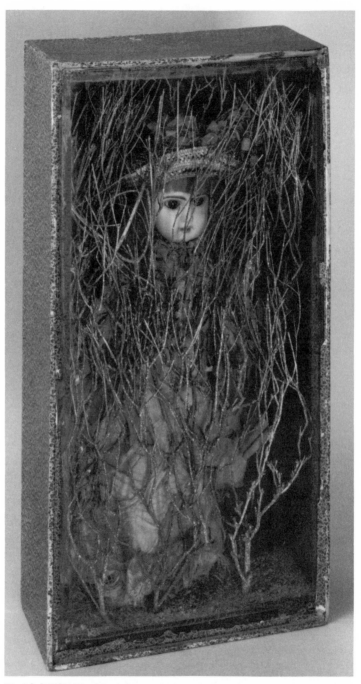

Untitled (Bébé Marie), early 1940s; construction, 23½ × 12⅜ × 5¼
(Collection Museum of Modern Art, New York. Acquired through
the Lillie P. Bliss Bequest)

It has often been said of Cornell's work that it has a tone of childlike innocence. This might seem true of *Bébé Marie*, Cornell's most explicit tribute to the enchantments of girlhood. Yet it would be wrong to view the box as asexual or to see its creator as a man who had no adult urges. Like so much of Cornell's work, *Bébé Marie* is all about sex, even though nothing about it is specifically sexual.

Cornell's pursuit of innocence might seem like a strange objective for a twentieth-century artist. So many modern artists have sought just the opposite, taking on the role of the debauched genius. Their idea of experience, their art informs us, is not confined to staying in a studio and painting masterpieces; it is the chance as well to endure suffering, illness, and even depravity. If Picasso's *Demoiselles d'Avignon* heralded the arrival of modern art, the painting's cast of five prostitutes also announced the artist's intimate familiarity with vice. Promiscuity was as central to Picasso's self-image as abstinence was to Cornell's, and in his art Cornell was able to live out what might be called a fantasy of chastity.

Many artists have been accused of depicting women as objects rather than as individuals, and Cornell can justly be accused of this, too. But instead of reducing women to sex objects, he reduced them to objects of purity, and whether his subject was Greta Garbo, a Romantic ballerina, or a toy doll like Bébé Marie, you sense that these icons of femininity all had a similar charge for him—the charge of an imagined innocence. Paradoxically, the purity he projected onto women (and onto their photos and life stories) allowed him to fall in love with them. Innocence excited Cornell, though his work is not at all innocent and is very much the product of an imaginative vision that found sexual pleasure in the act of putting off sex in order to prolong the fantasy.

In 1943, Cornell participated in a Christmastime show at the Julien Levy Gallery, by then a mere shadow of its previous self. During his stint in the Army, Levy had briefly closed his gallery and arranged for some of his regular artists, Pavel Tchelitchew included, to exhibit instead at Durlacher Brothers, a long-established, London-based firm of dealers in Old Masters. Its New York division was run by a friend of Levy's from Harvard, R. Kirk Askew, Jr., whose specialty was seventeenth-century Italian art, but who, much to Levy's dismay, soon realized he preferred selling modern artists and convinced Tchelitchew to stay on with him. Reopening his gallery in

the spring of 1943 with yet another loan from his father, Levy moved into a smaller space at 42 East Fifty-seventh Street. Fittingly, perhaps, his Christmastime show, "Through the Big End of the Opera Glass: Marcel Duchamp, Yves Tanguy, Joseph Cornell" (December 7–28, 1943), was devoted exclusively to small objects. Tanguy contributed tiny abstract paintings, Duchamp showed a miniature version of his *Large Glass*, and Cornell unveiled the newly completed *Bébé Marie* in addition to a handful of more diminutive works. Prices started at thirty dollars.

Reviewing the show in *The New York Times*, Edward Alden Jewell was surprisingly harsh in his comments about Cornell. While praising Julien Levy as a "modernist maestro," Jewell added in a weary but petulant tone: "Cornell's art I shall have to leave altogether, I'm afraid, in the reader's hands (but handle with care, for it is fragile). Somehow, while looking with curiosity at his neat little bottles filled with this and that, his pretty shells and devious gadgets and the doll enmeshed in silvered twigs, I remembered that there is a war, and after that, try as I might, I couldn't find my way back into Mr. Cornell's world."

Cornell was deeply wounded by the review, and to the end of his life referred to the "Jewell affair." It didn't help matters that Jewell had been fairly sympathetic to Surrealism as a whole from the moment it made its Manhattan debut at the Levy Gallery a decade earlier. But clearly he had no sympathy for Cornell's work, mistaking the artist's self-absorption for irrelevance. What made his comments so disturbing to Cornell is that the artist wondered if Jewell was right. As Cornell was the first to admit, he cultivated a spirit of nostalgia in his work and sought to bring long-gone figures back to life, at least in his imagination, which at times made him feel that his art was too "escapist" (a word he used often) to suit modern tastes.

Was Jewell's charge true? Was Cornell too escapist to have *any* relevance to the war-torn modern scene? Hardly. His backward glances were expressed in the most forward-looking style. In what is perhaps the central irony of his career, Cornell spent his life pursuing visions of childhood purity in a style that's the height of aesthetic *impurity*, mingling sources from high and low culture in defiance of the lofty rules of art history. His blurring of boundaries harked back to Cubist collage while anticipating the brash high-low show known as Pop art. But it would be a long time before his modernity and artistic relevance were fully recognized by his contemporaries.

Something else his detractors failed to realize is that Cornell was not a

slave to nostalgia but rather its master; what really excited him was a nostalgia for people he had never known, for places he had never been, for an innocence that had never existed. The past is not innocent, and neither, as we know from Freud, are children; this was all Cornell's creative invention.

Nonetheless, even Cornell at times bemoaned his dreamy tendencies, and it was probably Jewell's dismissive review that led him within a few days to conceive a box relating to World War II. *Habitat Group for a Shooting Gallery*, of 1943 (which is now owned by the Des Moines Art Center) is unusual among the artist's boxes in that a shot of violence is allowed to intrude. In it, hand-tinted cutouts of a cockatoo, two parrots, and a bird that could be either type perch against a white wall upon which are scattered words and pictures pertaining mainly to France. This is no shooting gallery for children, however. A mock bullet hole has cracked the glass pane (turning it into a small version of Duchamp's *Large Glass*) directly in front of the central bird's crown, where red paint is splattered like blood. Splotches of blue and yellow pigment hint at further bloodshed, as do the fallen feathers in the lower right corner of the box. A bouquet of dried flowers adorns the upper right corner. The box, one of Cornell's most richly colored, is his personal memorial to a civilization ravaged by war.

While Cornell's participation in "Through the Big End of the Opera Glass" had failed to endear him to Jewell, it did receive a rave from at least one viewer—Tilly Losch, a renowned Austrian dancer and actress whom Cornell knew in passing. Word got back to him that she had stopped by the gallery to see the show twice. Flattered by her interest, he sent her a letter. It took a long time to compose. After "much travail," he noted in his diary on December 21, he discarded his first draft and came up with a satisfactory version, which he hand-delivered to the Ambassador Hotel in Manhattan, where Losch was staying.

The letter was typed on a piece of paper that Cornell cut in the shape of a Christmas tree and embellished with glued-on stars. Losch was then thirty-six years old, a famous and fashionable appendage to the social set around the photographer Cecil Beaton, but Cornell preferred to think of her in more innocent terms. In his mind he envisioned her as the schoolgirl-ballerina who had made her debut in *Wiener Walzer* at the State Opera House in Vienna when she was only twelve years old. His letter requested that she "accept a little Christmas tree with things hung upon it just for herself and make believe that *she* [emphasis added] is a little girl again." In addressing

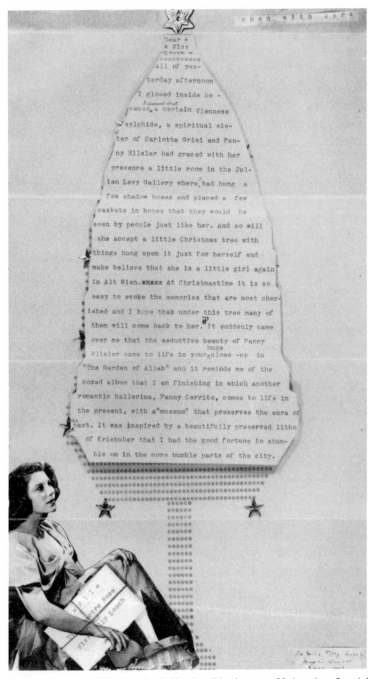

open with care

Dear
Miss
Losch

All of yes-
terday afternoon
I glowed inside be -
cause a certain Viennese
sylphide, a spiritual sis-
ter of Carlotta Grisi and Fan-
ny Ellsler had graced with her
presence a little room in the Jul-
ien Levy Gallery where had hung a
few shadow boxes and placed a few
caskets in hopes that they would be
seen by people just like her. And so will
she accept a little Christmas tree with
things hung upon it just for herself and
make believe that she is a little girl again
in Alt Wien. xhaxx At Christmastime it is so
easy to evoke the memories that are most cher-
ished and I hope that under this tree many of
them will come back to her. It suddenly came
over me that the seductive beauty of Fanny
Ellsler came to life in your huge close -up in
"The Garden of Allah" and it reminds me of the
boxed album that I am finishing in which another
romantic ballerina, Fanny Cerrito, comes to life in
the present, with a "museum" that preserves the aura of
past. It was inspired by a beautifully preserved litho
of Kriehuber that I had the good fortune to stum-
ble on in the more humble parts of the city.

Cornell's letter to Tilly Losch (Collection Binghamton University, Special Collections, Max Reinhardt Archive)

Losch as "she" instead of "you," he seemed to be writing not to her but to some invisible person they both knew.

Cornell arranged to meet Losch at the Ambassador Hotel soon afterward, inaugurating a friendship that was fleeting but predictably intense. Losch was then married to Edward James, an eccentric British multimillionaire who was keen on Dali and Tchelitchew and owned a good deal of their work. Feeling artistic urgings of her own, Tilly Losch had just moved to New York to devote herself to painting. Cornell was supportive of her efforts and was delighted when she gave him two of her watercolors, both whimsical scenes of children. On a visit to Utopia Parkway, Losch kindly volunteered to color an antique print in his collection that depicted her in her distant youth among the celebrated Viennese dancers.

A dark, striking beauty with a talent for putting people at ease, Losch enchanted not only Cornell but also his mother, who later wrote: "She was always the most glamorous person I ever met." Mrs. Cornell liked the dancer so much that she once attended an art show of hers at the Bignou Gallery, on East Fifty-seventh Street, thinking that Losch would be thrilled to have her at the opening reception. Rather, Losch was disconcerted when the frumpy Queens housewife arrived at the gallery. Years later, in a letter to her son, Mrs. Cornell recalled sorrowfully, "When I introduced myself she said, 'Where is Joseph?' and seemed so disappointed that I was sorry I went when she only wanted you."

In truth, of course, Losch had no more romantic interest in Cornell than she did in any other of her many fans; she by no means shared Mrs. Cornell's dewy-eyed view of him. No one, it seems, could take him quite seriously as a suitor, this seemingly needy yet standoffish man who guarded his privacy and always made sure that his sociability stopped short of intimacy. Cornell's withdrawals inevitably left him alone with his art, and only there could he achieve the sense of romantic union that eluded him in real life. If anything, Losch was baffled by Cornell's interest in her. After he sent her a box one day, Losch telephoned her friend Robert Motherwell, who recalled her asking whether "this mad, distant suitor was for real or not."

In January 1944, Cornell left his job at Allied Control, but by spring he was looking for work once again. It was always the same: he would dream of having time to himself and then quit his job only to wonder why he had done such a careless thing, condemned himself to days of aloneness and

shapeless yearning. Downstairs, in his basement workshop, it was rarely quiet. He could hear his mother pacing in the kitchen one flight above, could hear her brisk footsteps, the metallic clanging of pots and pans, the sound of the water swishing through the pipes and filling the sink as she washed his laundry, her very industry reminding him of his own seeming idleness and the uncertainty of his worth as an artist.

Cornell had his supporters, yet his worldly achievements assuaged his self-doubts hardly at all. He wished it were otherwise—wished he could believe the poet Mina Loy, who once told him in a telephone conversation (words that he bothered to jot down), "You can't help making beautiful things; stop analyzing so much." At the same time, he lived in the space of his uncertainty. In his copy of Walter de la Mare's *Memoirs of a Midget*, Cornell, revealingly, underlined this sentence: "Could there be any doubt at all, too, that men had always coveted to make much finer and more delicate things than their clumsiness allowed?" A midget, that was him, hiding from the footsteps resounding upstairs and eager for the reassuring routine of a nine-to-five job.

This time, Cornell took a job at the Garden Centre, a nursery in Flushing located at Northern Boulevard and 194th Street, not far from Utopia Parkway. It was owned by a Christian Science practitioner whose company Cornell enjoyed, and he would later look back on the period of "GC 1944"—as he entitled a new dossier devoted to his Garden Centre explorations—as a meaningful and almost mystical time. While on most days he did little more than tend the cash register, he never forgot "the superlative effects of the summer of 1944," when he was able to escape the tense atmosphere of his home and the feelings of "resentment and persecution" it so often bred in him.

Acquiring a used bicycle from his brother-in-law, Cornell rode it to work, a stringbean of a man peddling leisurely through the tree-lined streets of Queens. Some of his most contented moments that year were spent touring different *banlieus*—his French appellation for the nearby neighborhoods he saw from the seat of his bicycle. A favorite destination was the "house on the hill" in the waterside community of Malba, where he might scout for driftwood or dried grasses for his boxes, and be equally pleased, as he noted in his journals, "by the fantastic aspect of arriving home almost hidden on the vehicle by the loads piled high." The relics of the natural world—shells, dead wood, dead grass—satisfied his scavenging passions as much as any antique photo or print he picked up in the city.

Bicycle riding, Cornell felt, allowed for a kind of mental voyaging that other forms of movement inhibited. Walking, he noted in his journals, "inevitably produces fatigue, and the inspiration of initial enthusiasms [is] soon lost." He never learned how to drive a car and cared little for being a passenger: "Riding by car one takes too much for granted, and personal reactions [are] lessened by conversation." Bicycle riding, by contrast, provided rich opportunities for daydreaming. On most mornings, riding to the nursery, he would arrive downtown before the stores opened, before shoppers filled the streets. These peaceful early-morning hours made Flushing appear suddenly and startlingly unfamiliar, "a dream place," as he described it.

Among his art-world friends, Cornell excused himself from gallery openings and other social events by citing his new job. "A flower shop" is where he said he was working, his voice inevitably brimming with regret. Still, he continued to visit Manhattan, mostly to tend to his projects for *Dance Index*. The magazine, which was read by everyone in the dance world, had been founded in 1942 by Lincoln Kirstein, who was aware of Cornell's interest in dance and had recruited him early on to design collage-covers. Kirstein admired the work Cornell did for the magazine and wrote on one occasion that "his taste and erudition are a constant source of amazement."

By 1944, however, Kirstein had joined the Army and left his magazine in the hands of Donald Windham, a soft-spoken playwright and novelist from Atlanta. Windham, fifteen years younger than Cornell, soon became one of his most devoted friends. *Dance Index* was located in a shoddy office building at 637 Madison Avenue, at Fifty-eighth Street, and on the days when Cornell rode the creaky elevator to the fourth floor to deliver a new collage, Windham would invite him to lunch at the Hampton Cafeteria, across the street from the office. In Windham's novel *Tanaquil* (1972), Cornell appears as a memorable character named Dickinson (after the poet?), a tall man with "a gaunt face and bright, birdlike eyes." One scene is set in a Madison Avenue cafeteria: "Dickinson was eating, a bowl of cabinet pudding and a slice of chocolate cake, alternating a bite of one with a bite of the other."

Windham was a close friend of Tennessee Williams, of whom he would later write a memoir but who at the time was just a budding playwright. In 1944, the two were collaborating on the script of *You Touched Me!*, a romantic comedy that opened on Broadway the following year. Sometimes Williams would do his writing on the typewriter in the office of *Dance Index*. Cornell always enjoyed seeing him, particularly after he learned of

the similarities in their family situations. Williams had a mentally troubled sister who served as the model for Laura, the helpless woman inhabiting a world of dreams in *The Glass Menagerie*. Cornell was fascinated by the playwright's extensive knowledge of birds, noting his "predilection for exotic birds" and happily joining him in detailed discussions on ornithology.

Some of Cornell's sojourns to *Dance Index* were not quite so social. He often slipped across the hall from the offices of the magazine into the rehearsal studios of the School of American Ballet, where he could watch young ballerinas practicing their pliés and pirouettes. There was a bench in front of the mirrored wall where a visitor could quietly observe the dancers. While Cornell might feel "stimulated by a class in rehearsal," as he noted one day in a letter, his spirits were not always so easily lifted. Windham recalls glancing into the rehearsal studio and seeing the disturbing sight of Cornell "sitting in the corner, with his hands over his face." This was a frequent pose of his, adopted to ward off his recurring migraine headaches and shield his eyes from the sharp light of day.

The covers Cornell designed for *Dance Index* more than hinted at his intensity. Who else had such an extensive archive of dance ephemera? He did a cover on Loie Fuller, a cover on Ruth St. Denis, a cover on Allen Dodworth, a largely forgotten mustachioed gentleman who achieved fame in nineteenth-century America for his classes on "social dancing." While Cornell's "montage covers," as he called them (the word "montage" comes from the French *monter*, to assemble), lent the magazine true artistic distinction, he dismissed his efforts as mere commercial work. He was paid about twenty dollars per cover, which he claimed was the only reason he bothered with them at all.

His main interest at this time was not in designing an occasional collage-cover but rather in publishing his "albums" or portfolios in their entirety. He mentioned to Donald Windham that he hoped to publish his albums in large, cheap editions and wondered whether they could be sold in dime-stores. "He thought this was a practical idea, and a potentially profitable one, too," Windham later recalled with amusement, adding that it seemed not to have occurred to Cornell that the people who frequented five-and-dimes to purchase nail polish and mixed nuts might not be as interested as he was in collecting pictures of Fanny Cerrito.

As impractical as his album plan may sound, Cornell was hardly the first modern artist to try to publish his work. His compendiums of illustrations, although unbound, deserve to be understood in the context of the illustrated

book, an important modern tradition. Cornell's albums are reminiscent of the productions of the Russian avant-garde, which were similarly designed to take advantage of inexpensive printing techniques and to reach a wide readership. Yet while the publishing arm of the Russian avant-garde was motivated by political ends, Cornell's albums were apolitical and other-worldly—not a poster raised in a debate but a tumble down into inwardness.

Cornell's most ambitious publishing project was done in the pages of *Dance Index*, after Donald Windham agreed to turn over an entire issue to him. Readers of the summer 1944 issue—price, fifty cents—were treated to a 22-page album conceived in tribute to Fanny Cerrito and her brilliant peers in the days of Romantic ballet. Cornell's album was first of all a collage of photographs, engravings, and text, with extensive quotations in tiny, hard-to-read print from a mixed group of ballet appreciators, including Théophile Gautier, Sir Francis C. Burnand, Paul de Musset, Isak Dinesen, and Emily Dickinson ("I cannot dance upon my toes . . ."). This jumble of material told very little of the techniques of ballet, yet by selecting a paragraph here and a page there and assembling them with a keen sense of style, Cornell vividly evoked ballet's glory days. Only Cornell could have put together a whole magazine in which there were no original articles but rather "ready-made" stories and pictures—a book compiled from other people's books.

As much as Cornell valued his work for *Dance Index*, one suspects he would have preferred to spend his time cultivating something more satisfying than fantasies of intimacies with long-gone ballerinas. But he somehow felt that actual relationships were beyond his capabilities. One day he was reading about Rainer Maria Rilke when he came across a comment that he felt applied to himself and typed it up: "In the letters written between 1910 and 1914, we find Rilke (continually) expressing a longing for human companionship and affection, and then, often immediately afterwards, asking whether he could really respond to such companionship if it were offered to him, and wondering whether, after all, his real task may not lie elsewhere."

Despite his acknowledged lack of social skills, Cornell made at least one new friend—one new living friend, that is—in 1943. She was Marianne Moore, the poet. A generation older than Cornell, she lived in a frame house

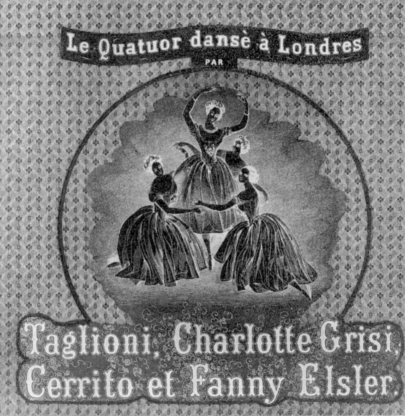

Cornell's cover for *Dance Index*, July/August 1944 (Collection the Joseph Cornell Study Center, National Museum of American Art, Smithsonian Institution. Gift of Mr. and Mrs. John A. Benton)

in Brooklyn, a sixtyish spinster in a black cloak and tricorn hat. Moore and Cornell had much in common. Both were arch-modernists who lived with their mothers in the outer New York boroughs. Both were legendary prudes. Both were appreciators of the ballet and had contributed to *Dance Index*. Both were drawn to poetic portraits of animals—the pangolin, for instance, in Moore's case; the bird, in Cornell's—as a form of self-portrait. And more generally, both sublimated sensuality into dispassionate, nearly taxonomic precision in their work, and over time would come to stand for the artistic power of reticence.

Cornell became acquainted with the poet's work through Charles Henri Ford and Parker Tyler, who assiduously courted her for *View*. Tyler was enamored of Moore's poems and had published an interview with her in one of the first issues of *View*. The interview had been conducted at Grand Central Terminal, and Moore appears in the article as a punctilious old maid, her gaze straying anxiously toward the station's giant clock because "she was to meet her mother at the dentist's."

Moore first became aware of Cornell's work in the pages of *View* and admired him immensely. She mentioned in a letter to Charles Henri Ford that she particularly liked Cornell's *Berenice* collage, and Ford passed along her compliment to Cornell. Touched by her interest, Cornell sent along a gracious typed note. Her comments, he wrote on March 23, 1943, were "the only concrete reaction I've had so far, and they satisfy and affect me profoundly. I had felt that the whole thing was much too subtle and complex to attempt in the comparatively limited space of a magazine, and without your appreciative words, I would continue to think of [the Berenice project] as futile. Will you please accept the heartfelt thanks of both Berenice and myself?"

Cornell soon after invited Moore to Utopia Parkway, where he gave her a tour of his basement workshop and introduced her to his mother, who liked the poet very much and would later send her occasional greetings. In the next few years, Cornell carried on his own affectionate if fitful correspondence with the poet. While both were inordinately formal in their relationships—he addressed her as Miss Moore and she always called him Mr. Cornell—their letters were marked by a spirit of generosity. Cornell sent her obscure books on animals and embellished the margins of his letters to her with cutouts of pangolins, jerboas, and other exotic, wary creatures that so often surfaced in her poetry. She, in turn, sent him rather fussy

analyses of his letter-collages, while entering into his creative universe by referring to Berenice as if she were an actual child.

Moore supported Cornell publicly as well. Early in 1944, *View* was investigated by the U.S. post office after running some reproductions of Picasso nudes that the government considered pornographic. In a letter published in the May issue of *View*, Moore stated her opposition to "any kind of censorship," while adding that she felt "indebted" to the magazine for "making me somewhat closely acquainted with the work of Joseph Cornell." He was the only contributor she mentioned.

Despite Moore's interest in his work, Cornell was not an easy acquaintance. He brought to their relationship the same cautious advances and withdrawals that characterized nearly all his relationships, reluctant to commit himself to the demands of friendship even through the scrim of the page. Though their letters were filled with extravagant praise for each other's work, Cornell could be astonishingly tardy in replying to Moore. In letter writing, as in so much else, he could not bring the slightest task to completion without hesitation. In 1944, when he sent Moore a "Valentine package" (enclosing a rare book with an illustration of a pangolin), it was not February 14 but April 9—and a whole year since her last letter to him. "I have meant to write before," Cornell apologized, "and thank for your letter of a year ago and coming into the gallery in December. And in the meantime I owe you extra thanks for the encouraging things about my work expressed in your recently published letter in *View*."

Moore sent him a copy of her poetry volume *Nevertheless* when it was published in the fall of 1944. Cornell carried the book around in his coat pocket and read it on the subway. In a letter to Moore, he acknowledged her "recent sheaf of poems," which in his appraisal were "exquisitely and rightly proportioned." Cornell particularly liked the poem "Elephants," in which a line about "Houdini's serenity quelling his fears" filled him with the happy memory of seeing the magician perform on the old Hippodrome stage.

Cornell visited Moore several times at 260 Cumberland Street in Brooklyn, lingering over a pot of tea with the poet and her ailing, octogenarian mother. But he and Moore were too reserved to cheer each other in person. They did better in writing, where they felt comfortable expressing, at the very least, their "ever grateful wonder" (her phrase) at each other's work.

10

The Hugo Gallery

1945-49

In the thirteen years that had passed since Cornell made his artistic debut, his prospects of living from the sale of his work had improved hardly at all. Through the 1940s, he supported himself mainly with commercial art work. Following the example of Pavel Tchelitchew, a regular contributor to *Vogue* and *Harper's Bazaar*, Cornell became interested in magazine illustration. This might sound peculiar, since Cornell could not draw, and, unlike Tchelitchew or his Neo-Romantic colleague Bébé Berard, a leading fashion illustrator of the forties, he certainly could not furnish a magazine with illustrations of slender models in the latest Dior dresses. But Cornell had something his colleagues did not: an amazing archive of pictures, enabling him to supply magazines with antique illustrations or with collages done on commission.

One useful contact for Cornell was Alexander Liberman, at that time the art director of *Vogue*. An artist himself, who had been raised in Paris, Liberman prided himself on his art-world connections and was interested in bringing leading talents to *Vogue*, Cornell among them. Every so often, Cornell would gather up some photostats, place them in a manila folder, and head over to Liberman's office, which was located over Grand Central Terminal in the Graybar Building, at the time the largest office building in the world. He would leave his package on Liberman's desk and quietly exit the building. The art director would leaf through the material at his leisure: charming engravings of European palaces and leaping ballerinas and gentlemen in top hats riding in horse-drawn carriages. The magazine had always made a practice of inserting Victorian linecuts into its pages, and Cornell's little pictures similarly lent an aura of the past to the fleeting here-and-now concerns of fashion publishing.

The Graybar Building became one of Cornell's regular stops on his trips to Manhattan. He would call before he paid a visit, but said little once he arrived, a reticent interloper who felt awed by the willowy models and stylish editors strutting the halls of the magazine. "There was something very severe about him," Liberman later said. "He seldom looked you in the eye. The eyes were gray and clouded and not very open, with heavy eyelids. Hooded eyes. It was a face out of the Middle Ages. He looked like Joan of Arc's inquisitor."

Cornell was appreciative of Liberman's patronage. On February 20, 1945, after receiving a check for $425 from the magazine, Cornell noted in his diary that it represented "the largest amount I've received at one time since leaving William Whitman in 1931." A week later, he visited *Vogue* to present Liberman with a token of his gratitude: *Mémoires de Madame la Marquise de Rochejacquelein*, a miniature box containing blue sand, cut-up sentences, and snips of clothing, and conceived in memory of a French aristocrat who's so obscure that no one including the box's current owner (Francine du Plessix Gray, the writer and Liberman's stepdaughter) seems able to unravel the mystery of her identity.

Cornell's forays to *Vogue* often ended at Grand Central Terminal, which was connected to the Graybar Building by a ground-floor concourse. The train station ranked as one of Cornell's favorite landmarks. He loved to sit in its vast waiting room, and often felt inexplicably calmed by the sight of commuters streaming by. And of course he enjoyed gazing up at the elaborate ceiling, with its "celestial blue heavens and golden constellations," as he noted in his journals. Grand Central Terminal, more than any other place in New York City, stood for the adventure of travel (even if most of the trains were no more exotic than the 5:10 to Scarsdale). Certainly its symbolism was not lost on Cornell, an anchorite who was the quintessential vicarious traveler, voyaging inward into his own heart and imagination. Sitting by himself in the waiting room, an anonymous man in an overcoat, he felt the full romance of this Beaux Arts crossroads where thousands of lives intersected daily as people descended on Manhattan or rushed to catch the next train out.

Besides doing commercial work for *Vogue*, Cornell soon became involved with other fashion magazines and also picked up some extra money in advertising. Layouts and collages done for *Harper's Bazaar*, *Town & Country*, and *Mademoiselle* all helped pay the bills. He did at least one project for the advertising agency N. W. Ayer & Son, which had begun to use artwork to

enhance the image of corporations. One of Ayer's clients was De Beers Consolidated Mines, the importer of diamonds, and Cornell was commissioned to design a series of shadow boxes that traced the origin of bridal customs. While the works have since been lost, one suspects that Cornell, with his yearning for youthful female beauty, did a really winning job on the series of constructions listed in Ayer's records as *The Betrothal Ring, The Wedding Cake*, and *Bridesmaids Dressed Alike*.

Cornell's commercial work was done at the time when fashion magazines were at their creative height. Liberman of *Vogue* and Alexey Brodovitch, his counterpart at *Harper's Bazaar*, gave the role of art director at a popular magazine a new prestige. It makes sense that Cornell felt comfortable in this world, whose obsession with ever-changing styles dovetailed with his own feeling for pop culture. But where fashion follows the new, Cornell sought the antique: he relished the baubles of popular culture only after they ceased to be popular. Ultimately, his interests were too obscure to bring him any real success at the Condé Nast empire. "Upon awakening worked in cellar on white da Vinci Beauty Cover (never used) for VOGUE," he noted in February 1945, a reminder of the countless projects of his that never quite panned out.

To supplement his income, Cornell applied for a grant from the John Simon Guggenheim Memorial Foundation in the fall of 1945. It was the first time he had ever applied for a grant, though the project he proposed was so bizarre one wonders if anyone could have understood what he meant. His plan, he wrote on the application, was to complete some new boxes, as well as "a series of monographs presenting documents and notes on several subjects . . . This material would be presented in individual boxed albums, or portfolios, designed to become units for exhibitions, both local and traveling . . . There are also probabilities of publication."

What did the committee make of his proposal? Nothing Cornell wrote indicated that his so-called monographs were not just dusty stacks of documents but a new and lyrical form of art. Cornell asked three prominent friends to write recommendations on his behalf, and even they were a bit mystified by his proposal. Lincoln Kirstein, in a short but persuasive statement, remarked that Cornell "has a very eccentric and genuinely American talent for creating objects out of significant fragments . . . He is entirely sincere in his creative aims, although they might seem peculiar to some people."

Marianne Moore was her usual studious, fussy self, hailing Cornell as a

"virtuoso" while faulting him for his poorly written proposal. "I note the lack of finish in the exposition of plans for work," she commented, "and it is to be regretted, but the offerings are all finish." She added facetiously, "I think the lack of Harvard or Oxford could be pardoned."

A more sympathetic letter came from Monroe Wheeler of the Museum of Modern Art. He, too, was skeptical about the project Cornell had proposed, noting that it might seem "nonsensical," but argued that Cornell needed the grant precisely because he was so inept at worldly matters: "He lacks the prosaic sense of reality which enables unimaginative pictorial craftsmen to get along." Much to his disappointment, Cornell was not awarded the grant.

By now Cornell was giving serious thought to leaving the Julien Levy Gallery. Ever since 1943, when Levy returned from the Army and reopened his gallery in a smaller space, the place had seemed diminished in more than just size. It could no longer compete for excitement with the days a decade earlier when Levy introduced the Surrealists to New York, partly because many of his regular artists had left for more fashionable galleries. The Surrealists could be found at Peggy Guggenheim's Art of This Century, while Tchelitchew and the Neo-Romantics were showing with Kirk Askew of Durlacher Brothers, as well as with Alexander Iolas, a onetime ballet dancer who had just opened the Hugo Gallery amid a flurry of publicity.

Levy still had a few notable artists, including Max Ernst, who after his divorce from Peggy Guggenheim found himself inconveniently obligated to sever his relations with her gallery as well. He ended up showing one block to the east, at Julien Levy's, as did his new wife, Dorothea Tanning, an Illinois-born Surrealist with whom Cornell became quite friendly and whose company he far preferred to that of the sardonic Ernst. Once, the artist Jeanne Reynal later recalled with amusement, she and her husband visited Cornell along with Ernst, Tanning, and another couple. When the time came to share his work with his visitors, Cornell would permit only the women to enter the garage where his boxes were stored, handing Ernst and the other husbands copies of Gérard de Nerval's books to keep them occupied in the meantime.

In the course of his thirteen years at the Levy Gallery, Cornell had sold very little work, and he wondered whether he could do better financially with another art dealer. What's surprising, perhaps, is not that he wanted

to leave the Levy Gallery but that he stayed for as long as he did; his relationship with Levy was by far the most enduring professional relationship of his life. Cornell's feelings toward art dealers were most contradictory: he resented it when they couldn't sell his work, and resented it even more when they could. The key to his longevity at the Levy Gallery perhaps lies in his very lack of sales. In 1956, the art dealer commented in a letter that he could not locate the sales book for his Cornell exhibitions but had "a feeling that I sold nothing except to myself." Several pieces had also been purchased by James Thrall Soby during the brief period when he was a partner in the gallery.

In the fall of 1946, Cornell followed Pavel Tchelitchew and others of the Neo-Romantics to a tony new showplace. The Hugo Gallery was located at 26 East Fifty-fifth Street, on the second floor of a quaint brownstone. Alexander Iolas (pronounced "Yo-las"), who was Greek, plump, and greatly elegant, gold rings on every finger, had begun his career as a ballet dancer in Paris but, after a ruinous episode as the director of the de Cuevas ballet, had retired from dancing and moved to New York to open his gallery. The place was named for his financial backer, the Parisian socialite Valentine Hugo, whom he preferred to introduce as the Duchesse de Gramont.

Today, the Hugo Gallery is only a footnote to the 1940s art scene, remembered, if at all, as a belated promoter of Surrealism and the less engaging art of the Neo-Romantics. And the name of Alexander Iolas, unlike that of Peggy Guggenheim and Julien Levy, remains unburnished by legend. Yet the gallery was once as fashionable as the European artists it promoted. When it first opened—on Thursday, November 15, 1945— an extravagant party was held on the premises; an article by Edward Alden Jewell in the next morning's *Times* reported on everything from the "first-rate" paintings to the sumptuous decorations, the work, he surmised, of "most of the florists in town." The entire dance world, or so it seemed, turned out for the reception, surely less for the chance to contemplate paintings by Chagall and de Chirico than for an up-close view of Pavel Tchelitchew and Tamara Toumanova.

The gallery's inaugural exhibition, entitled "Fantasy," was organized by Cornell's devoted friends from *View*, Charles Henri Ford and Parker Tyler (the latter was cutely quoted in the *Times* story lauding fantasists everywhere, "from the humblest worker to the most eccentric genius"). It was a natural fit for Cornell, who enjoyed the scene that revolved around the gallery.

Stopping in from time to time, he never knew whom he would see. Two weeks after the gallery opened, Cornell reported in his diary with his customary attentiveness to haberdashery: "Met Dali 1st time in years—blue dress top coat, black suede shoes . . . talked for about half hour. He is going to make a film for Disney." (Fortunately for art lovers, he never did.)

Iolas wasted no time in tapping Cornell for his gallery. Only one month after the place opened, Cornell was included in a Christmastime show, "The Poetic Theatre," along with Dali, Tchelitchew, and the rest of the gallery's European regulars. As the only American to exhibit at the Hugo, Cornell once again found himself among a group of artists to which he could never fully belong. But Iolas was supportive of his work and convinced him to stay on at the gallery for the next four years. "Cornell was such a genuinely poetic person, almost to the extent that he was on the very brink of the ridiculous," Iolas later said. "But he was certainly by no means mad. I liked his work because it was a plunge into the past, totally unique. He was in that sense a necrophiliac, pulling you with him back into that past where he found beautiful visions."

In December 1946, about a year after he joined the gallery, Cornell had one of the most intriguing exhibitions of his career. It was called "Romantic Museum at the Hugo Gallery: Portraits of Women by Joseph Cornell," and the title alone says much about Cornell's unique sensibility. The phrase "romantic museum" might appear to be an oxymoron, since the cataloging, taxonomic approach of museums seems to go against the notion of romance. Yet Cornell was an artist who was always cataloging amorous images inside his museum of the mind. He spent all year preparing for the show, which celebrated his favorite movie stars, divas, and ballerinas. While women had often surfaced in his work, Cornell had never before devoted an entire show to them, and his "Romantic Museum" would take his adulation of female performers to new heights.

For this exhibition Cornell conceived one of his most ambitious works. The untitled piece, known as *Penny Arcade Portrait of Lauren Bacall*, is a small, striking, blue-tinted box that occupies a place of pride in Cornell's oeuvre as his one major homage to an actress. He had tried making film-related pieces before (a collage for Hedy Lamarr, boxes for Greta Garbo), but his Bacall tribute stands apart as a powerful evocation not only of one man's lonely fandom but of an entire movie-adoring age in America. It captures a time when the Hollywood studios were at their zenith, fan magazines were perfecting the genre of the gushy puff piece, and the Amer-

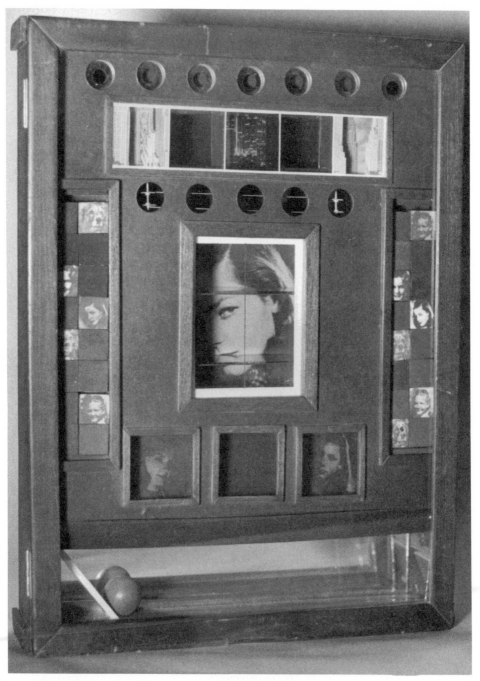

Untitled (Penny Arcade Portrait of Lauren Bacall), 1946; construction, 20½ × 16 × 3½ in. (Collection Lindy Bergman, Chicago)

ican public was discovering the pleasure that comes from basking in the aura of manufactured stars.

Cornell first became fixed on Bacall one rainy Monday afternoon after stumbling alone into a movie theater in Flushing. Bacall was making her film debut in *To Have and Have Not*, in which she plays a woman named Marie Browning trying to get off the island of Martinique during World War II. Abetted by a vast Warner Brothers publicity campaign, the twenty-year-old actress was touted as "the look" and became an overnight sensation. Cornell initially felt that the movie, co-starring Humphrey Bogart, was little more than "pure Hollywood hokum," as he jotted in his diary on February 26, 1945. But that did not diminish his feelings for its superbly photogenic female lead. He found himself haunted by close-ups of Bacall's large, handsome face, and noted its "interesting Javanese modeling"—as if it were a wooden mask.

Cornell was nothing if not a loyal fan. In coming months, he saw *To Have and Have Not* five more times, closely followed gossip about Bacall in newspapers and magazines, and compiled a bulging dossier relating to her career. Stored in a blue cardboard portfolio, the dossier came to include personal notes, publicity photos of Bacall in a checkered blazer, clippings from the *World-Telegram* on her marriage to Bogart ("Bogey, a Bit Nervous, Sips Martini, Then Leads Lauren Bacall to Altar"), multiple copies of *Screenland* and *Silver Screen* magazines (15 cents each) with cover stories about Bacall, and pages torn from *Mademoiselle* that include snapshot photos of Bacall as a little blond-haired girl, smiling sweetly for the camera beside her pet cocker spaniel, Droopy.

It pleased Cornell to think of Bacall in girlish terms. As he studied his photos of her, he believed he saw things that no one else could see. Underneath her veil of sophistication, "underneath all this cheesecake," lingered the creature that no one really knew, "a girl of Botticellian slenderness with a jeune fille awkwardness." In his boxed portrait of her, Cornell hoped to cut through the "usual cheap Hollywood publicity" and capture Bacall as the virtuous heroine he believed her to be, willing her into the fantasy of chastity that had always seduced his imagination.

The masterpiece Cornell made in her honor—*Penny Arcade Portrait of Lauren Bacall*—is modeled on the penny-operated game machines Cornell recalled fondly from the amusement parks of his youth. He had already explored this concept in his *Medici Slot Machine* of 1942, yet the Bacall box takes it one step further: the box has moving parts and is meant to be

"played." The viewer operates it by dropping a wooden ball into a trapdoor at the top of the box, right side, then watches the ball flash in and out of view as it descends in a zigzag past images of the Manhattan skyline, the young Bacall and her cocker spaniel, and Bacall the actress as captured in a looming close-up of her face. The ball makes a *plink plink plink* sound as it drops onto glass runways, before finally landing in a mirror-lined compartment at the bottom of the box. All in all, the box is ingeniously playful. Its wandering ball suggests a man who is in and out of Bacall's life and has a special familiarity with the details surrounding her.

In spite of his intense feelings for Bacall, Cornell apparently made no effort to communicate with her. One suspects he would have been elated to hear Bacall exclaim of his box years later, "I love it and wish I had it!"

Unfortunately, there are no installation shots of Cornell's "Romantic Museum" show, which gathered a dozen of the artist's heroines into an unforgettable pantheon. Madame de la Pasta and Maria Malibran, two of the great divas of the nineteenth century, surfaced in "found" lithographic portraits. Their dancing contemporary Fanny Ceritto was represented by *Portrait of Ondine*, the album of mementos that Cornell had assembled over the past decade. Did the danseuses and divas of the nineteenth century have any peers in the twentieth century? Movie stars, perhaps. His "Romantic Museum" glanced wistfully toward Hollywood in three works, *Legendary Portrait of Greta Garbo*, *Penny Arcade Portrait of Lauren Bacall*, and *Souvenir for Singleton*, a box named for the character played by Jennifer Jones in the movie *Love Letters*.

As was often the case with his exhibitions, Cornell was given a small back room of his own. There he displayed his boxes in a theatrical environment of blue velvet, hairpins, and coins. Somehow it all looked as meticulous as the "set-ups for a still life by Pierre Roy," as Henry McBride noted in *The Sun* (referring to the French Surrealist painter of hallucinogenic still lifes). Cornell also designed a clever exhibition announcement. It reads like an erudite version of *Screenland* magazine, with four pages of photos, notes, and literary quotations lovingly assembled into a tribute to the stars of the "Romantic Museum." Only Cornell could have found imaginative links between dead divas, living film sirens, and his antique toy doll Bébé Marie, each striving toward "an abstract ideal of feminine beauty," to borrow a line from Isak Dinesen that Cornell quoted in his announcement.

For all the effort and ingenuity Cornell brought to his "Romantic Museum," the critics were unmoved. They tended to overlook Cornell in favor of his glamorous co-exhibitor, Bébé Berard—handsome, French, and now forgotten—whose show of paintings and designs for the ballet occupied the gallery's large front room. In an article that surveyed the variety of shows on view during the Christmas rush, Howard Devree, writing in *The New York Times* on December 15, 1946, devoted a respectful paragraph to Berard before concluding with crushing dismissiveness: "Elsewhere in the gallery are various doodads in dada by Joseph Cornell."

When his show at the Hugo Gallery came down, Cornell had just turned forty-three. For his birthday, his mother baked a cake and gave him a two-dollar gift membership to, of all things, the Flushing Historical Society— as if eager to have him further immerse himself in the past (and in Flushing). Christmas, one day later, was equally uneventful, not that he hadn't tried to gather a few friends for the occasion. "The invitation still holds to visit us," Cornell had proposed hopefully to Donald Windham on December 11, "and why not with possibly some danseuse to whom the nostalgic quality of my work might appeal?"

In spite of all the time Cornell spent pining for the company of beautiful women, he remained tense in the presence of the few he met. Ernst Beadle, a photographer for *Harper's Bazaar* who befriended Cornell through the magazine, relates a telling anecdote. One afternoon Cornell stopped by Beadle's midtown studio during a shoot. A model was posing for a fashion spread with her dress dropped off her shoulder to expose a tantalizing bit of bare flesh. As Beadle snapped pictures, Cornell lurked silently in the background. But suddenly Beadle heard loud breathing, a steady, raspy sound coming from the back of the room. He thought to himself, I didn't know Cornell had asthma, before realizing that the artist was panting with sexual excitement.

One imagines that Cornell was panting with anxiety as well. He probably had never seen a naked woman; and in spite of his great sexual curiosity, he continued to harbor an inordinate fear of the adult female body. It was enough to simply gaze at clothed women and girls on the street, an activity he occasionally mentioned in his diary. Sitting in a diner, for instance, he once noticed "a young slight blonde Scandinavian girl burgundy coat neatly dressed." Grocery shopping in Bohack's one summer day, he espied a "girl

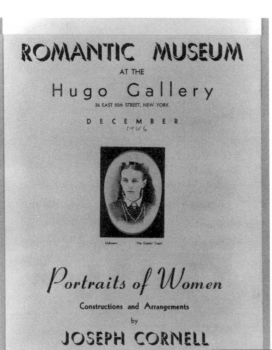

The announcement for Cornell's exhibition "Romantic Museum at the Hugo Gallery," 1946 (Collection of the Joseph Cornell Study Center, National Museum of American Art, Smithsonian Institution. Gift of Mr. and Mrs. John A. Benton)

in pink dress." During a visit to relatives in Nyack, he went to a bakery and, while waiting in line to pay, kept "watching the activities of girls behind counter." That same autumn day, after wandering "unexpectedly" into a neighborhood baseball game, he reported not on the teams or the score but on an " 'Indian' drum majorette leader with feathered head-dress" plus "five sweater girl cheerleaders"—no wonder, as he noted, he "stayed for the game"! Like a rapt birdwatcher, Cornell derived great pleasure from his "sightings," staring at cheerleaders and and shop girls as if they were exotic species and their clothing beautiful plumage.

At times it seemed that the only other sensual pleasures Cornell could guiltlessly allow himself were pastries and sweets. In the diary for 1947 he made note of many cherished snacks. On February 6, on his way home from Penn Station, he enjoyed a cherry Danish. On March 1, lunching in a diner, he treated himself to "banana cream pie, doughnut and drink." On June 3, he savored two chocolate drinks and a slice of layer cake at a midtown Automat. On July 8, at two in the morning, he baked himself "a cream-filled lemon cake." On August 18, he indulged in a cherry Danish "with butter." On November 21, he scarfed down a lemon Danish plus a doughnut at a Bickford's in Queens and was overcome with a sense of the "leisurely enjoyment" he often felt in city restaurants while eating and gazing out a window. What is perhaps even more startling than Cornell's obsessive consumption of sweets was his penchant for recording what he ate in his diary and finding pleasure in the recollection of Automat pies, train-station Danish, and food for lonely cosmopolitans.

Cornell's most gratifying relationships during this period were probably those he conducted by mail. He had a wide circle of epistolary friends, excelling at relationships in which there was no possibility of physical contact. (Cornell would have thrived on the Internet.) His correspondents were both eminent and obscure, ranging at this point from Albert Béguin, Nerval's biographer, to less distinguished Europeans. During the war years, when food was scarce, he had started sending care packages abroad to people whose names he had acquired from listings in *The Christian Science Monitor*. He responded to their predicaments with a disarmingly selfless empathy. Cornell's capacity for giving was a contradictory aspect of his nature. Though generally stingy, he could be extravagant with those he cared for, especially if they happened to be in straitened circumstances.

Of all his correspondents, Cornell was surely most fond of Sonja Sheremietjew, a Polish teenager living as a refugee in a German camp. She wrote

him dozens of letters, her tiny script squeezed from edge to edge of tissue-thin aerograms. Sonja dreamed of moving to New York to open a flower shop, and Cornell assured her he would make every effort to bring her to the States. The care packages he sent her were singularly imaginative parcels. In addition to such staples as powdered milk and crackers, he enclosed objects meant to amuse, noting, for instance, on July 10, 1947, that he had purchased for Sonja "a Shirley Temple movie mag."

As Cornell sat home on Utopia Parkway, his work traveled across the country. In September 1948, he made his West Coast debut when "Objects by Joseph Cornell" opened at the Copley Gallery, a bungalow in the heart of Beverly Hills. The place was run by William N. Copley, whose charmed life sounded almost like a Surrealist invention. Born in New York in 1919, orphaned as an infant, he was adopted by Ira C. Copley, a publishing tycoon who owned sixteen newspapers in Chicago and San Diego. After attending Yale and working as a cub reporter for *The San Diego Tribune*, Copley became friendly in the late 1940s with the assorted Surrealists then living in Los Angeles, particularly Man Ray. Copley was twenty-eight years old when he opened his gallery, the only one on the West Coast to specialize in Surrealism; the inaugural show featured Magritte.

Copley met Cornell in 1947, the year he started the gallery. He and his partner, his brother-in-law John Ployardt, were on a buying trip to Manhattan when they stopped at the Hugo Gallery expressly "to pick up more Surrealists." Before they left, as Copley later recalled, "a gaunt, cadaverous, Charles Addams–like character wandered in with a heavy paper shopping bag. He didn't expect to be noticed and we assumed he belonged there. But we were mesmerized when he rather ritually disemboweled his package. One after another, he arrayed a floor full of magical toy-like boxes, each one quite a wonder."

Copley purchased a group of boxes on the spot for less than a hundred dollars apiece and then took Cornell to lunch to discuss the prospect of a show. "He looked hungry," the art dealer recalled, which doesn't mean that Cornell proceeded to order a meal. "He asked if he could have an ice cream soda. He seemed afraid we would say no."

The California show was an unmitigated commercial flop. None of the boxes sold, and after the exhibition came down, Copley gave most of them away to his friends and relatives. His sister-in-law, he recalled, "made lamps

out of hers." Southern California, as it turned out, was not the best place to proselytize for Surrealism; as Man Ray once noted, there was more Surrealism rampant in Hollywood than all the Surrealists could invent in a lifetime. Copley closed his gallery within a year, though his failure as a promoter of Surrealism marked the beginning of his dual careers as a collector and an artist. He eventually became known as a belated Surrealist painter, creating gently humorous dream scenes of nude women and men in proper Edwardian suits. Cornell, in the meantime, couldn't forgive him for the show. "He said we had loused it up by charging too much for his boxes," Copley recalled. "He was sulky with us for a long time."

In 1949 a new ballerina entered Cornell's life. She was Renée "Zizi" Jeanmaire, a twenty-five-year-old Parisian dancer and revue star who visited New York that fall to perform in a new production of *Carmen* at the Winter Garden Theatre. The ballet, based on the Bizet opera, was the work of her future husband, Roland Petit, a rising young star who was already the director of his own dance company, Les Ballets de Paris. Jeanmaire, though not a great ballerina, was certainly a colorful personality. She resembled the young Sarah Bernhardt, and traveled everywhere with her two pet canaries, Johnny and Nana, which were featured onstage in their cage as part of the set of *Carmen*—a detail that would not be lost on the bird-loving Cornell.

Cornell, who knew of the ballerina before she arrived in New York, first met her through Alexander Iolas, who had befriended Jeanmaire during his ballet days in Paris. On October 26, 1949—a Wednesday that would live on fondly in his memory—Cornell stopped at the Hugo Gallery after attending a noonday church service. Iolas greeted him warmly and was as entertaining as always, responding to Cornell's questions about Jeanmaire with a wealth of anecdotes, while impersonating her with her fan in *Carmen*. Then Cornell overheard the ballerina's "light laugh" as Iolas spoke to her by telephone. He arranged for Cornell to attend the ballet that very night and meet Jeanmaire in her dressing room afterward.

It turned out to be an "extraordinary" encounter, as Cornell later noted in his diary. During their brief backstage meeting, he asked Jeanmaire for her autograph, handing her a scrap of paper from his pocket. *"Pour Joseph,"* she wrote, *"avec mon amitié and le plaisir de vous connaître."* Then she signed her name. Cornell also asked her to provide an autograph for his younger brother; she wrote on the same sheet, *"Pour Robert, Un souvenir cordial . . ."*

Cornell kept the two autographs until the end of his life, filing them away in a folder that would thicken over time with Zizi mementos.

On October 31, five days after meeting Jeanmaire, Cornell returned to the Winter Garden Theatre with the hope of seeing her again. But it was not to be. There was no performance that Monday afternoon, nor was there a rehearsal, and the only event he reported in his diary was seeing a carpenter fix the stage floor. Wandering through the empty theater, Cornell was overcome with "a sense of aloneness," as he later noted, the price of an afternoon without art.

As the weeks went by, Cornell had no more success in befriending Zizi Jeanmaire. Unlike Tamara Toumanova and Tilly Losch, the French dancer remained indifferent to his advances. In later years, sadly, she could barely recall ever having met him and was surprised to learn that she had served as an inspiration for his work. Nonetheless, there can be little doubt that Cornell was briefly in love with her in his usual platonic way; the handful of works that he made in her honor attest to an ethereal love, a passion untainted by the confusions implicit in sexual relations. Among his tributes was a striking photo-portrait, *Daguerreotype*, in which the sultry star of *Carmen* becomes the most delicately Victorian of muses, her gaze softly focused on her two caged birds.

That November, while *Carmen* was still playing in New York, Alexander Iolas held a small show at the Hugo Gallery to coincide with it—a display of set designs from Roland Petit's many ballets. During the three weeks the show remained on view, Cornell mounted a personal tribute to Jeanmaire in the small back room of the gallery. "La Lanterne Magique du Ballet Romantique of Joseph Cornell" (November 15–December 5) was every bit as florid as its title. Boxes and collages made just for Jeanmaire were displayed amid decor that included flowers and caged songbirds—real chirping birds—so that the room itself became a ballet box, a walk-in version of Cornell's smaller creations.

Cornell was looking forward to having Jeanmaire see his show. Though they had met only once, during that backstage visit when she gave him her autograph, he believed she would instantly understand his feelings when he unveiled his work for her. Departing from his usual practice, Cornell attended the show's opening reception, which was held on the evening of November 14, a Monday. Eager to watch the actress's face as she gazed at his work for the first time, he excitedly awaited her entrance. It didn't go as planned, however. Jeanmaire and Roland Petit finally sauntered into the

gallery and greeted their guests affectionately in French, but they seemed not to notice Cornell. When she moved toward his display of artwork, he was too nervous to reintroduce himself. He returned home that night racked by disappointment.

Cornell's tribute to Zizi Jeanmaire marked his last show at the Hugo Gallery. And with his departure from the gallery, he also ended his affiliation with the Surrealists and Neo-Romantics with whom he had exhibited for his whole career. When his show came down on December 5, 1949, a decade was drawing to a close, and already the art scene had changed dramatically in the short time since the end of the war. While eras end more neatly for journalists than they do in real life, the era of Surrealism truly did end as if on cue after World War II.

People and places were disappearing overnight. Julien Levy, the first to recognize Cornell's talent and give him a show, had closed his gallery in April 1949, deciding to retire to his Connecticut farmhouse and devote himself to writing. Peggy Guggenheim, too, had closed up shop. Charles Henri Ford's *View* published its final issue in the spring of 1947. Most of the Surrealists had left New York—Max Ernst was in Arizona, Matta was in Italy, and André Breton had sailed back to Paris, an aging, ornery legend whose stern pronouncements attracted few disciples now that Existentialism had replaced Surrealism as the literary fashion *du jour*.

In New York, critics were on the lookout for a new school of artists who could go beyond Cubist painting and whose work could hang on the wall, on equal terms, with that of the modern masters. If there was one artist who represented the new American painting, surely it was Jackson Pollock. At thirty-seven, he had just become a household name, having been pictured in the August 8, 1949, issue of *Life* moodily smoking a cigarette beside his 18-foot-long "drip" painting, *Number 9*. The story's headline asked, most sarcastically, "JACKSON POLLOCK—Is he the greatest living painter in the United States?" Although *Life*'s readers weren't sure whether Pollock's drip paintings were the apex of Western civilization or something that their kids could splash out, Pollock himself looked the part of the great American artist—big, rugged, photogenic.

Everything about this audacious painter seemed to sum up New York at mid-century, a city that no longer looked to Paris with yearning. The action was at home, and Abstract Expressionism would soon become the first American art movement to command the international spotlight. And Joseph Cornell? His funereal presence, love of a fantasy past, and intimately

scaled artwork might seem to make him the polar opposite of an artist such as Pollock. Cornell, of course, is not usually associated with the Abstract Expressionists. Yet as much as he became a Surrealist fellow-traveler in the 1940s, he now became a fellow-traveler of Abstract Expressionism, which provided the social and artistic milieu where he alighted in the coming decade.

I I

The Aviaries

1949

In 1949, Joseph Cornell joined an adventurous new gallery. Run by the penny-pinching bohemian Charles Egan, it occupied a space not much bigger than a closet: a 15-by-15-foot studio apartment on the top floor of a building at 63 East Fifty-seventh Street, on the stretch between Fifth and Park Avenues, where most of the city's galleries were then located. For storage space, Egan used the bathroom. He had opened the gallery in February 1946 with a show of paintings by Otto Botto, a talented but little-known Swiss-born modernist. While he also represented such leading émigrés as Isamu Noguchi and Josef Albers, when we think back to the Egan Gallery today we think "Ab Ex." In the late 1940s, Egan's was one of the three or four galleries in the city where a young American could get a show, guaranteeing it a lasting place in the paint-rags-to-riches saga of Abstract Expressionism.

Egan had the good fortune to open his gallery at a heady moment in American art. From one month to the next, a visitor stopping in could see the latest work of Aaron Siskind, Jack Tworkov, Philip Guston, or Franz Kline. And it was at the Egan Gallery that Willem de Kooning made his famously belated debut. His first one-man show was held in the spring of 1948, when he was forty-four, an age that only enhanced his standing as a world-class painter (and agonizer). The black-and-white paintings in the show brought instant recognition to this artist who supposedly could never finish a picture and who was rumored to have wiped many a masterpiece off the canvas.

When Cornell joined the gallery, Egan was a small, intense, dark-haired man of thirty-eight. Hardly a shrewd entrepreneur, he was too much like his artist friends to have real success selling their work. In the course of his workday, he would often get bored and tell the elevator operator to keep

an eye on the gallery while he went downstairs for a drink or two. Artists, inevitably, knew where to find him: huddled over an Irish whisky at the bar in Schrafft's. But the unenlightened wondered what was going on when they arrived at the gallery and found the front door unlocked, with no one on the premises. It would have been easy to walk off with a painting, though at the time the art seemed hardly worth the trouble.

For all his weaknesses as a businessman, Egan had a talent for friendship, and would turn out to be Cornell's most supportive dealer. Born in Philadelphia in 1911, to working-class Irish parents, he began his career selling paintings at Wanamaker's department store; later he sold modern masters at the J. B. Neumann Gallery. But he preferred the company of artists to collectors and befriended most of the future Abstract Expressionists while hanging out at the Waldorf Cafeteria on Sixth Avenue in Greenwich Village. Cornell first met Egan while making his usual rounds of the Fifty-seventh Street galleries, and they took an instant liking to each other. When Cornell invited him out to Queens, Egan obliged, arriving by subway to tour the artist's habitat. Cornell was then working on a new series of boxes, his extraordinary Aviaries, and wondered whether Egan would be interested in showing them.

Cornell at the Egan Gallery? On the surface it was an odd pairing. Unlike the artist's previous dealers, Egan did not handle Surrealism, Neo-Romanticism, or anything French. Rather, he specialized in abstract painting by American artists. True, Cornell was decidedly American, and a contemporary of the Abstract Expressionists. He was born the same year as Mark Rothko (1903), one year ahead of de Kooning and Clyfford Still, and two years before Barnett Newman. But Cornell's colleagues didn't think of him as belonging to their generation. Everything about this pale, bony man and his antique-looking shadow boxes made him seem like an intruder from another century, if not another world.

Though stuck in the past, Cornell wanted his work to belong to the future. That helps explain his Aviaries, which marked a sharp break from his earlier work, jettisoning the image-heavy style of Surrealism in favor of something astonishingly lean. In the end, Cornell really did belong at Egan—a perfect showplace for an artist who, at forty-five, was finally ready to end his creative servitude to France and make the leap into the American pantheon.

. . .

With his Aviary series, Cornell initiated an altogether new phase in his art. Virtually overnight, he left behind the fairy-tale motifs that had engaged him throughout the 1940s—the child princes and princesses, the glimmering pink palaces, the enchanted forests where prima ballerinas performed pirouettes and alert owls lingered in the soft moonlight. He put all that aside for now. He even stopped using his favorite color, blue—the color of dreams and divine light, of medieval windows and Matisse's *Blue Nude*. Blue is the color of France. While Cornell's early work was done in the shadow of Surrealism, his Aviaries belonged to the era of Abstract Expressionism—with all that that implies about direct gestures and blunt truths.

Cornell's Aviary boxes take their theme from bird houses or cages, and they are easy to recognize. Most of them consist of a prim, white-painted habitat for a paper cockatoo or parrot (the cutouts of birds are mounted on wood). From one box to the next, the birds variously perch amid a stack of drawers, eye themselves in broken bits of mirror, or listen, bemused, to actual musical boxes hidden behind a wallpaper of old travel posters. It makes sense that Cornell made boxes about birds, this strange man who was passionately invested in pigeons and starlings but who fluttered off as if in scared flight from human encounters. By now he had acquired a birdbath for the family's back yard in Flushing. He spent many contented moments observing the birds that settled on it and wrote up their appearances in his journal.

Cornell had made various bird-related boxes before his Aviaries. An inveterate night owl, he had produced a series of Owl boxes in the mid-forties, dreaming his way into moonlit forests. As early as 1939, he had made his *Fortune Telling Parrot*, in which an actual stuffed parrot resides inside a music-playing box. In *Object 1941*, seven parakeets occupy a nest contrived from twigs, tree bark, and snippets of printed paper arranged like a Cubist collage. The glass pane of the box is spattered with rivulets of white pigment—a "drip" painting of sorts done six years before Jackson Pollock began his legendary drip paintings. The box is a fascinating art-historical object, encapsulating all at once the French Cubist past and the more painterly American future. These tendencies would now find their most eloquent expression in Cornell's Aviaries of 1949, in which he stripped away the French trimmings of his previous work in order to create boxes that, by his own admission, he wanted to be "clean and abstract."

What are we to make of the solitary birds perched in the white settings

of Cornell's Aviaries? Are they literal stand-ins for the artist, capturing him amid the quietude of his white-painted kitchen? Cornell, too, was a caged bird, caged by his family and not free to have lovers. Or are the birds not a self-image at all but, rather, objects of desire, symbolic sisters of the ballerinas and divas of Cornell's earlier work? From the evidence of notes he made in his diary, Cornell, at least in certain works, associated birds with female performers. Birds are curvaceous, clad in feathers, and capable of song, qualities which Cornell's Aviaries, with their colorful cutouts and actual music boxes, abundantly suggest.

While Cornell's Aviaries have generally been seen in straightforward terms—i.e., as charming homes for birds—the boxes, in fact, continue Cornell's furtive obsession with female performers. It is the nature of obsessions, of course, to resist the lessons of time and experience. Yet while obsessions do not change, artistic styles do. In his Aviaries, Cornell kept his feelings of longing at their usual intensity while ridding his boxes of some of their arcane detail and visual clutter. Seeking to express himself in more economical terms, he abbreviated form and tried to get by with as little physical substance as possible.

Some of the bird boxes have no birds in them. Boxes such as *Abandoned Cage* and *Abandoned Perch* suggest cages from which the birds have disappeared, leaving only a few feathers scattered on the floor. These boxes are among Cornell's most abstract works. They have a lush blankness and seem ready to vanish. As in an unpopulated plaza by de Chirico, a haunting absence cries out. But who or what, exactly, is gone? Are the departed birds intended as a vehicle of metaphysical speculation, alerting us to a soul set free? The scattered feathers also suggest a performer—a singer, perhaps, who has taken her bow and exited the stage to applause, a few stray feathers from her dress falling behind her. The boxes hint at the impermanence of a star's performance and the persistence of a fan's longing.

"A room," Cornell noted in his diary in 1949, could be "a compensation for the ephemerality of a career." His Aviary boxes are each their own white-walled room, a memorial to ballets and arias that would never be performed again—and a re-creation of the little rooms on Utopia Parkway where, day after day, Cornell sat alone, yearning for the romance of the past.

Cornell's debut show at the Egan Gallery was among his most outstanding. "Aviary by Joseph Cornell" (December 7, 1949–January 7, 1950) brought

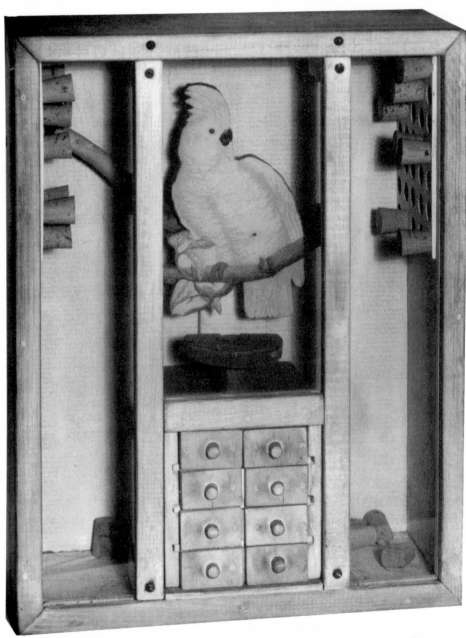

Napoleonic Cockatoo, 1949; construction, 17¼ × 13½ × 5⅝ in. (Collection Jeanne Bultman, New York)

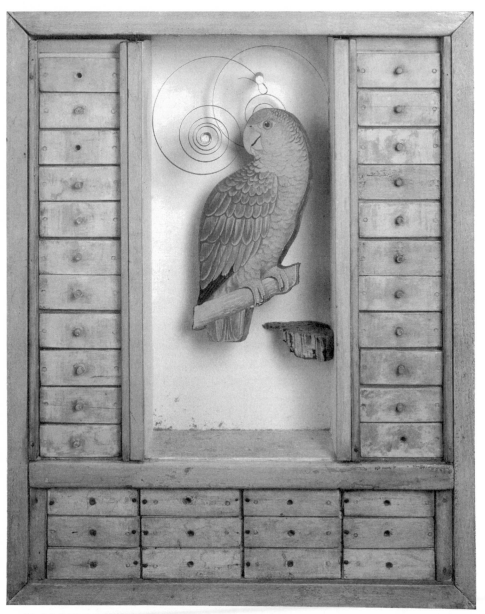

Untitled (Parrot Box with Drawers), 1949; construction (Collection Mr. and Mrs. Robert Lehrman, Washington, D.C.)

Keepsake Parakeet, 1949–53, 20¼ × 12 × 5 in. (Collection Donald Windham)

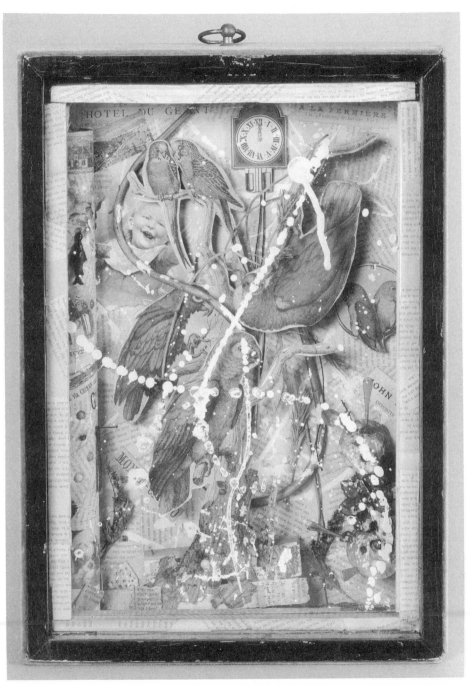

Object 1941, 1941; construction, 14½ × 10½ × 3½ in. (Collection C & M Arts, New York)

together twenty-six bird boxes, nearly all of them made in 1949. In spite of his procrastinating habits, Cornell could work quickly when the occasion demanded it. His "Aviary" show opened just three days after his exhibition at the Hugo Gallery closed; that was the show intended as an homage to the actress Zizi Jeanmaire and that included live canaries chirping in cages. Friends who followed Cornell's career wondered among themselves whether Jeanmaire and her two singing canaries weren't also the inspiration for his new Aviaries. Cornell himself claimed that he had conceived the series while visiting a pet shop in Maspeth, Long Island, and gazing at birds in their cages.

A little brochure accompanied the show, a single folded sheet containing a checklist of the works on view. During the summer, Cornell had considered asking Marianne Moore to write a foreword, knowing of her interest in birds. Unfortunately, however, he could not bring himself to write to her until after the show came down. In a letter to Moore in February 1950, Cornell confided that he had felt quite "awkward" about asking her to write something on his behalf, which would have interfered with her "consecrated" work while requiring a "tedious trip" to Flushing to see his work.

Happily, Cornell did enlist his friend from *Dance Index*, Donald Windham, to write the foreword. Windham began his statement by saying: "Birds are remarkable for the distances they travel, for their faculty . . . of knowing the relations between remote places. The essence of Joseph Cornell's art is this same genius for sensing the connection between seemingly remote ideas." In appreciation of Windham's one-paragraph statement, Cornell gave him one of the most striking boxes in the show, *Keepsake Parakeet*.

As was his customary practice, Cornell created a special setting for the exhibition. But in contrast to his previous shows, where lowered lights and velvet trappings suggested a stage set from the era of the Romantic ballet, the decor for his "Aviary" show was as lean and clean as the boxes themselves. Installation shots taken by the photographer Aaron Siskind show a brightly lit room with boxes perched all around on ledges of various heights. The gallery, that is, was made to resemble a bird shop, and every visitor became a sharp-eyed birdwatcher in the wilderness of modern art.

Most of the reviewers found the show ingenious, relishing its "fun, surprise and beauty," as Stuart Preston noted in *The New York Times* on December 10, 1949. Yet what was surely the most important review was not admiring at all. Thomas B. Hess, the influential editor of *Art News*, had deep reservations about Cornell's latest work—as well as his entire

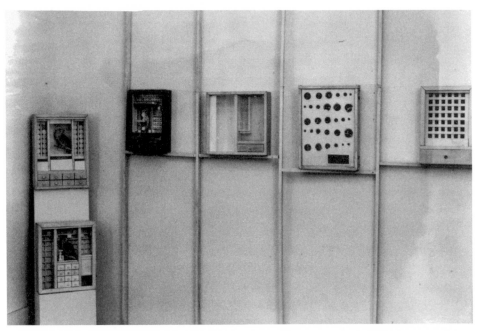

The "Aviary" exhibition at Egan Gallery, New York, 1949 (photograph by Aaron Siskind)

career. "Joseph Cornell has taken the surrealist construction . . . combined it with patient carpentry and after-dinner-conversation wit, and comes up with an art-form which is personal, precious, diverting and almost insignificant," the critic (identified as "T.B.H.") wrote in the January 1950 issue of the magazine. "Cornell's earlier juxtapositions of Mid-Victoriania [*sic*], shells, French newspaper clippings and photographs of quaint beauties were only chic—and that in a rather unfortunate, interior-decorator sort of way." The new bird boxes, he felt, with their slimmed-down modern appearance, were generally superior to "the older, velours-lined jobs. But how far anyone can go in this most limited of fields is problematical."

This dismissive appraisal may seem surprising coming from one of the most insightful critics of his time. Hess, an independently wealthy and urbane Yale graduate, had recently taken over the editorship of *Art News* and was trying to turn the magazine into as prescient a record of contemporary art as *Cahiers d'Art* had been in the Paris of the twenties. In later years, Hess would revise his initial assessment of Cornell and write sympathetically about his work. For now, however, he was committed to Abstract Expressionism in general, and de Kooning in particular. His

enthusiasm for the new American painting left him with little patience for anything that did not conform to that movement's bullying orthodoxies.

In the years since, much has been written about the struggles of the Abstract Expressionists. By now we all know that their shows yielded few sales. We've read a lot about their bohemian way of life, about cold-water flats with a bathtub in the kitchen and no phone. But not enough has been said about what can only be called the Ab Ex mafia and the climate of intolerance within the postwar art world that made it difficult for any artist who was *not* an Abstract Expressionist to thrive. The leading critics of the period—Hess, Harold Rosenberg, and Clement Greenberg—all earned their reputations as champions of Abstract Expressionism, and together their voices formed a chorus of aesthetic tyranny. True, it's not entirely fair to lump them together or pretend that they represented just one kind of art. Rosenberg's writing, which has stood up the least well, was couched in the rhetoric of existentialism; and Greenberg's writing, which has stood up the best, is among the most penetrating commentary of this century. Even so, these very different critics together fostered an atmosphere in which only abstract art could be considered "major."

Cornell's small boxes were obviously far removed from the aesthetic that inspired the paintings of de Kooning and Pollock. It wasn't only that Cornell didn't paint. Everything about Abstract Expressionism, with its gargantuan scale, brash gestures, and all-or-nothing plunge into emotion, was alien to his intimist's way of thinking. Yet what no one yet realized was that, in his own way, Cornell was as radical and as wholly American as any Abstract Expressionist.

This is not an idea that is completely accepted even today. Many critics still view Cornell's work as an appendage to either French Surrealism or the Symbolist movement that preceded it in Paris by half a century. It is understandable that such misconceptions have prevailed. Cornell was always fond of the work of Mallarmé and the other Symbolist poets, and his artistic principles might seem similar to theirs. He was devoted to the fleeting sensations of inner experience. He invoked experience in a subtle way, and prized harmonies and patterns of imagery over explicit messages.

Still, Cornell did not see himself as akin to the nineteenth-century Symbolists, and it is ultimately beside the point to speak of him that way. It was Cornell's accomplishment to take the principles of a group of poets who believed in fleeting visions and to express them with the most prosaic of materials. Cornell mingled French Symbolism with American literalism.

His work relates to the strain of American realism that produced a painter such as John Frederick Peto in the late nineteenth century. Like Peto's *trompe-l'oeil* still lifes, Cornell's boxes are an inventory or audit of humble things that together can hint at life's impermanence. When the critic Sanford Schwartz once wrote of Peto that he "gives his subjects the quality of being substitutes for people or things that are no longer there," he might have been describing Cornell.

If Cornell's work harks back to nineteenth-century American realism, it also looks forward to a movement that within a decade would restore realism to avant-garde art. That movement was Pop art, and as it emerged in the early 1960s, critics including Tom Hess, Harold Rosenberg, and other champions of Abstract Expressionism would begin to realize the truth about Cornell: what once looked like a rehash of French tradition on his part was instead an anticipation of a whole new movement, based in New York, that glamorized the products of consumer culture.

In the meantime, one person who did appreciate Cornell's Aviary boxes was Willem de Kooning, the artist who loomed the largest at the Egan Gallery, if not in all of the New York art world. By now de Kooning was a legendary figure. Born in Rotterdam in 1904, he had come to the United States in his twenties as an engine-room wiper aboard a cargo ship. By the time of his first one-man show at Egan in 1948, he had developed a formidable underground reputation, which was only abetted by his charisma and ready accessibility to other artists. Younger painters eagerly imitated his thrusting, wristy brushwork and even his personal mannerisms. It soon became the vogue on Tenth Street to wear a black seaman's cap like de Kooning and say "Terrific" with a Dutch accent.

De Kooning first stopped into Egan to see the "Aviary" show on a Monday when Cornell happened to be at the gallery. De Kooning liked the exhibition and said so, and his comments meant everything to Cornell, who, on January 3, 1950—four days before the show came down—scribbled a note in pencil on the back of a random gallery announcement. "At evening an unexpected burst of working," he reported, going to record some thoughts about "the bird boxes with their 'architecture' (of which de Kooning had made a point yesterday in the gallery)—a real burst of inspiration."

What, exactly, did de Kooning mean by the "architecture" of the bird boxes? The comment was probably a throwaway, yet Cornell mused upon

it again and again, as if it might hold a secret. As late as 1964, as Cornell noted in his journals, he was still reflecting on "de Kooning's *mot* about my boxes' 'architecture.' " One supposes that de Kooning meant that he admired the rigorous form of the boxes, their pleasingly spare geometry. To be "architectural" was to be modern, to value structure over subject matter or sentiment. De Kooning's own paintings did not lack for so-called architecture: a majestic order underlying the loose daubs of pigment. Or did he intend the comment more literally? Did he mean that Cornell's bird boxes each resembled a room, an actual wooden-walled chamber where poignant little dramas were played out?

It is worth pondering de Kooning's comment only because Cornell did. "Architecture"—the word lingered in his thoughts, an idea, an inspiration, an incantation. With his usual tardiness, he wrote to de Kooning almost two years later: "Dear Willem de Kooning, More than once I have thought back with something more than pleasure to your remarks concerning 'architecture' in my boxes shown at Charles', and I hope that there will be opportunity in the near future to talk again."

It may seem odd to speak of de Kooning as having influenced Cornell. We know that he influenced many others; at a certain time, it was common for young artists to have gone through a "de Kooning phase." But Cornell? De Kooning was just beginning his ferocious "Women" paintings, with their mammoth breasts and bared teeth, a vision so different from the wistful emanations of the mother-bound Cornell as to be almost their opposite. Yet Cornell's associations with other artists had greater bearing on his work than has been acknowledged, and his Aviary boxes—whose paint-rich white walls can be seen as expressive abstract paintings in their own right—might seem to reflect his interest in the pioneering black-and-white paintings with which de Kooning made his debut at the Egan Gallery.

As removed as his work was from the paint-slinging bravado of Abstract Expressionism, Cornell did want to participate in the movement in his own clandestine way. No one really understood this about him. His contemporaries took one look at his shadow boxes and figured they existed outside the mainstream of modern art. Even today, there is a certain tendency to romanticize Cornell as a creative solitary, a man who pursued private dreams from the past while remaining oblivious to the contemporary scene. Yet Cornell, in truth, was singularly receptive to the various avant-garde movements of his time. As much as his work from the 1930s and 1940s represents a cautious dialogue with Surrealism, his work from the 1950s carefully

acknowledges Abstract Expressionism. Cornell's relation to modern art was as conflicted as everything else about him. He was fascinated by avant-garde developments, yet in his own work echoed them in such a hesitant way he all but muffled them. His passion for the current scene, like most of his passions, remained a secret.

Cornell also harbored intense feelings for artists themselves, though he could no more open up completely to artists than he could to artistic styles. Margins were where he felt safe. As he had once lingered on the edges of the dance world, and the fringes of Neo-Romanticism and Surrealism, he now hovered around Abstract Expressionism. Of course his friendships were always unusual by conventional standards—close and distant at the same time. On one hand, the most casual encounter could leave him exhilarated, in part because he was so lonely, but also because he held other artists in such high regard. On the other hand, if Cornell subsisted on mere crumbs of friendship, crumbs were all he could stand. As much as he wanted to be part of the art scene, he felt an even stronger compulsion to draw back, to fly away from the city and take his lone perch on Utopia Parkway.

Most of the artists Cornell met through the Egan Gallery lived and painted in Greenwich Village, whose narrow, twisting streets he knew intimately from his frequent jaunts to the bookstalls along Fourth Avenue. Franz Kline was then living on the top floor of 52 East Ninth Street. De Kooning's studio was just a block away, at 85 Fourth Avenue, a dilapidated loft on the corner of East Tenth Street. Next door was Jack Tworkov, the gifted abstract painter. He, too, showed at Egan, and Cornell became especially friendly with him. Tworkov, a soft-spoken intellectual, had been born in Poland and had studied at Columbia University. He was very much the dependable family man, and proved to be a loyal ally of Cornell, sending him supportive notes ("My wife and children as well as myself are enthusiastic admirers of your work") and taking the whole family on visits to Utopia Parkway.

If Cornell enjoyed meeting the Abstract Expressionists, he was positively delighted to meet their daughters, with whom he seemed to feel a special affinity. He made a real hit with Tworkov's two daughters, Helen and Hermine, who were not yet thirteen and who were flattered by the attention he lavished on them. "I want to thank you for the most interesting time we had at your home today," Hermine once wrote him. "We were all surprised by the little bottle. Helen wants to know how you got the little gale bells in the small neck of the bottle." (How indeed did he?) From time

to time, Cornell sent the Tworkov girls notes and letters, sentimental communiqués that at times consisted of just a collage, a sheet of tissue paper adorned with drawn birds and snippets of sheet music. He signed his notes to them "Love, Joseph."

Another of Abstract Expressionism's artist-fathers was Mark Rothko, who peered at the world through thick glasses and painted myopic rectangles of color. One day Cornell encountered him at the Automat on West Fifty-seventh Street, and they talked briefly. "Won't sell museums," Cornell noted in his diary, presumably referring to Rothko's distrust of the art establishment and his bitter refusal to sell his paintings to the Whitney Museum of American Art, which already was being criticized for following art-world fashion and slighting artists of real merit.

For all their obvious differences, Cornell and Rothko were both spiritually inclined, and their work reverberates with a similar refinement of feeling. Both, on some level, were great religious artists. Rothko, though not observant, said that he wanted his art to recapitulate the sense of awe that had once been associated with the human figure in art. Cornell, too, was after transcendence; for him the metal rings, old photos, and other common discards in his boxes were sacred objects. In their desire to ascend to some purer realm, Rothko emptied his work of worldly references while Cornell *loaded* his work with worldly references. In this sense, Cornell was closer to traditional Christian belief, especially the notion of the sacraments, each an outward sign of an inward grace. So, too, Cornell believed in the afterlife. He lived in the light of eternity and felt that even the most humble objects could make the invisible visible, not only in this world but in the next world as well.

Cornell was interested to learn that Rothko was a great admirer of Fra Angelico, the fifteenth-century artist-monk, and had seen his frescoes at the San Marco monastery in Florence. The news inspired Cornell to send a book on Fra Angelico to Rothko's young daughter. Her mother wrote back: "Kate is very thrilled with her Fra Angelico book and well aware of the compliment implied by its being so grown-up." Rothko, too, was appreciative. "I wish I could approach your genius for expressing to people how you think about them and about what they do," he once wrote to Cornell. "But I do want to tell you that I think of you and the uncanny magic of the things you make."

Cornell was still on friendly terms with Robert Motherwell, whom he had met nearly a decade earlier, when he was part of the circle around Matta

and the other European émigrés. Motherwell had since divorced the Mexican actress with whom Cornell had been so enchanted, and was living near de Kooning at 61 Fourth Avenue. Over the years, he had sent Cornell many supportive if somewhat self-aggrandizing letters, remarking in a typical moment: "I am one of the few (actually you are the only other one I know) American painters to be an intellectual." In December 1949, Cornell presented Motherwell with a special gift, a box, *Untitled (A Suivre)*, whose title refers to an inscription on the back that means "More to follow." As he had done in certain earlier boxes, Cornell splashed and dripped poster paint across the newsprint-lined interior of the box, as if touchingly eager to remind Motherwell of his own interest in spontaneous effects and his ability to drip with the best of the pack.

It wasn't only through his boxes that Cornell was reaching out to his fellow artists. After all these years, he was still collecting old movies, and with the rise of a new American bohemia, he found another audience with which to share his cinematic passions. By now it was well known in the art world that Cornell had an amazing collection of old movies ("including," Motherwell points out, "the only known example of Loie Fuller's famous dance with draperies"). Indeed, Cornell's vast collection contained literally thousands of films from cinema's so-called primitive period. He once calculated that 90 percent of his collection fell between 1900 and 1923. People who collected movies in America—then a tiny coterie—all knew the name Joseph Cornell but didn't necessarily realize that he was an artist. Film buffs wrote to him all the time to try and swap with him or make copies of his movies.

Cornell devoted much time and expense to the maintenance of his collection. For a while he had relied on the help of Francis Le Doublier, a cameraman who had once worked for the Lumière brothers, the pioneering team of French filmmakers who had produced some of the earliest movies. In the 1940s, Le Doublier was living in New York and working at a studio called Major Labs. Cornell had often stopped by with his motion-picture purchases. It is a basic property of film that it curls and shrinks over time, and the footage Cornell acquired at junk markets was often too warped to be run through a projector. Le Doublier was able to assist him by taking the damaged original prints and making usable copies of them.

Cornell enjoyed the elderly man's company, later remarking that "the pleasure of hearing from him first-hand regarding the old days was intense." Yet their relationship had recently soured. To Cornell's great disappoint-

ment, Doublier exploited his trust, copying hundreds of Cornell's rarest movies for his own personal collection. While Cornell obtained just a few Lumière movies from Doublier, the cameraman, Cornell wrote, "appropriated the liveliest part of his cinematic anthology from my own subjects, taking for granted our friendship."

Cornell made this comment in a letter to James Card, a film collector on the staff of the George Eastman House in Rochester, New York, a new museum devoted to photography and film. Card, too, was interested in obtaining copies of Cornell's movies. He first contacted Cornell in 1949 in the hope of acquiring a copy of *Sumurun*, an Ernst Lubitsch classic that was all but impossible to find. Cornell owned one of the few extant copies. At Card's suggestion, he once paid a visit to Rochester and had the pleasure of running off a selection of movies in the attic screening room of Card's house. Card wondered about this "lean-faced fellow with an alarmingly haunted look in his deepset eyes," as he later recalled. Only after Cornell's death did Card learn that he was a respected artist. During Cornell's visit to Rochester, Card gave him a carefully chosen gift, Emile Cohl's *Le Tout Petit Faust*, an animated doll film from turn-of-the-century France. Cornell was delighted, but still refused to hand over the desired Lubitsch film. He did, however, offer something else in its place. Upon his return to Utopia Parkway, he sent a marvelous box to Card's infant daughter, Callista. Her mystified parents assumed it was a toy.

Not until the 1960s were silent movies widely valued as an art form, but Cornell's colleagues in the art world at least knew enough in the meantime to value his obsession with the art. As he had once run off movies for the Surrealists, he now visited the clubrooms of Greenwich Village to host an occasional "film soiree" for a new generation of artists. It was something he had done almost since the beginning of his career, taking his cue from the itinerant projectionists who, at the turn of the century, had traveled with their own equipment from fairgrounds to circus tents to vaudeville theaters to put on short, self-contained acts. In his latest programs, Cornell included the work of many different directors—but made a point of excluding his own homemade movies, never having recovered from Dali's hysterical attack on his collage-film *Rose Hobart* in 1936.

At the invitation of Robert Motherwell, Cornell held two screenings early in 1949 at Subjects of the Artist, which occupied rented upstairs rooms at 35 East Eighth Street. Founded the previous fall by Motherwell, Rothko, David Hare, and William Baziotes, Subjects of the Artist called itself an

art school, though things were pretty casual in its two semesters of existence. On Friday nights, the art world gathered for lectures and concerts that ranged from a de Kooning talk "on a desperate view," as the program was billed, to "bashes" of recorded jazz and live performances of John Cage's percussion music. The two programs Cornell put on, held on January 21 and March 4, 1949, were not quite so swinging. But they were among his most charming productions. As before, his dream was to re-create the vanished world of the nickelodeon, and perhaps only film buffs (or five-year-olds) could have fully appreciated it. Arriving with his own movie projector and phonograph, along with reels of film and scratchy record albums, Cornell showed classics from cinema's earliest days, some just three or four minutes long. There were Méliès trick films, an early Chaplin comedy, snippets of animation. Cornell played mood music to go with the snatches of action on the screen, Offenbach being his composer of choice.

The two screenings were well received, though they were marred for Cornell by something unfortunate Motherwell did to him. At the end of each program, Motherwell had tried to coax Cornell into saying a few words to the audience about his film collection. Cornell, naturally, declined, and later sent Motherwell an accusing letter: "At the soirees on Eighth Street you told large audiences on two occasions that 'the guy won't talk' etc., etc., giving the impression of unresponsiveness and lack of cooperation. The facts are that you asked me to inaugurate the soirees with a program of films & music but I never contracted for any kind of talk."

Cornell's colleagues weren't always supportive of his cinematic projects. He had little success at the Eighth Street Club, the legendary meeting place founded by a group of artists after they wore out their welcome at the Waldorf Cafeteria, whose manager had never seen anyone, bums included, linger so long over nickel cups of coffee. Friday evenings at the Club were relatively highbrow. William Barrett expounded on existentialism, Harold Rosenberg philosophized about painting, and Frederick Kiesler lectured on design. The audience gathered on folding chairs around a big pot of coffee. For liquor, the Cedar Street Tavern, that misnamed hole-in-the-wall nowhere near any Cedar Street, was just around the corner on University Place.

While the Club had an air of intellectualism, Cornell's "film soiree" there was not taken as seriously as he had hoped. He arrived on that Friday night with his own equipment, once again lugging along his own projector, which, as people remarked, looked like it weighed more than he did. The lights dimmed and he reeled off his footage—the black-and-white images of clowns

and magicians and pretty maidens—only to realize that many of his contemporaries found him absurd. "The audience laughed at Cornell," recalled Ileana Sonnabend, later an eminent art dealer. "He was very hurt. He took the projector and left in a huff. This was a macho time in New York City, so people thought he was funny. He was so fragile, and anyone could see that."

In spite of such defeats, Cornell looked back on this period as a relatively happy one. He once told Dore Ashton that "the Egan period was the only time I really belonged," perhaps because he was finally exhibiting among other American artists for the first time. Moreover, no one had ever valued his work more than Charles Egan. The art dealer often rode the subway out to Queens to see how Cornell's work was progressing, and visitors to the Egan Gallery were accustomed to hearing him speak about Cornell with undisguised awe. Among the listeners was the young Robert Rauschenberg, who was soon to have a show of his own at the gallery. "Charlie told marvelous stories about Cornell," Rauschenberg recalled, "which I'm sure were all true. I heard about Cornell's file cabinets, where he would keep something for like twenty years, and then remember it, and go directly to it, and make a work. I listened forever, and thought Cornell was a romantic character. Charlie was a closet poet, and Cornell is a poetic artist. Charlie loved him, and was fascinated by him."

But Egan, of course, was the exception. Outside the tiny quarters of the Egan Gallery, Cornell could not count on much support or loyalty. And he remained something of a stranger on the downtown scene. Not surprisingly, he never set foot inside the Cedar Street Tavern, which, though no Café Deux Magots, did represent the fraternity house of the new bohemia. What was Cornell but a flight-bound visitor, haunting the studios of Greenwich Village before rushing off to the noonday service at the Christian Science Church on Fifth Avenue and disappearing into his constricted life out in Queens? And yet he felt that things had recently brightened. In making friends with at least a handful of the members of the American avant-garde, he felt he had secured something crucial.

12

The Egan Years

1950-53

One of Cornell's favorite haunts was the New York Public Library. He was a frequent visitor to the main branch, on Fifth Avenue at Forty-second Street, a landmark Beaux Arts building rising above a set of grand steps and guarded by two stone lions out front. The main reading room on the third floor remains one of Manhattan's most cherished public spaces, but Cornell usually headed for the basement instead. Room 73 then housed the Picture Collection, an archive of illustrations clipped from books and magazines, with 10,000 subject headings ranging alphabetically from "Abacus" to "Zoological Gardens." Each illustration was neatly mounted on a sheet of cardboard and filed in its proper place, in sharp contrast to the seeming anarchy of Cornell's extensive clipping files at home.

Here, in this unremittingly dreary room, with its gray-painted walls and fluorescent lights, Cornell could often be found rummaging through the rows of wooden bins where the illustrations were kept. Over the years, he located innumerable images for his boxes and collages in Room 73, poring over them at a long wooden table where winos and crazies passed the hours beside him. He couldn't keep the library's pictures, but he was allowed to check them out. His customary practice was to photostat the images at a camera shop and use the photostats in his work. From the beginning, he had favored the use of photostats over originals, which allowed him to keep his clipping archive intact.

Librarians who met Cornell tended to like him, perhaps because he himself was a punctilious amasser of knowledge with a boundless respect for books and other printed matter. And naturally they were impressed by his reputation. The curator of the Picture Collection was a Russian-born spinster named Romana Javitz. In appreciation for her years of help, Cornell once

gave her one of his boxes. By the time she sold it, it was worth enough to help support her in her retirement.

Down the hall was Room 78, the Central Children's Room. Cornell had first made use of its holdings in 1945, while collecting information on Hans Christian Andersen for a special issue of *Dance Index* magazine. Andersen, though best known as the author of "Thumbelina," "The Little Match Girl," and "The Little Mermaid," was also a balletomane. He made ingenious cutouts of ballerinas, several of which Cornell owned. You can see why Cornell found him poignant, this writer who was dismissed during his lifetime as a "children's poet" wasting his time on fairy tales. A lifelong bachelor, Andersen nursed an unrequited passion for the actress Jenny Lind, the so-called Swedish Nightingale. In compiling material for his special issue of *Dance Index*, Cornell had befriended another librarian, Maria Cimino, who kept extensive files on Andersen and felt that Cornell uncannily reminded her of the Danish writer. As she once remarked, "He was long and thin and misunderstood, the way that Andersen was."

In March 1950, Miss Cimino wrote to Cornell praising his recent "Aviary" show and asking whether he could assist with a fairy-tale show she was planning for the Central Children's Room at the library. She hoped he might provide illustrations, and Cornell apparently agreed. In the end, the project fell prey to his habitual procrastination. As the librarian later noted in an annual report: "He offered to turn the room into a fairyland by making us some large designs for the walls. However, when Mr. Cornell came to the children's room one day (very near to the time of opening this show) to tell us that his pictures were not ready and that the thought of meeting the deadline prevented him from actually making them, we made some quick mental calculations." One suspects she had never before heard anyone use the word "deadline" as an explanation for a spell of inactivity.

Cornell ended up lending seven of his most romantically lush boxes to the library—including two castle boxes, a *Swan Lake* box, and another ballet box in which the mermaid Ondine perches gracefully on a seashell. The works were displayed beside cheap posters for "Sleeping Beauty" and other children's tales, and the show was called "The Fairy Tale World" (June 5– November 4, 1950). The atmosphere of the room, with its hubbub of children clambering over miniature furniture, was obviously far removed from the imposing air of the galleries along Fifty-seventh Street. But Cornell was always drawn to the idea of sharing his work with children, and this was the first of three exhibitions he designed for them during his career.

Cornell was gratified when, only a few days after the show opened, Miss Cimino sent him a flattering letter. His boxes, she informed him, had elicited praise from nearly everyone who had seen them at the library, including the poet Muriel Rukeyser and her young son. Cornell wrote back on June 13, 1950, typing his comments on a sheet of blue paper. He had been expecting "a long, drawn-out affair through the desultory summer months so far as any concrete reaction could be expected," he wrote. "Therefore I was greatly surprised and delighted to find your appreciative lines in the mail."

It seems only natural that Cornell would exhibit his boxes for children, with whom he seemed to feel some secret bond. Yet it is wrong to think that he sought an audience composed only of amateurs. He was far more ambitious than that. By 1950, his main goal was to be a somebody at the Egan Gallery, to create a body of work that could take its place at the forefront of the avant-garde.

A year after his first show at Egan, Cornell had another well-received exhibition at the gallery. It was called "Night Songs and Other New Work" (December 1, 1950–January 13, 1951) and was mounted at Egan between exhibitions for Franz Kline and the photographer Aaron Siskind. Cornell's show introduced his new Observatory series—whitewashed boxes that were more stark and spare than his Aviaries of the previous year. The colorful birds were gone now, and in their place were astronomical charts tracing the course of the constellations. An observatory, of course, is a building equipped for astronomical research. There is no reason to suppose that Cornell ever visited one or that his Observatories are based on anything so literal. In his journals, he referred to his kitchen as his "observatory," and it is from this sparsely furnished room that Cornell conducted his research on stars. But the heavens, for him, also had an obvious religious dimension. His Observatories, like so much of his other work, deftly combine the spiritual and the theatrical. They redefine the stargazer as a voyeur who peeps at both Garbo and God.

The critics were lavish in their praise. Stuart Preston, reviewing the show in *The New York Times* on December 17, 1950, could hardly come up with enough positive adjectives, finally giving up and saying of the boxes, "They must be seen to be believed." A more memorable review came from Henry McBride, who had retired from *The Sun* but was now writing a column for

Art News magazine. At eighty-three years old, McBride was surely the oldest critic on the scene, and the only one who had followed Cornell's career since the artist's very first show two decades earlier. His review of Cornell's latest exhibition at the Egan, which appeared in January 1951, was accompanied by a reproduction of *Observatory: Corona Borealis Casement*; the caption beneath it commended the work for its "subtle sense of placement." It was the first photograph of Cornell's work ever to accompany a review; none had appeared in a newspaper so far.

But what was perhaps the most gratifying response came two weeks after the show closed. On January 30, 1951, the Museum of Modern Art purchased a Cornell box—its first—for its permanent collection. Alfred Barr and his associate Dorothy Miller were on friendly terms with Egan and made a point of seeing every show at his gallery. From Cornell's latest exhibition, they selected *Central Park Carousel–1950–in Memoriam*. The title refers to the electrical fire that had destroyed the old carousel in Central Park a year earlier, an event which greatly distressed Cornell and which he cited as the inspiration for the work. The museum paid $300 for the box, a price that sounds ridiculous today but was certainly respectable at the time.

Dorothy Miller expressed further interest in Cornell later that year, selecting him for an upcoming MoMA show called "Fifteen Americans." It was one in a series of exhibitions that would be remembered for introducing the Abstract Expressionists and other (not-so-new) "new talent" to a wider public. But it didn't quite work out for Cornell. One day he came into the museum and sat down in the curator's office. "He said that he would want to make his gallery into a complete environment," Miller explained, "and I willingly agreed that he should design it exactly as he wished. He went home to think about it and called me shortly afterwards to say that he feared there was insufficient time before the opening of the show for him to do as he wished." Sadly, he backed out.

Every once in a while Cornell would slip and allow a box to make its way into a group show. He participated in the now-historic Ninth Street Show (May 21–June 10, 1951), a salon-style exhibition organized by the artists themselves and intended to announce the arrival of a new avant-garde. Most of the work was by the Abstract Expressionists and their followers; the entire downtown community, it seemed, was painting in the "loose-elbow" style of de Kooning. Held in a defunct antique shop, in a building that was about to be torn down, the show consisted of about sixty

works by as many artists. Cornell's entry to the exhibition remains uniden-
tified, though we know from installation photos by Aaron Siskind that one
of his recent all-white boxes was included; it looks a bit overwhelmed
between a huge Jackson Pollock "drip" painting (mistakenly hung on its
side) and a Giorgio Cavallon. While Cornell wasn't listed on the poster for
the show, his name is penciled in on the copy that survives at the Museum
of Modern Art library—another testament to his habitual procrastination.
Presumably he submitted his entry to the show at the last minute.

In spite of his string of recent successes—or because of them—Cornell was
beset by all kinds of suffering. His chronic migraines were now accompanied
by matching neck pain, back pain, and cramps in his legs. In the winter
of 1951, he endured a period of three months when he felt "incapacitated
by varying claims of pressures in spine, right leg, etc." In addition to his
physical aches, his diaries refer repeatedly to "dullness," "stagnation," and
"oppressive sluggishness." On countless days, he felt dead inside, and found
it difficult to muster the energy for work.

Such depression, of course, was only compounded by Cornell's "unresolved
ménage condition"—his discreet French phrase for the accumulating bur-
dens of his domestic situation. As he became better known, he received
more visitors; they were startled to discover the circumstances in which his
art was created. While Cornell would inevitably introduce his brother,
Robert, to his guests, he rarely made an effort to include his mother, with
whom his exchanges remained tense. She apparently thought nothing of
criticizing him in front of company. "It was strange," says Susan Weil, a
young painter who had recently divorced Robert Rauschenberg and who
accompanied Charles Egan to Utopia Parkway on several occasions. "We all
felt Cornell was someone we revered, but his mother treated him like a not-
very-well-behaved young person, nagging him about the Venetian blinds.
None of his works were in the house. They were all in the garage, and she
didn't seem to have any interest in his work at all." But then Mrs. Cornell
was perhaps at her least gracious in the presence of her son's female visitors,
especially the ones who were attractive and unmarried.

While Mrs. Cornell failed to endear herself to most of her son's guests,
Joseph admired her as much as ever. By now she was seventy years old, but
quite vigorous, and kept herself busy with sundry matronly activities: gar-
dening, bridge parties, and luncheons sponsored by the Daughters of the

American Revolution, to which she belonged. She went on occasional trips out of town with her friends, sending home letters that brusquely reported on the fun she was having. ("Went over to Gimbels and got my Burpee seeds," she once wrote from Philadelphia. "Hope you are all right.") While Cornell and his mother never traveled anywhere together, he enjoyed the hours they passed in the yard in warm weather. On countless peaceful afternoons, Joseph and Robert would sit beneath the quince tree watching squirrels scamper around and feeding them peanuts as their mother tended to her hyacinths.

Nonetheless, the bickering continued. One ongoing source of conflict was the question of Robert's care. Joseph often read to his brother from Mary Baker Eddy's writings, and he believed that prayer could help assuage Robert's long suffering. Their mother remained opposed. "I'm sick and tired," Cornell wrote to his sister, "of mother going to the end of her days doing everything in the world but looking into a healing truth." Cornell was well aware that spiritual healing could accomplish only so much, and felt that Robert's troubles would come to an end only when his life did, a prospect he contemplated with equanimity. "Every page of *Science and Health* tells of something better than this 'ghastly farce of material existence,' " he wrote to his sister, quoting Eddy and referring to the afterlife. "Let's be grateful that we have its comforts."

Cornell's jaunts to the city had always allowed him to escape the stifling atmosphere at home. But the city, he felt, was no longer what it had once been. He complained to his friends that the quality of the books in the Fourth Avenue secondhand stalls had declined since the war and there was no longer any point in browsing. Instead, he usually ended up shopping for records, lingering in Record Haven and other stores along Sixth Avenue in midtown. And he often ducked into the Forty-second Street Library on Wednesdays at noon to hear a free "Concert of Recorded Music." Cornell's latest fascination was with Franz Schubert, one of many composers who glowed with a special incandescence in his imagination. Reading a recent biography by R. H. Schauffler, Cornell was moved by the story of Schubert's life. It was disheartening to realize that this composer whose songs had few equals in melody and charm had gone largely unrecognized during his lifetime. He was forced to spend his time teaching, and died at the age of thirty-one after years of disappointment. After finishing the biography, Cornell reported a "newly awakened feeling for music" based as much on Schubert's compositions as on a series of buying sprees on Sixth Avenue,

where any given day he might come away with what he described as a "windfall."

Cornell's records meant so much to him that sometimes he couldn't even bring himself to open them. After acquiring a set of recordings of Schubert's "Trio in E Flat," Cornell noted in his diary: "I await the proper moment to unfold its loveliness and enjoy it in the proper spirit of reverence and appreciation it deserves." But how long would it be before that moment arrived? Cornell's friends report that he rarely played the records he owned; his phonograph was in his basement workshop, and he claimed that the room was too dusty for objects as prized as his record albums. He mostly listened to the radio, tuning in to the classical station WQXR. Visitors to his house were often mystified by the sealed albums heaped by the hundreds in the glass-enclosed front porch of his house. Like many of Cornell's other collectibles, his records apparently brought him pleasure only in the moments when he first discovered them. After that, it was enough just to have them, to know they were there.

The oddity of Cornell's record collection was consistent with everything else about him. When Cornell put something off, he didn't wait just a day or two; he waited a year or two, or longer. Just as he didn't open his records when he bought them, he seldom read his mail on the day it arrived, letting it accumulate in a pile in his basement until he felt ready to attend to it. He was predictably slow in sending off letters, often waiting before composing them, or composing them right away but forgetting to mail them. While he had waited two years before responding to de Kooning's comment about "architecture," that wasn't long at all compared to a letter he once sent to his sister Betty, which included a separate note that cutely confessed: "Only five years late!"

Similarly, the notes Cornell was always writing to himself on scraps of paper sometimes didn't find their way into his journals for several years. It is not unusual to come across a heading in his journals that says "entered 2/17/47 from note of 9/19/44." Most important, the photos, clippings, and handwritten notes that Cornell filed away as background material for a given box would typically remain unconsulted for several years before he was seized with a sudden desire to make a box relating to them. If Cornell acted with haste in anything, it was mainly in his hesitations. He resisted finality at every turn.

Once he began work on a box, it was rarely an open-and-shut case. At any given time, Cornell had many boxes-in-progress, conceiving new pieces

while "refurbishing" (a key Cornell word) boxes conceived years earlier. He seldom signed or dated his pieces, which in later years would create a thicket of problems for art historians eager to chart the exact development of his work. To sign and date a work is to acknowledge that it is finished, and Cornell was wary of such acknowledgments; he preferred to think he could return at any point to all that he started, that even the past was never really past, to paraphrase Proust. (One of Cornell's boxes in the Museum of Modern Art, *Object [Roses des Vents]*, bears the date 1942–53.) Although the sides of his boxes are nailed together, in most cases the top plank is secured with screws; thus, Cornell could easily remove it and slip off the front pane of glass when he needed to get back "into" a box. His tinkering could be guaranteed to end only when a box left his house and was safely ensconced at a gallery or the home of a collector.

Cornell's day-to-day routine was pleasantly interrupted in September 1951, when he left Utopia Parkway for a month-long vacation at his sister Betty's six-acre chicken farm in Westhampton. Robert accompanied him on the trip, wheelchair and all, and the two brothers shared a small, simply furnished cabin on Betty's property. Their mother stayed home in Queens. To judge from Cornell's diaries, it was a relatively happy time for him. He enjoyed waking to gaze out at the flat, tranquil landscape, with golden meadows stretching in every direction. He would set out each morning on a stroll, exploring the woods behind the house or collecting bits of driftwood along the ocean shore. Robert, too, was interested in birds and would often wake his brother at dawn so they could listen to the whippoorwill's call.

Among the luggage Cornell brought along on his trip was his manual typewriter. During his stay in Westhampton, he sat down nearly every evening at a table in the cabin to type up a single-spaced page of diary notes. Much that was noteworthy, he felt, transpired during "my packed days here." He typed notes on the walks he took, the species of birds he spotted, the constellations he glimpsed at night. He commented on the authors he read—or rather reread, immersing himself in the collected writings of Marsden Hartley and James Huneker, the former music critic for *The Sun*. Apparently Cornell did not alter his eating habits during his vacation; it was nice to walk in the woods, he noted one day, "after a lunch of pistachio ice cream."

Back on Utopia Parkway at the beginning of October, it took only a few

days before the "warm aftermath of the vacation [had] worn off," as Cornell wrote in his diary. He resumed his solitary ambles in the city, and obsessive thoughts cluttered his head. Cornell was still focused on de Kooning and eager for his friendship. Earlier in the year, he had stopped by de Kooning's studio, at 85 Fourth Avenue, in hope of paying a social call, but no one was there.

The closest Cornell came to an encounter occurred on June 16, when, as he noted, he "saw de Koonings for first time on 4 Ave. from inside bookshop"—a quintessential Cornellian moment. He had never met de Kooning's wife, Elaine, an able painter and critic, and it did not occur to him to run out of the bookshop and say hello. It was enough simply to savor the coincidence that had momentarily brought the de Koonings into view through a pane of glass, and then write up his sighting in his diary.

Upon returning from his summer vacation, Cornell typed a letter to de Kooning announcing his plans to stop by the studio again. He wrote three drafts of the letter, deeming each somehow inadequate. Which letter, if any, did he finally send? Probably the last, the most concise, in which he reports that his trips to the Fourth Avenue bookstalls were not nearly as numerous as they had once been. "I lost complete interest in that section (4 ave.) following its hitting bottom in the immediate post-war era but lately the past has been coming back with an amazing upsurge even though the buildings are dustier and grimier than ever."

On November 8, 1951, Cornell finally found de Kooning at home in his loft, willing to receive company. Many worshipful artists and acolytes had made this pilgrimage before, banging on the door downstairs and waiting to see de Kooning's blond head pop out of an upstairs window. "Who's dat?" he would shout. Cornell's meeting with him was cordial, if hardly momentous. He lingered in the studio for two hours, during which time they sipped tea, snacked on petits fours, and chatted about "Einstein, time, space, etc. nightmare, Holland," as Cornell noted in his diary.

A few months later, Cornell paid another visit to de Kooning's studio, this time arriving to find the critic Harold Rosenberg chatting away with his usual erudite intensity. A tall, dark man with craggy features and a thick mustache, Rosenberg was an imposing presence and could practically cow people into agreeing with him on the basis of his appearance alone. He was then writing for *Art News* and was about to publish, in December 1952, his famous treatise on "Action Painting." "At a certain moment the canvas began to appear to one American painter after another as an arena in which

to act," the article began. While the piece did not mention any artists by name, everyone in the downtown community assumed it was about de Kooning, who was known to be Rosenberg's favorite living artist. In coining the phrase "action painting," Rosenberg drew heavily on Existentialism and helped give rise to a distorted view of the Abstract Expressionists as artistic superheroes whose risks with the brush mattered more than the pictures that resulted.

So far, Rosenberg had never reviewed a Cornell show, which isn't surprising, since he had little interest in any contemporary art other than Abstract Expressionism. And if ever there was an artist not given to "action," it was the retentive Joseph I. Cornell. Still, Cornell made every effort to befriend the critic. He thought Rosenberg might be interested in his Dovecotes, a recent series of boxes inspired by nesting houses for pigeons, and the most abstract boxes of his career. In a typical Dovecote, a white-painted box is divided with wooden strips into thirty small, square compartments, all of them intriguingly empty.

In a letter to Rosenberg of February 8, 1952, Cornell invited the critic out to Utopia Parkway, assuring him that "your family would be welcome to join you in a spot of tea or early dinner." Cornell was very eager to show Rosenberg his Dovecotes, and if he couldn't entice the critic to come to Queens, he was willing to visit him at his apartment on East Tenth Street in Greenwich Village. "I might drop by with just the DOVECOTE," Cornell proposed. He went on to say that "I like to think of the DOVECOTE project as having a special appeal to the author of the 'study in white' in 'Moby Dick' "—a reference to an essay Rosenberg had written. In spite of Cornell's gracious invitation, Rosenberg declined to take him up on it. In a startling critical oversight, he failed to review a Cornell exhibition until 1967, when he finally and belatedly lauded Cornell's "masterworks" in *The New Yorker*.

Supported by critics or not, Cornell was now doing some of his best work. Since 1949, when he unveiled his Aviary boxes at Egan, he had carried his new whitewashed boxes through many different incarnations. From one season to the next, they changed in astonishing ways. Bird cages with colorful parrots turned into starry Observatories, which in turn became the grid-filled nesting places of the Dovecotes. And now his white boxes would come to encompass two of Cornell's most powerful subjects: Emily Dickinson's

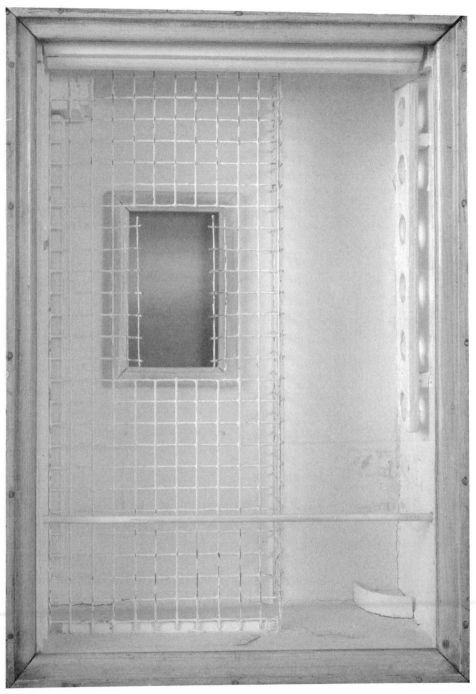

"Toward the Blue Peninsula" (for Emily Dickinson), 1953; construction, 14½ × 10¼ × 5½ in. (Collection Mr. and Mrs. Robert Lehrman, Washington, D.C.)

bedroom in Amherst, Massachusetts, and the rooms of small European hotels.

In September 1952, after returning from what was becoming his annual vacation at his sister Betty's house in Westhampton, Cornell visited the Flushing Library on Main Street and took out two biographies of Emily Dickinson. He had first become acquainted with her work many years earlier, after reading the chapter Marsden Hartley devoted to her in *Adventure in the Arts*; as he reread the book during the summer, she returned to Cornell's imaginative life. It seems appropriate that he would become engaged with Dickinson at this point, when he was keenly interested in the Abstract Expressionists—in the American avant-garde rather than the European one—and was perhaps looking for a kindred poetic spirit less French than Mallarmé or Gérard de Nerval.

And who could have been a more suitable object of his fascination than Dickinson, the eccentric, quivering, overstrung recluse who famously declared, "I'm Nobody! Who are you?" She and Cornell had much in common as devotees of the grand indoor life. They never married, lived with their families, and relied on books to escape the circumscription of their lives. Both were religious and worried about guilt and salvation. In the silent spaces of night, Dickinson wrote poems in her upstairs bedroom and Cornell made boxes in his basement workshop. Their work leaves us with a similar impression of the vastness of time and the finality of the grave.

In his typically obsessive and autodidactic fashion, Cornell immersed himself in Dickinson's poems and every available biography of her. On Indian-summer afternoons, as he referred to the cherished days of autumn, he sat beneath the quince tree in his fenced-in yard lost in the details of her life. The book he found the most compelling was Rebecca Patterson's just-published *The Riddle of Emily Dickinson*, which presented the poet as a secret lesbian. Supposedly, one of her crushes was a woman named Kate Scott, and Cornell was moved to learn of Dickinson's unrequited love for her. He made note of page 286 of the book, where Dickinson is described as so starved for Kate Scott's affection that "she had given up hoping for love and had learned to exist in isolation, 'like god.' "

As Cornell read about Dickinson, his art-world acquaintances and the hubbub of the Egan Gallery undoubtedly seemed far away. Whatever inspiration he derived from de Kooning and the rest now paled beside the gratifications of sitting alone with a book in the haven of his back yard. Writing in his journal at the kitchen table one October morning, Cornell

reflected on Dickinson's "torturous seclusion," as if wondering whether her denial of the worldly was what made her so expressive. One day in the city he was excited to stumble upon a daguerreotype of her in an old biography by her niece Mabel Loomis Todd; the memory of the poet's austere, homely face haunted him as he made his way home that night on the subway.

Cornell's feelings for Dickinson became the basis for a small group of boxes. Surely the best is *Toward the Blue Peninsula*, which is named for a Dickinson poem and consists of a whitened box in which a vertical window facing a strip of wire mesh opens onto a radiant blue sky. Seen as a whole, the box has the clean, pristine look of a house on a typical New England street, reminding us of the poet's stay-at-home existence. And what of the window, the rectangle of blue promising relief from the box's confinement? Cornell offers Dickinson an escape—perhaps the "blue peninsula" of her longings, which, as interpreted in the Patterson biography, represents exotic Italy, where her friend Kate Scott traveled in the 1860s. *Blue Peninsula* provides two homebody poets—Dickinson and Cornell—with a romantic union they never knew in real life.

Cornell, at this time, was also working on a new series of boxes—the Hotel boxes. For years he had been collecting turn-of-the-century guidebooks to European cities, many of which included advertisements for hotels. Cornell clipped out the ads and filed them away. He had ads for dozens of hotels—Hôtel des Trois Rois, Hôtel de l'Etoile, Hôtel du Cygne, Hôtel Royal des Etrangers, and Hôtel Bon Port, most of them shabbily charming places on the side streets of Paris. Cornell's Hotel boxes are all recognizable by their ads, which he glued onto the inside back walls of the boxes, turning them into Cubist collages. He often baked the boxes in the kitchen oven or left them out in the sun to give their white walls a vintage look, and in the best pieces the walls themselves—with their cracked and peeling paint—give off a strong whiff of the past.

Hotels as such are hardly a popular theme in art history. Edward Hopper springs to mind as art's one hotel enthusiast. Hopper, at the time, was living on Washington Square North in Greenwich Village and had recently represented the United States at the Venice Biennale, along with Pollock and de Kooning. Is it just a coincidence that Hopper and Cornell—both natives of Nyack, New York, that once-fading resort town where dilapidated hotels dotted the shore of the Hudson River—ended up obsessed with hotels? Or did these two cinema-adoring artists take the motif from the movies? (*Hôtel du Nord*—the title of some of Cornell's Hotel boxes—was also the

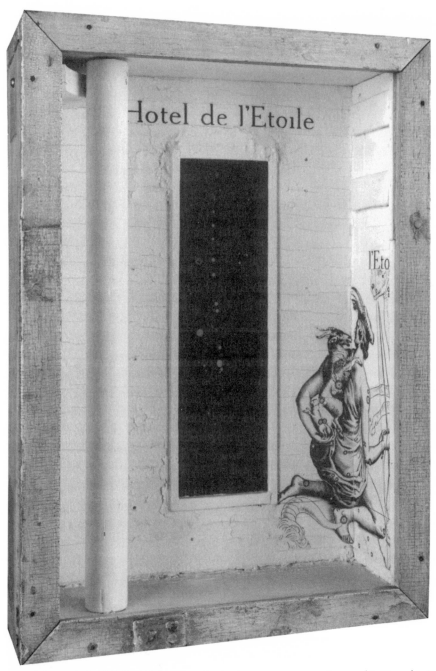

Untitled (Hotel de L'Etoile: Night Skies, Auriga), 1954; construction, 19¼ × 13½ × 6¹⁵⁄₁₆ in. (Collection Art Institute of Chicago, the Lindy and Edwin Bergman Joseph Cornell Collection)

title of a 1938 film by Marcel Carné, a saccharine love story in which the French actress Arletty achieved permanent fame by virtue of a single word: "atmosphere.") Hopper's first *Hotel Room* was painted in 1931 and shows a young girl sitting on the edge of a bed, gazing down mournfully as she holds a note in her hand. What does the note say? Has she been jilted? Cornell's Hotel boxes, by contrast, are not set in midtown Manhattan and do not concern themselves with big-city sadness. Yet both he and Hopper (whom Cornell greatly admired, later noting his "appreciation for Edward Hopper's world") are poets of loneliness, and their hotel rooms are similar in spirit. They're inhabited less by guests than by the empty spaces of romantic yearning.

Then again, one doesn't have to look too far to understand the source of Cornell's Hotels, a theme that encapsulates his passions more than any other. Cornell, an armchair traveler, his head filled with dreams of distant places, really did roam far in his thoughts. In his mind's eye, he followed peripatetic Romantic ballerinas on world tours and envisioned them in the cramped, meagerly furnished rooms where they rested overnight. In his Hotels, Cornell gets to spend the night with them and partake of the titillating anonymity of the back streets. But his Hotel boxes are not strictly sensual places. They're also spiritual palaces. Often haunted by a ghostly reproduction of an almond-eyed girl from a painting by Parmigianino, they allow Cornell to gather his visions of feminine beauty into a place that exists on no map. For the journey he is making is not merely between one city and the next. The journey is also between life and the next station that awaits us, and in his Hotels he guarantees his beloveds a life that outlasts mere flesh.

Cornell's third show at the Egan Gallery was called "Night Voyage" (February 10–March 28, 1953), and the reviewers were consistently impressed. Two new critics—both accomplished artists themselves—joined in the chorus of praise. The sculptor Sidney Geist reviewed the show for *Art Digest*, where he began by saying: "For years, while so many artists have been leaving so much out of their paintings, Cornell has been making the beautiful, shallow, glass-faced boxes into which he puts everything he loves." Fairfield Porter, who was on his way to winning a loyal audience for painting figurative pictures in the age of abstraction, was equally supportive in his review in *Art News*, intriguingly noting that "each box is like a stop on the railroad line."

Unfortunately, "Night Voyage" turned out to be Cornell's last show at the Egan Gallery. While he periodically felt the need to withdraw from even his most constructive relationships, his break from Egan probably was based on more than just nervous caprice. By now Egan had alienated many of the artists in his stable. He was so casual about running the gallery that stories still circulate about a "three-week" de Kooning show that remained on view for six months. Moreover, Egan owed many of his artists money and was notorious for failing to pay them on time when a work was sold. As early as 1951, Cornell had complained in a letter to his sister that "Mr. Egan had a head injury which has kept me from being paid from the Gallery for the year."

Not that he sold many works. During his four years at the gallery, when his boxes were priced between $250 and $300, Cornell sold about a dozen, according to sales records. In addition to the purchase by the Museum of Modern Art, boxes were acquired by people like Parker Tyler (he chose a *Crystal Palace*); the artist Fritz Bultman (who received a special price, paying off *Napoleonic Cockatoo* at the rate of ten dollars per month for a year); Babs Simpson, whom Cornell knew from *Vogue*, where she worked; and Leonard Weil, a Connecticut writer who learned of Cornell's work through his artist-daughter, Susan Weil, and who generously purchased three boxes as birthday gifts for his wife.

From here on in, Cornell tried to have several dealers handle his work rather than just one, thus ensuring that no single person gained too much control over him. Only two weeks after his final show at Egan closed, his work was introduced to the collectors of Chicago in a one-man exhibition at the Frumkin Gallery. Alan Frumkin, a tall, genial art dealer in his twenties, had opened his gallery the previous fall, in a brownstone at 152 East Superior Street. It was virtually the only gallery in Chicago to specialize in contemporary art (it later moved to New York). Frumkin first visited Cornell on the recommendation of Matta and asked if he might borrow some works for his gallery's inaugural season. Cornell lent him some pieces from the 1940s, nearly thirty in all, enough to constitute an exhibit sweepingly entitled "Joseph Cornell: 10 Years of His Art" (April 10–May 7, 1953), as the cleverly designed, circular invitation to the show announced.

In the next few years, Frumkin would place works by Cornell with several leading Chicago collectors, including Joseph Shapiro, Morton G. Neuman, and Edwin Bergman. As much as Cornell appreciated Frumkin's interest in

his work, he treated the dealer with the same exaggerated caution that characterized nearly all his relations with art dealers. "Cornell was very possessive about his art," Frumkin once remarked, "and was concerned about it being dispatched too quickly. He didn't like to sell his best pieces. His idea of a good relationship was to occasionally sell things of lesser quality." In other words, he was an art dealer's nightmare.

Several times a year, Frumkin would visit Cornell on Utopia Parkway in the hope of securing some new works to display at the gallery. These visits always took the same form. When Frumkin arrived, there would be two or three boxes set out on the kitchen table for his consideration. He was not permitted to wander downstairs to see the trove of boxes stored in the basement, a privilege accorded to very few. Instead, the art dealer was entertained (if that is the word) in the kitchen area, where, he recalls, he was usually served a cup of tea and some "heavy-duty pastries" as Mrs. Cornell milled around in the background.

As limited as Cornell's offerings were, even they could not be procured easily. Frumkin quickly learned that if he showed too much enthusiasm for a particular work on the kitchen table, Cornell might decide to keep it for himself. "I'm not quite ready," the artist would say, gazing down at the floor. "Maybe next time." He would usually offer a variant of the desired work, some weaker piece from the same series, a substitute fetched hastily and unapologetically from the basement.

Cornell's work was beginning to be taken more seriously, if only because of his recent affiliation with the Egan Gallery. Museums were finally waking up to his existence. In the spring of 1953, Cornell was included in the Whitney Museum's "Annual Exhibition of Sculpture, Watercolor and Drawing" (April 9–May 29), which marked his belated debut at that institution. The Whitney at the time was just about to move uptown from its original location at 10 West Eighth Street, and for years had been organizing big and usually mediocre survey shows known as Annuals. (They were superseded by the now infamous Biennials in 1973.) The Annuals alternated shows of painting with shows of sculpture, and Cornell was tapped for the latter category. He exhibited a box from his Observatory series, *Gemini—Orion*, which the critics consistently overlooked in their rush to praise Robert Cook, Milton Hebald, Lu Duble, and other "masters" whose work had titles like *Cain* and *Battle of the Amazons*. But then Cornell cannot properly be called a sculptor, and his inclusion in this sculpture show only serves to remind

us that even in his choice of media he courted ambiguity. While he worked in three dimensions, his objects are not in the round but frontal, and as such belong to the pictorial mode.

Later that year, Cornell was given his first museum retrospective—though "retrospective," at least as the word is understood today, is too grand to capture this small, last-minute, and unscholarly show. Held at the progressive Walker Art Center in Minneapolis, the exhibition was organized by H. H. Arnason, the museum's director and the future author of *The History of Modern Art* (1968), as well as of a monograph on Robert Motherwell. His preparations were strikingly casual. After learning of the recent gallery show of Cornell's work in Chicago, Arnason telephoned Alan Frumkin to request that the show be sent to Minneapolis. Sight unseen, a cache of twenty Cornell boxes arrived at the Walker and were hung in a single gallery. Supplemented by five more boxes from Cornell's personal collection, the show offered a top-notch selection of his work, ranging from an early "thimble garden" to his *Penny Arcade Portrait of Lauren Bacall* (1945) to some recent Hotels. It remained on view for the rest of the summer (July 12–August 30, 1953), and Midwestern tourists must have wondered what to make of it all.

Arnason was on good terms with Robert Motherwell and asked him to write a short statement on Cornell's behalf to be used in conjunction with the show. Motherwell generously obliged, producing two pages of plain-spoken praise. "His work forces you to use the word 'beautiful,' " Motherwell noted. "What more do you want?" In place of an exhibition catalogue, plans were made for the statement to appear in the fall issue of the *Everyday Art Quarterly* (which later became *Design Quarterly*), a leading journal of art and design published by the Walker Art Center.

Unfortunately, however, Motherwell's essay was not published, and no existing documentation explains why. One suspects it was Cornell who personally scotched the project after seeing a copy of the statement. He had never forgiven Motherwell for publicly accusing him of "shyness" during his film screenings at the Subjects of the Artist school; in the four years since, their rift had deepened. In one particularly tense telephone conversation, Cornell, who resented being called a hermit, pointed out that it was he, not Motherwell, who had made the greater effort to sustain their decade-long friendship, traipsing many times to Motherwell's home rather than the other way around—a charge that prompted Motherwell to insensitively

remark that a trip to Utopia Parkway inevitably entailed a tedious encounter with Cornell's family.

Cornell was stunned by Motherwell's comment. Someone else might have chosen to ignore it, but Cornell could not; it touched too deeply on the complicated web of tenderness and guilt he felt toward his mother and his brother. Several drafts of a letter that survive among his papers attest to his injured feelings as well as his tendency to overreact. In one draft, Cornell wrote defensively: "When I have made by a conservative estimate 15–20 trips to your various addresses without getting a *single* reciprocation in my direction should I be thought of as the 'shy' one? My brother is not difficult to approach nor my mother the bridge-playing type of matron distasteful to you." Defending his family was more important to Cornell than capitalizing on any professional benefits to be gained from the well-connected Motherwell, and their friendship came to an abrupt and bitter end.

In spite of his disappointment in Motherwell, Cornell was grateful for the Walker Art Center's interest in his work, so much so that he was reluctant to ask to be reimbursed for the expense of shipping the five boxes from his personal collection (via Railway Express) to the museum. He brooded on the matter for several months. Two weeks after the show closed, Cornell finally wrote the museum staff. In shipping the boxes, he noted politely, he had "incurred a local expense of $8.00 . . . I submit this for your consideration without wishing to make a matter of pressing it." While he had spent the past year on an extravagant dream tour of European hotels, he declined to visit Minneapolis for his first one-man museum show.

13

The Birds

1954-55

In February 1954, a revival of Jean Giraudoux's *Ondine*, starring Mel Ferrer and Audrey Hepburn, opened at the 46th Street Theatre in New York City. The play was based on a fairy tale about a water sprite who falls in love with a mortal man, and was one of the hits of the Broadway season. Cornell, of course, was already well acquainted with the play. The original production, staged in Paris in 1939, had alerted him to another Ondine—Fanny Cerrito, the Romantic ballerina who had danced the role of the sea siren a hundred years earlier. Now, in June, Cornell read the Giraudoux play in the back yard on Utopia Parkway, taking to his wooden armchair amid "the hush of early morning," when the sunshine was "fresh" and birds converged for "breakfast" at the table beside him. He felt newly captivated by the tale, a love story about a pair of opposites and the impossibility of union between mortal and spirit—a theme that echoed his own relationship with the long-departed Cerrito. Reading the play, he noted in his diary, "brought back the romantic picturesque" of his discovery of the ballerina fourteen summers earlier.

Before June was out, Cornell made a new box in tribute to her, *Owl for Ondine*, in which a paper cutout of a blank-faced owl perches amid a woodsy, bark-encrusted setting. Owls, he explained to friends, were once a good-luck symbol for actresses. His new box, one presumes, was intended as much for the original Ondine as for her latest incarnation. At age twenty-four, Audrey Hepburn was about to win a Tony for her performance in the play. Eager to present her with a token of his admiration, Cornell had his boxed owl delivered to her at the 46th Street Theatre. He hoped that she would be pleased to own it. But Hepburn didn't know what to make of

this most unconventional gift, and Cornell, according to friends, was "deeply hurt" when she had the box returned to his home.

Rebuffed by Hepburn, Cornell continued to think with great affection of her nineteenth-century predecessor. So much of his work had been directly inspired by the ballerina. Pulling out his *Portrait of Ondine*—the small black valise which he still kept under his bed—he leafed through his collection of Cerrito-related photos and prints for the first time in years and felt moved by his early attachment to her. He recalled the summer of 1940, when he had first retrieved Cerrito from antique prints and books—a bittersweet memory for the fifty-year-old artist. It saddened him to think that most of the Fourth Avenue bookstalls where he had sought Cerrito's image had disappeared in the years since. His pursuit of Cerrito, which had begun as a pursuit of the past, had itself slipped into the ghostly past, and he felt nostalgic for the very nostalgia that had brightened his now-vanished youth.

Cornell looked back on his relationship with Cerrito the way other men might look back on a brief, torrid, unforgettable love affair. Cerrito had acquainted him with something close to perfect happiness, but that was long ago. Such exquisite passions no longer seemed possible. Day after day, he continued to complain about feelings of "stagnation," as if weighed down to the point of immobility by a lifetime of accumulated family burdens. The year had begun badly; on January 6, he had injured his hand during some sort of "trouble with Robert." The injury required stitches. In the future, he noted in his journals, he must try to avoid "the state that brought on incident of gashed hand." The accident prevented him from visiting Manhattan for a few weeks, but perhaps, it seemed to him, the accident had happened in the first place because he rarely had the energy to go into the city or lift himself out of his despondency.

The city was no longer the place it had been before the war. Buildings, vistas, and entire blocks that Cornell had explored since the 1920s were disappearing under a wave of glass-and-steel construction. Streetscapes seemed to be changing beyond recognition every time he looked. Cornell was particularly distraught by the news of plans to demolish the Third Avenue El. He had always liked riding the elevated train, not least because of the views it afforded into the windows and buildings along its route. Third Avenue was then a dreary, down-at-the-heels stretch of bars and tenements. The presence of the railroad, with its massive steel structure and all-night rattle, had discouraged the construction of elegant buildings. For

Cornell, however, the El was one of the city's treasures: a great moving landmark whisking him past miles of windows and filling his head with daydreams about the anonymous lives he glimpsed behind the panes of glass.

News of the El's impending fate would now give rise to one of Cornell's most ambitious projects. His idea was to make a movie about the El, capturing the train in the twilight splendor of its last days. Cornell had never filmed a movie before—he had only spliced—and he hoped to find a professional filmmaker who was willing to do the shooting for him. He refused to operate a movie camera himself, an odd gesture on his part, yet one that was not wholly surprising for an artist who never owned a still camera or learned how to drive, claiming to dislike machinery. Cornell envisioned his new movie as a collaboration. In some sense all of his work might be said to be collaborative; since he made use of found images and objects, he was always mingling visions with Watteau, Anguissola, or whomever. Yet in this case his collaborator would be living, and one suspects that the project was motivated at least partly by his desire to shake his loneliness and reclaim Manhattan as a stalking ground for his art.

Cornell, of course, had made movies before. Back in the thirties, he had mixed and matched footage from found B-movies in a style indebted to the deliberate fracturing of Surrealism. Now, twenty years later, he embarked on a second phase of moviemaking, this time leaving the solitude of his basement to work side by side with distinguished filmmakers. His movies from the fifties are, at least to this writer, superior to his early collage movies. While the collage films recycle existing footage into a stern surrealist experiment, the fifties movies consist of original footage made under Cornell's supervision, and virtually every frame seems imbued with his lyrical vision of things. There are a dozen movies from the fifties altogether. They tend to be short, from three to ten minutes in duration, and most are set in the streets and parks of New York. If they share a theme, it is the yearning for transcendence played off against the grubbiness of city life.

Cornell first conceived his El project in 1953, and approached the film-maker Rudy Burckhardt. Following up with a letter, Cornell reminded him: "I should still like to travel around on the El with you and hear your ideas about filming 'the last days of the El.' " Burckhardt was interested, but slow to act. By 1955, a deadline was looming: the El was scheduled to make its last trip that May 12. Cornell anxiously tried to find another cameraman. His choice was Stan Brakhage, a twenty-three-year-old experimental filmmaker recommended to him by his film-critic friend Parker

Tyler. Later, Brakhage would be revered as the preeminent poet of independent cinema (his magnum opus, *Dog Star Man*, would be obligatory viewing for the art-house crowd), but at the time he was just a hungry young artist living in a tenement on the Lower East Side.

Cornell had not met Brakhage before. With Tyler acting as an intermediary, he arranged a rendezvous, not at a coffee shop or a cafeteria, but at the main branch of the New York Public Library. Cornell was once again exhibiting his work there, having lent a few of his boxes to an exhibition commemorating the 150th anniversary of Hans Christian Andersen's birth. An inspired show, it brought together a bust of Andersen, porcelain figurines of characters from his tales, and three of Cornell's lushest boxes, all dedicated to Lucille Grahn, a ballerina mentioned in Andersen's *Story of My Life*. Cornell asked Brakhage to meet him on the designated day in Room 78, the Central Children's Room, assuring him that they would somehow find each other.

Brakhage, who knew of Cornell's work and considered him a genius, was nervous about the meeting. The filmmaker then owned just one suit and had it pressed for the occasion. Arriving at the library, he found the Children's Room virtually deserted. Cornell was lingering behind a pillar; he peered at Brakhage for a few minutes before finally stepping forth to introduce himself. Then he asked Brakhage whether he had ever ridden the El. Brakhage had not. A couple of days later, Brakhage was surprised to find six subway tokens in the mail. He used them to ride the train and telephoned Cornell to say he found the experience "wonderful." Soon after, the mail brought a roll of Kodachrome film—which, Brakhage correctly surmised, was to be used for one purpose only.

Wonder Ring was the title Brakhage gave to the four-and-a-half minutes of color footage he filmed while riding the El. Cornell was disappointed by the results, however, and he accused Brakhage of failing to follow his instructions. Instead of making the documentary that Cornell had envisioned, Brakhage had made a semi-abstract film, a kinetic study of light and motion. It was the last thing Cornell wanted, bearing no relation to his own experience of riding the train and waiting for it to arrive at a station. As Brakhage recalled, "He loved to stand on the platforms of the Third Avenue El, where you were close to the windows of working women and could watch them work."

Cornell eventually found another use for Brakhage's footage. A dozen years later, he released his own version of *Wonder Ring*, re-editing it hardly

at all but making the footage his own by reversing it. The images appeared upside down, the film ran backward, and in titling his more abstract creation Cornell reversed the letters in Brakhage's title to come up with the unpronounceable *Gnir Rednow*. Most memorably, Cornell added a final message to the movie, "The end is the beginning," which at first might sound like clever wordplay but might instead be understood as an affirmation of religion and the belief in life after death. The line, perhaps, is also an allusion to Eliot's *Four Quartets* ("In my end is my beginning").

In spite of Cornell's criticism of *Wonder Ring*, he and Brakhage got along splendidly. Cornell liked to visit the filmmaker at his apartment, which was just a short walk from Little Italy, where they'd go to a café for Italian ices. Brakhage, in turn, was fascinated by Cornell and made many trips out to Utopia Parkway, marveling at his collection of old movies and his vast dossiers on French ballerinas of the last century. Brakhage could expect to be welcomed not only by the artist but by his peculiar family. He became well acquainted with Mrs. Cornell, "the archetypical Flushing mother," as well as Robert, who, he later noted, "was hard to communicate with, but was a very sweet man and lively in the eyes." It was Cornell, not his mother, who inevitably prepared a frugal meal for his guest. "Three sardines, crackers and a glass of pink lemonade was a typical lunch," Brakhage said.

One June day, not long after the El film was shot, Cornell suggested to Brakhage that he come out to Queens with his movie camera. An old house in his neighborhood was about to be torn down, and he wanted a record of it on film. Cornell accompanied Brakhage to the house to shoot *Centuries of June*, as the ten-minute silent film was eventually titled, after a poem by Emily Dickinson. This time, Cornell provided the shooting instructions, comfortably playing the role of director by pointing out what he wanted recorded: the house and its tower, a fluttering butterfly, children scampering out front. Cornell edited the footage into a wistful, elegiac film, his second and final collaboration with Brakhage.

Today, many people familiar with Cornell's boxes remain unfamiliar with his films. Yet his movies enjoy a devoted, nearly cultish following among cineastes. Brakhage credits Cornell with exerting a great influence on his own career. *Wonder Ring* and *Centuries of June*, the two movies Brakhage made with him, had neither performers nor narrative, and as such turned out to be crucial links between Brakhage's early psychodramas and his mature first-person style. "I know this will sound preposterous," Brakhage noted, "but I think Cornell's contribution to the art of film far exceeds anything

he did in any of his boxes or his collages. It's just that film isn't valued by society the way that art is. Cornell is a monumental figure. He was shamanistic in his approach, always after magic and magical conjunctions."

Before the year was out, Cornell had hooked up with another "cameraman," one who would turn out to be his most regular collaborator. Rudy Burckhardt was a painter, photographer, and experimental filmmaker whom Cornell had known casually for several years. Born in Basel, Switzerland, in 1914, Burckhardt was a medical-school dropout from a good family who could claim the historian Jacob Burckhardt as a distant relation. Short and slight, Rudy seemed never to say a word but somehow always had a lot of fascinating friends. Upon arriving in this country in 1935, he shared a Chelsea loft with the dance critic Edwin Denby (who spoke of him as "my little Swiss friend") and had his portrait painted by their next-door neighbor, Willem de Kooning. At the time, Burckhardt was working mostly in still photography, producing winningly unpretentious pictures of the Brooklyn Bridge and other city sights. When Cornell met him, he was still living on West Twenty-first Street and was a well-known figure in downtown circles, a "subterranean monument," as John Ashbery once called him.

Burckhardt first met Cornell in 1949 through Robert Motherwell, who invited him to one of Cornell's "film soirees." Burckhardt had also seen Cornell's shows at the Egan Gallery and admired the artist and his work. "His face was almost a tragic face, so sad and melancholy," Burckhardt later said. "But once in a while he smiled, and he had a beautiful smile."

In the next few years, he and Cornell would make nine movies together. Although nearly all of them are set outdoors in Manhattan, the quintessential modern city, the story Cornell wishes to tell in them is a nineteenth-century one, or at least one that's far away in time. The movies might be described as urban pastorals that ignore the pace of the city and coat Manhattan in romance and nostalgia.

Cornell's first collaboration with Burckhardt was entitled *Aviary*, and it's one of his best movies. It was shot in Union Square, at the time a cheerless park not far from the Fourth Avenue bookstalls. Once the site of radical politics, Union Square had since lost the glamour of its soapbox days and was known mainly for its southern border, Fourteenth Street, a decrepit strip where harried shoppers scouted for bargains at S. Klein and other stores. Many artists before Cornell, of course, had drawn inspiration from

the park, in part because they had studios in the neighborhood. Painters who belonged to the Fourteenth Street School, including Kenneth Hayes Miller, Edward Laning, Raphael Soyer, and Isabel Bishop, turned out scenes of shop girls and Depression-worn pedestrians who they believed personified modern life.

Cornell, too, relished the tawdriness of Union Square, the pretty shop girls, the hard-bitten waitresses, the jostle of flesh on the sidewalk. Yet he could also view the neighborhood in more innocent terms. He particularly liked the part of the park around the fountain, a mecca for birds. On countless afternoons, he had paused to admire the city pigeons as they perched on the fountain's perimeter or ascended in a flock across the sky. He loved to watch them, these wildly gentle creatures flying so close to him that their feathers almost brushed against him. For reasons he could not quite say, they reminded him of Fanny Cerrito. His *Portrait of Ondine*, that valise of Cerrito-related mementos, included a photo of pigeons taken in 1940, the year he had discovered her. Like the birds, Fanny could rise from a fountain, which she did in the second half of *Ondine*. And like a Romantic ballerina, a pigeon is peripatetic—a traveler, a wanderer, roaming the globe as if on its own world tour.

As the title of his movie *Aviary* might imply, birds are the protagonists; the movie is a vehicle for pigeons. "Aviary," of course, had also been the title of Cornell's 1949 show at the Egan Gallery, and he now tried to extend the theme of his boxes into film; he turned the park into a virtual Cornell bird box, with the buildings around it serving as walls. The movie was filmed in November and December of 1955, and a spare, wintry mood pervades every frame. On three different Saturdays, Cornell and Burckhardt met at the fountain in Union Square and then wandered through the park in pursuit of subjects. Cornell, inevitably, found much of interest: "Shooting at Union Square with its unexpected yield of incidents and enrichment," he noted in his diary on November 13. As Burckhardt looked through the lens of his Bell and Howell movie camera, Cornell pointed. He pointed to the fountain, the surrounding trees. He pointed to pigeons taking flight, to leaves blowing in the gusty wind, to a little boy holding his mother's hand. "Get that," he would say, "get that." He did not allow himself to be filmed, preferring to play the role of director.

He was hardly a self-possessed auteur, however. At one point a male dwarf, dressed properly in an overcoat and hat, strolled into the park.

The dwarf in the film *Aviary* (Collection Anthology Film Archives, New York)

Burckhardt elbowed Cornell, knowing his interest in misfits. "Yes, yes, film him," Cornell whispered excitedly, "but don't hurt his feelings!"

Aviary is only five minutes long, but it's easy to recognize as a Cornell creation. The black-and-white movie transforms Union Square into an oddly serene and even spiritual place. As the camera roves, documentary style, through the sprawl of the park, we see bare tree branches, flying birds, and isolated bits of statuary. Cornell knew a metaphor for the fragility of modern man's existence when he saw one, and he seized on the departing city pigeons as if he had been searching for them all his life.

In terms of imagery and rhythm, *Aviary* is an arresting piece of film-making. Cornell establishes a hushed aura from the start, so that the grungy, garbage-littered park becomes a timeless setting for reverie, and the viewer can almost feel the weight of "Winters Past"—the name of the orchestral piece by the composer H. Barlow he used for the movie's sound track.

Soon after completing the movie, Cornell and Burckhardt collaborated on a second production set in the park, *Joanne, Union Square*. It starred a

thirteen-year-old girl whose name was not Joanne but Jean Jagger, Cornell's niece. She was visiting her uncle one gray, drizzly Saturday when he asked her to accompany him to the park. He sat her down on a bench and told her not to move. "I sat there for what seemed like an eternity," she remembered. "I thought Rudy and my uncle had disappeared, and didn't know what to do." To her relief, she eventually realized that the two *auteurs* were standing a few hundred feet behind her, filming her from the back.

Cornell had never used a live "actress" before, and he certainly succeeded here in creating a memorable role for Jean. By filming her from the back, from a distance, enshrouded in mist, he turned her into a half-seen, ambiguous creature who belongs as much to the silence of the past as she does to the metropolitan present. Cornell, however, was unhappy with the results. *Joanne, Union Square*, seven minutes of black-and-white footage, was left unfinished. In his moviemaking, as in his box making, Cornell had a hard time satisfying himself. What was he aiming for? What vision was it that lay so stubbornly beyond the reach of the camera lens? In his diary, Cornell mentioned the difficulty of trying to capture his "love of humanity," the flood of feeling that came over him as he observed little children and other passersby in the park. "No matter how much might be taken on film . . . there is always the thing the camera cannot catch."

It wasn't only through the medium of film that Cornell set about trying to express his so-called love of humanity. Unknown to most of his friends, who so often found him withholding and standoffish, Cornell was capable of great acts of kindness. He could always be counted on to reach out to children and the handicapped, devising his own projects on their behalf. A diary entry from August 1954 refers to a trip to a variety store to shop for little trinkets to "make up gift packages for children in hospitals." Not gifts, but gift packages, assortments of dimestore *objets*. Even in his gift giving, he favored the medium of assemblage.

Cornell was also kind to the children in his neighborhood. True, he had no natural ease around them; friends report that he was stiff and awkward in the presence of children. Yet he eyed them with a keen appreciation and seemed to feel a special affinity with them. A lucky few received gifts of artwork from him. Stan Brakhage recalls his surprise when a back-yard lunch at Utopia Parkway was interrupted one day by a little girl who came traipsing across the lawn. She was carrying one of Cornell's boxes and told its creator: "I'm tired of this one. Can I have another?" Cornell seemed not

to mind her criticism. He took the box and went into his garage to fetch another that he hoped would please her.

For all his tender feelings for "humanity," Cornell's most satisfying relationships belonged to the stillness of the past. He pursued phantoms with the help of many different media: his life was an ongoing multimedia show. During this period, besides making movies, he was also involved in a publishing venture—albeit a rather uncommercial one. As he had once designed special issues of *Dance Index*, he now published two pamphlets devoted to two great divas. *Maria* (1954) was dedicated to Maria Malibran. And *Bel Canto Pet*, done the next year, was his tribute to Giulia Grisi. Cornell printed the pamphlets at his own expense, in editions of 100, and sent them to his friends.

Cornell had loved opera ever since his family gathered around a Victrola to hear Caruso and Farrar on the Red Seal albums of his childhood. Yet the divas Cornell loved most were the ones who had lived long before him. Giuditta Pasta and Guilia Grisi of Italy, Maria Malibran and her sister Pauline Viardot of Spain—these long-departed greats were his favorites. As he had once imbibed every last detail about Cerrito and her peers in the Romantic ballet, he now amassed backstage knowledge about divas from the same period. He picked up information from sources ranging from Delacroix's journals to back issues of *Opera News*. He had just finished reading a 1926 biography of Turgenev; he felt "preoccupied," he noted in his journals, by Pauline Viardot, for whom Turgenev felt an insane passion, following her and her husband to Paris and becoming an expatriate on her account.

It fascinated Cornell to think of Viardot as half of a sisterly pair. Pauline and Maria—two mezzosopranos linked by the ties of flesh and blood. Cornell loved thinking about doubles, perhaps because his own identity was so inseparable from that of his brother, Robert. But Cornell, of course, was part of less fraternal pairs as well. In his mind he was always joining with someone else—some dancer from the past, or an actress on a movie screen, or a character he read about in a book.

At any rate, the two singing sisters, Malibran and Viardot, had come to know very different fates. Malibran, in her lifetime dubbed a "bird of song," was a paradigm of the tragic heroine. In 1836, at the height of her fame,

the twenty-eight-year-old singer fell from a horse in an accident that ended her life. Cornell kept an extensive file on her and enjoyed combing through his clips. On August 22, 1954, he noted in his journals: "Reading from Malibran file to Robert in bed one weekday—very emotional reaction to account of her making debut in New York City."

While Cornell was a well-known balletomane, virtually nothing has been written about his interest in opera. This may be because opera was rarely an overt subject of his work. But it's certainly a covert subject. Many of his bird boxes bear opera-related titles (*A Parrot for Pasta, Parrot Music Box, Ristori Cockatoo*, etc.), and comments in his diary suggest that Cornell associated birds with stars from opera's "golden age."

Cornell's pamphlet *Maria* was almost as cryptic as his bird boxes. It doesn't even give the singer's last name. All text, no pictures, it consists of an excerpt from the German author Elise Polko and relates the story of an unnamed diva who becomes enraptured with a nightingale's song. From this experience she learns to prefer "a short but intoxicating life of love to a long, soundless, unadorned existence." Long, soundless, unadorned—a melancholy string of adjectives that evoke Cornell's life only too well. Was Maria Malibran someone to worship? Or was she someone he wanted to be? Amid the chaos of his yearning, Cornell found himself longing for the dazzling and fiery life of a diva.

In the course of working on his movies, Cornell often thought how much he would like to work with a professional actress. He imagined a film that would be a kind of city-park ballet, following a young woman as she silently explored a fountain—and discovered birds. True, Cornell's reputation as a film director was not exactly that of D. W. Griffith, and he wondered how he might find a young actress willing to participate in his cinematic experiments. To this end, he enlisted the help of his friend the writer Donald Windham, who lived with the actor Sandy Campbell and had extensive contacts in New York's theatrical community.

It was through Windham that Cornell met Lois Smith, a Topeka-born actress who, at twenty-five, had already embarked on a successful career on Broadway. In the fall of 1955, she was starring in *The Young and Beautiful*, an adaptation of F. Scott Fitzgerald's "Josephine" stories. Cornell, of course, had always preferred staying home and dreaming about performers to actually seeing a show, so perhaps it's not surprising that, according to Windham,

he attended the play at the Longacre Theatre only to spend the evening "with his hands over his eyes," apparently warding off a migraine. Yet he saw enough to make a collage in Lois Smith's honor, *For Josephine*, named for her role, and included a photo of her cut out from a Playbill. He asked Windham to hang the collage in his apartment and give it to the actress as a gift should she pause to admire it—which she did. So began an affectionate friendship, though time did not permit the Broadway actress to appear in a Cornell movie.

Yet by now Windham had found another actress who did have time to assist Cornell with his movies. Gwen Van Dam was a slim, graceful woman with auburn hair who had moved to New York from San Francisco a few years earlier. At twenty-eight, she was every inch the struggling actress. She lived in a studio apartment in Greenwich Village, supported herself with a waitressing job, and so far had appeared only in Off-Off-Broadway plays. She had no promise of a dazzling stage career, but that did not lessen Cornell's feelings for her. From the moment he first climbed the long flights to her apartment and introduced himself, he was enraptured by the actress and felt moved by her seeming vulnerability.

Cornell often stopped by in the afternoon to find Gwen alone in the cramped little room on West Eleventh Street that she rented by the week. Gwen felt flattered by his interest in her. "I didn't know he was a famous artist," she later said. "To me he was just a sweet man. He loved birds, and would attach bird stamps to the letters he sent me." One day Cornell arrived with a box, *Untitled (An Owl for Gwendoline)*—in which a cutout of an owl is sequestered behind a pane of blue glass—and gave it to her as a gift. He told her that Audrey Hepburn had declined to accept a similar owl and how delighted he was that Gwen felt differently. On the back of her box, he had glued a poem, Edith Sitwell's "The Bird as Confidante," as if eager to remind Gwen that he considered her a trusted friend. Concerned about her financial situation—she worked the day shift at a luncheonette —Cornell offered her money from his savings account, but she was too proud to accept a handout.

Once Cornell actually asked her out on a date, escorting her to Stan Brakhage's loft on the Bowery for a private screening of experimental films. He was fifty-one; perhaps it was the first time he had ever asked a woman on a date. Nonetheless, like other women he pursued, Gwen could not imagine that their relationship might ever be anything but platonic—and not because she found the avant-garde movies he had taken her to see utterly

incomprehensible. "He was very Victorian, very pure in his ideals about women and art," she said. "He was like a pure spirit walking around New York."

Cornell was eager to have Gwen appear in one of his movies, and arranged to meet her along with Rudy Burckhardt early one morning in Union Square. His plan now was to film the young actress walking through the park in the misty dawn light, a flock of pigeons fluttering around her. He knew that she had a younger sister, Jeanie, and asked that she come along, too —the movie was to capture the two women interacting with the birds. But he never made the footage into a finished movie. After the shooting, Cornell sent Gwen the reel of 16-millimeter film, and though the footage was just two minutes long, he told her he felt "too discouraged" to edit it.

This discouragement was a frequent complaint of his. The elation Cornell felt filming his movies invariably evaporated when he sat down at the dining-room table to edit the loops of celluloid. Again and again, he was struck by the seeming slightness of his work compared to the fullness of feeling that accompanied his Saturday-morning shooting session. With his boxes, he had frequently complained about the same thing, lamenting in his journals that "the feeling of creation that so often seems to come with leaving the house . . . is invariably lost on returning," as he noted on February 20, 1945. Emotion is boundless. Can art be the same, or is it doomed to be something less complete—a fragment, an instant, a scrap of paper, a dusty object, a specific moment stopped and frozen?

Besides, moviemaking is a collaborative art whose scheduling demands at times made it difficult for Cornell to record anything at all. He often bemoaned to his friends that his "cameraman," Burckhardt, wasn't as available as he would have liked. Burckhardt is the first to admit that he could not begin to accommodate Cornell in his desire to record every last sight and vision that moved him. There were mornings when Cornell would telephone him as early as seven, saying he had spotted a bit of beauty in his back yard and wanted Burckhardt to come out to Utopia Parkway with his camera. "I would tell him I'd come later," Burckhardt said, "and he would sound depressed. No, he would say, that would be too late." Cornell wanted to freeze every impulse, to embalm every surge of feeling before it ebbed and disappeared. It pained him to think that his movies and his boxes could do no such thing.

14

The Stable Gallery

1956-57

By now Cornell had joined another gallery. The Stable Gallery was located at 927 Seventh Avenue, off Fifty-eighth Street, directly across town from Egan, Betty Parsons, and the other vanguard galleries clustered around Madison Avenue. It occupied a former horse stable and, on warm days, still smelled pleasantly of hay and leather. The place was run by Eleanor Ward, a New York socialite remembered with affection by the artists she exhibited. The daughter of the architect William Berry, she had grown up on Manhattan's Upper East Side and was toted to the Frick Collection as a child. She began her career in advertising and promotion, and parlayed her experience into a position as an assistant to Christian Dior in Paris. After returning to New York, she opened her gallery in 1953 with the help of the painter Nicolas Carone, renting the building for $300 a month and stunning her *Social Register* friends by deciding to focus on avant-garde art.

At a time when most of New York's established galleries still specialized in European painting, Ward was more interested in the local artistic population. Today, she remains best known for hosting the Stable "Annuals," big, salon-style exhibitions held every winter (through 1957). The event, modeled after the Ninth Street Show of 1951, was juried by artists and usually filled all three floors of the gallery with the work of more than a hundred exhibitors.

Cornell made his debut at the Stable in the gallery's third "Annual" (January 27–February 20, 1954), submitting a box at the suggestion of Robert Rauschenberg, whom he knew from the Egan Gallery. It wasn't until the show came down that Eleanor Ward first met Cornell. "When the Annual was over," she once commented, "the Cornell box stayed on and on. Finally, one day Cornell came in to pick it up. I said how sad I'd be

without it. He said, Would you like to keep it?" She offered to give him
a one-man show, and would represent him until the end of the 1950s. In
joining the Stable's "stable," Cornell joined a gallery that represented various
rival cliques. John Graham, Elaine de Kooning, and Lee Krasner were about
his own age and moved in the Abstract Expressionist orbit. Other artists
at the gallery belonged to a new generation, and most of them were obsessed
with the same old master—Willem de Kooning. Joan Mitchell was perhaps
his most talented acolyte, while another faction, led by Rauschenberg and
Cy Twombly, was openly challenging him. At twenty-eight, Rauschenberg
was looking for a way beyond Abstract Expressionism, a drama that acquired
distinctly Oedipal overtones in his *Erased de Kooning Drawing* (1953), the
product of one month and forty erasers spent rubbing out the crayon, grease
pencil, and ink markings of a drawing that de Kooning had good-naturedly
given him as a gift.

Cornell soon became a regular visitor to the Stable Gallery, which provided
a convivial place for artists to meet and talk. Dressed in a Dior suit, cigarette
in hand, Eleanor Ward cut a glamorous figure as she chatted with the many
artists who came to see her, inviting everyone who passed through the door
to sit down at her black marble Noguchi table and join in the conversation.
A great beauty, Ward was often likened to the movie queens of the 1940s,
especially Bette Davis. Cornell treated her with his usual polite reserve.
While most people in the art world called her Eleanor, Cornell addressed
her as "Mrs. Ward," as if she were one of his mother's friends. Still, he
found her easy to talk to and was notorious among the other artists for his
overly long stays at the gallery.

During his visits, Cornell, inevitably, could count on seeing Rauschen-
berg, who had recently returned from a sojourn in Rome with his friend
Cy Twombly and was living on Fulton Street near the fish market. He
worked as the Stable Gallery janitor, mopping the floors and helping to
hang shows to compensate his dealer for his lack of sales. "Cornell would
come in and was very quiet," Rauschenberg later remarked. "He might
stop by the gallery just any time he was in town. He would sit around with
Eleanor and I don't know what they talked about. He might say 'Hello,'
and then six hours later, he would say, 'I'm going now.' And that was his
form of socializing."

Rauschenberg was among several young artists who were fascinated by
Cornell's use of commonplace materials. Cornell's boxes offered an alternative
to the "Tenth Street touch"—a reference to de Kooning's address and the

paint-clogged surfaces of his paintings. Following Cornell's lead, Rauschenberg was then working on "hanging fetishes" and "elemental sculptures" that were notable for their accretions of recycled objects. Rauschenberg was even making boxes, such as *Music Box* (1953), a foot-high wooden crate intended to be picked up; if you shake it, stones tumble across a wall of nails to create sounds.

Already Cornell's legacy was evident. In the twenty-five years since he began his career, he had single-handedly transported the tradition of assemblage from Paris to New York and kept it alive during the heyday of abstract painting. To be sure, Cornell was not the first artist to work in assemblage: his art belongs to an honorable modern tradition that began with Duchamp's readymades and Schwitters's use of common discards. But Cornell *was* the first artist of any note to stake his entire career on a medium as supposedly slight as assemblage. (Duchamp and Schwitters both made paintings in addition to their better-known experiments with found objects.) Cornell's achievement was to carry assemblage from 1930s Paris to 1950s New York, making it available to a new group of artists—to artists in America, where assemblage would find its most memorable expression. Rauschenberg was one of the first in the generation that began to draw on Cornell's work, and he openly acknowledges his debt. "The only difference between me and Cornell is that he put his work behind glass, and mine is out in the world," he once commented. "Cornell was rarifying the treasures of his thoughts, and I was trying to get people physically involved. He packed objects away, and I was *unpacking* them."

Eleanor Ward was glad to count Cornell among the artists she represented. She later described him as "one of the great originals." His work, she added, belonged to "a romantic world that only he knew and we were privileged to enter." To be sure, Cornell was not easy to work with and was predictably unpredictable in his business dealings. A week or so prior to each of Cornell's shows, Ward would be given a preview on Utopia Parkway—only to have an entirely different batch of boxes arrive at the gallery a few days later.

By the mid-1950s, a market for contemporary American art was developing, and Ward was delighted to find she could sell a Cornell box every now and then for around $300. But Cornell was not eager to part with his work. Of course he was not alone in this. It was almost obligatory among artists of the 1950s to bemoan the crass, philistine public and maintain a stance of purity. Mark Rothko famously wrote that exhibiting a painting is "a risky and unfeeling act . . . How often it must be permanently impaired

by the eyes of the vulgar." Yet even Rothko found Cornell shockingly uncommercial. Rothko thought that he had heard wrong one day when Cornell complained to him at the gallery, "The trouble with Eleanor is that she lets things get away from her."

After joining the Stable, Cornell made many gestures of friendship toward the younger artists who showed there. He invited Cy Twombly to Utopia Parkway and, on June 14, 1955, noted tersely in his journal: "Twombly here." Cornell was also interested in Joan Mitchell, a gifted young painter from Chicago. She first met Cornell one summer afternoon, after Eleanor Ward telephoned to say that he had just left the gallery and was on his way down to her apartment in the East Village. The stated reason for his visit was that he knew Mitchell had spent time in France and was hoping she could enlighten him on the subject. "He wanted to know about Versailles," Mitchell recalled, "and live France through my telling of it." Cornell arrived on St. Marks Place carrying two cups of coffee and two fresh Danishes from a Greek diner, and charmed Mitchell with his courtliness.

During his years at the Stable Gallery, Cornell increasingly won the respect of his peers. In the summer of 1955, he had a joint show at the gallery with Landes Lewitin, an Egyptian-born artist who specialized in small-scale figurative collages. Without exception, the critics were impressed, not only by Cornell's latest boxes, but also by the personality they projected. It was rare to find "so pure and so uncompromising a spirit in our midst," Frank O'Hara observed in *Art News* in September. O'Hara, a young poet who also had a sizable reputation as an art critic and homosexual man-about-town, was the first person to use the word "genius" in a Cornell review. Though clotted with dense language, his criticism abounds with nearly manic enthusiasm for contemporary art, which helps explain how he ended up working as a curator at the Museum of Modern Art. In 1955, shortly after seeing Cornell's work at the Stable, O'Hara wrote a poem in tribute to him, "Joseph Cornell," which wittily inhabits two box-shaped stanzas. (O'Hara specified "print like boxes" on his manuscript.)

At the end of the year, Eleanor Ward gave Cornell a one-man show at her gallery. Scheduled for the four weeks around Christmas, "Winter Night Skies" (December 12, 1955–January 13, 1956) took astronomy as its theme. Working with fairly simple props—cut-out fragments from sky charts, engravings of Greek mythological figures—Cornell managed to introduce a whole new cast of female legends. Auriga (the charioteer), Andromeda (the princess), Cassiopeia (the queen)—of the eighty-eight official constel-

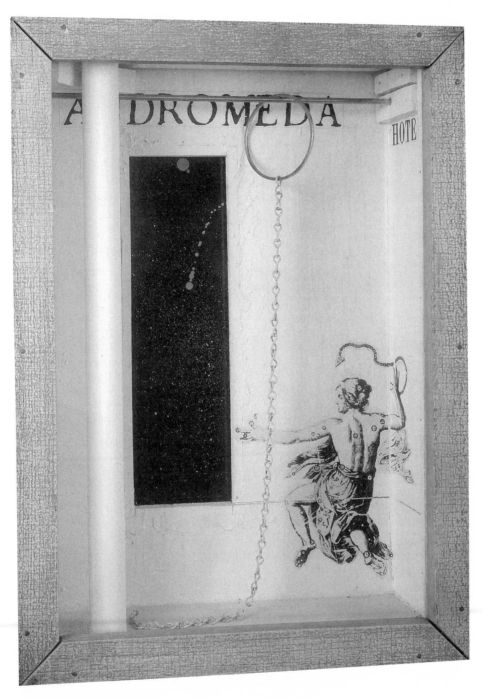

Untitled (Andromeda Hotel), c. 1953–54; box construction, 19 × 13¾ × 4¼ in.
(Collection Mr. and Mrs. Robert Lehrman, Washington, D.C.)

lations, Cornell favored the ones named for women. He brings them inside his boxes only to have them dream of being outside; they gaze at windows and reach for chains that can take them beyond the bare architecture in which Cornell has confined them. In the Night Skies boxes, Auriga and her luminous peers are made to join birds, divas, and ballerinas on the imaginary journey that was always winding through Cornell's art.

The Night Skies boxes continued the nocturnal theme of Cornell's two previous shows, "Night Songs" and "Night Journeys." It makes sense that Cornell loved the night. In daylight his world was full of family obligations; at night, Cornell could be alone with his desires. And at night there was so much to see. For Cornell, stars were more than an artistic conceit. An inveterate stargazer, he knew a good deal about astronomy. Sitting in his cramped kitchen in the long, soundless hours of night, he often looked up from his books to glance out the window and take in the enormity of the sky.

In his adolescence, Cornell had trembled before such a sight, quivered at the thought of infinity. But now the winter sky only excited him. He knew most of the constellations by name and relished the moments when the borders of his home stretched to encompass the heavens. He wrote up his sightings in his journals, noting his "first glimpse of Andromeda" on a certain day, or the general "elation of star gazing." Looking at the constellations, Cornell took leave of his usual anxious thoughts; took leave, it seemed, of his very skin, traveling across time and space to arrive at some realm where stars of the sky and performing stars—Fanny Cerrito, Maria Malibran—glittered with equal brightness. He was watching them, always watching, from the modest observatory of the kitchen.

The critics liked Cornell's latest boxes, which "beckon the spectator to lose himself in the firmament," as a reviewer observed in *The New York Times.* Despite the escapist tenor of his work, Cornell's boxes were beginning to be very visible in the here and now. Nineteen fifty-six began auspiciously for him. At the Museum of Modern Art, one of his works could be seen in a "recent acquisitions" show. *Taglioni Jewel Casket,* of 1940, the best of Cornell's ballet-related works, had been purchased by James Thrall Soby in the days when he was a partner at the Julien Levy Gallery. In 1953, as chairman of MoMA's collection committee, Soby donated the box to the

museum (making it a less than recent acquisition by the time it ended up in the "recent acquisitions" show).

Cornell had never liked Alfred Barr, the museum's imperious director, but was on friendly terms with his wife, Margaret, and sent her a note on February 16, 1956, expressing his "intense pleasure and satisfaction" at seeing his box on view at the museum. Moreover, he sent Mrs. Barr a gift for her personal collection, a miniature variation on the *Taglioni Jewel Casket*, a tiny 2-inch-square pillbox containing rhinestones, fragments from an actual letter of the ballerina's, and other items to satisfy his reliquary passion.

While it pleased him to see his career progress, Cornell remained as ambivalent as ever about assisting with that process. Dorothy Miller, Barr's assistant, at the time was organizing "12 Americans," the latest in an important series of shows meant to introduce leading new artists (and perhaps appease those critics who accused the museum of championing Paris while ignoring the talent in its back yard). Miller hoped to include Cornell in her show, along with Philip Guston, Franz Kline, Larry Rivers, and a handful of other New York artists. As he had done once before, Cornell made her task all but impossible by insisting that he could not be "rushed"—which for Cornell meant facing any deadline at all. So he was jettisoned from her show. "He and I mutually agreed to postpone it until another occasion," the curator wrote with disappointment to Julien Levy.

At the Whitney Museum, meanwhile, Cornell was similarly resisting the chance to reach a wider public. He had regularly participated in the museum's "Annuals" since 1953, but when a curator named Hermon More spoke to Eleanor Ward about the possibility of organizing a one-man show of his work, Cornell became rattled. "I should appreciate your relaying to him my regrets of not being able to accept," he wrote to Ward, offering little explanation for his rebuff beyond the fact that his work "matures very slowly" and he felt the moment wasn't right.

Despite his success at the Stable Gallery and his increasing prominence on the New York art scene, Cornell remained an elusive figure who felt compelled to disappear from time to time to a place where no one could follow him. He had a secret life, a life beyond the world of galleries and museums, and in the next two years it revolved around his movies. Hardly anyone knew about them. He did not screen them. He wasn't even sure they were

anything more than amateur productions. Still, he relished his Saturday-morning outings with Rudy Burckhardt to the parks and squares of Manhattan, not least because his moviemaking allowed him to become personally acquainted with an ever-widening circle of fetching young actresses.

If Cornell gave any thought to the reviews of his recent Stable show, he did not say so in his journals. Instead, the year began with him noting the arrival of a new female friend. He noted calling her from Grand Central Terminal. He noted visiting her at her apartment on Mulberry Street in Little Italy on New Year's Day, and "acquiring Van Gogh's letters the day before." He happily noted the convergence of his fifty-third birthday with "Suzanne's first visit to Flushing."

Cornell was referring to Suzanne Miller, whom he had met the previous summer, when she appeared with his friend Gwen Van Dam in an Off-Off-Broadway production of Moss Hart's *Climate of Eden*. Suzanne, a fresh-faced teen with short black hair, had been cast in the play as a boy. "Cornell was captivated by her," Gwen Van Dam recalled. "He thought she looked like his Medici Boy and Girl." Indeed, here was a creature who seemed to be at once male and female, a living embodiment of the Renaissance children whose androgynous faces for years had peered from his work.

Cornell didn't waste any time in casting Suzanne Miller in a movie. *A Legend for Fountains* would turn out to be his personal favorite. It's also his longest (seventeen minutes). The film, set in Little Italy, follows Suzanne as she traipses through rain-splashed streets and pauses to peer into shop windows. It differs from Cornell's other urban pastorals in that it is set in the streets rather than in a park or garden. The shots are often framed by windows and decrepit store façades, and recall Atget's photos of turn-of-the-century Paris. In Cornell's movie, Suzanne Miller appears to be a boyish young woman of perhaps twenty, her cropped black hair falling into her eyes. She is dressed in a trench coat, a scarf around her neck, her breath visible on this chilly winter day. As she strolls through Little Italy, she can be understood as a stand-in for the artist, a sexually ambiguous Nervalian wanderer in search of the marvelous unseen. One reason we know we're supposed to see her as an inspired poet is that Cornell has intercut the movie with lines and phrases from García Lorca's *Poet in New York*.

Birds make an appearance, of course. The film's climax occurs when Suzanne turns her head to see a flock of pigeons rise and glide through the sky. Similar moments appeared in earlier Cornell movies—birds inflaming a woman's interest. Here he intercuts the imagery with the line "Your

Solitude, shy in hotels . . ." As a result, flying birds are linked with the lonely travels of ballerinas and divas, and potently suggest the artist's longing for the female star's permanence.

Though Burckhardt filmed *A Legend for Fountains*, it was Cornell, as in all of their collaborations, who edited it. After they had finished a session of shooting, Cornell would take the rolls of film, have them developed, and work with the footage on his dining-room table. His revisions were distinctly minimal. Usually he did very little cutting, keeping nearly every frame intact, even the mistakes, the scenes that had been shot two or three times. This helps explain why *A Legend for Fountains* opens on a repetitive note, with two consecutive sequences of Suzanne Miller descending the staircase outside her apartment.

Burckhardt once tried editing some of the documentary footage himself. Using the material he had shot in Little Italy, he made a movie called *What Mozart Saw on Mulberry Street*; the title refers to a portrait bust of Mozart he had spotted in a store window. Cornell was unhappy with the results. The movie, he felt, was overedited, too neat and tight and linear, failing to acknowledge the element of chance—of undesigned, random discovery —that gave his wanderings in the city their character. "It took me a long time to realize what was wrong, in his opinion, about this film," Burckhardt once commented. "I finally realized that he just didn't like any kind of manipulation. He wanted things to be found, like his objects. He wanted them to be things that accidentally came his way. It's the opposite, say, of a Hitchcock movie, where he plans every shot: this will set them up, this will scare them. Cornell was against that, completely. He left most everything in the films."

As Cornell continued his search for actresses to appear in his films, he met many new women. Some of them starred in his films; others whom he hoped to cast never appeared in a movie at all, and he liked them no less for it. Such was the case with Carolee Schneemann, later a well-known performance artist. Cornell met her through Stan Brakhage when she was seventeen years old, an art student at Bard College with long blond hair and doll-like features. Dressed in ballet slippers and a full skirt, Carolee would visit Utopia Parkway for long afternoons beneath the quince tree. "Everything would be arranged like a little tea party," she later said, "and it was enchanting."

In spite of their age difference, Cornell, who was now fifty-two, felt comfortable around his teenage friend. He confided his artistic ambitions to her and encouraged her own fledgling efforts at art. When Carolee had her first one-man show, in a basement gallery on Minetta Lane, Cornell tried to drum up interest. "We both hope you can catch her things there," he wrote to Parker Tyler on May 22, 1956. In the case of his own projects, however, Cornell was not nearly so inviting. In a letter to Carolee on June 13, Cornell requested, "Please don't speak too glowingly about my dreams re: film to Stan [Brakhage]. After effusions I find it necessary to remind myself that a wicked amount of time has been consumed with them and very little to show as compared with my medium proper." His medium proper, of course, was box making, which he considered his main artistic activity but found increasingly difficult to pursue amid the exquisite sensual distractions of his movies.

Of all Cornell's new acquaintances, surely the most distinguished was Allegra Kent. At nineteen, she had just become a principal dancer with the New York City Ballet. Cornell had first become interested in her in October 1954, when she appeared in Balanchine's *Ivesiana*. She danced in the section called "The Unanswered Question"—a space dance, meaning she never touched the floor. Out of the darkness she appeared aloft, carried by a team of four men, as a shadowy fifth tried unsuccessfully to reach her. Cornell did not actually go to City Center to see the ballet. Rather, he sat home and daydreamed about it after seeing Kent's picture in *Newsweek*. He was so taken with her impassive, feline beauty that he actually telephoned the magazine to request a copy of the photograph for his files.

Once he started making movies, Cornell felt he had a reason to contact the ballerina personally. He hoped to cast her—to choreograph her—in one of his films, themselves a kind of ballet following the motions of women through the city. After obtaining Kent's phone number from Eddie Bigelow of the City Ballet, Cornell called her on July 1, 1956. She agreed to see him the following day at her home, a one-room apartment on East Sixty-first Street that she shared with her sister, Wendy Drew, an actress then appearing on the soap opera *As the World Turns*.

The meeting didn't go as well as Cornell had hoped. Kent, who knew nothing of his art, was taken aback by the gray specter who materialized at her door. "He was terribly thin, a strange, gaunt, intense-looking creature," she later remarked. "I noticed his hands, which were discolored from perhaps shellac or varnish. I immediately sensed that he really liked me,

which was a little scary. Fans can be crazy. You don't know what to expect from a fan. That was my fear even though he transcended a mere fan, since he had a profound knowledge of dance and related subjects, such as music." While vague about his plans for his proposed movie, Cornell told her it would involve a girl who "haunted thrift shops" and lived in the past. Without a second thought, she declined to appear in it.

Despite the chilly reception, Cornell felt flooded with inspiration after their encounter. Ten days after his visit, he began work on *Via Parmigianino (for Allegra)*, the first in a new series of boxes and collages he dedicated to the ballerina. Its title refers to a Parmigianino painting, *The Madonna of the Long Neck* (c. 1540), whose young, wide-eyed girl can perhaps be understood as Allegra Kent's Renaissance twin. Cornell used a photostat of the girl's head in his box, setting it amid a flaking white interior that returns us once again to the realm of hotel rooms and the travels of weary ballerinas.

On August 18, Cornell drafted a note to Kent explaining he had finished a box for her in lieu of a film (though the film idea was "tempting and still possible"). But his note was never sent—and it was not until 1964, when they met again and actually became close friends, that Cornell presented her with a box he had been saving for eight years, *Villa Allegra*.

As much as Kent weighed on his thoughts, Cornell remained imaginatively involved with various ballerinas whom he had never met and never would. He had an undying allegiance to Fanny Cerrito, the long-gone star of the Romantic ballet. It never occurred to him that his worship of Fanny might be a waste, taking him nowhere. Rather, he thought it took him places. His daydreams wandered to theaters he would never step inside, the distant stages where Fanny had shone a century earlier.

He was still, after all these years, amassing material for his *Portrait of Ondine*, that small black valise packed with photos, engravings, postcards, and other memorabilia. Cornell, who had always loved reading biographies, was himself a kind of biographer, forever compiling data on Cerrito, stuff on paper, a record of a life. Or was it merely a record of an absence? Like most biographers, Cornell bemoaned the inherent problems of his craft. He felt he could never have enough material, enough paper fragments, enough *objets* to completely encompass a personality. Wittily, he described his *Portrait of Ondine* as an "unauthorized biography" of Fanny.

Cornell found a way to share his dusty souvenirs with the public when

he arranged that November to have his *Portrait of Ondine* inaugurate a new art gallery at the Wittenborn Book Shop, a cozy, fourth-floor store on East Fifty-seventh Street specializing in art books. "He leaves the door ajar for further additions and a later exhibition," Lawrence Campbell noted in his review in *Art News*. Would he ever stop going backward in time, searching for phantoms?

As 1957 began, Cornell continued that search mainly through the medium of film. *Nymphlight* was his most ambitious film that year, and departs from his other movies in that it has an actual story line, or at least a beginning, middle, and end. Set in a city park, the movie takes place near a gurgling fountain and features a cast of real-life urbanites. Paunchy men read newspapers on a bench, a white-haired lady walks a dog. The main action involves a young woman who's wearing a long Victorian dress and appears to belong to another era. The film opens with her running through the park, then turning her head to watch a flock of pigeons in the sky. She disappears, and the pigeons take over. The closing sequence shows the girl's broken parasol discarded in a trash can, a reminder of the fleeting nature of fantasies.

Nymphlight was filmed in Bryant Park, the back yard of the New York Public Library. It was one of Cornell's favorite parks, in part because he spent so much time in the tomblike silence of the library's picture collection.

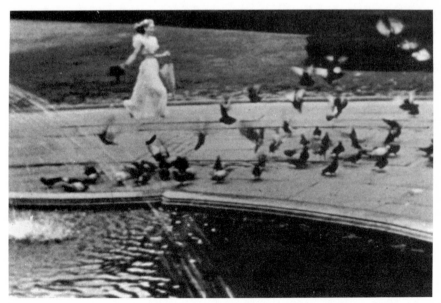

Scene from the film *Nymphlight* (Collection Anthology Film Archives, New York)

Outside, Bryant Park seemed to attract mostly derelicts and crazies, but for Cornell it held indescribable pleasures. A formal square, it had statuary, pathways, and a majestic stone fountain where he often paused to admire the inevitable city pigeons. The "star" of the movie he set in this park was Gwen Thomas, a pretty, willowy twelve-year-old student at the School of American Ballet whom Cornell had met through Rudy Burckhardt. Her mother, the painter Yvonne Thomas, was a friend of the filmmaker's, and in this mother-daughter pair Cornell found two new friends.

Nymphlight focused on Gwen Thomas's interaction with pigeons. "Cornell wanted the movie to be about a young girl going into the park and discovering the birds," she commented. "I was supposed to go and sit there and wait until the birds came. It was not that precise." Who, one wonders, are the flight-bound nymphs of *Nymphlight*'s title—the running young girl or the pigeons who so inflamed Cornell's interest?

While all Cornell's movies were conceived in a spirit of preservation, one movie was conceived to preserve the memory of a particular friend. On July 31, 1957, Pavel Tchelitchew died at age fifty-nine, after a heart attack. For the past few years, he had been living with Charles Henri Ford in a penthouse apartment in Frascati, outside Rome. Cornell, grieved by the news, decided to make a work in his memory and acted with what was for him relative swiftness. He wrote to Charles Ford on November 19: "Just recently I asked someone to take an especially moving color movie of an angel and fountain nearby and in spirit at least it is dedicated to Pavlik."

The movie he was referring to was *Angel*, another Cornell–Burckhardt collaboration. Only three minutes long, it was filmed in a Flushing cemetery not far from his house, in the brilliant light of an autumn afternoon. The angel of the movie's title is actually a statue, a conventional funereal ornament; it appears in the film's opening sequence crisply framed against an expanse of blue sky. And, as in nearly all of Cornell's movies, we see a fountain—in this case a modest structure, with dry leaves floating on the water's surface. These images have to do with seasons and mortality, and with Cornell's desire to save a spirit from oblivion—Cerrito's spirit, Tchelitchew's spirit, his own.

In December 1957, two years after his previous one-man show at the Stable, Cornell had his second and (as it turned out) last show at the gallery. Between his stints of moviemaking, he had continued to work on his boxes, though

he was no longer breaking much new ground. There was no single theme to the show; the exhibition announcement, printed on white tissue paper, instead promised "Selected Works." As was often the case, Cornell shared the gallery with other artists. There were abstract painters on the ground floor, sculptures by Isamu Noguchi one flight down, and, on the second floor, a room of Cornell boxes displayed with theatrical flair. Dark gray walls and spotlights made each box appear to recede into a well of shadow.

While most of Cornell's new boxes reworked earlier motifs, there were some new developments. As his Aviary boxes had once provided images for his movies, his movies and their city-park backdrops now provided imagery for his boxes; intimations of flying and fountains recur throughout the new work. The Bleriot boxes, named for the first man to fly across the English Channel, were empty except for a coiled spring device, suggesting flight. More successful was a second series inspired by fountains—the ingenious Sand Fountain boxes, in which a stream of sand (sometimes tinted blue) is made to pour from the top of the work into a wineglass below. The Sand Fountain boxes are part art object, part hourglass; the viewer shakes them up and down to make the sand flow into the glass. They give us eternity in a Woolworth goblet.

Then there were the Space Object boxes (also known as the Celestial Navigations). Cornell's final series of boxes, they have the trademarks of a "late" style: they combine intense emotion with an outward austerity, while casting a glance toward the heavens. The boxes are intended as a universe-inside-a-box in the most literal way. Their walls are lined with cutouts from sky charts and constellation maps; painted cork balls suspended in space on horizontal metal rods suggest the movement of planets. (Tilt a box and the balls actually roll.) Metal rings dangle from the rods, evoking all at once the earth, a performer's bracelet, and the chains from which Houdini escaped. Below, the material world beckons with an assortment of symbols, ranging from a white clay pipe—intriguingly broken into pieces—to rows of from one to six cordial glasses, each one containing its own tiny relic (a marble, a postage stamp, a sea shell, etc.) while together suggesting the like-minded members of a family.

The Space Object boxes, despite their coded symbolism, are as autobiographical as any Cornell made. Their rolling balls suggest mobility and adventure, and stand in sharp contrast to the other elements in the boxes —particularly the broken clay pipes, with their hint of sexual impotence. The cordial glasses, too, have discomfiting associations; they're brittle, fra-

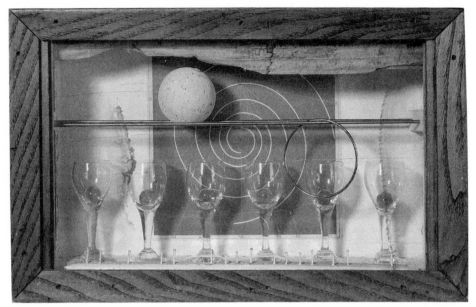

Untitled, c. 1956–59; construction, 10½ × 14½ × 3¼ in. (Collection The Joseph and Robert Cornell Memorial Foundation; photograph courtesy C&M Arts, New York)

gile, cold to the touch. All in all, Cornell's Space Object boxes, with their gently rhyming circular shapes, hark back to his very first shadow box, his *Soap Bubble Set* of 1936. Yet now the childhood bubbles have vanished; coldly orbiting planets appear in their place. The boxes hint at a longing for romantic attachment and a kind of sexual frozenness that makes romance impossible, except as experienced through the artist's solitary celestial navigations.

Cornell's final exhibition at the Stable Gallery received a good deal of attention in the press. In addition to the usual brief reviews, a lengthy feature on Cornell appeared in the December 1957 issue of *Art News*. Howard Griffin, a young poet, visited Utopia Parkway to interview Cornell for the article—the first profile of his career. The artist, wearing a nondescript sweater, entertained his visitor in the kitchen, serving coffee at the "chipped enamel table," as the article reported. Cornell apparently spoke with ease, volunteering comments on constellations, the films of Méliès, Hölderlin's madness, and other favorite subjects. Readers probably thought he was joking when he told his interviewer, "Two things have changed my life."

The first was a visit to a pet shop in Maspeth, Long Island, where, he said, "I heard a voice and I saw a light. And the second thing was on West Fifty-second Street. I saw Fanny Cerrito on top of the Manhattan Storage Warehouse."

The article, at seven pages, was by far the most extensive piece to be published on Cornell so far. If he was pleased by it, he did not say so in his journals. He did not even keep a copy of it. But then Cornell had never kept reviews of his shows, never bothered to clip them from newspapers or magazines—a startling oversight for an artist who was always snipping and cutting, who was stirred by archival passions. Perhaps even stranger than the otherworldly visions he had confided to the readers of *Art News* was this disavowal of his career. He had dozens of articles on Lauren Bacall. He had a suitcase of clippings on Fanny Cerrito. About himself, however, he had nothing. He made no effort to record his worldly accomplishments, as if somehow pained by the very notion of them.

15

Breakfast at Bickford's

1958-59

As Cornell grew older and his vigor diminished, he journeyed into the city less frequently and spent more time in Queens. To be sure, from time to time he was still struck with "wanderlust," a word that appears so often in his diary you might think he sought to roam new continents. But his travel plans were infinitely less ambitious. In fact, he wanted only to escape the tense atmosphere of his home for a few hours. In lieu of a foray to Manhattan, his wanderlust could be satisfied with a ten-minute bus ride to downtown Flushing. His usual destination was Main Street, where he might take in a new movie at the RKO Keith's, stop for a snack at Shelley's bakery, or browse in the public library. He spent many contented hours wandering the aisles of variety stores such as Woolworth's or Fisher-Beer's, in search of a special object.

Of all his Flushing haunts, his favorite was Bickford's—or "Bick's," as Cornell called it, a local outpost of the national coffee-shop chain where he would often settle in for a late and leisurely breakfast. His usual practice was to wake around 6:30 and savor the morning's spirit of "freshness" before heading downtown around eleven o'clock. Arriving at Bickford's with a book under his arm, he would read while consuming some sort of junk food—his latest weakness was for french fries. Cornell often used his time at Bickford's to keep up with his diary writing. He jotted down notations on subjects ranging from his progress on his boxes, or lack thereof, to the ever-widening pool of minor actresses who captivated him: "Joan Collins in new Esquire," he observed on March 18, 1958, adding that the article was "possibly [my] best find though completely accidental."

Bickford's had a large plate-glass window with a view of Main Street, and Cornell liked to be seated at the table fronting it. "Ringside seat by

window," he noted appreciatively one day when such fortune was his. Gazing through windows—the act always had an edge of excitement for him, even at plebeian Bickford's, where the sights he beheld were unspectacular. He wrote them down anyway, then was stuck with the jottings since he was unable to consign to the trash anything with writing on it: "June Dairy truck unloading into basement in front of plate-glass window," reads a random notation.

Most of the sights that caught Cornell's fancy were the girls on Main Street, and he recorded his sightings with an eerie fidelity. Starting in 1958, his diary became crowded with reports of nubile teenagers glimpsed on the street, as if his recent experiences in moviemaking had freed him from any inhibitions about staring. Or perhaps it was his advancing age that released in him a newly compulsive need to look. Writing up his experiences now, he referred to the girls as "teeners," and liked to remark on their clothing. He seemed to think of them as unsung versions of the famous actresses he admired—sisters stepping one by one into the burning spotlight of his vision.

Cornell reported on literally dozens of sightings in 1958 and 1959, and they leave a bizarre cumulative impression. Waiting for a bus, he observed a "teener fixing her white kerchief and hair." Heading toward the local church, he saw a "teener with red scarf, well-groomed." Waiting in line for stamps at the post office, he spotted a "Chinese teener in a striped sweater, with an exquisite profile." Inside the library, he saw some "teeners in doorway." Behind the library he saw a "teener on bench reading and eating from bag." At a subway stop, he saw a "girl in white blouse on escalator." Riding the subway, he noticed a "gal in pink linen skirt reading thick tome on Freudian theory." He was as focused on their clothing as anything about them, as if kerchiefs and skirts were themselves objects of desire.

Cornell's staring conjures up unsavory stereotypes, namely, that of the lecher in the raincoat hovering around bus stations and taking pleasure in furtive glances. Hunched at a table in Bickford's, recalling the "teeners" he had seen as he downed his breakfast of french fries and apple juice—this suggests not so much charming eccentricity as complex deviancy. Yet it needs to be said that Cornell was not a voyeur, at least not to judge by the standard definition. He did not leer through bedroom windows at disrobing women. He looked at "licit" rather than illicit sights. If he injured anyone with his behavior, it was himself. In spite of his apparent sexual curiosity,

he remained hampered, unable to allow himself any erotic pleasure besides the acts of staring and "visual possession" with which he brought images of women into his inner museum.

If Cornell's activities had an erotic edge to them, he did not acknowledge it in his diary. He had amazing powers of denial. Anxious about his desires, eager to atone for seeing what he saw, he ignored the sensuality of his gaze and focused on humanitarian thoughts instead. Time and again, he mentioned his "appreciation" of the people he spotted in public places, while worrying about the "world they are growing up in."

Cornell's gestures of sympathy were not confined to his diary. He often made donations to charities for underprivileged or handicapped children. In the late 1950s, when his diary notations were dominated by accounts of "teener" sightings, the organization he chose for his philanthropy was the New York Institute for the Education of the Blind! The organization (today the New York Institute for Special Education) is based in the Bronx and dedicated to helping blind children and teenagers. Cornell first indicated his support for the institute with a $50 donation, which in coming years would be followed by many more gifts, as well as friendships with a number of its students and staff members.

Cornell's involvement with the blind might seem to hint at his fundamental conflict over the act of seeing. As someone whose sensual life was lived almost entirely through his eyes, he might have felt blindness to be the ultimate deprivation. On the other hand, one imagines he felt deeply attracted to the blind, the safest and least threatening of living sexual objects: they could not see him seeing them.

But it seems just as likely that Cornell actually identified with the blind. Though his own vision was twenty-twenty, he had a history of psychosomatic eye problems, ranging from an unexplained case of eye inflammation at the time of his first one-man show (which had led him to use a cane) to frequent migraines and what he referred to as "eye pressures" in the decades since. Perhaps not irrelevantly, friends report that he never looked them in the eye, talking at his lap instead. It was as if he wished to be freed of his staring compulsions, to see nothing at all.

Cornell was hardly the first artist to give serious thought to blindness. "Memoirs of the Blind," an exhibition held at the Louvre in 1990, brought together some seventy master drawings by Rembrandt, Fragonard, and many others depicting blind people—fictional, historical, and biblical. Drafts-

men, like blind men, "are apprehensive about space, they apprehend it with their groping, wandering hands," wrote Jacques Derrida in the accompanying catalogue. Cornell, though not a draftsman, might be said to have explored issues of blindness in his work. In his boxes, he refused to see with an eye that was too natural, carnal, or literal. He turned his gaze inward, ignoring the body and exteriority in favor of the shadows that passed before him. His boxes are like the dream visions seen behind closed eyes.

Compared to his artwork and the waking visions that inspired it, Cornell's actual dreams can seem disappointingly banal. He often wrote them up in his diary. One night he dreamed that he and Allegra Kent were discussing stage design. Another night he dreamed of a "strange shop that had cream horns," a kind of pastry whose appellation might have arrested Freud. In yet another dream he saw Mary Baker Eddy, the long-dead founder of Christian Science, sitting on a park bench in Manhattan.

Was Cornell perfectly honest in his diary about the content of his dreams? Diaries are ostensibly written for an audience of one, yet most every diarist knows in his heart that he is writing for what he imagines to be a wider readership, and he tailors his comments accordingly. There is reason to think that Cornell was as given to self-invention as anyone and withheld from his diary information he felt was personally compromising. He may have been most candid not in his diary but with a young doctor whose office was down the street from his house and whom, in spite of his loyalty to Christian Science, he had consulted on Robert's behalf. Dr. Samuel Lerman, an internist, had started his practice a few years earlier and would come by the Cornell residence once a month to look in on Robert and clip his toenails. ("They were thick as horns," the doctor commented. "You needed a wire cutter.") The doctor had no idea that Cornell was an accomplished artist. Rather, he thought of him as a "scary kook" padding around the house silently in his slippers, his head lowered. Robert, he thought, was the more gregarious of the two brothers, since "he laughed and was jolly and was always smiling."

After the doctor had finished with Robert, Joseph would invite him into the kitchen and they would sit and talk. He seemed eager to talk about his dreams. "He would discuss them in a guarded way," the doctor recalled. "He would describe things from dreams about himself and young women. They all involved nakedness. He was troubled by his dreams; they upset him. He would talk about them in a troubled way, never looking at you. There was no eye contact during the confessions." It seems fitting that

Cornell chose a doctor to confide in, as if his desire to see women's bodies represented a disease.

During his visits to Utopia Parkway, Dr. Lerman also took note of Cornell's intense attachment to his brother. "Robert was like Joseph's child," the doctor added. "He represented the only emotional warmth in Joseph's life, the only tangible warmth." Robert was now in his late forties, and caring for him was increasingly burdensome. While Robert had his sunny moments, there were nightmarish days when his problems were compounded by epileptic seizures. Cornell felt relieved by the doctor's visits, and in a typical moment he noted: "Dr. L. for Robert's toe nails a.m.—beautiful part of day."

While uncomplaining about his brother, Cornell felt far less tolerant of his mother, who was now in her late seventies and suffering from a host of ailments. He continued to resent her incessant demands on him and was hoping his two sisters on Long Island might help him out by offering to have her move in with either of them. Though Cornell and his sisters corresponded extensively on the subject, Mrs. Cornell stayed put on Utopia Parkway, mainly because that's what she wanted. She and her son occasionally had a peaceful exchange ("lunch with mother kitchen harmonious"), but more often Cornell felt her presence as a maddening intrusion. "Just steering clear of murderous home tension," he noted in his diary on May 21, 1958. "Bickering about screens from attic."

Some relief from this depressing scenario could be found in his basement workshop. Still, his art was unremitting labor, and more and more of his time seemed to be spent just classifying his stacks of material. The ratio between the material Cornell collected and the material that ended up in his boxes was probably a thousand to one; the boxes that made it out of his workshop and into the world did not tell the story of the material left behind. In his basement, the ceiling-high shelves literally sagged from the weight of his collectibles, the cardboard boxes stuffed to overflowing with shells, watch springs, cordial glasses, owl cutouts, rings, bells, maps—a galaxy of everyday objects that accumulated around the artist as if to turn the basement itself into yet another Cornell box, mingling desire and dime-store debris.

Cornell diligently avoided the world of artistic careers and artistic feuds. Yet recognition came his way in spite of his prickliness and erratic work

pace. In 1959, he appeared in a number of group shows that confirmed his place as a leading artist on the New York scene. In January, his boxes could be seen in the latest Whitney Annual and in an equally prestigious survey show at the Carnegie Institute in Pittsburgh. In the late 1950s, his boxes also appeared in a succession of group exhibitions at the Contemporary Arts Museum in Houston. The museum was run by Jermayne MacAgy, a protégé of Dominique de Menil, the prominent Texas arts patron and a collector of Cornell's work. Overall, Cornell was generous about lending his work to out-of-town shows. While he often became unduly anxious at the prospect of a sale—a separation so permanent that he experienced it as a kind of small death—a loan was something else altogether. It meant that his boxes could reach a new public and then return safely home.

And he took steps to make sure that they stayed at home. While Cornell was happy to lend his *Façade* to the Whitney's 1958–59 Annual, he became uncooperative when a collector tried to purchase it. The offer was made through John Baur, the director of the Whitney. A memo in the museum's files, from November 3, 1959, reports: "Joseph Cornell called to say that . . . the piece we asked for is slated for traveling exhibition and he doubts if he will be inclined to want to sell it." Slated for traveling—it appealed to Cornell, this notion of his boxes journeying to the capitals of culture, like ballerinas on a grand tour.

In the two years since his last show at the Stable Gallery, Cornell had decided against having another one-man show there or anywhere else in Manhattan. Yet he found himself pursued by a new generation of art dealers, and he did agree to sell some boxes from time to time. For now he favored out-of-town dealers, as if their geographical distance could somehow separate him from the merchandising of his work. Among the newcomers was Richard L. Feigen, a distinguished art dealer who today runs a gallery in New York but who, in 1959, was still in his twenties and based in his native Chicago. His gallery, at 53 Division Street, occupied two floors beneath his third-floor residence, and specialized in Surrealism, German Expressionism, and the modern masters. Feigen soon became a regular visitor to Utopia Parkway in the hope of obtaining Cornell boxes.

Cornell would receive him with his usual style of cautious hospitality. While Feigen was denied entry into the artist's basement studio and packed garage, Cornell was willing to display three or four boxes on the kitchen table for his visitor's consideration. Usually they were fairly recent pieces, which disappointed Feigen, who had to go elsewhere to obtain Cornell's

pieces from the 1930s and 1940s. "Whenever I mentioned to him that I had acquired an earlier piece, Cornell would become tense," Feigen once remarked. "So I stopped mentioning it to him when I got an early work."

Cornell also agreed to sell a few boxes to Irving Blum, later a founder of the Blum Helman Gallery in Manhattan. An aspiring actor who spoke in a booming baritone and was often likened to Cary Grant, Blum had just been hired to run the Ferus Gallery in Los Angeles, the first gallery in the city to specialize in the California avant-garde. Founded in 1957 behind an antique shop on La Cienega Boulevard, the Ferus was owned by the artist Edward Kienholz and Walter Hopps, a young art historian at Stanford. They started the gallery after writing out an informal contract on a hot-dog wrapper; before long they had brought in Blum to provide day-to-day management and front-office elegance.

Blum first met Cornell in 1959, after calling him up and asking if they could meet the next time Blum was in New York. He later recalled Cornell warily asking him, "What do you do, Mr. Blum?" The art dealer had no choice but to confess. "Well, you know," Cornell softly replied, "I don't see dealers. I'm taking a respite from showing."

Blum eventually managed to finagle an invitation from Cornell by saying he wanted to "just look." He came away from his first visit to Utopia Parkway with a substantial purchase: four boxes, though all of them were "variants," as Cornell called his recent variations on earlier themes. The earlier pieces Cornell kept for himself; the "variants" he sold to the dealers. This was all fine with Blum, who was relieved to get any work at all from Cornell and who, on many future visits, left the artist's house happily carrying another group of newly purchased variants.

Blum's delicate negotiations with Cornell were aided immeasurably by his Los Angeles address. "I couldn't tell him enough stories about Hollywood and movie stars," the art dealer said. "He wanted to hear Marilyn Monroe stories. I had never met her, but I certainly came up with stories! Eva Marie Saint"—who had already appeared in *On the Waterfront* with Marlon Brando—"used to come into my gallery and I once got her to write Cornell a letter, which I carried to New York and gave to him. He was beside himself with happiness." As much as Cornell appreciated Blum's dispatches from the West Coast, one imagines that he agreed to exhibit at the Ferus because of its very distance, which guaranteed, among other things, that the artist would never have to see his own shows.

At least one New Yorker, however, did manage to procure a Cornell box

during this period. Cornell felt gratified when Marcel Duchamp renewed their friendship in the mid-1950s, visiting Utopia Parkway with his new wife, Teeny, the daughter of a Cincinnati eye surgeon and the previous wife of the art dealer Pierre Matisse (the son of the great painter). Cornell took an instant liking to her, and she later remembered several visits to Utopia Parkway when Cornell served the couple tea and set up his projector in the living room for a private screening of his "very old movies." On one of their visits, Duchamp and his wife both admired a box from Cornell's Sand Fountain series, those hourglass-like works contrived from a goblet and tinted sand. Duchamp, too, had once made a *Fountain*—the title he gave to his readymade urinal of 1917—and of course was himself a master of glass. Gazing at Cornell's comparatively chaste Sand Fountain box, Duchamp wondered aloud, "What period of sculpture does it remind you of?" There was talk of ancient Egypt and of Greek excavations. Cornell was delighted, and agreed to sell Duchamp the piece at a special price.

Julien Levy did not fare nearly so well. He was visiting Duchamp's apartment one day when, as he later wrote, he "saw a beauty"—the newly acquired Sand Fountain box. Levy was determined to get one for himself. In the decade since he had closed his gallery, Levy had watched the rise in Cornell's reputation with mixed feelings. While proud of his "discovery," he was frustrated to see everyone profit from Cornell's success except him. He had failed to purchase much of the artist's work for his own collection in the years when it was available for next to nothing and so had little to show for his early recognition of Cornell's talent. He owned only one of his boxes, *L'Egypte de Mlle Cléo de Mérode*. Perhaps because he had given Cornell his very first exhibition, Levy assumed the artist would happily do him the small favor now of selling him one of the dozen or so works in the Sand Fountain series. But Cornell, ever wary of art dealers, refused, and Levy had to settle for a box from the Dovecote series instead.

As Cornell grew older, he became more suspicious of anyone who tried to purchase his work. As the value of his boxes increased—they were now fetching about a thousand dollars apiece—so did his discomfort about their commodity status. He had never liked selling his boxes in the first place, preferring to give them away to actresses and young female friends who he felt could understand their purity of spirit. While he needed money, his expenses were minimal—the house was paid off, he would never see Paris, he didn't drive—and he could afford to turn away collectors.

Cornell had recently started making collages again for the first time since

the 1930s, in part to replenish his supply of gifts. "He could no longer expect a young corps-de-ballet dancer, presented with a keepsake [box], to stow it on her dressing table," Donald Windham once noted. "It was too valuable not to be sold or stolen." The collages, however, which sold for under a hundred dollars, were relatively untainted by market values. As withholding as he was with collectors, in coming years Cornell would give away dozens of collages to his friends and acquaintances.

In the meantime, hopeful buyers continued to arrive at Utopia Parkway. Among them was Edwin A. Bergman, a name well known in the annals of American art collecting. In 1982, he and his wife, Lindy, would donate to the Art Institute of Chicago some thirty-seven boxes and collages by Cornell, about half their holdings. No museum anywhere has a better selection of works by Cornell.

Bergman, an affluent Chicago businessman, was the sort of collector that most artists dream of knowing but are rarely fortunate enough to find—a man of tremendous means who thought of art as something more than a financial investment. When artists meet such a collector, their response is often the same: they become miraculously charming beings, and even the most surly are likely to invite the collector to openings, meet him for dinner, and volunteer helpful comments about their work. Cornell, however—need one say?—would extend none of these courtesies to Bergman. Because he was reluctant to part with his works, he would later look back with genuine regret on the day he first allowed Bergman into his home.

They initially became acquainted in the fall of 1959, not long after Bergman purchased his first Cornell box from the Frumkin Gallery in Chicago. Deciding he had to meet Cornell, Bergman sent him a letter. But his letter went unanswered. Despite the rebuff, Bergman's interest intensified. For help he turned to Piero Dorazio, an Italian painter whom Cornell had known since their days together at the Stable Gallery. Dorazio was now living in Rome, and it was at his home that he and the collector hatched a clever plot. Dorazio proposed that Bergman write to Cornell saying he wanted to visit Utopia Parkway not to purchase a work of art but rather to drop off a "package" from Dorazio. The assumption was that when Cornell heard the word "package," with its intimations of a European surprise, he would be unable to resist.

Their guess proved correct. On September 11, 1959, Cornell entertained

Bergman and his daughter, Carol, at Utopia Parkway. They ended up staying all day. Bergman, a warm and affable man of forty-two, ate with relish when Cornell offered him a snack of "stale sweets," and was thrilled when his host agreed to sell him a recent Night Skies box for a thousand dollars. Cornell was so captivated by the collector's fourteen-year-old daughter that he gave her a collage, *Untitled* (*Julie Spinasse*), at no charge. Writing to Bergman on September 20, Cornell sounded appreciative of his new patron, reporting that the box had been shipped via Railway Express and thanking him for "bringing me the fairy tokens from the Dorazios."

Bergman, a Chicago native, had made his fortune in his father-in-law's aluminum-smelting business, the U.S. Reduction Company. ("Aluminum Alloys for Every Occasion" was the company's not-so-catchy slogan.) He and his wife had started collecting in the mid-fifties, following the lead of their friend Joseph Shapiro, a Chicago businessman with a premier collection of Surrealist work. The Bergmans, too, were interested in Dada and Surrealism, and in the next three decades built up a collection that was one of the best of its kind in the country. They had in-depth holdings of the work of Max Ernst, Matta, and other European masters, but became best known for their unrivaled holdings of an American: Cornell.

Six weeks after his first visit to Utopia Parkway, Bergman traveled from Chicago to New York again. He purchased two more boxes, *Untitled (Sun Box)*, of 1955, and *Untitled (Dream World)*, of 1957. He hoped to acquire some earlier pieces and was especially fond of the ballet-related work from the 1940s, but Cornell, not surprisingly, declined his request. Already the artist was beginning to withdraw from their relationship, even if Bergman was the only collector to be purchasing his work in a serious and sustained way. In a letter to Bergman of November 8, Cornell cautioned him: "Yes, I should enjoy 'corresponding' but until certain aspects of my work are resolved I'd better be preoccupied more with actions than words."

As Cornell fretted, his mother rejoiced at their good fortune. Here was this Chicago Maecenas who was spending thousands of dollars on her son's work and who, moreover, was unfailingly considerate, not only of Joseph, but of herself as well. Mrs. Cornell found Bergman to be a perfect gentleman, and began her own correspondence with him, sending off notes to thank him for "your nice visit and . . . the beauty of those anemones. They lasted 10 days and were just lovely . . . What a lucky mother I am to enjoy meeting all you wonderful people."

While Bergman continued to visit Utopia Parkway on his frequent busi-

ness trips to New York, he could not always count on coming away with a box or two. In spite of his mania for collecting, Cornell could not stand it when someone tried collecting *him*. Bergman's bulk purchases made him uncomfortable; it pained him to think of one person owning so many of his boxes. Moreover, Bergman was an enthusiastic collector, but by his own admission, he felt no great empathy with Cornell. He once said of the artist, "He spoke English, of course, but he was off in another world."

Still, Bergman loved the boxes and continued to acquire them however he could. If Cornell wouldn't sell, Bergman didn't necessarily need his permission to buy from art dealers, and he purchased many choice pieces from Frumkin and Richard Feigen in Chicago and Eleanor Ward in New York, among others. News of his purchases got back to Cornell, who was not pleased. His letters became icy: "I regret that I shall not be able to take any phone calls or enjoy visiting with you during your coming trip, and my family joins me in regrets."

Eventually Cornell picked a fight with his patron. It started when Cornell instructed Bergman to return on his next trip to Utopia Parkway with photographs of the works he owned. "I brought pictures," Bergman explained. "I guess I might have had twenty boxes at that time. He looked at the pictures and cried, 'Oh my God, I don't make boxes like this anymore. Why did I ever sell this one?' And 'Oh my God, I never should have sold that one,' and 'How did this one ever get into your hands?' "

Cornell later told various friends that he rued the day he met Bergman. He felt the collector owned "too many good boxes," as he once complained to William Copley, the artist and dealer. Bergman felt hurt by their rift, but could do nothing to repair it. In later years, he once wandered into a Manhattan gallery and tried to buy a Cornell box, only to hear an art dealer remark: "You're Bergman from Chicago? I'm not supposed to sell you anything." Nonetheless, to the end of his life, Bergman would continue to collect Cornell's work on the sly, purchasing his boxes and collages at various galleries around the country.

As 1959 drew to a close, Cornell received more support from Chicago. The Art Institute of Chicago tapped him for a prestigious survey of contemporary art, the 63rd American Exhibition of Painting and Sculpture. On December 2, the day before the show opened, Cornell was awarded a $1,500 prize for his collage *Orion*, which continues the theme of his astronomy boxes while

introducing a new character, Orion, the hunter from Greek myth who was blinded as punishment for falling in love. To see or not to see—for Cornell, that was the question.

That same month, Cornell was given a one-man show at Bennington College in Vermont. The women's school had a reputation for putting on shows that captured the brashness of the New York scene. Its New Gallery, which was located in a carriage-barn on campus, had opened in the spring of 1958 with the first retrospective anywhere of Barnett Newman's work. The gallery was then run by E. C. Goossen, a critic and art historian at the college who was a great admirer of Cornell. At a time when the art world still operated in a casual fashion, Goossen was able to assemble a virtual mini-retrospective of Cornell's work with relative ease. After telephoning the artist to see if he was interested, Goossen headed to Queens in his station wagon to pick out boxes—seventeen in all—and drive them up to Bennington. Cornell liked the idea of reaching an audience composed mainly of students (and female students at that), and in the course of his conversations with Goossen he surprised the art historian with his transparent desire to meet a few of them. "He kept asking if I knew of any girls who could work for him," Goossen commented.

Cornell gave an elaborate title to his Bennington show: "*Bonitas Solstitialis*: Selected Works by Joseph Cornell and an exploration of the Colombier" (November 20–December 15, 1959). The Bonitas phrase was merely a Latinate way of wishing the students happy holidays (did he draw on Latin in memory of his own school days?); his promise of an "exploration of the Colombier" referred to a new work designed for the show that was neither a box nor a collage but something altogether different. He had sent along a cardboard box containing material relating to the theme of *colombier*— French for pigeon house or aviary. At his request, the material was tacked to a wall of the gallery, which became a kind of arcane bulletin board. It was not the first time Cornell had chosen to display found photos and cutouts untransformed by his creative alchemy, as if the images he clipped from magazines were themselves autonomous objects of beauty.

Cornell, of course, did not travel to Bennington to see the show, excusing himself on the basis of his "home responsibilities." Writing to Richard Feigen on December 22, a week after the show closed, he wondered dejectedly whether the event had been worth his time. "The Bennington thing was too far afield to expect results from," Cornell lamented. "I do not believe

the student response was of sufficient intensity to warrant such preparations." It was typical of Cornell's ambivalent nature to prefer showing his work in out-of-town settings removed from the Manhattan art circuit and then regret the lack of attention.

Still, the season was not without its rewards. He considered December "a wonderful time of year to revive precious memories," as he wrote to Feigen, and managed to find satisfaction in the completion of a box he'd started years earlier. The last few days of 1959 were spent working on this Juan Gris cockatoo—one in a superb series of bird boxes dedicated to the quiet master of Cubism.

Cornell had first begun his Juan Gris series in the autumn of 1953, after stumbling upon one of his paintings on Fifty-seventh Street. He later wrote: "The original inspiration was purely a human reaction to a particular painting at the Janis Gallery—a man reading a newspaper at a café table covered almost by his reading matter." The painting was *Figure Seated in a Café* (1914), in which a man is hidden behind his morning newspaper, his face an insubstantial flicker of shadow compared to the blocky pages of *Le Matin*.

On the surface, Gris may seem like an unlikely muse for Cornell. Over the years, many artists had aroused his curiosity and enthusiasm, but he had never dedicated boxes to them. Instead, he chose the likes of Emily Dickinson or Fanny Cerrito, or even mad King Ludwig II, selecting figures outside his field and eschewing the canon of Western art. To tether himself to another artist was to bespeak his ambition, not an easy admission for Cornell. His Juan Gris boxes are his only boxes openly dedicated to another artist. Aesthetically, they were kindred spirits, these two artists who loved the world of mass production and sought to extract a measured poetry from ordinary things—wineglasses, windows, and the like. Behind its fragmented imagery, almost every Gris painting is a precisely rendered still life, as is every Cornell box.

It was often a person's life as much as his art that drew Cornell into an imaginary relationship with him or her; this was certainly true of his "relationship" with Gris. As the often overlooked third in the mighty Cubist triumvirate that also included Picasso and Braque, Gris doubtless appealed to Cornell's love of marginal figures. New York was a city full of obsessed artists, and for most artists of Cornell's generation the main obsession was Picasso. In choosing Gris as his muse, Cornell chose an artist who was not only overshadowed by his peers but whose version of Cubism—which was

more severe and classical, and less spontaneous than that of Picasso and Braque—paralleled Cornell's own relationship to Cubism as expressed through his collages and the collaged interior of his boxes.

And Gris's life was as difficult as any. He died prematurely, at the age of forty, in 1927; his struggles with poverty and severe depression were well known. Not irrelevantly for Cornell, Gris found an escape in his passion for dance and the ballet. It surely was noted by Cornell that Gris had nearly the same name as a diva he prized, Giulia Grisi.

Cornell completed at least fifteen boxes relating to Gris between 1953 and the mid-sixties, making the series one of his most extensive. The works are easy to recognize. Most of them feature the omnipresent cut-out paper bird—in this case often a white cockatoo—perched gracefully in a habitat whose walls have been collaged with paper texts. Whereas previously Cornell had set his birds in bare white rooms or hotels with peeling walls, his Gris boxes are set in what might be called Cubist parlors, small rooms whose high, narrow walls are covered with wood-grain paper, black silhouettes of bottles, and other elements borrowed from Cubist collages.

Probably the best work in the series is the *Untitled (Juan Gris)* box owned by the Philadelphia Museum of Art, in which the familiar white cockatoo perches gracefully on a branch. Behind it we see a wall of newsprint, its black-and-white austerity relieved by the addition of a radiant blue window directly behind the bird's crest. When we peer inside this Juan Gris box, what room are we seeing? Are we inside Cornell's basement workshop, that cramped space overflowing with books and newspaper clippings? Or are we across the world in Paris, in Gris's studio, where he glued snippets of newsprint onto canvas as if to announce (to borrow Ezra Pound's line about literature), "Art is news that stays news"?

Cornell himself seems to have thought of the boxes very differently. From the evidence of notes he made in his diary, we know that he associated the Gris boxes with the nineteenth-century diva Maria Malibran. This link has confounded art historians intent on decoding Cornell's symbolism. Yet if we accept that the white cockatoos—like so many of Cornell's birds—are literally stand-ins for Malibran, a "bird of song," the intended meaning of the Gris boxes becomes clear. They are mute arias all, bringing the sublime pleasures of music into Gris's studio. Malibran and Gris were both Spaniards who died young; Cornell sought to unite them. Her silent but demonstrative presence—evoked not only in the form of the bird but in the metal bracelet dangling above it—is intended to console Gris, offering him a flight of

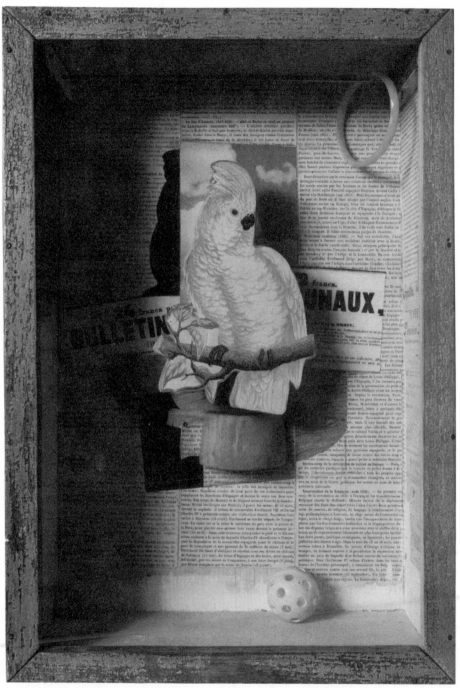

Untitled (Juan Gris), c. 1953–54; construction, 18½ × 12½ × 4¾ in. (Collection Philadelphia Museum of Art)

escape from everything oppressive about his life. The entire series might be
viewed as a *Serenade for Juan Gris*, as two of the boxes are actually titled.

Cornell enjoyed conducting research into Gris's life and immersing himself
in the literature about him. He ended the year in a good mood brought on
partly by the discovery of a new book. On Christmas Eve, 1959—his fifty-
sixth birthday—he recorded in his diary a happy evening at home. Gazing
out the window at a neighbor's house, he was amused to spot an angel
enshrouded in blue (electric) light. He spent the night reading a new book
on Cubism by the British art historian John Golding, all the while remem-
bering "this image of the teener in the library," a young girl in a black
kerchief he had spotted the day before.

Looking at art books, glancing out the window, gawking at girls in the
public library—these are very different activities, yet each calls forth strong
feelings while demanding no social interaction. At times it seemed that the
act of looking, the search for phantoms, brought Cornell whatever happiness
he knew.

As he sat at home that Christmas Eve, Cornell had other reasons to feel
content. A year was almost over, as was a whole decade, and if he looked
back on the fifties he must have felt gratified. It had been a prolific decade
for him. He'd had three shows at the Egan Gallery, two at the Stable, and
produced an extraordinary body of work. First came the caged birds of his
Aviaries and then a wild creative flight. The boxes had taken him to gridded
Dovecotes and starry Observatories, to the bedroom of Emily Dickinson,
the parlor of Juan Gris, the hotel rooms where Fanny Cerrito once rested
—nearly all of this expressed in white-painted boxes notable for their spare
eloquence.

True, the art dealers and collectors were already clamoring for his earlier
work, the boxes from the 1940s. Today, too, there remains disagreement
over the value of the various periods of Cornell's work. Some feel his work
declined in the 1950s, when his boxes went white and shed their symbolist
trappings; dealers can tell you that the Surrealist-influenced boxes from the
1940s, especially pieces from the Medici Slot Machine series, bring the
highest prices. The art market is a sincere critic but hardly a very discrim-
inating one. Not nearly enough attention has been paid to the boxes from
the 1950s, particularly the Aviaries, which are among the high points of
Cornell's career and offer a stunningly austere counterpoint to the more

literary works of the 1940s. A great late style combines "intense emotion and outward stillness," the art historian Erwin Panofsky once wrote in reference to Titian. Cornell's boxes from the 1950s suggest a similar conjunction of opposites and deserve to be seen as works of a triumphant late phase, or at least a later phase. He had arrived at them through a strange convergence of private need and art-world events, distilling the concerns of his earlier art just as Abstract Expressionism was calling for an art of blunt gestures.

But by 1959, of course, the adventure of Abstract Expressionism was over. Jackson Pollock had been dead for three years, killed in a car crash at age forty-four. And Willem de Kooning, of whom Cornell was so fond, could no longer be found in his loft on East Tenth Street. He, too, had moved out to East Hampton, signaling the end of the bohemian scene that had swirled around him. Charles Egan had shut down his gallery, and many of the artists who had exhibited alongside Cornell had gone to the more commercial Janis Gallery, a symbol of the growing prestige of American art and the prices it was beginning to command. What was once a boundary-breaking movement had by now become just another "ism" for the textbooks.

Cornell had now outlived two avant-garde movements, Surrealism and Abstract Expressionism. The end of a movement can often augur the end of an artist's career, condemning him to obsolescence. But Cornell, who never joined any one movement, could not be brought down by any movement's demise. He would continue to develop his art in the coming decade, the 1960s, when he became interested in the Pop artists and they became even more interested in him.

16

Pop Goes the Art World
1960-63

When did the 1960s art scene get under way? Perhaps in February 1957, when Leo Castelli opened a gallery in the living room of his apartment at 4 East Seventy-seventh Street. Visitors squeezed into a small elevator for the ride to the fourth floor, where they were greeted by the ferocious barking of the art dealer's dachshund. Castelli wasn't sure which artists he wanted to show at the gallery, and initially sold Picassos and Matisses along with the work of Paul Brach, Norman Bluhm, and other second-generation Abstract Expressionists.

But his direction soon became clear. In January 1958, Jasper Johns's first one-man show at Castelli left everyone in the art world talking. The story of his debut, which brought together paintings of targets, numbers, and the American flag, is now well known. His work could not have seemed more incendiary had he decided to *burn* the flag. What, after all, could a painting of a flag, even if it was painted in lush encaustic strokes, reveal about the mysteries of existence? Nothing that easily revealed itself, and that was the point. As Johns himself later said, "I don't want my work to be an exposure of my feelings."

In the midst of the excitement over Johns's new work, no one paused long enough to realize how much it owed to Cornell. Works such as *Target with Four Faces* and *Target with Plaster Casts* (both from 1955) appropriate the Cornell box in the most literal way: a row of three-dimensional wooden boxes is lined up across the top of each painting. While Johns's work was introduced by his champions as a direct descendant of the Duchampian readymade, its basic tenor—the melancholy symbolism, the tender nostalgia, the boxed, compartmentalized forms—is much closer to Cornell.

The two artists met only once, in an accidental encounter in 1952. Johns

was then an unknown artist working as a clerk at the Marboro bookstore on West Fifty-seventh Street. One day Cornell came in and asked for two books, which he said he wanted sent. Johns recalled, "I asked him what his name was and he couldn't answer. He couldn't say." Johns had Cornell fill out the mailing slip himself. Looking at it afterward, Johns recognized the name and was astonished by this artist who seemed even more secretive than himself.

As a new generation of artists emerged in the 1960s, Cornell gained many new admirers. He was one of the few artists on the New York scene whose reputation transcended partisan cliques, and it was hard to find a young painter or sculptor who did not admire his work. By now Cornell was in his late fifties, but he looked about a decade older, a pale, gangling man with white hair, his high forehead rendered ever more bony by his receding hairline. With his long saint's face and wracked features, he was beginning to look a bit like Samuel Beckett. Younger artists knew who he was and were respectful when they had the good fortune to cross his path.

Castelli, soon to emerge as the celebrated purveyor of Pop art, was interested in showing Cornell's work. After opening his gallery, he visited Utopia Parkway in the hope of purchasing some boxes, but Cornell refused to sell him any. On a second visit, Castelli tried harder. Having heard that Cornell was fond of girls, he brought along Lee Bontecou, a striking young artist who he hoped could entice Cornell to part with a couple of boxes. Cornell was predictably enchanted by Bontecou ("extraordinary creature," he gushed in his diary), but could not be swayed in his feelings toward the art dealer. "He was reluctant to sell," Castelli commented years later, "and his prices seemed high to me. He did prepare some very nice tea which was properly served. He was a very mysterious character, and you really could not communicate with him except by looking at his work."

Castelli was hardly the only art dealer who found Cornell uncooperative. Since his last show at the Stable Gallery, in 1957, Cornell had drifted away from the gallery without joining another one. Eleanor Ward pleaded in writing for his return ("We receive constant requests for your work"), but without success. Cornell's exhibitions became erratic as he shuffled restlessly from one gallery to another, showing a few boxes with Rose Fried, a few with Allan Stone, a few elsewhere, making it hard for even his most devoted admirers to keep abreast of his work.

Cornell continued to prefer out-of-town dealers to New York ones, but could be difficult even so. While Cornell allowed Richard Feigen to exhibit

his boxes at his Chicago gallery, Feigen wasn't always permitted to sell them. On January 17, 1961, Cornell instructed the art dealer by telegram: KINDLY FREEZE ALL UNSOLD WORK. Two months later, he sent another dispatch: KINDLY KEEP UNSOLD WORK FROZEN. In response to the news that a collector had put a reserve on a particular work, Cornell fired off yet another telegram: SORRY BUT MUST REQUEST THAT 'HOTEL' BOX REMAIN FROZEN. KINDEST REGARDS.

Cornell had never followed fashion, but now it followed him. With the rise of Pop art, his recycling of non-art materials acquired a startling relevance. Pop art marked more than just another abrupt transition in the ruling order of art. It also signaled the vindication of mass culture, and Cornell had been mixing up boundaries—between high and low, between art and debris—long before doing so became the mission of contemporary art.

Long before Rauschenberg started mixing images and real objects into his discordant "combines," Cornell was working with marbles and metal rings. Long before Roy Lichtenstein made paintings based on advertisements, Cornell was pasting cut-out ads for chocolates and hotels into his boxes and collages. And long before Andy Warhol painted portraits of Elizabeth Taylor and Marilyn Monroe, Cornell, easily his match in being star-struck, was creating tributes to Greta Garbo, Hedy Lamarr, Lauren Bacall, and other movie stars of his generation. As to Marilyn Monroe, Cornell beat Warhol to the punch; he had kept a special dossier on her since 1955.

To be sure, Cornell specialized in a fragile poetry that had nothing in common with Pop art's screaming irony. And the scale of his work was very different from the billboard-like productions of Pop art. Cornell's instinct was to work small. His genius was an intimate one; many of his best boxes are just a foot high, and they speak their secrets in a whisper. Still, Cornell deserves recognition as a forerunner of Pop art.

Cornell's influence could also be felt on Minimalism and its various offshoots. The critic and poet John Ashbery was the first to comment in writing on the link between Cornell's boxes and "the radical simplicity of artists like Robert Morris, Donald Judd, Sol LeWitt or Ronald Bladen." Indeed, the formal spareness of Cornell's Hotels, Dovecotes, and other whitewashed boxes from the 1950s appealed to the more geometry-inclined artists of the 1960s. LeWitt, who was then just starting work on the modular aluminum cubes that secured his reputation as a Conceptualist, put it as

well as anyone when he observed: "I think Cornell was ahead of his time by using this sort of reductive approach. Nobody was doing that stuff then. They were doing Abstract Expressionism or just expressionism."

The depth and intensity of Cornell's influence has not been properly considered. Perhaps art historians have slighted him because he was so quick to downplay his own efforts. By introducing recycled objects into his work while presenting them with an almost priestly austerity, Cornell helped prepare the way for the two opposing groups that dominated the 1960s art scene—the jesters of Pop and the monks of Minimalism.

Yet Cornell exerted his largest and most direct influence as a pioneer of another movement altogether—assemblage, which refers to three-dimensional art which is neither carved nor molded but assembled from found objects. The movement had gotten off to a dignified start with Picasso's collages of newsprint and crayon, but it was in the hands of Americans that assemblage found its most eloquent expression. All his life, Cornell had eschewed painting and sculpture in favor of marginal materials. It did not occur to him that one day the marginal would become mainstream.

Cornell received deserved attention in the fall of 1961, when the Museum of Modern Art organized its great salute to the scavenging instinct, "The Art of Assemblage." The show was curated by William Seitz, a well-liked professor who had recently left the faculty at Princeton to join the museum staff. He gave Cornell a leading role in the "Assemblage" show. Along with Marcel Duchamp, whose readymades occupied their own gallery, and Kurt Schwitters, who was represented by three dozen collages, Cornell was given a show within a show. Fourteen of his best boxes were displayed in a theatrically darkened room dominated by his *Medici Slot Machine* (1942).

Though proud of gaining recognition alongside Duchamp, Cornell did not relax his critical view of the Museum of Modern Art. In a letter to his sister of September 11, 1961, he reported calmly: "The MoMA is giving me a section (alike with Duchamp & Schwitters—a little room apiece) in an all-over exhibition of assembled art . . . I have been thinking of trying to get away from any resultant business in connection with it. It's all borrowed from collectors. There's a ring of the pretentious in about everything they do."

In retrospect, Cornell viewed the "Assemblage" show as a turning point in his creative life. He spoke of an impasse in his work immediately following

the exhibition, which he blamed on the stresses of his domestic situation. While he continued to appeal to his sisters for help in caring for their mother, no assistance came his way. Mrs. Cornell by now was nearly eighty years old, but by no means too frail or aged to stop provoking Joseph. Visitors to their home were invariably taken aback by what they saw: an ancient widow and her bachelor son locked in a dance of rancor.

It was nearly always the same. When visitors arrived, Mrs. Cornell would greet them at the door, a stout matron in a black dress with a lace collar, her gray hair in a bun. Although she liked to meet curators, collectors, and whoever else came to the house, Joseph made no effort to include her as he escorted his guests down to the basement or out to the garage. Not that this kept Mrs. Cornell from mingling with his visitors. Trailing after him, she would criticize his behavior, her comments filling the air like darts. "What I remember most of my visit was the tension between Joseph and his mother," David Solinger, then president of the Whitney Museum, later commented. "Nothing was said without an edge."

Mrs. Cornell could be counted on to receive her son's female guests with added harshness. The art historian Dore Ashton first contacted Cornell in connection with a magazine article she was writing. "I thought of his mother as a big oak tree blocking the door," Ashton once remarked. "She was a terror, that lady, so ungracious, glowering at me from across the room." Other visitors came away with a disturbing memory of Mrs. Cornell's belligerence toward her children. When Julien Levy paid a visit with his new wife, Jean, Cornell asked his mother to stay upstairs while he discussed some business with his former art dealer in the basement. "She was resentful that she wasn't included," Jean Levy noted. "She was like Queen Victoria and she had her two sons under her thumb. She talked Joseph down and blamed him for everything, and just ignored Robert."

Cornell's deteriorating relationship with his mother could not be blamed solely on her advanced age. Their day-to-day conflicts were aggravated by what appeared to be a new urge for independence on Cornell's part. In his dealings with his mother, Cornell had long ago retreated into resignation. Sexless loyalty was her implicit requirement, and for years he obliged. Yet his obedience no longer brought him peace of mind. As Cornell grew older, he longed for some kind of transforming experience, and seemed increasingly unable—or unwilling—to keep his sexual instincts at bay. In his sixties, he found himself weakening in the face of temptation. Perhaps there is a connection between the falling off in his work in the sixties and his sudden

willingness to risk sensuality. Art mattered little compared with the sad prospect of an unlived life, and he was determined not to grow old without having tested his instincts.

A telling incident occurred in July 1961, after the distinguished film-maker Hans Richter, a founder of the Dada movement, wrote to Cornell to generously offer him surplus reels of film from his personal library. Cornell crankily informed him that he already had "too much" material, though nudity was always of interest. Richter replied on October 9: "I found 2 little rolls of nudes by accident among my material for Dadascope" and obligingly sent them along.

Eager for female companionship, Cornell thought about hiring an assistant to help organize his basement workshop. Silently, he addressed her in his mind. He imagined her sorting his papers and books, diligently clipping magazines for his extensive files. In May 1960 he placed an advertisement in the classified section of his local newspaper, the *Long Island Star-Journal*: "Girl Over 16 Fine Scissors Work on Pictorial Clippings Assisting Artist —limited Part Time."

Cornell's first assistant arrived not through the help wanteds but through his network of friends. She was Carolee Schneeman, the future performance artist, whom Cornell had met a few years earlier through Stan Brakhage. They agreed that she would assist him a few days a week, organizing his workshop and the boxes stored in his garage. It soon became clear that Cornell saw any change, no matter how mild, as a personal threat. One day Carolee was rummaging around the garage when she discovered an exquisite drawing by de Kooning, a gift inscribed to Cornell. "Put it back," Cornell told her in an annoyed voice, "I don't want to think about it." She also found an inscribed drawing from Max Ernst; and that, too, Cornell told her, "was really too much to deal with." Left with nothing to do, she took refuge under the quince tree in the back yard and quit after a few days.

Cornell soon found another assistant with the help of Eugene Goossen, who had organized his Bennington College show and who now came through on the promise he had made to find Cornell a female helper. Pat Johanson, who started work in January 1961 (and whom Goossen would later marry), was a junior majoring in art and was thrilled at the prospect of spending a semester in New York in the company of an important artist. During her first days on the job, Cornell struck her as a charming oddball. It was the dead of winter, and he would toss bird seed on the kitchen table and open a window so that sparrows flew in from the yard. The birds ate off the table

as Cornell looked on, as if willing the dream of his Aviary boxes into life. "When you saw the man *in situ*," she later remarked, "that was the interesting part: he lived all those tableaux that appear in his boxes. All of them."

But Johanson, an attractive brunette, soon became afraid of Cornell. There was something disturbing about the attention he lavished on her. She suspected that he looked at her in strictly sexual terms and was twisted by ungratified desire. "Whenever I arrived," she said, "he would chase his mother upstairs, and if she didn't want to go, he'd become insistent. 'Out, out, out.' I think he wanted to be alone with me. I think he wanted to just look at me." Acting with uncharacteristic impatience, Cornell brushed aside Robert as well. One evening he served his brother a Swanson's frozen dinner without bothering to heat it up. "It was so pathetic," Johanson said. "Robert just sat there stabbing at this piece of ice with his fork."

After Johanson had been working for Cornell for about a month, she went downstairs to the basement one day and was startled to find *Playboy*s and other girlie magazines lying open on his worktable. Suddenly the basement acquired an ominous air, and she shuddered at the sight of his "shoeboxes filled with little pink plastic dolls from Woolworth's, with arms in one box and legs in another and torsos in another." Did Cornell fantasize about sex with her? Did he imagine sadistic acts that gave him power over women? She quit that day, though Cornell would continue to court her with letters and phone calls.

It's not hard to understand why Cornell could seem a little scary, eyeing women with a tense excitement that suggested the dry harsh breath of lechery. Yet if anyone suffered from his anomalous behavior, it was he. As much as he seemed to long for a normal sexual life, he remained unable to initiate relationships with women who might return his affection. Instead, he settled for imagined intimacies with actresses, who continued to command leading roles in the dark theater of his desires.

Cornell's latest crush was Patty Duke, who was all of fifteen years old and already a veteran actress; she had appeared in the stage and film versions of *The Miracle Worker*. On March 24, 1962, Cornell attended a matinee performance of her latest Broadway show, *Isle of Children*, in which she played Deirdre Striden, a young girl who is dying from a heart condition and trying to make sense of her fate. The next morning, at "7:25 a.m.," as he noted in a fan letter to her, Cornell sat down at the kitchen table to compose his tribute. "Dear Miss Duke," it began. But he crossed that out and started again. "Dear Deirdre," he wrote instead. By nightfall, he had

discarded several drafts and was still trying to perfect his letter. "It just comes over me now—towards midnight—the sadness of not being able to see Deirdre again—and it is unbearable to think of you being sad, but the serenity and radiance that pervaded your curtain call—that is something to remember."

Presumably Cornell finally managed to compose a letter to his satisfaction, and to send it off with a trinket of his affection. Surviving among his papers is a handwritten note from Patty Duke, which starts off like this: "Dear Mr. Cornell, Thank you for your most unusual and beautiful gift."

Cornell was aware that he was prone to obsessive behavior, and at times it saddened him to think how little control he had over his feelings. Yet in brighter moments he wondered whether his emotional turmoil might instead be seen as a sign of his authenticity as an artist. In October 1962, he was visiting the Flushing library when he came across an article by John Updike and took the trouble to copy down one sentence on a scrap of paper. "The willingness to risk excess on behalf of one's obsessions," Updike observed, "is what distinguishes artists from entertainers, and what makes some artists adventurous on behalf of us all."

By 1962, Cornell had overcome his block of the previous year and was back at work. He continued to tinker with boxes, "refurbishing" works he had started long before by taking them apart and substituting different parts. That December he would have a one-man show at the Ferus Gallery in Los Angeles, but it would consist of earlier work rather than new work; he had no new boxes to show. Most of his time was now taken up with collage, a medium that had seemed freshly promising to him since the late fifties. Cornell relished collage partly for its relative technical simplicity, its cut-and-paste ease, especially after a hand injury he had suffered while sawing wood for a box. According to his doctor, Samuel Lerman, one day Cornell nearly "sliced off his thumb" with an electric saw and had to be rushed to nearby Parsons Hospital to receive stitches. Cornell later told the doctor he never worked with a saw again because he was "too afraid," though he did have his assistants fabricate the outer shells for his boxes so he could continue making new ones.

At any rate, starting in 1962, collages began emanating from Cornell's studio by the dozens, constructed on standard 12 × 9-inch Masonite boards. They varied widely in subject and quality, yet together they marked an

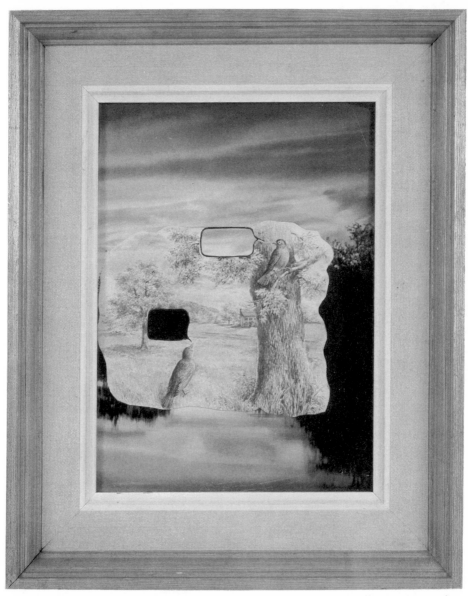

Where Does the Sun Go at Night?, c. 1964; collage, 11 × 9 in. (Collection Mr. and Mrs. Robert Lehrman, Washington, D.C.)

important departure from his earlier work. Cornell, of course, had made collages before; in the thirties and forties, he had recycled black-and-white Victorian engravings into suitably exotic surrealist dream scenes. But whereas the early collages have the muted tones of a page from an old book, the sixties collages were photo-collages; they were made from vibrantly colored photographs that Cornell clipped from magazines, and often resemble record album covers. As if taking his cue from the Pop artists, Cornell stripped the patina of age from his work and instead strove for raucous color combinations—hot-and-cold mixes of oranges, blues, and blacks—that captured the hedonism of their moment.

Cornell's themes were hardly those of the Pop artists. While some of his collages look like miniature James Rosenquist paintings—both made montages from bland, banal fragments—their messages were all his own. Rosenquist recycled trash as a gesture of social satire, whereas Cornell was more interested in the true feeling of which trash is sometimes a surprisingly affecting expression. In most of his collages, cut-out photos from magazines are fitted neatly together to suggest a sentimental story. In the series *Where Does the Sun Go at Night?* two robins—complete with Pop-art word balloons—sweetly ponder the riddle of the work's title one evening at sunset, a pink-streaked sky glowing above them. In *Portrait of the Artist's Daughter by Vigée-Lebrun*, a young girl from a painting by Elisabeth Vigée-Lebrun gazes at herself in a mirror; three nesting chicks and their vigilant mother complement this unlikely but happy family scene. Birds, children (often seen in double), rainbows, and sunsets are recurring motifs in the collages, which, despite their Pop style, are imbued with the fantasy of innocence that shaped so much of Cornell's work.

Not all the collages were quite so chaste. In a startling development, Cornell introduced into some of his collages the first openly erotic images of his career. Cutting out soft-core photos from magazines like *Playboy* and *Gent*, Cornell now brought voluptuous young women along on his imaginary journeys. *Untitled (Blue Nude)* is centered around a soft-focus photo of a bosomy nude who's seen in profile from the waist up. She appears to be swimming underwater and might be viewed as the pin-up version of Cornell's beloved mermaid, Ondine. Two fragments from a sky chart, arranged in a horizontal bar that divides the composition, suggest a schism between the sensual and the spiritual, and Cornell's desire to encompass the two in his work. Like other collages from this period, *Blue Nude* is a diffidently erotic composition that never quite rises above its sources; it is interesting mainly

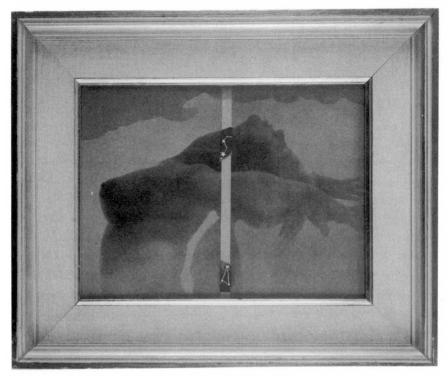

Untitled (Blue Nude), c. mid-1960s; collage, 11¼ × 8¼ in. (photo by Edward De Long; Collection Mr. and Mrs. Robert Lehrman, Washington, D.C.)

for the way it reflects the artist's desire to escape the cloister of self-denial and finally express his sexual secrets.

As he had befriended the Surrealists in the 1940s and the Abstract Expressionists in the 1950s, Cornell became friendly in the 1960s with the latest generation of vanguard artists. Now, however, instead of his seeking out artists, artists came to him. Largely through word of mouth, nearly everyone in the New York art world became familiar with the stirring details of Cornell's life; they knew that this maker of exotic objects lived in the plainest of white houses in Flushing—an address that aroused even more curiosity than that of Gauguin in Tahiti or Balthus in his Swiss castle. The most guarded of hosts, Cornell seldom permitted any one visitor to see too much of his house, and his guests competitively traded anecdotes with one another about the visiting privileges he extended them. Most stayed on the first

floor. Some managed to get upstairs, which usually required faking a trip to the bathroom. A handful were admitted to Cornell's garage, where he stored his work, and only a chosen few were given a tour of his basement workshop.

Among Cornell's new acquaintances were Walter De Maria and Robert Whitman, two shaggy-haired twenty-eight-year-olds on the cutting edge of art. In the heyday of "happenings," the two artists were part of a downtown scene that was trying to free art from the commodity system, and they ran their own performance space in a storefront loft at 9 Great Jones Street in Greenwich Village. De Maria first visited Cornell in April 1963, after learning about his movies from Rudy Burckhardt; he hoped he might screen them on Great Jones Street. De Maria and his wife returned a few days later with Whitman, who recalled that Cornell, "thinking he could help us raise some dough for our projects," agreed to lend them a selection of his homemade movies from the 1930s and 1950s, the latter of which had not yet been seen. Cornell declined to attend the screening himself.

De Maria and Whitman found Cornell most intriguing, especially after their efforts to engage him in a conversation about his avant-garde films instead sent him off on a curious tangent. "He was very taken with Princess Summer-Fall-Winter-Spring from *The Howdy Doody Show*," Whitman remembered, "this Indian princess who he was clearly in love with." The children's TV show had gone off the air, but before it did, in a tragedy that continued to distress Cornell, Judy Tyler, who played the princess, had died in a car wreck at the age of twenty-four. Unknown to his visitors, however, there was another young woman on whom Cornell was fixated— and she was standing right in front of him. Writing up De Maria's first visit in his journals, Cornell overlooked the artist in favor of his pretty wife: "Susanne de Maria yesterday and her husband." Within a few weeks, Cornell had hired her as his assistant.

Later that year, Cornell was visited by the pope of Pop. He and Andy Warhol had more in common than either probably would have cared to admit. Both lived with their mothers, made plotless movies, and collected obsessively. Both kept files rivaling those of the FBI. Both worshipped movie stars and turned their fandom into a key subject of their work. Cornell was very interested in meeting Warhol, or so he confided to his old friend Charles Henri Ford, who knew most of the Pop artists. On June 25, 1963, Ford ran into Warhol at an art opening, along with James Rosenquist and Robert Indiana. When Ford proposed a trip to Queens, after checking with

Cornell by phone, Warhol and his friends piled into Rosenquist's car like frat boys off on a rowdy adventure.

Cornell entertained them most cordially, offering them his four-star tour—which is to say, entry to his garage and basement. There was mysteriously little to see, however. "The boxes were wrapped up in newspaper to protect them," Indiana later said, "so we didn't see anything except wrapped-up boxes." Afterward, tea was served on the front porch. "It was a sedate visit because Cornell's mother was there," Indiana continued. "Warhol's mother was always well hidden away, but not Cornell's. For me, it wasn't much fun, but it was the thing that should be done. And Warhol, I know, enjoyed it." So did Mrs. Cornell. Until the end of her life, she liked to tell the story of her encounter with the pale, bewigged Warhol, invariably exclaiming: "Such a sweet young man!"

Warhol visited Cornell at least one more time, purchasing an untitled collage (with a suitably pop blend of a female nude and bowls of fruit) for his personal collection. Cornell saw much more of James Rosenquist, who returned to Utopia Parkway many times, in part because his mother-in-law then lived in nearby Jamaica Estates. "When I visited her, I'd call Cornell up and he'd say, Come over," Rosenquist later explained. A soft-spoken native of North Dakota who was thirty years old when they met, Rosenquist greatly admired Cornell. Several times, in a spirit of camaraderie, he offered Cornell raw material for his boxes and collages. Once he sent along a set of doll's clothing he had bought at Woolworth's; another time, he offered Cornell a photograph of a trapped deer he had found while cleaning his studio. Naturally, Cornell never used them. It was neither the first nor the last time that someone had presumed to locate material for him, denying him the pleasure of the sacred Search while pretending to know his taste. A trapped deer? That was too obvious an image for Cornell, whose taste in junk and everyday castoffs amounted to its own inscrutable connoisseurship.

Cornell responded to his new social popularity with predictable ambivalence. Visitors to his home could never be sure whether or not he would see them. Arman, a prominent member of the assemblage school (who somehow never managed to assemble a first and last name for himself), was among the many artists eager to meet Cornell. Raised and educated in France, he first learned of Cornell's work through art magazines and became an instant convert to assemblage. After moving to New York in 1961, he asked William Copley, the artist and Cornell's former dealer in California, to take him to Utopia Parkway. "Cornell couldn't receive us," Arman later

said. "He came out on the doorstep for five or ten minutes and then went back inside. Frankly, he seemed to be reserved and secretive, and a little bit strange." Just a little bit.

In December 1963, Cornell had a one-man show in New York—his first since the show at the Stable Gallery six Christmases earlier. But this show wasn't at a gallery, and nothing in it was for sale. It was held at the Loeb Student Center at New York University (the school's Gray Art Gallery had not yet opened) and was entitled "A Christmas Present to the Students of New York University" (December 2, 1963–January 31, 1964). Installed in the lobby of the student center on Washington Square South in Greenwich Village, the show brought together a modest selection of "seven assemblage boxes and five never-before-shown collages," according to a university press release. Not surprisingly, the show was passed over for review by the New York critics, and it's hard to know if anyone saw it other than students rushing through the Loeb lobby on their way to the cafeteria downstairs.

But that was precisely what Cornell wanted. The exhibition was organized by Ruth Bowman, curator of the university's art collection, who recalls that Cornell first contacted her to discuss the possibility of "sharing his work with students." About a month before the show opened, she went out to Utopia Parkway to meet the artist. To Cornell's apparent disappointment, Bowman was accompanied by a male escort, Howard Conant, the chairman of N.Y.U.'s art department; it had not occurred to her that Cornell, perhaps, had been looking forward to spending the afternoon alone with her. "He made Howard stay on the front porch for two and a half hours while he took me on a tour of his house and his garage," Bowman remembered, adding that she was surprised to find dozens of boxes stored in a one-car garage whose door Cornell didn't bother to pull down. Anyone driving by his house could see his artwork from the street. Casual as he was about the garage, Cornell remained choosy about whom he admitted to the inner sanctum of his house. As for the hapless art-department chairman languishing on the front porch, Bowman said, "Cornell wouldn't even let him use the bathroom."

Several weeks later, Bowman returned to Utopia Parkway alone, in a borrowed station wagon, to pick up the boxes and collages for the show. She found Cornell in his darkened living room watching the news of President Kennedy's funeral on television, as Mrs. Cornell spoon-fed Robert by

the bluish light of the screen. Heading down to the basement, Cornell selected the works for the exhibition himself. "He said that he wanted the students to have some of his work," Bowman noted. "But then one day he called me up right before the show closed and said it was time for the works to come back. I was startled. I thought they were a gift to the school." The curator was by no means the last person to be unsettled by Cornell's indecisive behavior. He often gave works away with the best of intentions, only to decide later that he could not part with them after all, even in the case of universities, whose student viewers he was beginning to prefer to the collectors, curators, critics, and fellow artists who saw his work on the New York gallery scene.

Of course, not all Cornell's admirers belonged to the clubby purlieus of the art world. Among his most recent enthusiasts was, of all people, Tony Curtis—who was born Bernard Schwartz in the Bronx and who, now thirty-eight years old, had acted in dozens of films, including *The Defiant Ones*, *The Vikings*, and *Some Like It Hot*. Unbeknownst to most of his fans, Curtis was an art collector and an amateur painter who—under Cornell's direct influence—was about to become a devoted box maker. "What I loved about his work," Curtis noted passionately years later, "was how ununderstandable it was, how mysterious it was. His boxes were like dreams and you had no idea where they came from. A stamp, a photograph, a rubber band, a butterfly, marbles that had perhaps outlasted the lives of the children they were made for . . . all these different objects were somehow tied together and interrelated to one another like a mosaic, like"—here Curtis paused to use a distinctly L.A. metaphor—"the inside of a swimming pool."

Curtis first met Cornell on January 28, 1964, after Richard Feigen (who had recently opened a New York branch of his Chicago gallery) thought that he and his wife might enjoy visiting Utopia Parkway. Curtis's wife, Christine Kaufman, was an Austrian actress still in her teens whom he had married the previous year after divorcing Janet Leigh. By now Feigen had become accustomed to having Cornell decline requests for visits. "I'm just not up to seeing anyone," Cornell used to mumble into the phone. But when Feigen called up and told him, "I have Tony Curtis standing right here," Cornell made an exception.

Traveling to Queens by limousine, the Curtises had Feigen join them. They stopped on the way at a bakery to purchase "a big box of marzipan fruits" for their host. Arriving at the Cornell home, they were greeted at the door by the artist's mother, who assumed that Feigen had brought along

two students and gaily instructed the visitors, "Now, you young people just make yourselves comfortable!" Robert, however, a devoted television watcher, recognized Curtis instantly, and his face lit up when the actor walked in. Curtis, too, had a handicapped brother, and he went out of his way to be kind to Robert, whom he later described as "a very intelligent guy who couldn't express himself because of his illness."

But if Robert was star-struck by the actor, Cornell himself was apparently more interested in Curtis's kittenish wife. He invited her for a tour of the basement workshop while leaving Curtis stranded upstairs. ("I don't know of any man who went down there," Feigen once remarked.) The couple ended up purchasing three works, including a Medici Princess box. Feigen watched with dismay as Cornell declined to give them the ten percent discount normally extended to collectors.

It was the beginning of an affectionate friendship between Cornell and Curtis, who, though he lived in Los Angeles, often passed through New York on his way to Europe. Cornell's house was relatively close to both the New York airports, making it a convenient stop for out-of-town visitors. "Whenever I arrived by plane in New York," Curtis later said, "I would zigzag over to Utopia Parkway and catch the family. They were always home." Curtis found Cornell to be a poignant character, a great romantic destined for disappointment. "He adored women," Curtis said, "but relationships weren't possible for him. He wasn't able to put two and two together, to go from step to step with a woman—from holding hands, to 'I'll see you later, come back at four, we'll go to the movies,' to sticking your tongue in her mouth . . . These things were alien to Joseph and they didn't make any sense to him, so it was hard for any girl to find him appealing."

Arriving directly from the airport, Curtis would ask Cornell to accompany him into Manhattan, and together they would ride in the back seat of the stretch limousine. Curtis was good company—warm, loquacious, eager to please—and liked to take the artist to lunch at the Carnegie Deli. Their outings were often interrupted by a publicity interview that Curtis had scheduled, but that was no problem; he would disappear into the Sherry Netherland while asking Cornell to wait outside for a half hour or so until he returned. Cornell would promise to wait. "And then I'd come out," Curtis said, "and he'd be gone! But I'd circle around the block and there he was peering into a window, and he would show me something he found."

As much as Cornell enjoyed Curtis's company, their relationship was soon

complicated by the support Curtis expected for his own art. Curtis, too, made boxes, and his usual practice was to arrive at Utopia Parkway with two or three new ones he wanted to share with the artist. On each occasion Cornell would look at the boxes carefully and note their superficial similarities to his own work. If he used wineglasses, so did Curtis. If he used photos of ballerinas, there they were! The actor hoped to impress Cornell with his homage and fierce devotion to him, but found it hard to win his approval. Whenever Curtis showed him a box and tensely awaited a verdict, Cornell "would look at it for a long period of time, then look at me, then look back at the box"—all the while saying nothing.

Cornell, one presumes, was not too happy to see his ideas duplicated. He told several friends that it eventually became necessary to put some distance between himself and Curtis, largely because he felt "horrified by Curtis's copies of his work," according to the writer and curator Henry Geldzahler. It was not the quality of Curtis's work that bothered him but, rather, the intensity of the actor's interest. Cornell was better at worshipping someone else than at being worshipped himself. Nonetheless, Cornell stayed on good terms with the actor's wife, the latest European beauty to join his pantheon. Over the years, he wrote to her regularly, addressing his letters "Chère Christine" and signing off "Con Amore."

17

The Life and Death
of Joyce Hunter
1964

Manhattan was once a city of anonymous coffee shops, and the Strand Food Shop, at 1121 Sixth Avenue, behind the New York Public Library, was much like any other. But for Cornell the little coffee shop held a special appeal. He had often ducked into it with Rudy Burckhardt during their moviemaking sessions and passed a pleasant hour or two there. On February 9, 1962, a bitterly cold day, he once again was accompanied by Burckhardt. The two friends stopped for a snack after shooting some footage.

A few months earlier, Cornell had noticed a young waitress who worked at the coffee shop, admiring her appearance as she tended to tables but saying nothing to her. Now he would make her acquaintance with a gesture that allowed him to preserve his silence. As they were about to leave, Cornell surprised Burckhardt by pulling a package from his overcoat pocket, inside of which was a collage. "It was nicely wrapped," Burckhardt later remembered, "and he wanted me to give it to the waitress as a Valentine's Day gift. He was too shy to give it to her himself, though he wanted to watch her face as she opened it."

Little about Joyce Hunter could have led anyone to suppose that she might ever become the romantic obsession of a great artist. A petite, plump eighteen-year-old, Joyce was sweet but plain-looking, with stringy blond hair that fell down her back. As Cornell was soon to find out, she was the unmarried mother of a baby daughter and lived in a tenement in Harlem. A runaway from Pennsylvania, she had no higher education, knew nothing about art, and cared even less. She changed boyfriends and addresses with alarming frequency. Anything for money, of which she never seemed to have enough.

To Cornell, however, Joyce possessed something far more than her coarse

outlines suggested. He saw her as a fallen innocent, a vision that said far more about him than it did about her. In his art, Cornell had always sought to become the savior of a lost purity; in the figure of Joyce Hunter he would find a living symbol of his quest. Yet whereas art is a safe place to enact fantasies, life is not, and Cornell's relationship with his working-girl muse would turn out to have a disastrous denouement, ending not in his imagined Eden but amid tragedy and violence in a city hotel room.

Cornell had always been drawn to the working girls he encountered in the city. He liked to admire them from afar and write up his "sightings" in his journals, which brim with passing but poignant references to a multitude of ordinary girls—to cashiers at Woolworth's and waitresses in luncheonettes, to hat-check girls and supermarket checkout girls and secretaries who sat on park benches in nice weather, eating their sandwiches from brown paper bags. Cornell viewed them all in the same terms, believing they were valiant and vulnerable; he looked upon them as the unsung sisters of the legendary ballerinas and other performers on whom he lavished so much thought. Long ago, in his youth, he had tried to make his affections known to at least two women. There was Anne H., his workmate in the defense plant, who responded with little besides a Christmas card. He had even less success with the movie clerk at the Bayside Motion Picture Theatre, who had been so frightened when Cornell presented her with a bouquet of flowers she had called the police.

As Cornell grew older, his fixation with working girls remained unchanged. But what did change is the degree of interest that working girls demonstrated in him. Even the most common waitress could see that Cornell was "somebody"—a man with a reputation and a good deal of money who was likely to be exceedingly generous toward any girl who showed him the least bit of kindness.

Which helps explain how Joyce Hunter came to be involved with Cornell in what was in fact his first real-life romance. Amused by his attention, Joyce did not discourage his coffee-shop visits. He certainly seemed harmless enough as he sat at a table with his tea and his books, reading quietly and scribbling notes on his paper napkin. Looking up, he might observe Joyce from across the restaurant or catch her reflection in the mirrored walls. There was a little jukebox, and he would ask Joyce to play him songs. He who had seen Anna Pavlova's last performance at the Metropolitan, and whose daydreams had wandered to the Paris Opera and the Vienna Hoftheater—

to the turf Romantic ballerinas had conquered a century earlier—now came to view the Strand Food Shop in similarly exalted terms. As he watched Joyce wait on tables, he delighted in "the kind of 'theater' she unconsciously supplied for an audience of one," as he later noted.

Sometimes Joyce would sit down at his table and keep him company as he sipped his tea. When he asked her questions about herself, she didn't hesitate to talk about the disreputable people among whom she moved, all of which only strengthened Cornell's conviction that Joyce was an angel whom he alone could save. Writing up their meetings in his journals, he began referring to her as "Tina," the name he gave to his feminine ideal (perhaps because it sounds like "teener"). He never knew what shift she would be working or when he would see her, and on a typical day might duck into the coffee shop more than once "in case of Tina showing up." He found her every gesture captivating, and once described her "adorable earnestness" as she sat at a table polishing her nails.

At Cornell's invitation, Joyce paid a visit to Utopia Parkway, where he introduced her to his family and gave a tour of his dwarfishly small basement workshop. She stood amid the dust and debris as he pulled out a few of his shadow boxes as a way of explaining what he did for a living. He mentioned to her that he was looking for a part-time assistant and wondered whether she was interested in such work. She couldn't take the offer quite seriously, but was glad to accept the box he offered her as a gift. She soon became a regular presence on Utopia Parkway, arriving in a borrowed black Chevy to try to coax more artwork from him. She knew how to charm him, saying things that led him to believe he was lending purpose to her life. What she failed to tell him is that she was selling his gifts as fast as she could to a private art dealer she had met through him.

Helen Cornell took one look at Joyce and was dismayed by what she saw. At eighty-one years, Mrs. Cornell was stooped, gray-haired, and deaf in one ear, yet she remained as possessive of her son as ever and quick to fault him for his infractions. It drove her crazy to see him take up with this teenager, and she suspected Joyce's need for money was tied to a drug habit. In the past, Cornell had invited other women to his home and spoken of them as if they were goddesses. But that was different. When Cornell fell in love with the ballerina Tamara Toumanova, the actress Tilly Losch, or the dancer Renée "Zizi" Jeanmaire, his mother could see that his romances with them were mostly in his head and that these European beauties would

never return his affection or intrude on the closeness of her household. But now here was this girl of the streets sitting at the kitchen table and actually flirting with her son.

One May afternoon, three months after their first encounter, Cornell picked up Joyce at the coffee shop and took her around to see some gallery exhibitions. He paused sometime during their outing to attempt what he later referred to in his journals as "the kiss," the first carnal kiss of his life. Did he kiss Joyce on the mouth or merely graze her cheek? Either way, Joyce was hardly inflamed by his gesture. By the end of the month, she seemed to have vanished. While Cornell continued to haunt the Strand Food Shop, days passed without any sight of her. The packets he left remained unclaimed. Finally, on May 23, she called him up. When he asked her why she hadn't been at work, she replied nonchalantly, "I don't go there anymore," as he later noted in his journals. She offered no further explanation, and he wondered disconsolately whether everything signified by their famous one kiss had "gone up in smoke."

By vanishing from his sight, Joyce gave Cornell the opportunity to prove his devotion anew. He could not see her, but he imagined her everywhere, linking her memory not only to the coffee shop where she worked but to the pedestrian flow on the streets outside it and the larger splendor of Times Square. He began work on a series of collages dedicated to Joyce, calling it the Penny Arcade series, a reference to the game arcades of his childhood where he could drop a penny into a slot and summon up instant amusement. The collages were composed from pristine arrangements of postage stamps, sky charts, paper cherubs, and, most strikingly, actual copper pennies—a symbol of both spiritual orbits and the pleasures to be purchased in the here-and-now. With this series of collages, Cornell brought the wayward Joyce into the safe haven of his dreams, allowing her to dwell forever in a realm of innocent enchantments.

In spite of the chaste tone of his homage, Cornell was hardly oblivious to the less wholesome aspects of Times Square. For years he had associated the Great White Way with Jeanne Eagels, an ill-starred actress he had seen on Broadway in the 1920s in *Rain*, which was based on a Somerset Maugham story about a minister who falls in love with a call girl. It wasn't only in plays that coarse women appealed to Cornell. In real life, too, he was drawn to women who did not strive to be good, who were not careful and virginal the way he was. Like the minister in *Rain*, Cornell was a spiritual man who worried about the salvation of his soul, yet who loved the tawdry present.

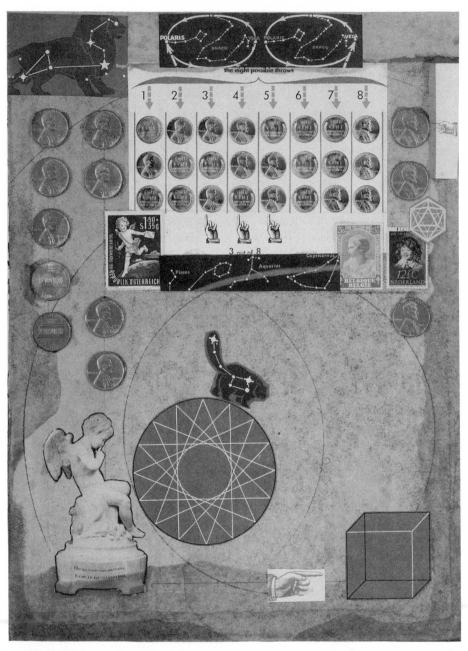

Penny Arcade (re-autumnal), 1964; collage, 12 × 9 in. (Collection The Joseph and Robert Cornell Memorial Foundation; photograph courtesy C&M Arts, New York)

In his Penny Arcade series, his passion for Joyce Hunter—and for all of New York, with its anonymous multitude of waitresses, cashiers, and struggling shop girls—found its most eloquent expression. The series is among his strongest work from the sixties.

A new year arrived, and Cornell saw little of Joyce. He seemed to be over her. On February 4, he walked by the Strand Food Shop only to realize that it had closed. "Tina gone (for good?)" he asked himself curtly in his journals. Not quite. Two months later she drove out to Utopia Parkway with a girl friend and asked if she could have one more box. She introduced her friend as a student, but as Cornell noted, "the guise was thin." He felt wounded by her lies and could not help but acknowledge that she lived in a world where deceit and betrayal were inevitable. She could not be saved, or even changed, and in his journals he bemoaned "the nightmare futility of doing things for her." He declined to give her any more work.

Ensconced in his basement workshop in Queens, Cornell was far removed from the chants of flower children and their escapades with hallucinogens and free love. Yet after a lifetime of frustrated desire, he was not indifferent to the activities of the 1960s counterculture. Much as he had once been secretly fascinated by the shocking eroticism of Surrealism, Cornell again found himself drawn to avant-garde figures who promised a liberating sensuality. At sixty years old, he increasingly dreamed about ending his lifelong celibacy. The sexual revolution of the 1960s spoke to his own urgent needs and his ever-intensifying desire to know carnal satisfaction.

This helps explain why Cornell became involved with some of the most outrageously exhibitionistic people on the sixties art scene. Because Cornell yearned to see, he found his perfect counterparts among people who wanted to be seen. Among them was Carolee Schneeman, whom Cornell had known since her student days at Bard College; she had since become notorious as a taboo-breaking performance artist. Her latest triumph, *Meat Joy* (1964), staged at the Judson Memorial Church on Washington Square, was part Happening, part butcher-shop extravaganza. A cast made up mostly of the artist's friends smeared their semi-nude bodies with raw fish and bloody chicken parts. "*Meat Joy* was ecstatic to do," Schneeman later said. "The participants were untrained, but we had to have lots of rehearsals so that they could interact fluidly."

The daughter of a physician, Schneeman had grown up amid the small-

town constraints of rural Pennsylvania, and spent the rest of her life defying them. Her subject was her body, her goal was to flaunt it, and she would later receive serious consideration as a forerunner of the body-art movement. She had first moved into performance art with *Eye Body* (1962)—thirty-six black-and-white photos based on a "Happening" in her West Twenty-ninth Street loft in which she subjected her flesh to various degradations (slathering herself with mud, entwining her limbs with a snake, etc.).

While Cornell missed the performance of *Meat Joy*, he did resume his friendship with Schneeman shortly afterward and turned to her as if for assistance with his own sexual emancipation. He sent her magazine photos of unclad women ("*Nymph en vacances,*" was his caption for a picture of a sunbathing girl) and hoped she would reciprocate with material from her own archive of erotica. In January 1964 Cornell reminded her: "Should you be able to forward pix of a poetic potential I'd like to work up some collages—perchance a new vein or direction—young blood—dancers, models, etc." He already owned a set of nude photos of Schneeman, which, he told her, he wanted to use "to practice drawing the figure." They discussed the possibility of undressing together to sketch each other's body, a plan that never materialized. Nevertheless, Cornell felt grateful to Schneeman for allowing him to confide in her one of his greatest and, to him, most shameful secrets—his desire to look at women's bodies, which he continued to think of as an aberration.

Schneeman was uncommonly attractive, a statuesque woman of thirty-five with almond-shaped eyes and flowing brown hair. She laughed easily and had a gift for putting people at ease. While Cornell did not make any physical advances toward her, she believed that he harbored romantic feelings for her. She recalls how he bristled at the mention of her live-in boyfriend, a musician, James Tinney, and seemed pained by the notion that her affections might be directed at someone other than himself. Cornell was certainly as generous toward her as any lover could be. That June, after learning that Schneeman was planning an extended trip to Paris for the European debut of *Meat Joy*, he tried to be of help. "I heard from a mutual friend that you have been trying to raise money for your trip," he sweetly wrote her. "Would you allow me to wire you at least $250 'noblesse oblige' for the very lovely inspiration of the weekend."

Through Schneeman, Cornell met several members of the Judson Dance Theater, for which she had choreographed some pieces. The troupe represented the avant-garde in dance, and was known for making dances out of commonplace movements such as walking and sitting down. Yvonne Rainer

coined the term "task movement" to describe their objectives; their pieces, which used neither props nor sets, often gave the impression of people carrying out the most routine activities. Cornell went to see one performance of their work. He cared for it not at all, and of course the dancers' arty black leotards were no match in sensuality for the sequins and tulle of ballerinas past. Still, he was drawn to the dancers themselves—their radiant physical presences—viewing them as the contemporary version of Fanny Cerrito and her dazzling peers of the Romantic ballet.

Cornell mentioned his love of ballet to Schneeman, adding that if he could somehow arrange to meet women from the Judson Dance Theater they might "spark rich associative images." Schneeman, in response, furnished him with pertinent addresses and convinced a few dancers to travel to Flushing. Cornell became friendly with Arlene Rothlien, the most ethereal of the group; he envisioned her as "a Russian princess, standing in the snow, dressed in a fur coat and holding a muff"; they corresponded for years. Cornell also befriended Deborah Hay, noting in a letter of May 1964 that "Debbie" had called him for the first time and "sounded so darling, enthusiastic, etc." that he had managed to produce a new collage inspired simply by "the wondrous expectancy" of meeting her.

Not all Cornell's new female friends, however, belonged to the world of the performing arts. As drawn as he was to women whose careers were centered around being "seen," he was also drawn to women who could not see at all. He remained a dedicated supporter of the New York Institute for the Education of the Blind and actually befriended several young women at the school; he visited them at 999 Pelham Parkway and corresponded with them regularly. Their typed letters brimmed with affection and gratitude, and he carefully filed them away. "During my spring vacation," wrote a young lady named Pauline in 1964, "I spent the time at Morristown, N.J. training with my new seeing eye dog. Mr. Cornell, thank you so much for both the kerchief and the money"—gifts that might seem more appropriate for a courtesan.

Cornell soon became involved with someone who was probably the most extravagant exhibitionist in the 1960s art world. Yayoi Kusama, a talented Japanese artist, was a small, dark-eyed woman in her mid-twenties, with black hair that fell to her waist. Kusama enjoys a substantial reputation for her soft cloth sculptures and for pattern-based paintings that prefigured

American Minimalism, but her creations inside the studio pale beside her antics outside it. She came to New York from Tokyo in 1957, eager to make a name for herself and, like Yoko Ono, turned to performance art to generate attention. Her preferred medium was her own naked body. Kusama is probably best known and least liked for the "Body Festivals" she staged in the parks of Greenwich Village in 1967, when she painted polka dots on the unclad bodies of any willing participants.

Cornell and Kusama met early in 1964, introduced by the art dealer Gertrude Stein (no relation to the legend of the same name), who then ran a little gallery at 24 East Eighty-first Street. Like other art dealers, Stein occasionally visited Cornell on Utopia Parkway in the hope of acquiring a few boxes, and enjoyed sipping tea with him in his back yard. Cornell seems to have trusted her more than other art dealers. "He used to tell me that he didn't think of himself as an artist," Stein later said. "He seriously felt that he was not an artist because he couldn't do what Ernst and Tanguy did—he couldn't draw. He said he really wanted to learn how to draw and asked me if I could bring him some models."

The art dealer obliged. She sent along Yayoi Kusama, who was already an admirer of Cornell's work, and who was happy to disrobe in his basement workshop so that he could sketch her. Was she the first woman Cornell ever saw in the nude? Quite possibly. A dozen or so of Cornell's drawings survive among her papers, and they're intriguing less as art than as reflections of the artist's anxious sensuality. They feature a squat female nude who resembles an ancient fertility icon. She's rendered with a jittery, almost indecipherable line and suggests Cornell was so excited by his model that his hands were actually trembling.

As by now had become a regular practice with the women he admired, Cornell offered Yayoi gifts of cash and artwork in exchange for her affection. "I believe it was love at first sight for Cornell when he first saw me," she later wrote. "After that first meeting, he began calling me day and night, and sending me an enormous number of letters. On one day, I received 13 letters from him."

His missives had the same gently adoring tone. "The birds are waiting for Yayoi to feed them," reads a typical note. "I am waiting also for Yayoi." Another day, another note: "Waiting for you-you-I," he wrote, punning on her first name.

Such tender sentiments contrast sharply with the blunt impatience Kusama brings to her recollections of Cornell. "Because of Cornell's almost

obsessional love for me," she says, "I was just not able to [have] any other boyfriends. I had a number of boyfriends then who were well-known artists, but they all left me because of Cornell. They complained that the telephone line was always busy when they tried to call me, among other things."

Yayoi was hardly the first woman whom Cornell envisaged as his feminine ideal. Yet she was the first to harbor any sensual interest in him. Whether inspired by political ideology or genuine physical attraction, she encouraged him to act on his impulses and apparently gave him his first true taste of sexual bliss. He was sixty years old, and finally, at last, he kissed a woman on the mouth and explored a woman's body with his hands, an experience he described in his diary as gratifyingly "erotique." Sex, in his mind, like so many other pleasures, was essentially French and could be captured only in that language. He once told a friend that his sexual experience included everything up to "soixante-neuf."

Intercourse, however, was not within the realm of possibilities. "Cornell was deeply impotent," Kusama noted. "To have sex with him, therefore, was impossible." It is not surprising to hear that Cornell suffered from impotence (a fact that would later be confirmed by other women). From the beginning, Cornell's reverence for women had been coupled with an extreme fear of the naked female body, which made it difficult for him to attempt intercourse. Moreover, the demands his mother made on him were so complete they all but required he withhold himself from other women.

Even now, in her enfeebled old age, Mrs. Cornell remained an impediment to her son's relationships with women. She made every effort to banish Yayoi from the house. Yayoi, reeking of defiant sexuality, was of course a mother's nightmare, and Mrs. Cornell was not subtle in making her disenchantment known. Once when Cornell was kissing the young girl in the back yard, Mrs. Cornell tossed a pot of water their way, as if to literally extinguish their passion. And whenever Yayoi washed her hands in the house, Mrs. Cornell would boil the towels she used, her objective being, according to Yayoi, "to sterilize them right in front of my eyes." Confronted with such distinct inhospitality, Yayoi eventually lost interest in Cornell and drifted off into the hedonistic swirl of the sixties art scene.

In September 1964, Joyce Hunter, the waitress from the Strand Food Shop, suddenly resurfaced in Cornell's life. While he refused to give her any more of his work, she decided she did not need his permission and would help

herself to whichever choice pieces she wanted. She knew that he stored most of his boxes in his garage and rarely closed or locked the door, even though his boxes were then worth about a thousand dollars apiece. Anyone driving by his house could see all the work stashed in his garage, and it never occurred to him to take the least precaution against theft. Burglars stole televisions and radios and jewels, not Cornell boxes. Except for burglars like Joyce. She and her boyfriend drove out to Utopia Parkway late one night and took a few boxes. They returned a few days later to take a few more. Soon they had nine in all.

Cornell's garage was so cluttered that he failed to realize a theft had occurred until someone else alerted him to the news. It was Richard Feigen who first called to inform him of "two teen-aged girls" who had been offering his boxes to various art dealers at suspiciously low prices. Checking his garage, Cornell was distressed to realize that works were missing. Feigen had heard on the art-world grapevine that the two girls were scheduled to meet that very afternoon with Eleanor Ward of the Stable Gallery, Cornell's former dealer, and proposed that the Flushing police turn out for the occasion to make an arrest.

At first, Cornell was reluctant to contact the police and cause Joyce any harm. As Feigen said, "The police told me they couldn't do anything unless Cornell called. I had the precinct chief on one line and Cornell on the other. Cornell said he couldn't press charges. I said he had to. Finally he assented and went over to the precinct and filed charges."

Arrests were made, and the next day, September 18, the story was carried in *The New York Times*. The headline read, 3 SEIZED IN THEFT OF ART IN FLUSHING. Joyce and her boyfriend, Wilfred Beauchamp, a twenty-year-old clerk, were charged with grand larceny, while the friend who had assisted her in the sale of the boxes was charged with a misdemeanor, the criminal receipt of stolen goods.

However upset he felt over the theft, Cornell blamed no one but himself and was determined to help Joyce once again. For legal counsel, he turned to Allan Stone, who owned a gallery at 48 East Eighty-sixth Street and had included a handful of Cornell boxes in a "Modern Masterpieces" show earlier that year. Stone, a Harvard-trained attorney, had once worked for the U.S. Department of Justice, as Cornell was well aware. "Cornell came to me and wanted to get Joyce Hunter off," Stone later said. "He didn't want her in jail. She couldn't make bond. I explained to him that there was nothing he could do since the state had already stepped in. He was smitten by her.

I thought of Cornell as one-third poet, one-third Yankee trader, and one-third madder than a hatter."

According to court records, Cornell put up the money for Joyce's bond —a thousand dollars, paying to free the woman who had committed a felony against him. She was released from the Queens House of Detention, where she had been incarcerated for a week. The following month the case was tried at the Queens Criminal Court. Cornell refused to testify, not wanting to return Joyce to jail. As a result, after two court sessions, the charges against her (as well as those against her boyfriend) were lessened from grand larceny to petty larceny—and then dropped.

Cornell moved his boxes out of his garage and rented storage space in Queens, but still he refused to hold Joyce responsible for the theft. Joyce was appreciative. She told him she had underestimated the value of his friendship and would do better in the future. Maybe she could go to school. Maybe she could study art. She broke up with her boyfriend and by the end of November had moved in with an eighteen-year-old named George Bradford, who rented a room in the Hotel Breton Hall, a rooming house at Broadway and Eighty-third Street, in a nice neighborhood on the Upper West Side.

For Cornell, the burglary coincided with an upheaval in his domestic life. In the past few years, he and his two sisters had often discussed the possibility of moving their mother out to Long Island, largely because her deteriorating health was making it difficult for Joseph to care for her by himself. On October 2, Mrs. Cornell tumbled down the stairs and broke her hip, and her daughters finally acted. Helen Jagger and her husband, Arch, moved into the house to assist with Mrs. Cornell's convalescence, staying for about about six weeks. When the couple returned home to Westhampton on November 21, they brought Mrs. Cornell with them. She was to live with them, in their three-bedroom ranch house, for the remaining two years of her life. Cornell was sixty, and his mother's departure from Utopia Parkway marked their first separation since his prep-school days at Andover.

Yet even after she moved out, Mrs. Cornell was never far from Joseph's thoughts. Living on Long Island, she wrote to him virtually every day and expected him to write to her at least as often. "Dear Joe," begins a letter of November 24, the first to survive among her extensive correspondence from Westhampton. "It's wonderful to get your notes every day! Thank

you . . . Only 2–3 days [in Westhampton] but it seems like *years*. Still busy unpacking. Boxes and boxes of my desk things—a Desk is my Life . . . Love always to my boys from Mama."

With his mother's departure, Cornell was left alone with his brother, Robert, whom he continued to care for with tender vigilance. For help, he hired a new assistant, Alexandra Anderson, a young writer who had recently graduated from Sarah Lawrence College. She could see it was a difficult time for Cornell. He seemed to feel frustrated by his inability to give proper care to his brother and often asked her to spend her workday reading aloud to Robert.

At the same time, Cornell was newly preoccupied by Joyce. In spite of her unforgivable behavior, he continued to feel moved by her neediness and and was incapable of casting blame. "He was very concerned about her," Anderson recalled. "He once sent me on an errand. He asked me to take a package of money to this rooming house where she lived." Anderson, unlike most of Cornell's other friends, found Joyce likable. "Cornell had always had a great admiration for cashiers, so I wasn't surprised to meet her. She was small and blond and very sweet."

On December 1, Joyce visited Utopia Parkway, arriving for lunch and remaining for the afternoon. Taking her upstairs, Cornell showed her the large front bedroom that for years had belonged to his mother. When Mrs. Cornell moved out, she had taken along her furniture, and the only trace of her now was the floral wallpaper. "Joyce saw Mother's empty room," Cornell later noted, as if brooding on his mother's absence and the consolation the young girl might offer him in her place.

It turned out to be the last time Cornell ever saw Joyce. On Friday, December 18, she was murdered by an acquaintance. According to police records, she returned to her room at the Hotel Breton Hall at three in the morning accompanied by a so-called friend, Lawrence "Frenchie" French, a twenty-three-year-old laborer from Louisville, Kentucky, who had recently been released from a state psychiatric hospital. Moments later, a second man arrived carrying a bundle of clothing, and Joyce asked him to leave. As he packed up he was assaulted by French. Once they were alone, French turned his rage on Joyce, killing her in an attempt "to assault and rob," according to the police. She died after she was stabbed on the left side of her neck and choked with her assailant's scarf.

Nearly twelve hours passed before Joyce's body was discovered. An electrician wandered into room 834 at noon that day to change a lightbulb,

but it didn't occur to him that anything was wrong. When he looked at the bed, he saw nothing unusual: a mound of clothing. At four o'clock that afternoon, a maid came in to clean. She removed the clothing from the bed. Beneath it she found Joyce lying face down in a short black dress, a man's scarf around her neck. The following day, the police arrested Lawrence French. (He eventually pled guilty to first-degree manslaughter and would die in jail while serving his sentence.)

News of Joyce's death was not carried by any of the New York newspapers. She was just another anonymous runaway adrift in the big city, and her death was no more worthy of public attention than her life had been. Cornell learned of her murder almost immediately, after a homicide detective contacted him to ask if he could come to the New York City morgue and identify the body. Inconsolable, Cornell sent a friend in his place. "He called me up in a very upset state and asked if I would do that," the artist Solomon Ethe later said, adding that he had met Joyce at Cornell's home. "All the police wanted me to do was identify the cadaver. I gritted my teeth and went through with it as an act of friendship to Cornell. It was obviously very painful for him."

Cornell was shattered by Joyce's death. Violence of any sort had always unnerved him, and he could hardly believe that his young friend had met such a grisly end. The day after learning of Joyce's murder, Cornell received a Christmas card from her in the mail—a detail that would haunt him to the end of his life. Joyce had died one week before Christmas, which only added an extra twist of sadness to the whole unfortunate affair. December had always been his favorite month, with its evocation of holidays past and of the many exhibitions he had held that time of year. Now, however, as the houses along Utopia Parkway glowed with colored electric lights and the stars glittered like points of ice in the winter sky—sights Cornell had always relished—he wandered the rooms of his silent house trying to make sense of the tragedy.

It was all too terrible to absorb, and seemed less like real life than film noir: a pitiless drama about doomed characters moving inexorably toward a violent end. Cornell's romance with Joyce had been played out against the backdrop of Times Square, which he could no longer pretend was memorable mainly for its long-gone penny amusements. In the past two years, he had tried to capture Joyce's "vital spirit," as he noted, through his Penny Arcade collages—tried to bring this troubled young woman into the penny arcade of his heart—but the fact of her murder thrust him into

some harsh, nearly unbearable place. He recorded nothing in his journals in the days and then weeks following the murder, a lacuna that attests to his distress perhaps even more than words would have.

Police detectives were able to locate Joyce's family ("father of the deceased one Arthur C. Steele contacted through Correspondence Bureau," a report noted), from whom she had long been estranged. Her family made no effort to have her body returned to her native Pennsylvania, and her many friends had neither the means nor the manners to consider arranging a funeral on their own. For twelve days her body lay unclaimed at the morgue, and it was only through Cornell's intervention that Joyce was spared the ignominy of a city burial. He volunteered to pay for her interment and selected the site. On December 30, Joyce was buried not far from Utopia Parkway, at the nonsectarian Flushing Cemetery. Cornell asked two detectives to try to locate her three-year-old daughter, Sharon. He offered to raise her, although it is hard to imagine him looking after a small child. At any rate, the girl was not found.

After her death, Joyce Hunter lived on fondly in Cornell's memory. He thought back many times to their felicitous encounters in the Strand Food Shop. He remembered her playing tunes on the jukebox and relished the "infinitely wondrous memory" of her face reflected in the coffee shop's mirrors. In years to come, he paid many visits to her grave, and one autumn afternoon had a friend make a short black-and-white movie of the site as a memorial to her. Her grave remains unmarked; he never put up a gravestone. Yet a form on file with the Flushing Cemetery Association indicates that Joyce's body lies in plot number 52b. She was buried, the form further reveals, in a "Wooden Box."

18

Goodbye, Robert

1965

Robert Cornell was now fifty-four years old, having lived much longer than victims of cerebral palsy generally do. His days remained as uneventful as ever. Confined to a wheelchair, he spent every day at home in the living room, with little to divert him besides his toy trains and shortwave radio and the whimsical pictures he drew of animals. None of this made him bitter, however. Over the years, he had the pleasure of meeting the many art-world figures who came out to Flushing. Nearly everyone remarked on his radiant high spirits and the tenderness that prevailed between Robert and his brother.

Saul Steinberg, the *New Yorker* cartoonist, once recalled a visit to Utopia Parkway during which Robert was seated at a table drawing as Joseph looked on admiringly. "Cornell was full of praise for his brother," Steinberg observed. "He showed me his brother's drawings, and raved over them. He was charmingly kind to him." The art dealer Alexander Iolas remembered his astonishment at the food Joseph prepared for Robert. "He loved his brother," Iolas said, "and the meals he made [for him] always consisted of the most incredible colors . . . He used to squeeze violets on top of mushroom soup to make it lilac-colored." Carolee Schneeman was similarly impressed by their fraternal ardor, later observing, "They had this intense closeness, like they were the same being, only one had been stricken."

Cornell routinely introduced his friends to Robert and encouraged them to spend a bit of time with him. When Donald Windham visited, he would volunteer to give Robert a shave, seeing how he enjoyed the attention. Richard Feigen had recently sent Robert a toy train for his birthday, and Robert replied with a thank-you note: "The locomotive is certainly an attractive addition to my collection," he wrote in surprisingly neat script

in July 1964. "Your nicely wrapped gift extended my birthday by about two or three weeks!"

Robert's comment, with its attention to the way a present was wrapped, sounds like something that Joseph could have said. They had similar sensibilities, these two prisoners of Utopia Parkway. Both were fascinated by opera, fairy tales, and old-fashioned toys. They worshipped Mary Baker Eddy and Christian Science almost as much as they did the movie queens of the 1940s. They both made artwork: Robert's openhearted drawings of a character he called the Mouse King, like Joseph's boxes, were one-of-a-kind pieces spun out in series. Was Robert following his older brother's example? Or was it Joseph who followed Robert, silencing his own desires and willing himself into a vicarious life?

By now it had become especially difficult to care for Robert. He was so frail and piteously thin he had "just enough body to keep a soul in," according to the artist Solomon Ethe. Joseph himself was not in much better shape. Devastated by the tragedy of Joyce Hunter's murder, he wondered whether Robert might be better off joining their mother on Long Island, where she had been living in her daughter's home for about six weeks. On January 7, after a lifetime of caring for Robert, Joseph took the dramatic step of bringing him out to Westhampton.

The arrangement worked out well for Robert, who could not have found better care anywhere. The Jaggers surrendered their master bedroom to him and put up shelves for his collection of model trains. His sister Helen Jagger seemed not to mind the sacrifices he demanded. "He was so happy," she later remarked. "He finally had a room with a door on it, so he had some privacy. And he could look at the windows and see the cardinals in the snowy trees."

Less than two months after his move to Westhampton, however, Robert caught a cold which developed into pneumonia. He died peacefully in his sleep on a Friday afternoon, February 26, 1965.

Cornell had spoken to Robert by telephone the day of his death. Hearing his brother's voice, which sounded desperately weak, Cornell consoled himself with religious thoughts. After hanging up the phone, he later noted in his journals, a bit dryly, "I went down into the cellar, put on the Glenn Gould Beethoven #4 (concerto) and with but the first three or so chords felt convinced that Robert had then attained that state on which the second

death"—mortal death—"has no power." The comment is in keeping with
the Christian Science belief that death does not exist and is merely an illusion,
and that spiritual attainments are the only ones that ultimately count.

Sending along news of Robert's death to his friends and professional
acquaintances, Cornell maintained a consistently calm tone. He referred to
death as "Eternal Rest" and indicated his relief that Robert would suffer
no longer. In a letter to the art dealer Irving Blum of March 12, Cornell
reported, "He went peacefully, out on the Island, where he had been staying
with Mother for about two months . . . Our common confidence in the
truths of Christian Science I am certain is bearing fruit in a magnificent
way."

Writing to his mother, Cornell refrained from referring to the Christian
Science doctrines she so disapproved of, while leaving little doubt that he
believed in the afterlife. "I am certain that Daddy & Nana did not take
long in welcoming Robert," he assured her. "Such a glory of course is too
much for our conception."

In a letter to E. B. Henning, the director of the Cleveland Museum of
Art, Cornell stressed his desire to properly honor his brother's memory. "I
pen in a state of prolonged bewilderment but am so grateful that I have
been able to take it," he confided. "It would be dishonoring Robert to give
in and do less than work for those in his condition with such time and
energies as I may be allowed."

Letters of condolence poured in to Utopia Parkway. "I will always re-
member his lively spirit and gentle humor which gave me such pleasure
each time I saw him," wrote Teeny Duchamp, the wife of Marcel. Other
friends commended Cornell for his years of self-sacrifice on Robert's behalf.
"I think you had helped him to make his life very full," Stan Brakhage
commented, "and your description tells me his life was full of things he
loved and cared for at the very end . . . That is all any of us can ask."
Dorothea Tanning, the painter and wife of Max Ernst, wrote from Paris:
"If thoughts were grains of sand I could send you enough for a whole beach."

For all their kind words and good intentions, Cornell's friends could not
know the true scope of his suffering. For with the loss of Robert, the loss
of Joyce Hunter filled his thoughts anew. To lose two people in just three
months—in the private forum of his diary, Cornell wondered what such a
coincidence meant. One night in a dream Joyce appeared before him "in
her baby blue dress, plumper and blonder than before." Another night that
winter he dreamed of "shopping for food to take home to Robert, including

a coffee cake." Cornell thought of Robert and Joyce as a pair, twins allied by their innocence and helplessness.

At times Cornell could picture their faces so clearly that a spell seemed to enfold him. Such a moment occurred on March 2, a week after Robert's death, when Cornell experienced what he called a "golden moment" while returning home from a shopping trip in Flushing on the Q28 bus. He took out his pencil and scribbled a note to Joyce: "Here now in sunny Eterniday—I am remembering you—blessed Joyce . . . Just now on Main Street I have bought a T. S. Eliot book for you and one for Robert." Until his last days, Cornell would continue writing notes to this odd-matched pair.

But Cornell's truest dialogue with his dead brother was conducted through his art. In the winter of 1965 he began an extensive sequence of collages dedicated to Robert's memory. He referred to the project as his "Memorial Collection," and his basement workshop became a sort of memorial chapel.

The collages were based on an unlikely source of inspiration: his brother's drawings. Robert had left behind hundreds of sketches in pencil and crayon—charmingly childlike pictures of hippos, mouse violinists, and little rabbits banging on drums. There were sketches of the dapper Prince Pince (a rabbit in a bow tie) and the improbably royal Mouse King, two characters Robert had invented. Poring over the drawings at his worktable, Cornell embarked on a strikingly selfless project: he would become, in effect, his brother's private curator by preserving the vast collection of drawings in either one of two ways—by mounting and framing them "as is" or by recycling them into his own collages.

In his work, Cornell had always appropriated imagery—master paintings, advertisements, photographs, etc.—since one of the rules governing his art was that nothing in it be original. Yet he had not previously borrowed from Robert, whose drawings belonged to the realm of amateur art or what today might more fashionably be called outsider art. Cornell's goal now was to turn Robert into an insider, and in the course of 1965 he would produce dozens of works meant to rescue Robert from oblivion.

Cornell's memorial collages are not well known in art circles, and they don't deserve to be. Yet it is easy to admire the deep feelings that led Cornell to undertake them. He knew the collages could not qualify as great art; they couldn't advance his reputation, and quite possibly could harm it.

Robert and Joseph Cornell, *The Heart on the Sleeve*, 1972; collage (Collection National Museum of American Art, Smithsonian Institution. Gift of Elizabeth C. Benton)

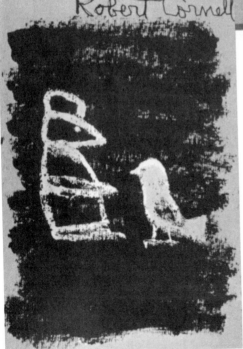

Exhibition announcement for "Robert Cornell: Memorial Exhibition," 1966, with a reproduction of *The Encounter* (Collection author)

Yet the considerations of his career didn't matter to him in the least. What did matter was his need to express all the love, faith, and guilt he felt toward his brother. Distressed by the disparity between his own stature and his brother's sadly unsung life, he refused to allow Robert's drawings to languish in obscurity.

Although Cornell was well aware that Robert's drawings could not be confused with the work of trained artists, he felt they had merit as amateur efforts. As he later wrote to John Ashbery, Robert "never had lessons nor drew with an unlabored stroke but what adorable poetry he put into his labors of love, the farthest remove from professionalism." Still, Cornell hoped that his brother's drawings would find recognition in the most professional quarters of the art world. In what may have been the most outrageously purehearted gesture of his career, Cornell soon began approaching art dealers and museum curators in the hope of interesting them in acquiring his brother's drawings, an offer that was met with predictably little interest.

Some of the collages were better than others. Among the stand-outs is *The Encounter*, in which a gentlemanly mouse in a coat and a hat offers some feed to a little bird. The mouse is not an anonymous creature but Robert's beloved Mouse King, and the drawing might be understood as an idealized double portrait of the two brothers. The meek and mousy Cornell here becomes a "king," as if through his act of kindness, and the wheelchair-bound Robert becomes a creature capable of flight. In making the collage, Cornell changed the original image as little as possible, cutting a bit and pasting a bit, while careful to preserve the basic spirit of Robert's artistry.

Not all Cornell's memorial collages incorporated Robert's drawings. Among the most affecting are those in the series Time Transfixed—the title a reference to a Magritte masterpiece owned by the Art Institute of Chicago. Cornell had always loved the Magritte painting, a classic of Surrealism from 1938 in which a steam engine emerges from a fireplace in an otherwise unremarkable living room. The painting is meant to capture the illogic of dreams, but for Cornell it was more real than surreal, recording the circumstances of his brother's life with an oddly literal fidelity. For years, after all, Robert had been confined to the living room with little to distract him besides model trains. Cornell's Time Transfixed series expresses his desire to stop time in its tracks and take all that he loved, his brother included, on a never-ending journey.

• • •

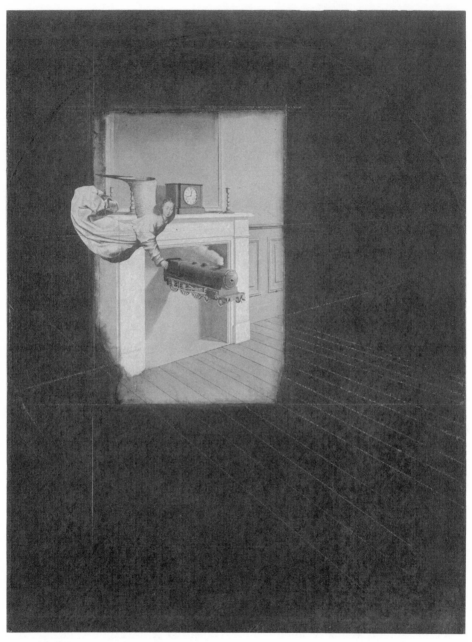

Untitled (Time Transfixed), c. 1966; collage, 12⅛ × 9 in. (Collection Mickey and Janice Cartin, Hartford, Connecticut)

Now that Cornell was living alone, he hoped to find "helpers" with whom he could settle into a new domestic regimen. Like Andy Warhol and Robert Rauschenberg, who were known to keep an entourage of studio assistants —a heresy among an older generation of artists who had struggled alone in the studio—Cornell began assembling his own live-in retinue. In years to come, he surrounded himself with young, well-educated people who felt privileged to be in his employ.

No sooner had Cornell's mother departed than a beautiful young woman arrived at Utopia Parkway to work as his assistant. Trudy Goodman, the niece of the art dealer James Goodman, was then a Bennington student and part-time assistant at the Allan Stone Gallery. While most other young women found Cornell painfully intense, Trudy, an adventurer, felt comfortable in his presence. She couldn't believe her luck: here she was, at nineteen, living with a great artist. He offered her free room and board in exchange for her help around the house.

Trudy considered the job easy. Her main responsibilities were preparing poached eggs and toast for Cornell—about all he ate these days—and helping him translate poetry and prose from French. "I totally understood his mind," she later remarked. "He had all my favorite poets on his bookshelf, and we used to read poetry together. It was an intellectual friendship." Cornell was delighted by her presence. Writing in his diary, he noted that "her sweetness is a natural thing" and wondered whether he was beginning to feel a "dependency" on her. She had no trouble noticing. When she woke in the morning, Cornell was often pacing in the hallway outside her room, and she could count on finding a note slipped under her door, a little missive stamped with a sun to herald the new day.

Cornell seems to have felt content with this platonic state of affairs. Finally he was free of the predatory gaze of his mother and living instead with an appealing young woman; yet faced with the possibility of physical intimacy, he backed off from wanting it. As much as he liked Trudy, Cornell continued to find memory more seductive than experience and, on a typical night, affectionately observed her "working at the dining room table," while thinking back to the safely deceased Joyce Hunter, her memory "presented afresh."

Trudy felt sorry for Cornell. Suffering from near-permanent insomnia and deepening depression, he looked haggard and would talk to her without raising his eyes. She could see he was in mourning for his brother and was astonished by the ways he chose to console himself. "He was so strange," she later

remembered. "At night, he would turn on the oven to a very low temperature and put his whole upper body in the oven. It was a comfort thing, like climbing back into the womb."

Only two months after she started working for Cornell, Trudy returned to Bennington College. Cornell made no effort to change her mind but was visibly distraught when she left. When a cab pulled up in the driveway to take her away for the last time, he seemed to be on the verge of collapse. "He stood at the top of the stairs and wept," she said. "He was incredibly lonely."

Cornell hoped to find someone to replace her. Writing to Charles Henri Ford later that spring, he mentioned that he was "looking for someone to sleep in here—light housekeeping, etc. Can offer room & board & compensations." He ended up instead with part-time help. Alexandra Anderson, the young writer who had worked for him the year before, came back to assist him two days a week. While she disappeared with the arrival of summer ("Alex is too expensive to keep," Cornell lamented in a letter to his mother), her feelings for him were genuine. "I worried because he never ate anything," she later commented. "I would prepare him dinner but he wouldn't touch it. He ate only this wretched cake, the kind from supermarkets with thick white frosting."

Like his other assistants, Alexandra never thought of Cornell as a possible boyfriend, in part because he seemed to harbor little romantic feeling for her. "He was interested in adolescent girls," she noted, adding that even at the age of twenty-one she apparently was over the hill. "He once told me that I was too grown up."

In September 1965, Cornell was fortunate to find a new assistant who happened to be an accomplished artist himself. Larry Jordan, at thirty-one years old, was one of the most promising young people in experimental cinema. A tall, lanky Harvard dropout, he lived near San Francisco and was part of the circle around the Beat poets. Yet his work is closer in spirit to Surrealism, and he eventually became known for films like *Once Upon a Time* (1974), a feat of animation composed from hand-colored Victorian engravings.

Jordan had first met Cornell in 1955, when the filmmaker was living in New York and sharing an apartment on the Bowery with his high-school friend Stan Brakhage. One day Cornell was roaming the neighborhood with

a young actress when he unexpectedly dropped in on Brakhage. Jordan was struck by his appearance, the magnificent blue eyes glowing out of a ghostly face. "He talked as if in ecstasy," Jordan remembered. "But only his eyes lit up. The rest of his face was cold."

After Jordan moved to San Francisco, he and Cornell corresponded regularly. Jordan felt that Cornell's collage movies from the 1930s were masterpieces of the experimental genre, and when Cornell mentioned that he was looking for a live-in assistant, Jordan leaped at the chance. While he could volunteer his assistance for only a month, since he was married, he was hoping that even a limited stay would allow him to realize his long-time ambition of making a documentary about Cornell. "He was shy," Jordan said, "and I knew there was no film footage of him."

During his stay on Utopia Parkway, Jordan was charmed by the habits of his host. While Cornell would usually stay up working into the small hours of morning, he would manage to be seated at the kitchen table when Jordan came downstairs for breakfast. "The month I was there he didn't sleep in his bedroom once," Jordan said. "He took three-hour naps around the clock and got up and worked right from the dream state. He would nap on the couch in the front room."

It had been about six months since his brother's death, and Cornell was still working on his memorial collages. They proliferated by the dozens. Cornell once told Jordan that he had "two hundred collages in progress." He stored them in the dish cabinets in his kitchen, placing each collage in a separate brown envelope. To Jordan's astonishment, Cornell somehow seemed to know the contents of each and every envelope.

As they had planned, Jordan spent much of his time on Utopia Parkway screening Cornell's homemade movies and getting them in order. Some Cornell had never shown; he confided to friends that he wasn't sure they were "finished." But Jordan found them absolutely perfect. While it has been previously reported that Jordan completed several of Cornell's movies, his involvement was mostly limited to resplicing footage and adding a musical sound track here and there. He felt privileged to be tinkering with such rich material: *Cotillion*, *The Children's Party*, and *The Midnight Party* —the strange and hilarious trilogy of films in which Cornell recycled reels of found footage into a kind of dream birthday party for children.

Cornell, in the meantime, thought of one more movie he wanted to make. It would be his last and could not be done without Jordan's assistance. What he wanted was a film record of Joyce Hunter's grave, as if even a

grave was somehow impermanent and could be preserved only through the durable medium of art.

On October 2, Cornell asked Jordan to accompany him to the Flushing Cemetery. Years earlier Cornell and Rudy Burckhardt had collaborated on the three-minute *Angel* in the same cemetery. The new movie—which, unfortunately, has been missing since 1972—was apparently drawn from the same repertory of themes. Describing the color movie in a letter, Cornell called it a "poetic documentary" contrived from images of passing children, a statue of an angel, and autumn leaves.

As he had hoped, Jordan managed during his stay to make a movie starring the artist. *Cornell 1965* is a short, unpretentious documentary, nine minutes of color footage shot in and around the Cornell household. The movie opens with Jordan saying (in a sound track that was added afterward): "This film came into being because Joseph really did want something of himself and his work recorded." But as the frames click by, we see far more of Cornell's work than we do of the artist. Cornell remains a phantom; most of the movie was filmed in his basement workshop when he wasn't there, so there was little to see besides his boxes. He liked the idea of having them filmed in spite of their obvious limitations as dramatic subjects for a movie.

Cornell appears briefly in the movie, but only as an elusive presence. He wasn't willing to be photographed, forcing Jordan to resort to devious measures to get him on film. One day Jordan was up in the attic when he glanced out the window and spied Cornell in the back yard. So, unknown to Cornell, Jordan filmed him from the attic window. The camera records a tall, balding man seen from the back as he goes about the peculiar business of tearing up cardboard boxes and throwing the pieces away. In a later scene, Cornell surfaces in his garage, barely visible as he stands beside a mound of newspapers, his arms crossed in front of his chest. What was supposed to be a film about Cornell's pursuits turned out to be a movie about the filmmaker's futile pursuit of Cornell.

By the end of the year, Cornell had something amazing to look forward to. He was planning a "memorial exhibition" in honor of Robert—a show that would feature his brother's drawings side by side with his own collages. Finding an art dealer who was willing to exhibit such personal—and sin-gularly uncommercial—work had not been easy. Cornell asked Allan Stone. He asked Richard Feigen. They both declined. However much they admired

Cornell's work, they could hardly afford to turn over their respective Upper East Side galleries to Robert Cornell's pictures of rabbits and hippos.

Happily, Cornell did manage to find an art dealer who was sympathetic to his proposal. Perhaps only Robert Schoelkopf could have said yes. Burly, bookish, and soft-spoken, he had studied at Yale and recently opened a gallery on the fourth floor of 825 Madison Avenue, on the corner of Sixty-ninth Street. The gallery was known for championing realist and representative painters whose work most dealers dismissed. At a moment when realism was viewed as old hat, Schoelkopf built up a following for Leland Bell, Gabriel Laderman, and other figurative artists. Cornell didn't exactly fit in, but Schoelkopf was a fan of his work and was delighted when Cornell wandered in one day to discuss the possibility of a memorial exhibition for Robert. Without hesitation, Schoelkopf put the show on his winter schedule.

"Robert Cornell: Memorial Exhibition" opened early in the new year (January 4–29, 1966) and presented Robert as an artist like any other. Cornell had picked out eight of his brother's most charming drawings, displaying them beside seven of his own collages and such "related varia" as an 1881 drawing of a locomotive by one Willie V. Morris in his thirteenth year—the picture was among Robert's most prized possessions. Cornell didn't mind exhibiting his work beside his brother's childlike drawings, to which he gave such titles as *Baby Hippo*, *Album Page*, and *Unbreakable Rabbit-drum*. The announcement for the show was nicely designed and featured a blue-hued reproduction of *The Encounter*, identified inside as the creation of "R.C. and J.C. jointly."

Could the reviewers take this seriously? Not always. In what was perhaps the most wounding review of Cornell's career, a critic named Jay Jacobs, writing in *Arts* magazine, didn't hesitate to lambaste Robert: "Robert Cornell is the putative subject of this memorial exhibition, but several recent collages by his better-known brother Joseph are the show's saving graces. While Robert's drawings (mostly of mice) are just too cute for the waste of any further words, Joseph's collages have a twilight aura about them that just skirts campiness."

Fortunately, the other reviewers were more temperate. "Robert died recently," reported a certain L.C., presumably Lawrence Campbell, in *Art News*. "He was the well-known Joseph's younger brother. His drawings, some of them childlike, have a personal strangeness and poetry."

A more penetrating review came from Hilton Kramer, who had joined *The New York Times* only three months earlier after a stint as the managing

editor of *Arts* magazine. Born in Gloucester, Massachusetts, in 1928, the son of a Russian tailor, Kramer had studied literature and philosophy at Syracuse University and soon after published his first article—a deft evisceration of Harold Rosenberg's concept of "action painting"—in *Partisan Review*. ("After it was published, I woke up the next day and found that the whole world considered me an art critic," he recalled with surprise.) Although he later became known for his blistering attacks on the contemporary scene, Kramer was in fact receptive to a good deal of new art and would now become Cornell's most influential supporter.

In his review of the latest Cornell show, Kramer sidestepped the issue of Robert's collages by ignoring them altogether and writing in more general terms about Joseph's work. He imagined the artist as an admirably pure man, a self-abnegating bachelor content to live through his daydreams. "His fantasy seems closer to the world of fairy tale and childhood romance than to the scandalous sexual encounters so much prized by the vatic voices of Surrealism," Kramer noted in the *Times* on January 23, 1966. "Not the pathos of experience, but the sentimental revery of an innocent dreaming of experience, has been his particular forte. Psychologically, Mr. Cornell's imagery has always been very knowing, but it is knowing in the manner, say, of the children in Henry James's stories—divining things they have never confronted in the flesh."

Cornell felt grateful for the Kramer review and sent him a small token of his appreciation. Kramer later recalled returning from an out-of-town trip and arriving in his office one day to find a big stack of mail. In his haste to dispense with it he initially overlooked the crumpled brown envelope from Utopia Parkway. "I almost threw it away," he remembered with amusement. Inside, he found a Cornell collage, with imagery on both the front and the back. Always the unappeasable critic, Kramer added, "The front was much better than the back."

In spite of the favorable notice in the *Times*, "Robert Cornell: Memorial Exhibition" was an unmitigated commercial flop. Of the sixteen works on view, only two sold: *The Encounter*, a collaboration between the two brothers, was purchased by the collector Lawrence Bloedel for $1,000 (of which Cornell received two-thirds, the customary percentage galleries then allotted to artists). And Cornell's *Zeno's Dichotomy of Motion* was purchased for the same

amount by S. Lane Faison, Jr., the director of the Williams College Art Museum.

The latter sale almost didn't happen. On January 22, in response to an inquiry from Faison, Schoelkopf confided in a vexed tone: "I have taken so long to reply because until yesterday afternoon, nothing in the show was for sale. As you may know, Mr. Cornell is somewhat eccentric and indefinite when it comes to disposing of his work, and he could not bring himself to quote prices."

On the Saturday the show closed, January 29, 1966, a small group of friends took it upon themselves to gather at the gallery. Some were kept away by the continuous and freezing rain, but Cornell, who arrived with a copy of Cyril Beaumont's book on the Romantic ballet tucked under his arm, seemed to be in high spirits. The writer Howard Hussey noted at the time: "He was jubilant because of an article in *Mademoiselle* tracing the lineage of Jean-Paul Belmondo"—the actor—"to Fanny Cerrito (his great-great-aunt). Cornell alluded to her as Miss Cherry-toes."

The "Memorial" exhibition represented one of the most poignant episodes in Cornell's career, yet he made virtually no mention of it in his diary. Then again, his diary had always skimped on his accomplishments as an artist. He seemed almost indifferent to his worldly successes. Perhaps it had to be that way. To have recorded them would have been to mar the impression of failure and longing that his diaries consistently convey.

By the time the "Memorial" show opened, Cornell's longings had become focused on someone new. Susan Sontag had recently emerged as America's most chic intellectual. Today, it might seem inconceivable that a weighty essay in a small-circulation journal could catapult a writer into national prominence. But such feats were still possible in the 1960s, and Sontag had become famous virtually overnight when she published her essay "Notes on 'Camp' " in *Partisan Review* in 1964. She was thirty-one years old.

Cornell first became aware of Sontag in July of that year, when he saw her on television "deploring the educational system," as he noted in his journals. Her appearance intrigued him, and he felt "momentarily inspired." But he gave her no further thought until November 21, 1965, when he read her review of Maurice Nadeau's *History of Surrealism* (a classic newly

translated from the French) in the New York *Herald Tribune*. He proceeded to purchase her just-published book of essays, *Against Interpretation*. He admired her striking looks. Tucked inside his copy of the book is a proof sheet with nine different head shots of Sontag, handsome in a turtleneck and jacket, her short hair framing a face devoid of makeup. The photos were probably given to him by Sontag herself, who now became a faithful and understanding friend of the artist.

Cornell first approached her through the medium of the fan letter. Or, rather, a fan package: he put together an imaginative parcel that included a carbon copy of *Monsieur Phot*, his Surrealist film scenario from 1933. Sontag was charmed. "Dear Mr. Cornell," she wrote in a typed letter on December 12, 1965. "Thank you very much for your letter, and your gift of the film script. I was very moved and delighted by both (as well as by the mysterious fragments which had come earlier in the week; I thought I should never learn the identity of the sender)."

Their first encounter took place five weeks later, on January 19, 1966, when Cornell paid a visit to Sontag's apartment on Washington Street in Greenwich Village. Describing the visit in his diary, he mentioned little besides the "image of Jeanne Moreau on the wall," as if getting two stars for the price of one. A week later, he was reading her first novel, *The Benefactor*, and savoring the memory of his brief visit: "A week ago this evening at 6:30 Miss Sontag met for the first time in her Village apartment," he noted in his journals, as if observing an important anniversary. Three days later, he telephoned Sontag and reported having "a decent talk."

For all his affection for her, Sontag could not take Cornell quite seriously as a suitor. It wasn't just that he was in his sixties and she was in her early thirties, a divorced mother raising a son. "Cornell seemed to be a person who lived in his head rather than in his body," she later remarked. "I saw what was there; he was fragile and thin and looked almost translucent. If I thought about what he did sexually, I guess I assumed he didn't do anything."

Yet Cornell's feelings for Sontag were genuine, and his obsession with her lasted for about six months. Her name showed up frequently in the heated nocturnal stenography of his diary. ("Sontag is *life*" begins one entry.) He telephoned her regularly and wrote her many letters, some of which he felt were too insignificant to send. He immersed himself in her writings and raved to his friends about *Against Interpretation*. "I had not been au courant with the pieces as published," he informed the writer Wayne An-

drews on February 26, 1966. "They are the most meaningful things I have come across lately."

Reading "Notes on 'Camp,' " the final essay in *Against Interpretation*, Cornell must have felt astonished by the degree to which it touched on the themes of his own work. Many of the artworks and individuals that Sontag mentions as examples of camp had surfaced in Cornell's boxes, such as *Swan Lake* and Greta Garbo, whom Sontag calls "the great serious idol of Camp taste." (She capitalized the word Camp throughout her essay, as if trying to promote it into approximate equality with the Romanesque or the Gothic.) What did Cornell think when he read that "opera and ballet are experienced as . . . rich treasures of Camp, for neither of these forms can easily do justice to the complexity of human nature"?

From the beginning, Cornell's work had seemed to flirt with the seductions of camp. His adulation of divas and movie stars, his democratic use of common objects—this hints at a sensibility that recognized aesthetic worth outside the canon of high culture. Still, it would be incorrect to deduce that Cornell's work celebrates camp. While he found inspiration in Garbo and Giulia Grisi and Romantic ballerinas, it wasn't because he felt amused by them. He was so involved with them it didn't occur to him to think of their exaggerated femininity as comic. Artifice aroused his most natural passions.

At any rate, it wasn't Sontag's essay on camp that most intrigued him. In a letter to her on January 14, 1966, Cornell indicated that he had been "wanderlusting around in *Interpretation* into the small hours, especially in the Leiris section." He was referring to her essay "Michel Leiris' *Manhood*," a review of an autobiography by the French anthropologist. You can see why Cornell was drawn to the piece, in which Sontag remarks: "Leiris records the defeats of his own virility; completely incompetent in the arts of the body, he is perpetually in training to extinguish himself; even his successes look to him like failures."

At Cornell's request, Sontag paid several visits to Utopia Parkway. "It was a great privilege to be asked," she said years later. "I certainly was not relaxed or comfortable in his presence, but why should I be? That's hardly a complaint. He was a delicate, complicated person whose imagination worked in a very special way. One went there to see his world." In the course of her visits, Sontag was amused to notice two refrigerators in the kitchen. "One was real," she recalls, "but one didn't work and he used it to store boxes."

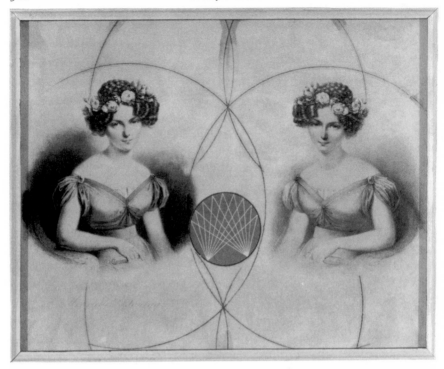

The Uncertainty Principle, 1966; collage, 8⅛ × 10⅛ in. (Collection Hirshhorn Museum and Sculpture Garden, Smithsonian Institution. Gift of Joseph H. Hirshhorn, 1972)

In addition to sipping tea in the kitchen, Sontag was accorded special visiting privileges. Touring the restricted realm of Cornell's basement, she admired his many antique books and prints, and was pleased when he played his Jacques Brel records for her. Eager to present her with special gifts, Cornell gave her two of his boxes and offered her material from his mammoth collection of film stills, insisting she take whichever ones she wanted. She gladly selected about a hundred photos for her own small collection. Most of her picks came from Cornell's fat folder on Erich von Stroheim's *Greed*, a 1925 classic about a homicidal dentist.

Cornell tried to think of other gifts that might appeal to Sontag's esoteric passions. Knowing her interest in André Breton, he attempted to obtain a trinket directly from the Frenchman's studio by writing to his friend Matta in Paris. Such an object was not easily acquired. (Matta's wife, Malitte, sent apologies: "I'm sorry you had to wait so long for the present for your friend—Breton is so difficult to find.") In lieu of an actual memento from

Breton, Cornell presented Sontag with the collage *André Breton*, which he created in her honor.

It was one among many collages Cornell made in tribute to Sontag. Early in 1966, he finally put aside the memorial project for his brother and initiated at least three series of collages inspired by his new writer friend. The most cryptic centered around Henriette Sontag, a nineteenth-century German diva. She bore no relation to Susan Sontag, but Cornell, relishing the coincidence of their shared surnames, liked to think of them as a pair—the Sontag sisters, imaginary twins whose doubleness captured the dreamy feelings of identification that made him their double as well. After obtaining a vintage print of Henriette—she appears as a delicate, fine-boned creature, her shoulders bared, a wreath of flowers in her braided hair—Cornell had it copied and incorporated the photostats into a series of collages. Among the best is *The Uncertainty Principle* (now owned by the Hirshhorn Museum)—a symmetrical composition with two Henriettes, one the mirror image of the other.

Cornell associated Susan Sontag with artists besides the singing Henriette. One was Breton, whose ideas served as a rich point of contact between Cornell and his latest muse. Sontag had introduced Cornell to a poem by Breton ("Le Tournesol de Minuit," or "The Midnight Sunflower") he particularly liked, and he referred to his Breton collages as his Tournesol project. They were based on a famous photo of Breton taken by Man Ray in the 1920s, though you would not guess from Cornell's collage-homages that Breton was the rebel who claimed that the ultimate Surrealist act was firing a gun into a crowd. In Cornell's collage *André Breton*, the once-scandalous Frenchman is encircled by a halo and made to look as humane as a priest. Then again, in *Laundry Boy's Change*, Cornell, acting with uncharacteristic Surrealist insouciance, outfitted Breton with extra curls and a false eyelash.

Of the many collages inspired by Sontag, only one depicts the writer herself. Entitled *The Ellipsian*, it, too, was based on a photograph—the suitably pensive portrait of Sontag that appeared on the back of the jacket of *The Benefactor*. In Cornell's collage, the photo of Sontag—torn at the edges to suggest the passage of time—occupies the upper right corner of the page, from whose heights she stares into space with cool self-possession. A scrap from a chart of the solar system and penciled circles endow her with an otherworldly dimension.

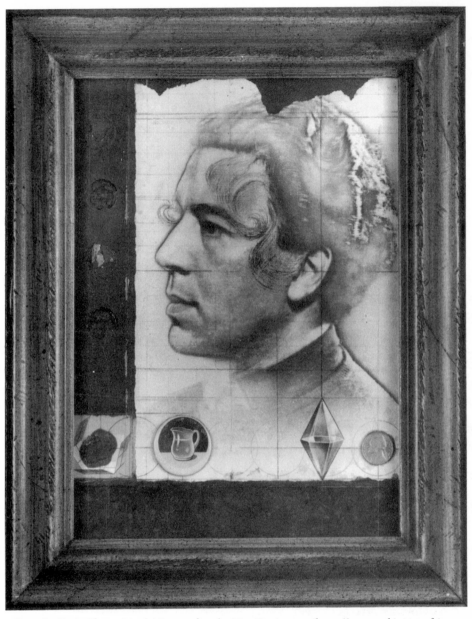

Laundry Boy's Change (André Breton photo by Man Ray), c. 1964; collage, 15½ × 12³⁄₁₆ in. (Collection André Baum, New York)

Curiously, Cornell's homage to Sontag has the same feeling as his Breton collages, coating a publicity photo with a haze of spiritual significance. From one collage to the next, we see a face turned to the side, and we see it in close-up, like the simple, flat images of the movie screen. Perhaps Cornell modeled these collages after film stills. They seem to say that famous intellectuals have their own mythic aura every bit as much as movie queens.

Over time, however, Sontag's aura was to fade for Cornell. He was a man of intense, episodic romances, each constituting a separate chapter with a euphoric beginning and a deflated, disillusioning end. "His heart was broken and mended so many times," Rauschenberg said on one occasion, "he should have got used to it."

Sontag was astonished one day when a young man who identified himself as the artist's assistant showed up at her Greenwich Village apartment and requested that the two boxes in her possession be returned. Of course she complied. It was the way so many of Cornell's relationships ended: the fantasy crumbled; the boxes came back to Utopia Parkway.

19

Goodbye, Mrs. Cornell

1966

From the time of her girlhood, Helen Cornell had often described herself as a person who "loves the ocean," as if that one detail conveyed something essential about her nature. Finally she was living within walking distance of the Atlantic Ocean. There were other consolations to her retirement in Westhampton. Of her four children, Helen Jagger, with whom she was living, was the one with children of her own, and Mrs. Cornell was now a great-grandmother who was fortunate to have two devoted granddaughters and two little great-grandsons nearby on Long Island.

Yet she was not happy at her new home. She missed Joseph sorely and pined for her days on Utopia Parkway, when, as she saw it, her life was given shape by the care she lavished on her distinguished son. At eighty-three, Mrs. Cornell still centered her emotions around Joseph.

Much of her time in Westhampton was spent at the desk in her bedroom. She passed the hours reading newspapers and writing letters, a plump, gray-haired widow absorbed in her solitary pursuits. She read with a pair of scissors at hand, clipping articles from *The New York Times* and the *World-Telegram* and enclosing them in her letters to Joseph. She knew what topics would appeal to him. Envelopes arrived at Utopia Parkway bulging with stories about the stars of the stage (JUDY HOLLIDAY'S GONE AND BROADWAY WEEPS), the wonders of nature (SEA SHELL MINIA-TURES STILL HOLD OLD CHARM), and the latest technological feats (PAN AM HELIPORT MAY OPEN DEC. I). Her mounds of clippings, she explained to her son with a secretary's deference, "may not be interesting but always hope one will interest you."

Mrs. Cornell wrote to Joseph at least once a day, and sometimes two or three times, as if he alone could understand her thoughts. Or perhaps she

was afraid that his loyalty might wither if her correspondence ceased for even a day. Eager to retain her central position in Joseph's life, she corresponded with his friends as well, sending off notes to everyone from his cleaning girl, Vivienne ("I hear glowing accounts of the 'gleaming' kitchen"), to the many art dealers, artists, and other "beautiful people" (her phrase) whom she had met through her son. In a letter to Richard Feigen in March 1965, Mrs. Cornell gushed: "I miss Joe very much and . . . all the 'beautiful people' who came to see him and added glamour to my life. I love every one of you. This country is peaceful and beautiful but I have always loved New York and Life— Thank you again, Dick, and please keep in touch. I can't bear to think I will never hear from all of you any more."

Writing to Joseph on October 28, she again stressed her fondness for the glittering city: "How I envy you—so many interesting people there— It added so much to my life always—I do miss it— Feigen has me on his mailing list which helps me a lot feeling I'm not wholly forgotten."

She dropped a line to the ballerina Tilly Losch, a crush of her son's from the 1940s. "Sometimes I feel no one Mother deserves two such devoted sons as mine," she informed Losch one winter day. "Never thinking of themselves—only what they could do for me—and needless to say my single aim was what I might do for them."

Mrs. Cornell depended on Joseph to forward her mail to any friends of his who were unlisted in the phone book: "Will you please address the enclosed to Miss Moore?" On another occasion, Cornell assured her: "Your letter to the Curtises is in the mail." It did not occur to Mrs. Cornell that people such as Marianne Moore or Tony Curtis might be too busy to answer her rambling missives. Much as she expected preferential treatment from her son, she expected special courtesies from everyone, and felt hurt and disappointed when, inevitably, she failed to receive them.

"Haven't had one word from Mrs. Duchamp for the letter I took such pains with and also I wonder if she ever got the little gift [which was wrapped] in my last gold & silver Lord & Taylor Gift Box," she once complained to Joseph. "People could take a minute or two to acknowledge little kindly things their friends do."

Mrs. Cornell felt similarly unappreciated by her two daughters, perhaps because they resented her closeness to Joseph. "Dear Joe," she confided in April 1965, "I wrote you a long letter yesterday, then this morning I tore it up—am tired of Helen & Sister (Helen most) telling me, Don't bother Joe writing 'little' things. Sorry I'm so 'little.' " Then, finding consolation

in the robust world of her son's professional attainments, she added: "Didn't even know you had collage work in new show at MoMA. Nice couple of Stuart Preston's sentences in yesterday's Times about you."

Over the years, visitors to Utopia Parkway had often seen Mrs. Cornell as a stereotypical old lady, dusting the kitchen curtains and watering her house plants as Joseph shepherded his avant-garde friends down to the basement to see his latest creations. In her matronly dresses, she seemed to dissolve into the background, a real-life version of the Vuillard paintings in which the artist's stooped mother merges with the living-room wallpaper. Yet Mrs. Cornell's letters present her in a different light. Few could have guessed at the intensity of her interior life, the degree to which she felt stirred and excited in Joseph's presence.

Cornell, who kept everything, of course kept his mother's letters. Several hundred survive among his papers. The cumulative self-portrait they offer is poignant, comical, and frightening. Mrs. Cornell emerges from her correspondence as a vivacious but needy woman who yearned for Joseph with an ardor more befitting a lover than a mother. Her letters were usually written on her personal stationery, plain white paper printed with the heading: "Mrs. Joseph I. Cornell, Box 121, Westhampton, N.Y." It's as if she thought she was married to her son.

The days passed, and the letters accumulated on the kitchen table at Utopia Parkway: "Yours, Mother." "Love & prayers from Mother." "Love from Mama." "Love and a billion thanks for a glamorous week of mail — MAMA." Every day brought new declarations of love from Mrs. Cornell, all of them written in her well-formed, exuberant script. Joseph did not always open her letters when they arrived. Sometimes he waited a day or two, a week even, until his bad mood lifted and he could appreciate them. One day, in his bathrobe, he pored over her "beautiful and heartfelt letters" and noted that they brought him "unexpected solace." Sometimes he jotted on an envelope "Read again," presumably an instruction to himself, as if his mother's letters were subtle compositions whose meaning could reveal itself only with multiple readings.

Mrs. Cornell's letters to her son are chatty affairs that abound with the usual hovering concerns of motherhood. Was Joseph eating well, getting enough sleep, wearing his rubbers in the rain? Why did his voice sound "a little serious" when she phoned the other day? She could not spend enough

time thinking about him. She renewed his subscription to *TV Guide*, shopped for him in the Riverhead stores ("Got you a *new clean* rubber bathtub mat!"), and tested recipes in anticipation of his next visit: "I made that new Tomato Gelatin in the copper heart mold especially for you."

Yet, for all their focus on daily events, her letters have a disturbing edge. Joseph was an alluring and even romantic figure to Mrs. Cornell, and her letters from Westhampton are dominated by her loneliness and her longing for him. "I was so critical so many times," she wrote on April 25 "—please forgive me—I don't excuse myself—I want you to feel you are free—I'm well taken care of—but miss you very, very much—you just can't live so close for so many years with anyone who means so much to you and in later life be separated . . . You have always had top place in my life—Robert second—you have fulfilled my most ardent dreams far beyond anything I ever imagined."

She seemed to live for his missives. "Joe dear," she wrote on March 23, "Thank you for your letter . . . When I hear from you every day, the time passes more pleasantly." Two days later: "Joe dear, you continually make my quiet life here so full of good things." Of course, phone calls brought her even more pleasure. "I have the answer to my homesickness on Sundays," she wrote on May 2 "—I call you up every week and feel so refreshed and happy." Best of all were actual visits. On June 29, a couple of hours after her son departed from Westhampton, Mrs. Cornell was back at her desk: "You are nearly in New York by now . . . Can't describe how much good your visit did me—I feel like a new person."

For a period of several months, Mrs. Cornell's correspondence was taken up with the details surrounding Robert's death. It was decided to have his remains cremated and buried in Nyack, at the cemetery where Joseph Cornell, Sr., had been laid to rest half a century earlier. But the ground was frozen on the winter day when Robert died and his ashes could not be interred immediately. The service was postponed until April 21, the Wednesday following Easter, and arrangements were made for a Mr. Bosch to deliver the final prayer.

Cornell, of course, planned to attend the service for his brother. But his mother, acting with astonishing possessiveness, persuaded him not to go. She felt that the three-hour car ride to Nyack was more than she herself was up to and conspired to have Joseph spend the day with her in Westhampton instead. Her two daughters and their husbands, she reasoned, would be attending the service. Wasn't that enough?

Writing to her son on April 13, Mrs. Cornell laid out her somewhat sinister plot: "Joe Dear, I would so love to have you here with me on Wednesday— It might be too much for you to go to Nyack plus the long drive—a burial after cremation is emotional—I don't think I could stand it—so the four could go & you could come here—but let us know what you will do— Your Mother."

As always, he did what she wanted. Whether or not he was comfortable with her request, he felt sorry for her, in her sad old age, and agreed to spend the day of the funeral at her side in Westhampton. At the hour the service was being held, the two of them, mother and son, went to the ocean to gaze out at the water and pay their final respects to Robert. Later, to cheer his mother, Joseph took her to lunch.

"Thank you for coming and giving me such pleasure by going to Wild Oak," she wrote on April 23, after his return to Flushing. "I really enjoyed every minute. Have always wanted to go with you to eat out."

Cornell's letters to his mother were, on the whole, as affectionate as hers to him. While his style was stiffly formal compared to hers, he admired her warmth, her lack of inhibition, and tried to reciprocate. He didn't miss her as much as she missed him, and at times felt burdened by her feverish sentiments. But he wanted to do what he felt was right, to summon the appropriate filial consideration and tenderness.

Such feelings came to him easily now. The discord and habitual bickering that had characterized their relations on Utopia Parkway ceased when she moved out. From a distance, Mrs. Cornell could become an ideal—the essence of benevolent maternity—and her son could believe in her completely. He felt unworthy of her affection and believed that she possessed a reserve of kindness that surpassed anything he had to offer. In his letters, Cornell commended his mother for her valiant self-sacrifice and modestly suggested that he was her moral inferior: "I never feel adequate," he informed her, "replying to your serious questions and wonderings."

In the same letter, written in May 1965, Cornell exhorted his mother to recall her devotion to Robert, to "think of all those long walks with the wicker chair in Douglaston and Bayside, all the care throughout the years, the increasing demands because of your getting older . . . All your children revere you profoundly in this world and in the one to come."

Most of Cornell's letters to his mother were less effusive. Instead, they

concentrated on the mundane. Cornell enlightened his mother on the food he ate, the birds he glimpsed through his cellar window, the progress he was making on the interminable task of cleaning out his cellar and garage. He mentioned the shows he saw on television and sent along news of the neighbors and the postman ("He asked about you with his big smile").

Cornell thought back with pleasure to the days when his mother was still living at home. Writing to her on a "quiet Monday" in July 1965, he mentioned "one bright spot this morning—for a change of pace [I went] over to Bayside West diner & on a fresh though chilly morning the clean air evok[ed] your marketing days over at the A & P . . . I had an apple turnover & coffee au lait . . . Thank you for the mop and macaroons; it was like you being here."

In addition to his frequent letters, Cornell treated his mother to delicacies available only in Flushing. He regularly went to Gertz's department store to buy a certain brand of liver-dumpling soup that she relished. Once he bought her a Bible at Gertz's—only to return it after she claimed with typical dissatisfaction that some pages were missing. And who knows what else he bought? "I never stop using and finding replacements of things you have bought for me," Mrs. Cornell wrote on March 21. "The last is the Pond's Face Cream—I'm nearly at the end of one jar and I find I have a fresh jar that you bought for me—and the useful eye cup!" Cornell also furnished his mother with a large, varied supply of stationery and Hallmark cards, along with such epistolary adornments as "TB seals and wildlife seals."

Cornell did all this without complaint. He no more entertained subversive thoughts now than he did in his youth, when he first placed his family's needs above his own. If Cornell dared to defy anything, it was the stereotype of the artist. So many artists astonish us with their unbridled egotism. Their art leaves them with little room for personal relationships, except for those that serve their ends, and we read biographies of great artists in part for the fascination of seeing how they wrecked the lives around them. A maxim maintains that "art saves," but art also injures, and the life stories of modern artists, from Picasso on down, tend to include teary tales of wives, lovers, parents, and children who have been betrayed.

With Cornell, it is the opposite. What stuns us is not his selfishness but his nearly scandalous selflessness—his docility, his meekness, his supine acquiescence to his mother's stratagems. He yielded to his mother as if in a deliberate "altruistic surrender," to borrow Anna Freud's phrase, and was

involved in a way that might seem to preclude having enough independence to make art. But outward passivity can give rise to its own strain of potent creativity, and to read through Mrs. Cornell's letters from Westhampton —with their fiery, baroque declarations—is to understand how emotionally wedded she felt to her son and why his relationships with other women had to be conducted in the locked privacy of his fantasies.

As the months went by, Mrs. Cornell often hinted to her son that she hoped to return to Flushing for her final days. By the middle of 1966, she had lost a good deal of her physical strength. She was almost deaf, and her eyesight had become so poor that she needed a magnifying glass to read. Lucid letters still flowed forth from her desk, but her handwriting was difficult to decipher.

She felt that her end was near, and did not hesitate to say so. To Mrs. Cornell, the notion of dying did not unleash thoughts about her spiritual life. Rather, it brought on practical concerns. She wanted to make sure that nothing went to waste, not even her clothing, and requested of Joseph on September 22, 1966: "Could you find out if any of the four Frances her mother or her two sisters is size 16 and a half? Please. I lay awake so many nights worrying about who to leave my good dresses to. Love, Mama."

In October 1966, almost two years after moving to Westhampton, Helen Cornell suffered a stroke that left her severely disabled. She was sent to Central Suffolk Hospital in Riverhead, where she spent the last week of her life. During her hospitalization, her children and grandchildren kept constant vigil by her bedside, though the stroke had rendered her unable to communicate with her visitors or even to indicate that she knew they were there.

Upon hearing the news of his mother's stroke, Cornell left home immediately for Westhampton, staying at the Jaggers' house. His plan was to remain there indefinitely, until his mother regained her strength. He apparently felt optimistic about her chances for recovery, likening her case to that of one of his favorite actresses. His niece Helen Batcheller later remembered, "The fact that Patricia Neal had survived her stroke and recovered made Joseph hopeful that Helen would recover from hers."

In Westhampton, Cornell thought about contacting various art-world acquaintances who lived in the Hamptons. He noted in his journals that

Willem de Kooning was on Woodbine Road in the Springs and Fairfield Porter on 49 South Main Street in Southampton. But the round of social calls he envisaged was never made. At the Jagger house, he stayed in his mother's room. He slept in her very bed and often sat down at the desk where she had written her many letters.

"Dearest Mother," Cornell wrote on October 13, ". . . Thursday now— at your desk looking out on the flowers and woods." The following morning, he noted in his diary: "Penning again at Mother's desk now before shaving, with another beautiful feeling of trust and gratitude for some deliverance from depression." It amazed him that "she could be in Riverhead" while he was experiencing "such a sense of [her] presence in her room."

Helen Ten Broeck Storms Cornell died on October 17, 1966, at the age of eighty-four. Her funeral was held three days later in Nyack, where she was laid to rest beside her husband and her son Robert. The long car ride to Nyack marked Cornell's first return to his hometown in years. He found the trip strangely interesting and experienced a sense of "harmony" while standing on the cliffs overlooking the Hudson River. Awash in nostalgia, he thought back to the rambling Victorian house where he had grown up and in his mind's eye saw every corner of the kitchen. His memory lingered on "the stone floors" and "the butter churn."

But that house no longer stood—it had burned to the ground a few years after the family moved out—and the woman who had once presided over it was gone, too. As was the case when Robert died, Cornell found himself unable to muster the appropriate feelings of loss and despair. He later recorded in his diary that at his mother's funeral, he felt nothing, except for "surprise at the absence of deep grief."

The comment was curiously unsentimental. Perhaps Cornell was emotionally spent, having sacrificed so much over the years to his mother's avid needs. His reaction—or lack thereof—suggests a masked hostility on his part, while also hinting at a basic unwillingness to confront his own mortality. From the beginning, he had been an escape artist, the Houdini of modern art, extricating himself from difficult situations by vanishing into dreams of the past. As he stood on the edge of his mother's grave, there could be no abracadabra, no magical flight from the reality of death. Still, he could escape his feelings about death by refusing to feel anything at all other than a dull detachment.

<div align="center">• • •</div>

On October 27, a week after his mother's funeral, Cornell returned home to Queens. He was almost sixty-three, a weakened bachelor shuffling through the silent rooms of his house. Much of his time on Utopia Parkway continued to be spent in the kitchen. While the rest of the neighborhood slept, he passed his insomniac nights at the table, sipping weak tea as he wrote in his diary or reread his favorite authors. Winter was coming, and the house was quiet except for the rattling of the radiator. After years of daydreaming about ballerinas and divas who had lived a century earlier, his mother was gone, and he had only to think back to last year or last month to mourn the irretrievable past.

He saw his mother's face in his dreams. And even during his waking hours, she seemed present to him somehow. While he could not shed tears at her funeral, in the weeks that followed he thought about her constantly. "I live for a revival," Cornell once wrote, and the memory of his mother moved him as deeply as any image from the past.

Holidays were predictably taxing for him. He spent Thanksgiving alone in his house, listening to the radio and thinking back to the previous Thanksgiving, when he and his mother and other relatives had met for a turkey dinner at a Howard Johnson's restaurant on Long Island. He had ended up eating "French fries only," and he smiled as he remembered the dinner now.

For a moment he pictured his mother at the restaurant, still lively despite her weight and gray hair. He saw her so clearly he felt moved to address her in his diary. "Sitting by kitchen stove in bathrobe," he reported on that November night, "just after the sign-off of Bill Watson's program and same overflow of the emotional, remembering just a year ago today . . . recalling the elan you brought to the dinner last year—remembering, too, my depression at over-worked waitresses."

Helen Cornell's grip on her son was not loosened by her death. On the contrary, she now joined the phantoms who consoled him day and night.

20

The Guggenheim Show
1967

Cornell was sixty-four years old before he finally received major recognition in the art world. In 1967, he was belatedly honored with two large and important retrospective exhibitions, one in California, the other in New York. The shows would bring him international attention and the unstinting praise of critics. But if 1967 marked a high point in Cornell's professional life, it marked a personal nadir. He was still grieving over the loss of his mother, and the prospect of a big retrospective deepened his already elegiac mood. His diaries from the period record the thoughts of a man who, for days on end, sat home in his navy-blue bathrobe, mourning "the nightmare of my empty house."

As Cornell remained bent in grief, his career took off on its own. By 1967, Pop art had reached its apex and art historians interested in the movement began reconsidering Cornell. No one could deny that his work prefigured the new fascination with popular culture. Among his champions was Lawrence Alloway, a former curator at the Guggenheim who had recently tapped Cornell for the Venice Biennale, an honor of the first order. Or so it was announced in *Time*, which, on July 8, 1966, ran a story on Cornell. Beneath a photo of the artist in which he looks quite depressed—he stares downward, his gaunt face pressed into his hand, with a paper canary trapped in a dark box beside him—readers learned that Alloway had picked Cornell as "one of four artists to represent the U.S. at this year's Venice Biennale." As it turned out, Alloway's choices for the Biennale—Cornell, Roy Lichtenstein, David Smith, and Jules Olitski—unfortunately were shelved as a result of a political squabble that left Henry Geldzahler in charge of the affair and eager to pick his own emissaries. So Cornell did not get to Venice, and he complained about the mix-up not a bit.

It was the Pasadena Art Museum that gave Cornell his first true retrospective. Housed in an imitation Chinese pavilion, the museum was then the most interesting in Southern California and the only place that collected twentieth-century art in any depth. In 1951, it had received the Galka Scheyer bequest, which included works by Klee, Kandinsky, and other members of the Blue Rider group. Moreover, it had Walter Hopps, who, at thirty-five years old, was widely considered the most gifted museum man on the West Coast.

Hopps was known for his elusive and eccentric behavior as well. A California native, he was tall and imposing, with flowing hair, and his most salient characteristic was probably his cavalier disregard for time. He never showed up for appointments, rarely could be found at his desk, and was rumored to hang his exhibitions in the middle of the night. Given Cornell's own indifference to deadlines and belief that every day was an "eterniday," it's hard to know how he and Hopps were able to get a show together. Tellingly, it was postponed three times before finally opening in January 1967.

By now Hopps had known Cornell for a decade. During his days as an art dealer in Los Angeles, he had shown Cornell's boxes at the Ferus Gallery and later at the Dwan Gallery. Hopps had always loved Cornell's work, in part because he loved the strain of modern art that glorified the found object. In 1962, the same year he joined the Pasadena Museum, he organized the first retrospective of Kurt Schwitters; the following year, he organized the first Duchamp retrospective. It was inevitable, perhaps, that Hopps would turn next to Cornell, whom he once described as "Schwitters' greatest successor." Aside from the show at the Walker Art Center in 1953, which was too small to really count as a retrospective, Cornell had never had a proper museum show, and Hopps felt the time was right.

Still, the Pasadena show ran into a host of problems that far exceeded the usual Hoppsian mishaps. Not least among them was that Hopps was fired from his job in August 1966, following a stay in the psychiatric ward of Cedars–Sinai Medical Center, where he acknowledged having a drug problem. James Demetrion, a young curator at the museum (and the future director of the Hirshhorn Museum and Sculpture Garden in Washington), became acting director of the Pasadena Museum, and his first act was to ask Hopps to stay on and install the Cornell show. Hopps gladly agreed.

But Demetrion encountered problems of his own. In December, a month before the Cornell show opened, Demetrion flew to Chicago to retrieve five boxes from the home of the collector Edwin Bergman. On the way to his motel, his taxicab was in an accident; he was severely injured, and a Cornell *Swan Lake* box was destroyed. That day, informed by telephone about the loss of the box, Cornell was surprisingly calm, urging Demetrion not to be "maudlin." As a result of this turn of events, Hopps became the *acting* acting director of the museum.

There was little time to assemble a catalogue, which featured in the place of an original essay a reprint of an article by Fairfield Porter that had appeared in the journal *Art and Literature* the previous spring. Cornell once described the piece as "the only decent thing yet published on my work," thereby snubbing a generation of art critics. Porter, of course, was an artist himself, and his piece on Cornell was a warm, jargon-free appreciation that warned of the difficulty of categorizing the boxes, especially on the basis of reproduction. "Because they are three-dimensional," Porter noted, "they communicate their quality as badly by photograph as sculpture does."

When "An Exhibition of Works by Joseph Cornell" finally opened at the Pasadena Art Museum (January 9–February 11, 1967), it showed remarkably few signs of strain. It brought together seventy-four works from all periods, the most comprehensive survey of the artist's career to date. Hopps did a superb job hanging it, making the show "the most dramatic example of his legendary wizardry in matters of installation," as the critic Philip Leider noted in *The New York Times*. Rather than resting on pedestals, the boxes were recessed into the walls or arranged on dark shelves, and spotlights made them seem like so many twinkling jewels.

While Cornell did not consider traveling to Pasadena to see the show, he felt honored by the exhibition and liked having his work on view in Los Angeles, home to so many of the actresses he admired. The museum staff was amused one day when a collage from Cornell arrived in the mail with instructions to pass it on to Yvette Mimieux, the fresh-faced blonde who had starred in *The Time Machine* and other sixties movies. "Cornell knew she was in Hollywood Land and wondered if we could get the work to her," Demetrion later said.

As extraordinary as the show was, it is hard to find anyone who actually saw it. The Los Angeles art scene was then rather limited, and the Pasadena Museum was lively in a small avant-garde circle of "about five and a half

people," according to Hopps. While the show confirmed Cornell's status as a major talent, his next show, back home in New York, would bring him the sort of broad recognition that had previously eluded him.

Only three months after the Pasadena show closed, a second retrospective of Cornell's work opened at the Solomon R. Guggenheim Museum, at Fifth Avenue and Eighty-eighth Street. It was not the same exhibition that was shown in Pasadena; it predated the phenomenon of the big "traveling" show. For Cornell, the Guggenheim exhibition represented a high tribute from one of the most cherished museums in the world. Only three Americans had ever had one-man shows at the "Goog": Rothko, Calder, and Barnett Newman. Frank Lloyd Wright's building, spiraling upward in coils of white concrete, was itself a landmark; to Cornell's admirers, it uncannily echoed the circular rings that appear in so many of his boxes.

The show was organized by Diane Waldman, a thirty-year-old research fellow who later became the museum's deputy director. Waldman had first met Cornell in 1963, when, as a graduate student at the Institute of Fine Arts at New York University, she wrote her master's thesis on his work. During her student days, she had often gone out to Utopia Parkway to gather information from the artist. Cornell seemed to enjoy her visits. Though reluctant to discuss his life, he liked hearing about hers and was fascinated to learn that she had posed in the nude for her husband, the painter Paul Waldman. "He told me that he admired the nude, and admired artists who drew from the nude," Waldman later said. In her eyes, Cornell was an American master, and it did not occur to her that he viewed her as a pretty brunette who broke up the monotony of his days.

Soon after starting work at the Guggenheim, Waldman fixed on the idea of a Cornell exhibition, which would be her first show at the museum. Cornell's boxes were still so unappreciated that even her boss, Thomas Messer, was only casually acquainted with them. On March 6, Waldman brought the museum director to Queens. Cornell took an instant liking to Messer, a native of Prague with a thick accent and courtly manners. "Cornell concluded in his dreamy mind," Messer recalled, "that I was born in the nineteenth century and was part of the pre–World War I bohème in Vienna." In keeping with this fantasy, Cornell presented Messer with a souvenir photo of the actress Eleonora Duse.

After his felicitous meeting with the artist, Messer lent his full support

to the show. Putting it together involved borrowing work from about three dozen people, some of them old friends of the artist (Donald Windham, Parker Tyler, Teeny Duchamp), others prominent collectors (Edwin Bergman, Joseph Hirshhorn). None was more prickly about lending than Cornell himself, who provided twenty-five pieces from his personal collection while requesting that his recent collages be included in significant number. He was aware that the museum staff valued his early boxes over his collages from the 1960s, an unhappy reminder of his waning creativity. "The negotiations were rather prolonged," Messer said, "and I let Diane do most of it because I think Cornell liked to look at Diane."

Even so, Cornell was ambivalent about the prospect of a show. He complained to friends that he lacked the strength for such an undertaking at a time when he was still in mourning for his mother. He assented to the show, he told the art critic David Bourdon, only after the museum staff promised to schedule it at the end of the school year, when students might have a better chance of seeing it.

Despite the artist's many reservations, "Joseph Cornell" (May 4–June 25, 1967) was a triumph. Installed on the top two tiers of the Guggenheim, the show brought together seventy-eight boxes and ten collages that went all the way back to the artist's very first work, his *Schooner* collage of 1931. To be sure, the Guggenheim's wide-open space was not the best setting for Cornell's intimate creations, but this drawback was offset by the opportunity the show represented. Over the years, Cornell had switched galleries so many times that even his admirers had found it hard to keep up with his work. The Guggenheim show gave New York its first extensive look.

The critics loved it, and national publications that had never devoted an inch of copy to Cornell's work could no longer ignore him. With the exception of Mel Bochner, a Conceptual artist and the lone voice of critical disapproval ("These are not the terms which artists are dealing with anymore," he complained in *Arts* magazine), the reviews were consistently positive. Hilton Kramer of *The New York Times* weighed in first, praising the show on the day it opened as "an exhibition of unforgettable beauty" that confirmed Cornell as a modern classic.

Harold Rosenberg was no less laudatory in his lengthy review in the June 3 issue of *The New Yorker*, his first piece ever on Cornell. Rosenberg was enamored of popular culture (he had previously worked in advertising) and saw Cornell as a kind of street poet whose boxes "are primarily descendants of the slot machine." Max Kozloff, writing in *The Nation*, instead

saw Cornell as "extremely knowing" about art and art history, and berated
his fellow critics for their patronizing attitude toward his work. "The usual
treatment at one time," Kozloff wittily observed, "was to sing or chirp
along with the boxes in verbal mimicry of their winsome oddments. More
recently it has become harder to resist giving factual but fascinating lists
of Cornellian imagery—with the effect, perhaps, of some of the more tit-
illating recipes in the gourmet cookbooks."

Surely no one was more appreciative than John Ashbery, who had recently
returned from a stint in Paris to become an editor at *Art News*. His review
of the Cornell show, a four-page spread in the magazine's summer issue,
was the sort that every artist dreams of receiving—well written, copiously
illustrated, and full of large but supportable claims. The Guggenheim show,
Ashbery declared, was "a historic event: the first satisfying measure of work
by an artist who has become legendary in his lifetime."

As befits a legend, Cornell's life was suddenly attracting as much attention
as his work. Reporters from newspapers and magazines began traveling to
Utopia Parkway to interview the great artist. Journalists who were well
aware of the bravura antics of Picasso and Jackson Pollock were astonished
to meet Cornell, who seemed so passive they wondered how he got out of
bed in the morning.

Of the many articles that appeared in conjunction with the Guggenheim
show, none brought Cornell more publicity than "The Enigmatic Bachelor
of Utopia Parkway," a 12-page spread in *Life*. It appeared in the issue of
December 15, 1967, which also featured stories on the first successful heart
transplant and the recent engagement of David Eisenhower and Julie Nixon.

This is not to imply that the editors of *Life* considered the Cornell
exhibition breaking news. The article appeared five months after the Gug-
genheim show closed. David Bourdon, then the magazine's art critic, recalled
his exasperation as weeks and then months went by and his already written
story was postponed again and again. Finally, he protested to his editor,
reminding him, "Cornell is a major American artist." "Oh," the stunned
editor replied, "why didn't you say so?" The piece ran the following
week.

Bourdon's article offered an amusing account of a visit to Utopia Parkway,
beginning from the moment he arrived on Cornell's doorstep and rang his
bell ("a black button with a crescent moon on it"). Bourdon happened to

be carrying a copy of Antoine de Saint-Exupéry's *Wind, Sand and Stars*, which got things off to a good start. After noticing the book, Cornell quietly retrieved a manila envelope from his files and showed his guest his impressive memorabilia: Saint-Exupéry's autograph, dated 1942, plus a photo of the author's wife and two or three of the original drawings for *The Little Prince*. Cornell and his visitor talked for several hours in the back yard, though not always with ease. "Cornell freezes at the sight of a notebook," Bourdon observed in his article, "and when I listened too attentively he drifted into another subject."

Their meeting ended disastrously. Without warning, Cornell became upset about a box he had shown Bourdon—its clay pipe, he claimed, was somehow not right—and virtually collapsed from the strain of the interview. As Bourdon recounted in the last paragraph of his article, "His expression became increasingly preoccupied and somber. Wringing his hands, he suddenly said the box in the dining room was all wrong. 'I never should have shown it.' He appeared to be on the verge of tears. Abruptly he hurried me into my coat and I was out."

When the article was finally published, Cornell could not believe what he was reading. He first saw it on December 13, on a newsstand in Grand Central Terminal, and described it in his diaries as "abortive." The following day he was still trying to regain his composure "after the Life monstrosity." Cornell did not hesitate to share his feelings with David Bourdon, who later remarked: "It was the first time an artist called me up and said he hated a piece."

The Guggenheim exhibition marked the pinnacle of Cornell's career, yet he could not enjoy his good fortune at all. In conversation with friends, he spoke about the show with unconcealed disappointment. He was especially critical of the catalogue, whose essay, by Diane Waldman, represented the first thorough consideration of his career and remains a highly valuable study of his work. While Waldman divulged few details about Cornell's personal history ("Little is known of Joseph Cornell's early life," her essay begins), Cornell found her comments obtrusive nonetheless.

He was particularly aggrieved to find himself described, on page 1 of the catalogue, as a "shy and reticent man." On page 16, there it was again: "A shy and secluded man," it said. The adjectives injured Cornell's pride, much as a similar comment by Motherwell had done many years earlier. Cornell

would not have assisted Waldman in her research, he lamented in his diary on June 5, "if I'd ever known that an essay would contain such personal and false allusions as 'shy and secluded.' " It distressed him to think that she could make such a claim after all their pleasant afternoons together and the wealth of friendship he believed he had lavished upon her.

Cornell was further vexed by Waldman's comments about his work. In a phone conversation with David Bourdon on May 19, he complained of the curator's "arid" scholarship, claiming that she looked too deeply for meaning while failing to credit his intuitive juxtapositions. He disliked her "analytical detailing" of the work, he said. He added that the Pasadena show was infinitely superior to the Guggenheim show, favoring the one that he had not seen.

It is often said of artists that they live in fear of being misunderstood. Cornell, by contrast, lived in fear of being understood. Nearly everything that was published in connection with the Guggenheim show—from the scrupulous catalogue to the more colorful revelations in *Life*—violated his sense of privacy and aroused his resentment.

From the very first, the notion of a Guggenheim retrospective had stirred such conflicted feelings in him that he could hardly stand to think about it. In the weeks before the show opened, as if trying to suppress any thoughts of self-advancement, he focused instead on the opportunity the show represented for his brother. One of Robert's drawings, a sketch of a drum-playing rabbit, was to be included in the show, albeit modified as *The Unbreakable Rabbit Drum* (1966), a collaboration between the two brothers. Would Hilton Kramer notice the collage? So Cornell wondered on April 10, when he jotted in his diary his hope of "the Times man viewing Robert's work at forthcoming Guggenheim" exhibition.

Cornell was in no hurry to see the show. He declined to attend the opening reception, an elegant affair held on a Wednesday evening, May 3. Yet while refusing to preside over the display of his work, he did urge friends and relatives to make an appearance on his behalf. He considerately sent tickets to his sisters, careful to mention that "I'll not be there myself." He also sent tickets to Elizabeth Thode, a teacher at the New York Institute for the Education of the Blind. She kindly attended the opening and later wrote him an appreciative note: "Dear Mr. Cornell, Enchantment dwelt in the Guggenheim Museum on Wednesday night!"

During the eight weeks the show remained on view, Cornell stopped by to see it twice. Inevitably it was a powerful experience, wandering down the

ramps of the Guggenheim and seeing his life's work unfurl before him, from his very first collages to the Pink Palaces and Medici Princes of the 1940s to the marvelous white magic of his 1950s boxes, the Aviaries and Observatories and Dovecotes and Hotels. He had every right to linger proudly in front of each work, but it seems more likely that he paused to look at next to nothing and tiptoed from the scene like an intruder. A diary entry, dated June 1, was recorded in the museum library, which, he noted, contained "original Van Gogh letters"; they perhaps led him to muse on Vincent's famous loyalty to his brother Theo. "Robert with all the geniuses," Cornell scribbled, revealing his own fraternal allegiances while deflecting his ambition onto his brother. He returned home that night dizzy from a migraine.

A museum retrospective can be a tribulation for even the most self-assured artist. It is common among artists to liken retrospectives to retirement ceremonies or even burials, rites for the creatively dead. In Cornell's case, the Guggenheim retrospective came at a complicated time, opening less than seven months after his mother's passing. As millions of Americans read about Cornell in *Life* or *Newsweek*, as they turned the pages of their magazines in commuter trains, kitchens, and doctors' offices, Cornell himself had little sense of the publicity swirling around him. He spent most of the year at home on Utopia Parkway, suffering from migraines and other bodily "pressures," particularly in his eyes and his neck.

It was a time of deep reminiscence. Day after day, he thought of his "Mother joined with Robert in heaven." Sitting near the stove in the kitchen, he felt affection for that very room, his "observatory," as he referred to it. The kitchen's mute white walls had been witness to many rich moments, not least among them the hours he spent gazing out the window. He had seen so many marvelous sights: "quince tree, birds, light, snows, rains, everything." The back yard was empty now, but it was easy to recall happier days, and in his mind's eye he envisaged "Mother in her garden, Robert's visits under the quince tree."

Flashbacks (his word) came to him frequently. He remembered his earliest trips to the city, when, accompanied by his mother, he was first enchanted by the dazzle of Times Square. His mother, too, had always loved Manhattan, and he felt a "strong debt" to her for introducing him to "the magic of the lights."

Nearly everything he saw and heard reminded him of his vanished youth. He was distraught to learn, that March, of the death of Geraldine Farrar at the age of eighty-five. Listening to a memorial concert on the radio, Cornell recalled the scratchy Red Seal albums of his childhood and the pleasant Nyack afternoons his family had passed around the Victrola. He borrowed Farrar's autobiography, *Such Sweet Compulsion* (1938), from the Flushing library and dedicated a collage to her memory.

In spite of his depression and chronic ailments, Cornell still had good days in his basement workshop. Collage remained his main medium, and he steadily produced new pieces. It bothered him that public attention remained focused on his boxes at the expense of his recent work, and he didn't hesitate to speak of his boxes as a finished chapter. As he was quoted lamenting in a *Newsweek* article by Jack Kroll, "I'm not very sanguine about the prospect of making more boxes—I don't think I'm strong enough anymore."

Still, he continued to work on his collages, composing them mostly from magazine cutouts. Physically, they were less demanding than his boxes, and indeed, the very medium of cutouts carries associations of invalidism. (One thinks of the wheelchair-bound Matisse snipping away with his scissors.) Cornell's collages from this period are not easily located, but the references he made to them in his diary suggest they were done as an extended gesture of mourning. There is mention of *Geraldine Farrar—"In Remembrance."* There is mention of *Vale of Hyacinths*, which was conceived in honor of his gardening mother, who happened to have been born the same year as the opera singer. And Cornell continued his long and fertile sequence of memorial collages for Robert. His latest creation was his Ravel-Rabbit series, in which he linked his brother's drawings of rabbits with the melodies of the French composer.

In the meantime, mail poured in to Utopia Parkway. Cornell carefully filed his fans' letters away, some of it from friends, some from strangers. Tamara Toumanova, his old ballerina crush, sent a telegram from Beverly Hills: DEAR FRIEND, NO WORDS TO EXPRESS MY HAPPINESS SEEING YOUR GREAT ART IN LIFE MAGAZINE . . . Donald Windham was his usual supportive self: "Dear Joe, Pleased to see the beautiful layout in Life." After a lifetime of pursuing stars, Cornell was now something of a star himself, and a certain Hilda Levy contacted him

from Hollywood to request that he autograph his portrait in *Life* for her.

Perhaps no response was more rewarding for Cornell than the two dozen letters he received from a fourth-grade class in Larchmont, New York, which had seen his show on a school trip. "Your boxes are good," student Lisa Marting wrote pithily. "I like them . . . Where do you get the ideas for your boxes?" Her classmate Lisa Heavilon added: "The one I liked best was Swan Lake. With all the feathers and the swan it looked like you put a lot of work into it." Cornell's young correspondents could not have known the degree to which he treasured their interest in his work.

After the Guggenheim show, Cornell became newly focused on children. Through the last months of the year, his diary was dominated by reports of boys and girls pedaling by his house on their bicycles or playing in the street. There had been other periods in his life when nothing seemed to engage him as fully as his compulsive need to stare. Yet whereas previously he had focused on "teeners," he now seemed more interested in younger children.

He was especially appreciative of the youngsters in his neighborhood. A rewarding encounter took place on October 21, when he noted: "Met Caroline and her friends. Very nice to me— Hope I can see them again some time." His comment suggests that even in his relations with neighborhood children, Cornell felt inadequate and was not at all sure his affection would be returned.

He was soon inviting the neighborhood kids into his house. He showed them the collages he was making in memory of his brother; he left boxes on the front porch so that his visitors could play with them. For the most part, though, the children preferred to play among themselves rather than with their bachelor neighbor, who seemed so strange they wondered whether he was the member of the Cornell family rumored to be handicapped. As Cornell noted in his diary, one of the children actually asked him, "Is your name Robert?"

But even on the days when the children could not be coaxed inside, Cornell was happy to watch them from a distance. "Caroline just by on bike again," he might note. She was his favorite, little Caroline Stankovich, and he described her in his diary—down to her two pigtails—with a rapture once reserved for his favorite performers. He was attentive to her clothing, and was intrigued one chilly autumn day to find her still wearing her "late summer costume of casuals." On some days he did not see her at all, but the memory of her brought him comfort. So it was on November 9, when

he jotted: "No Caroline all day but a wondrous sense of her." Children, to Cornell, were in some ways interchangeable with movie stars: they had the mystique of the inaccessible. In his work, he attached a childhood innocence to actresses and a theatrical aura to children.

Cornell ended 1967 by participating in an "Homage to Marilyn Monroe," a show that appraised the art-world fascination with Norma Jean Mortenson five years after her death. It was held in December at the Sidney Janis Gallery, at 15 East Fifty-seventh Street, and brought together the usual suspects—Andy Warhol, Claes Oldenburg, and James Rosenquist among them, a Pop contingent to which Cornell was at least superficially related through his adulation of movie stars. He had kept a dossier on Marilyn since the mid-fifties, though the two works he contributed to the Janis show made reference to her only in their titles. Critics found them subtler than anything else on view. While the show as a whole was "irritating, uneven and depressing," as Peter Schjeldahl noted in *The New York Times*, Cornell's *Custodian (Silent Dedication to Marilyn Monroe)* was among the standouts. Dominated by a cut-out fragment from a constellation chart, it "embraces the morbidity of the [show's] theme only to resolve it in a kind of lyrical celebration."

Cornell was pleased by Schjeldahl's comments and, as by now had become his usual practice, sent off a collage as a token of his appreciation. The twenty-five-year-old critic, who had just started writing for the *Times*, was astonished to receive the gift. "I was completely wowed and wrote him back a long, gushing letter," Schjeldahl recalled. "I got this terse little note back from him that said, 'Thank you for your letter, please do not write to me again.' I guess he was overwhelmed by my intensity."

Few people in the art world were privy to the details of Cornell's life on Utopia Parkway. They knew nothing of the friendships he maintained with his circle of young friends. Nor did they know of his commitment to Christian Science, in which Cornell now became newly active. While he had always been a diligent follower of Mary Baker Eddy's weekly reading lessons, over the years his attendance at services had been erratic. There were long stretches when he did not go to church at all. But after his mother's death, Cornell began to go more often, perhaps to allay his loneliness, perhaps because his mother was no longer around to criticize his adherence to Eddy's faith.

By now Cornell was a member of the Bayside Christian Science Church, which occupied a gray-painted wood frame house at 215–15 43rd Avenue, a few blocks from downtown Bayside. The church had been founded in the early 1960s as an offshoot of the Great Neck church to which Cornell had belonged for so many years. On Sunday mornings at eleven Cornell would join the other worshippers on folding metal chairs. Services lasted for an hour and consisted of a "lesson sermon," in which one person read from Eddy's *Science and Health* after another person read a passage from the King James Bible.

The Bayside church had a congregation of about fifty members, most of whom were middle-aged women from Queens. Nearly all of them knew Cornell personally and felt honored to have someone in their congregation who had been the subject of a story in *Life*. Cornell usually got a ride home from church with a schoolteacher named Paulette Diamond, who later described him as "a very charming gentleman of the old school," adding that she and her friends were baffled by his art. "We had one member who dabbled in art herself and she couldn't understand his work at all," Diamond said, which only heightened the congregation's amused appreciation of its resident avant-garde artist.

Another of Cornell's new acquaintances was Ruth Van Dyne, a founding member of the church who then worked as a switchboard operator for the American Bible Society. "He was one of the darlingest persons I've ever known," she later said, recalling an occasion when Cornell asked her for a special favor. The Bible Society published a wide variety of religious literature, and Cornell was wondering if Mrs. Van Dyne could furnish him with some brochures for his extensive picture archive. She brought him everything she could get her hands on. "He was so glad," she said, "he gave me a kiss."

As much as Cornell appeared to value his friends from church, he made no effort to acquaint them with his art or remind them of his renown. Edna Canarelli, an insurance broker, recalls an evening when a group of church members gathered for a business meeting. An argument erupted about what color to paint the exterior of the church. Mrs. Canarelli, one of the more gregarious members, finally said, "Why are we going to such lengths about color when we have an artist right here to help us?"

All eyes focused on Cornell, who perhaps felt embarrassed to be mistaken for a painter. The celebrated box maker sat quietly for a moment before informing the congregation, "But I'm not that kind of artist!"

21

"Bathrobe Journeying"

1968-71

As Cornell became famous, he became indifferent to the blandishments of fame. Letters went unanswered, phone calls unreturned. He ignored proposals for exhibitions and turned away would-be interviewers and photographers. When collectors wanted to visit, he put them off. When they grew persistent, he grew evasive. Still, they tried. The Manhattan art collector Alvin S. Lane recalls his surprise when he and his wife were abruptly denied a chance to visit Utopia Parkway after succeeding in setting up an appointment. "We were quite excited about visiting him," Lane said years later. "But Cornell had a young lady call to cancel our visit. She said he had a conflicting appointment, as if he were a dentist."

In spite of Cornell's inhospitable behavior, honors continued to come his way. Only a week into 1968, Cornell was notified by the American Academy and Institute of Arts and Letters that he had been selected to receive its "award of merit," which consisted of a medal and a cash prize of $1,000. The Academy is one of the oldest and most prestigious arts groups in the country, but Cornell was unfazed by his good fortune. On January 17, two weeks after first contacting him, the Academy reminded him: "Anxious to receive response to our letter . . . Also wish to receive photograph for publicity purposes." It was never sent.

In winning the award, Cornell joined an impressive roster of honorees. W. H. Auden, Alfred Barr, and Buckminster Fuller were among the other award recipients that year. A luncheon and award ceremony were held in their honor on May 28, at the Academy's stately building at Broadway and 155th Street. "If there is a Mrs. Cornell, she of course is included in the invitation," the Academy graciously informed the artist. But neither Cornell nor his imagined wife materialized for the event. During the afternoon

ceremony, the audience was informed that Mr. Cornell "is unfortunately unable to be with us."

Cornell had also stayed away a month earlier, on April 10, when Brandeis University presented its Creative Arts Awards at the Plaza Hotel in New York City. Cornell, who won, curiously in the "painting" category, was given a medal and a $1,000 stipend. The other winners were Virgil Thomson and Lionel Trilling, for music and literature, respectively. Declining to attend the presentation dinner, Cornell had his friend Donald Windham accept the medal for him. Three days later, it was announced in *The New York Times* that Cornell had been selected along with Donald Judd as a winner in India's first Triennale of Contemporary World Art, and although Indira Gandhi personally presented the awards to the fifteen prize-winning artists, Cornell, as one might have guessed, declined to make the trip to New Delhi.

The Brandeis award had come in conjunction with another honor: an exhibition of Cornell's work at the university's Rose Art Museum, in Waltham, Massachusetts. "Boxes and Collages by Joseph Cornell" (May 20– June 23, 1968) marked a coup for the small campus museum and had the distinction of being the first Cornell show in the Boston area. Organized by William Seitz, who had known Cornell for years, the Brandeis show was unlike any other. Instead of offering an overview of Cornell's career, it concentrated on his 1960s collages, which is exactly what Cornell wanted; he felt that his recent work had been slighted in favor of his earlier work. Cornell had recently decided to place a group of forty-three collages on extended loan to the university, largely for safekeeping, or what he called "sanctuary," and they formed the heart of his Brandeis show.

Cornell was pleased by the exhibition, in part because he generally preferred out-of-town shows that he never visited to New York affairs; in judging shows of his own work, he preferred the unseen to the visible. And he was delighted to be reaching an audience composed mainly of students. In his correspondence with William Seitz, the museum's director, Cornell inquired into the school's Upward Bound program, which prepared high-school dropouts for study at Brandeis and which he very much approved of. Moreover, he wondered whether the school's charitable spirit might extend to his own family. "Naturally," Seitz assured him in a letter, "I am eager to hear more of your thoughts about a memorial to your mother at this University."

Only one critic made the trip up to Waltham to review the show, and

he was sorely disappointed by it. Jerrold Lanes, writing in the July 1968 issue of *Burlington Magazine*, complained that the collages "do not show this artist at his best. The reason for this is that they reveal more clearly than they ought to what makes Cornell's work tick; or at least I thought I realized for the first time what it was. It is simply contrast . . . I do not mean to criticize this procedure, far from it, merely the obviousness with which, in most of the collages, it has been put into effect."

All this was true. Cornell's collages from the 1960s are not at the same level as his earlier work and are often marred by mawkish sentiment. To discuss Cornell's late work, for this writer, anyway, is to be pulled between the very different obligations of critic and biographer. The critic, of course, sets out to assess, to separate major achievements from less realized efforts. To the biographer, however, aesthetic failures have their own poignant worth, perhaps because they tell us something about an artist's dreams and aspirations that we would not otherwise know and the defeat of which can be moving to see.

There can be no pretending that Cornell's collages from the 1960s are all substantial. As a group they are highly uneven, and it is only the collages in the Penny Arcade series—in which copper pennies are made to acquire a wealth of metaphor—that are consistently first-rate. The 1960s collages are typically described as the two-dimensional equivalent of the boxes; they're certainly the product of the same junk-into-art sensibility. Still, the collages, I think, are generally less satisfying than the boxes. Something is lost by the absence of the pane of glass, and the viewer is deprived of what we most enjoy about the experience of looking at the boxes—which is to say, peering into a shallow, sealed space and seeing different objects floating there. Like a dream, whose power depends on closure (it's over when you wake up), the fragments in a Cornell box remain forever sealed off from us. The collages, by comparison, though seemingly as layered and random as a dream, don't inhabit the same poetically enclosed space.

On the other hand, it is easy to be sympathetic to the impulse behind Cornell's collages. He didn't want to make boxes any longer, and it mattered little that dealers hoped he would repeat past triumphs. The least commercial of artists, Cornell had no interest now in duplicating his signature pieces or permitting his work to harden into formula. Though he resisted change in his everyday life—for four decades he lived in the same unremarkable house and worked in his one and only basement workshop—in his work he was daring: he kept on inventing until nearly the end.

Cornell is often described as a one-note artist, a man who did nothing but make small boxes that all conjure the same fairy-tale mood. But it's astonishing to realize how versatile he was. His boxes from the 1940s (the Medici Slot Machines, Pink Palaces, etc.), which are often distinguished by a richness of detail, hint at his Surrealist roots and that movement's love of the enigmatic. His boxes from the 1950s (the Aviaries, Observatories, etc.), with their white interiors, reflect his interest in Abstract Expressionism and its exaltation of emotional directness. His collages from the 1960s, however uneven they may be, similarly speak to their moment. They have the bright, brassy look of Pop art and remind us that Cornell—despite his outwardly static existence—deserves credit for giving himself freely to artistic experimentation.

After his Guggenheim retrospective, Cornell made fewer and fewer trips into Manhattan. Most days, he established himself at the kitchen table to read, write, and receive an occasional caller. Wearing his blue terry-cloth bathrobe, he recorded his dreams in his diary with increasing compulsiveness. He dreamed about his brother and his mother. He dreamed he was back in the Strand Food Shop listening to the jukebox with Joyce Hunter. It became hard to say whether he was keeping a diary or whether his diary was keeping him. "Penning," as he referred to his diary keeping, was sometimes the only thing he did all day. He made reference to "kitchen penning," "penning in bathrobe," "bathrobe all day," "bathrobe 4th day," and, most memorably, "bathrobe journeying," by anyone else's standards a contradiction in terms.

As Cornell languished on Utopia Parkway, his reputation kept on expanding. In what was perhaps the greatest honor of his later years, his work was included in the controversial exhibition "New York Painting and Sculpture: 1940 to 1970" (October 18, 1969–February 1, 1970), the first in a series of lavish shows held to celebrate the hundredth anniversary of the Metropolitan Museum of Art. The show was organized by Henry Geldzahler, a bearded, rotund, and charismatic aesthete who, at age thirty-four, had recently joined the Met as its first curator of contemporary art. Geldzahler's show purported to offer a definitive overview of the New York scene, and it became the object of instant disparagement. Cattily lampooned in the press as "Henry's Show" before it even opened, "New York Painting and Sculpture" was the most bitterly debated exhibition of the decade.

The Met cleared its entire second floor of Old Master paintings to make room for the show, an elephantine gathering of 408 works by forty-three artists who fell loosely under the heading of New York painters and sculptors. Criticizing the show became an obligatory art-world sport, with the controversy centering on the omissions (Louise Nevelson, Larry Rivers, Marisol, Richard Poussette-Dart, etc.), as well as the odder curatorial decisions (Ellsworth Kelly got two rooms, while de Kooning had to share with Philip Guston). John Canaday, *The New York Times*'s senior critic, called the show "a boo boo on a grand scale . . . promoted by the museum's Achilles' heel, Henry Geldzahler." His colleague Hilton Kramer could not be sated with just one pan. He published three of them before the show closed.

Cornell was given a prominent place in the show, a gallery of his own that offered a generous selection of his work—twenty-two boxes, half from the 1940s and half from the 1950s. Geldzahler, as if to acknowledge Cornell's centrality on the current art scene, gave him a gallery right in the middle of the exhibition space. And in an attempt to duplicate the splendid effects of Cornell's much-praised (if little seen) retrospective at the Pasadena Museum two years earlier, Walter Hopps, who had curated it, was brought in by the Met to preside over the Cornell portion of its exhibition.

As it turned out, nearly every critic who reviewed the show commented on Cornell's presence. In an astounding critical lapse, however, the reviewers were so frantic to fault the Met that they utterly ignored the artistry of Cornell's boxes, focusing instead on the non-burning issue of how the Met had installed them. Tom Hess of *Art News* was the only critic who had anything good to say on the subject. "In an inspired bit of installation," Hess wrote, "Cornell's boxes are in a darkened room and, as many of the constructions include black apertures, the visitor ends up feeling that he is strolling inside of a Cornell [box]."

But other critics seized on the handling of Cornell's work as a sign of the show's general gaudiness. James R. Mellow, writing in *The New Leader*, complained that Cornell's boxes were spotlit like "a series of precious Tiffany displays." Philip Leider of *Artforum*—uniquely qualified to judge the display, since he was the only critic who had also reviewed the Pasadena show upon which it was modeled—concluded that it "failed rather badly; what was intimate and jewel-like in the context of the Cornell retrospective in the old Pasadena Art Museum was theatrical and precious in the context of this exhibition."

And Cornell himself? Naturally he missed the opening-night party, on

October 18, 1969, a now-historic bash attended by thousands; so many people showed up that extra guards were called out to calm the crowd of gate-crashers. Yet, while the exhibition was up, Cornell did deign to visit the Metropolitan. It was the first time he met Henry Geldzahler, who escorted him through the exhibition. "Cornell particularly liked the Olitskis and was enthralled by the idea of spraying color in the air," the curator later said. "He hadn't seen his work previously and found it beautiful, celestial."

At the end of 1970, only ten months after "New York Painting and Sculpture" closed, Geldzahler gave Cornell a one-man show at the Met. "Collage by Joseph Cornell" (December 10, 1970–January 24, 1971) was a modest affair, occupying a single, out-of-the-way gallery on the second floor of the museum. Nonetheless, it was the sort of exhibition that Cornell himself wanted most at the time, largely because it featured his recent work—the 1960s collages—and thereby suggested that he was still in top form. Like most artists, Cornell liked to think that his recent work was his best; it was too painful to consider the alternative. He lent forty-five of his own collages to the show, which stayed up for six weeks and was timed to coincide with Christmas.

However grand it may sound to have a show at the Met, Cornell's was done on a tiny budget and no catalogue accompanied it. And the scholarship surrounding the show was so casual that no one even knew for sure when the collages had been made. A press release issued by the museum indicated that the collages were "executed in the past eight years." Or were they "executed in the past five years," as Geldzahler stated in a brief item in the museum's *Bulletin?* Compounding the confusion was a notice in *Arts* magazine, which shortened the time in question to three years, reporting that "these collages represent Cornell's work during the years 1966–8." Such chronological chaos was perhaps inevitable for an artist who rarely dated his work, resisting finality at every turn.

During the time the show was up, the Met's education department sponsored a "Joseph Cornell seminar" for high-school students. Participants were instructed in the techniques of collage—and on one occasion had a chance to meet the master collage maker himself. After school let out one snowy December afternoon, a half dozen students traveled by subway and bus to Utopia Parkway. They were received graciously by the artist, who served hot cocoa and cookies in his kitchen; he passed a legal pad around the table and asked his young guests to write down their names and addresses. They

then moved onto his enclosed porch, where he looked at the collages they had brought along and offered constructive comments. "He was very accepting," said David Saunders, who went on to become an artist, "and I had never been treated that way by an adult before."

Toward the end of his life, as Cornell retreated from the Manhattan art scene, he became involved with various people he met locally in Flushing. Among his new haunts was Queens College of the City University of New York. He who had become accustomed to the New York Public Library and the Metropolitan Museum, to the waiting room of Grand Central Terminal, to the bookstalls of Fourth Avenue and the bright lights of Times Square, now uncomplainingly passed his time in the less grand environs of this branch of the City University, at 65–50 Kissena Boulevard, a ten-minute bus ride from his house. The school had a respected art department, and some of the most gratifying relationships of Cornell's later years were with members of its faculty.

Cornell was especially friendly with Helen Schiavo, a petite, energetic, middle-aged woman who taught a class on watercolor painting. A neighbor of his, she encouraged him to visit the school and introduced him to her colleagues on the faculty, who were thrilled to meet the only famous artist who resided in Flushing. Students, however, were generally less receptive. As Cornell traipsed through the halls in his frayed overcoat, he looked less like an acclaimed artist than a poor cashier and was easy to overlook in the age of shaggy hair and tie-dyed T-shirts.

Cornell was pleased when a small show of his work was held at the college at the end of 1968. Organized by Helen Schiavo, it took place in Kiely Hall, the bland white-brick edifice that then housed the school's art department. There was a gallery on the second floor, in room 208, a converted classroom whose exhibition roster consisted mainly of shows by students. In spite of the no-frills academic setting, Cornell liked the exhibition. He told Mrs. Schiavo that he had always wanted to exhibit his work in Queens and felt a debt to the people who lived there. He left a blank book in the gallery so that visitors could record their comments.

Among Cornell's new acquaintances was Creighton Gilbert, a leading scholar of Renaissance art who in the fall of 1969 became chairman of the college's art department. Cornell appreciated the professor's vast learning. Gilbert later recalled that Cornell liked to ask him about women artists

who had lived during the Renaissance. Cornell, of course, had always em-pathized with female artists and had long been familiar with the work of Sofonisba Anguissola, whose portrait of a slender, wide-eyed prince appears in several of his Medici boxes. One day Cornell arrived at the college with a reproduction of the painting. After summoning Gilbert from a meeting, Cornell asked him in a meek voice: "Is it all right if I use this in my work?" The professor was charmed.

From time to time, Cornell would drop in on classes. He seemed interested in being part of an academic milieu, though his visits could prove to be unrewarding for everyone involved. The sculptor Lawrence Fane recalls an embarrassing occasion when Cornell stopped by to meet his first-year art students, most of whom had never heard of him. "They looked at him," Fane says, "like, Who is this guy?"

Cornell hardly went out of his way to make himself known. True, in his mind he envisaged himself contributing to class discussions, a wizened elder sharing his wisdom with appreciative students. In reality, however, he was more likely to end up milling nervously in the back of classrooms. "He didn't want to be introduced," recalls the painter Louis Finkelstein, another faculty member who welcomed Cornell into his classroom after Cornell himself proposed the idea. "He told me, Don't tell them who I am and if I feel like saying anything I will."

Cornell, of course, had not attended art school in his youth. But now, as an artist in his late sixties with an international reputation, he became a campus regular. How do we explain this belated embrace of academia? Surely he enjoyed the camaraderie of school life. Moreover, drawing from the human figure is the foundation of all art education, and the presence of naked models in Kiely Hall would not have escaped his flesh-starved gaze. But one suspects as well that Cornell's presence at Queens College reflected a genuine interest in bettering himself as an artist and cultivating abilities he had previously left undeveloped. He often lamented to friends that he had never learned how to draw. He felt inadequate, he said, compared to more draftsmanly artists.

Astoundingly, in the fall of 1970, Cornell actually signed up for a life drawing class. He enrolled with Mary Frank, an attractive, London-born sculptor who was thirty years his junior and was married to the photographer Robert Frank. She considered Cornell an artist of the first rank and was bewildered by the notion of having him audit her course, not least because he seemed so profoundly troubled. "I couldn't imagine him in a class of

eighteen-year-olds who didn't know his work," she said years later. "I couldn't imagine what I'd do so that he could be comfortable. He looked like he had died a long time ago. He was all gray and unshaven and in a deep, deep depression."

Cornell attended her class five or six times, and apparently made an effort at drawing. He would sit on a stool at the side of the classroom with a sketchbook in hand—"the kind you buy in Woolworth's," Frank said, "smaller and cheaper than everyone else's." As students passed the session sketching from a male or female model, Cornell appeared to do the same. However, when Frank glanced at his page one day, there was nothing inscribed on it beyond "a curving line that crossed over itself." Cornell insisted that she keep the drawing as a gift. He liked her enormously and was amazed to learn that her father was Edward Lockspeiser, who had written an important book on Debussy in 1963. Naturally Cornell had read it. He told her that he knew it "by heart."

Cornell had less success in getting to know his fellow classmates. One day he mentioned to Mary Frank that he wanted to bring in some of his work and share it with the students. But his classroom vernissage turned out to be a painfully awkward affair. Cornell arrived on the appointed day with a few recent collages: cutouts of girls from Renaissance paintings mounted on boards. Sparer than his earlier collages, they looked unfinished, and no one knew what to make of them. "The students went blank and didn't have anything to say," Frank said. "He wanted to make the connection with them, but he didn't know how."

In spite of his despondency, Cornell managed to sustain an elaborate network of friendships in his later years. He went through periods when he was either "seeing people," as he might announce to his telephone callers, or "not seeing people." On the days when he was open to visitors, he could count on having interesting company. Unlike so many other artists whose social activity was confined to the Manhattan art scene, Cornell's contacts extended into the worlds of dance, theater, and art, and everyone from Broadway stars to starving art students traveled to Utopia Parkway to sip tea with him in his cluttered kitchen or chat beneath the quince tree.

Among the new arrivals was Yoko Ono, who was moderately well known as an artist before she met John Lennon. As a member of the Fluxus movement, she made art from ephemeral found objects. She was very interested

in Cornell's work and, on at least one occasion, visited Utopia Parkway accompanied by John Lennon. Ono later remembered little of her friendship with the artist, describing Cornell as "just someone else I knew then." But Cornell would always savor every last detail of her visit. The artist Ray Johnson recalled Cornell excitedly telling him that Ono had arrived on Utopia Parkway in a "see-through blouse," and that she and Lennon purchased ten collages from him that day. "Cornell said they could have them on one condition only," Johnson added, "if Yoko gave him a kiss on the cheek." She gladly obliged, and the deal was sealed.

Many of Cornell's visitors left his house concerned about his welfare. They remarked on his empty refrigerator. They said he looked frail and older than he was. His careworn face was made to seem ever more gaunt by a progressive loss of hair and was engraved with deep lines around the mouth. Was he subsisting on just tea and coffee cake? His friends commented that since his brother had died, he seemed to be doing little more than waiting to leave the world himself.

"I worried about what I felt was his sadness," said the ballerina Allegra Kent, who renewed her friendship with Cornell in 1969, more than a decade after he first sought her out and beseeched her to appear in his homemade movies. In the intervening years, Kent had become one of the best-loved principal dancers in the New York City Ballet; her latest triumph was her performance in Jerome Robbins's *Dances at a Gathering*. She resuscitated her friendship with Cornell, she recalls, at a time when her marriage to the photographer Bert Stern was crumbling; she valued Cornell as someone with whom she had "an easy, unguarded communication." She knew that she could call him any time of day or count on a warm reception at Utopia Parkway. "His greeting was very joyous and happy," she said, "although somehow visits were always hard to arrange, like getting to Russia. It might have been easier to travel to Russia than to Utopia Parkway."

There were other women to assuage his loneliness. By a stroke of good fortune, three of them arrived as a group, triplets descending on Utopia Parkway as if in a Cornell-like dream. This group of best friends consisted of Leila Hadley, a writer; Anne Jackson, the actress; and Betsy von Furstenberg, another stage actress of whom Cornell was particularly fond. A striking, willowy, soft-spoken blonde who was born in Germany, von Furstenberg epitomized the ethereal type of woman that Cornell had often been drawn to. At the time they met, she was thirty-seven years old and widely known. She had appeared on the cover of *Life* magazine when she was only

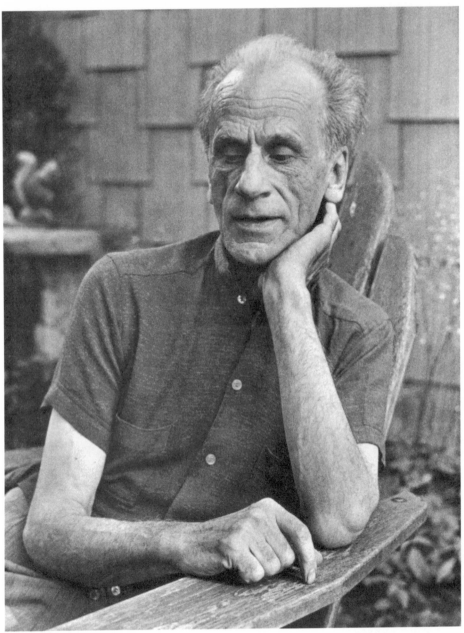

Cornell in his yard at Utopia Parkway, 1969 (photograph by Hans Namuth)

eighteen. Cornell first saw her in Enid Bagnold's *The Chalk Garden* in 1955; and though he didn't meet her until much later, her performance in the play as Laurel—an emotionally troubled teenager and incipient pyromaniac—remained sharply etched in his memory.

When von Furstenberg first visited Cornell in 1969, he presented her with a recent collage named for *The Chalk Garden*. Its imagery included a black-and-white photo of her clipped from a magazine. Cornell's feelings for the actress deepened over time. "There was obviously a fantasy romance going on," she later said, "although he never so much as touched my hand. It was all in his mind."

Von Furstenberg would usually visit Cornell accompanied by her girl friends. They each felt moved by him. He seemed so alone in his musty house, which had fallen into disarray now that his mother was gone. They wondered whether he had a housekeeper. The small kitchen table where he entertained was strewn with dishes, writing paper, and stacks of unopened mail. His style of entertaining was far from lavish. Cornell might offer his guests a slice of cake and a cup of tea, while removing just a single tea bag from a box. "Everyone would use the same tea bag," von Furstenberg said. "Then he'd pour us another cup of hot water and send the same tea bag around again."

In spite of his parsimonious habits, Cornell charmed his new friends with the grandeur of his feelings for them. He was drawn, they could tell, to the idea of a large and hopeless passion, and seemed curiously romantic for a man of his age. He sent von Furstenberg endless letters, variously addressing her as "Dearest, Darling Betsy" or, inspired by the character she played in *The Chalk Garden*, "Dearest Laurel." His letters were pure stream of consciousness and difficult to follow, though at times he assured her of his abiding affection in playful terms. As he wrote in December 1970, "I went out to you just now/Betsy sweet (suite)/not sensually so much/as essentially."

He also corresponded with her daughter, Caroline, who was about thirteen. His letters to the schoolgirl were relatively chaste, veering chattily from the recent moon landing to Borges's fiction to the birds he spotted through his kitchen window. "A jay is screeching now," he wrote to Caroline on November 19, 1969, at six in the morning ". . . means doubtless a call to relatives . . . However who can know too much of what they talk about . . . Did you know that E. E. Cummings and Ezra Pound broke up a lifelong friendship at variance about this? Well, it's true."

Cornell's relations with his new friends were not entirely platonic. There was one woman among this circle of female confidantes who saw him in a different light. She savored the prospect of having him as a partner. Leila Hadley was a radiant and spirited young woman in her thirties. A small, alluring beauty with long brown hair, she had a gift for making her friends feel appreciated. She would later marry Henry Luce III, the chairman of the Luce Foundation and the son of the founder of *Time*, but for now she was a twice-divorced travel writer struggling to raise four children on her own.

Hadley first met Cornell after sending him an admiring letter and eventually came to regard him as the most dependable person in her life. One day when they were having lunch at a Korn Kobbler restaurant in the city, she mentioned how encumbered she felt by school tuition bills. Cornell was touched by this. His own mother, too, had raised four children without a husband, and now he tried to provide Hadley with at least a bit of security. "He wrote me a check for $5,000," she later said of that day in the restaurant,

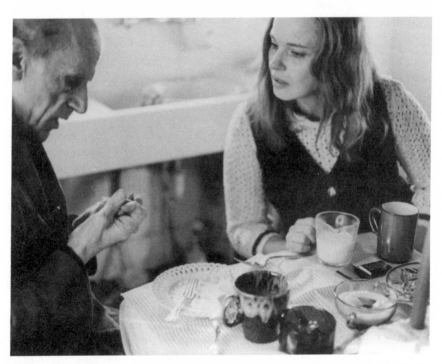

Cornell with Leila Hadley at Utopia Parkway, 1971 (photograph courtesy Leila Hadley Luce)

"and I was sort of overwhelmed." Because Cornell spent so little, he had saved a lot of money over the years.

At times he dreamed about marrying her. "He said it would be wonderful to be married," she said. "He wanted to be married in order to travel. He had only been to Nyack, and that was it." In truth, he had been as far as Andover, Massachusetts, during his prep-school days, but had never traveled beyond New England. Leila, by contrast, had traveled everywhere and written a book, *Give Me the World* (1953), chronicling her adventures in the Far East. Perhaps he imagined touring Europe at her side, a husband and wife wandering the labyrinthine halls of the Louvre and pausing for pastries at a café.

On the other hand, Cornell felt as incapable as ever of actually packing a suitcase or calling a travel agent. For much of his life he had claimed he couldn't take overnight trips because he had to be home to care for Robert. Now Robert was gone, and still he refused to travel. When Hadley asked him about his stay-at-home habits, he told her "he couldn't travel because his father traveled," an intriguing comment that hints at a deep unease over his father's frequent absences during his childhood. By staying home, Cornell could protect his mother from the disappointments of her marriage, caring for her in his father's absence. And by staying home, he could protect himself as well. He perhaps associated trips with the "departure" his father had made, not only by taking golf trips and business trips, but by dying young.

Unlike most other women, Hadley found Cornell physically appealing. He seemed "so kind and good," as she said, and she could see how he hungered for intimacy with a woman. She felt honored to be the object of his desires, and it did not bother her that his needs were unconventional. On one of her visits, Cornell requested that they take a bath together, and she obliged. On another occasion, she treated him to oral sex, reporting years later that he was "fully capable of having an orgasm." Nonetheless, Cornell had no intention of consummating their relationship the conventional way. He apparently remained impotent, which is to say, incapable of penetration. According to standard psychiatric theory, an impotent man may be able to achieve orgasm through a variety of means that include fellatio (an essentially passive experience), but is incapable of having sexual intercourse as a result of an inability to sustain an erection. By such a definition, Cornell was impotent. Though he recorded "wet dreams" in his

diary and apparently enjoyed fellatio, sexual intercourse was out of the question.

Or so he confided to Leila Hadley, offering a rather quaint reason for his abstinence from intercourse. "He felt he would lose his ability to be an artist if he had sex," she said, adding that he made this remark to her several times. Bolstering his argument with literary examples, he cited Balzac, who, he said, on one occasion after making love, stormed through a garden moaning, "J'ai perdu un livre"—There goes a book. Was this story just a charming cover for Cornell's sexual problems, or did he really think that intercourse was guaranteed to deplete an artist not only of semen but of creativity as well? Probably both. Cornell was determined to preserve himself, to suppress some vital aspect of his nature. He looked upon intercourse as an ordeal, full of unknowable hazards.

As Cornell grew older, many young artists sought him out, eager to meet the great man. They asked little of him, a thimbleful of time at his side. In spite of his difficulty befriending students at Queens College, Cornell fared better at home. He made himself available to countless young callers, who invariably came away impressed. They could see that he was free of arrogance, a spiritual man who seemed indifferent to fame and other worldly seductions.

Among his acolytes was David Saunders, who had first met Cornell as part of the group of high-school students sent out to Utopia Parkway by the Metropolitan Museum. At the time of that visit, Saunders, then sixteen, had copied the artist's phone number off the black rotary phone on the porch, never imagining that Cornell was in fact listed in the Queens directory. He called Cornell the next day to ask if he could come back. He ended up returning often and sensed that Cornell preferred the company of students to that of adults. Once Saunders asked him, If you could do anything, what would it be? Cornell replied without hesitation, "I'd start a school for young artists."

Saunders was concerned about Cornell's well-being. On one of his visits to Utopia Parkway, he brought along his girlfriend and they baked Cornell a huge pan of lasagna, enough to last him two weeks. On another occasion, Saunders lugged along what he considered the ultimate gift—a large cardboard box filled with ephemera he had saved since his childhood. There were glass shards, chandelier crystals, a sheriff's badge, old coins, wind-up

metal toys from early in the century. Knowing how much Cornell loved such objects, Saunders plunked down the box on the kitchen table, removed its contents, and generously said, "You can have everything!" Cornell appeared astounded. "Oh no, Mr. Saunders," he protested, "I couldn't take these. This is *your* marvelous collection." Nonetheless, Cornell did snatch one item from Saunders's box, a cocktail ornament in the form of a blue plastic mermaid.

Another new acquaintance was Steve Wood, a twenty-two-year-old student at the University of Hartford who first contacted Cornell by letter. Cornell invited him to visit, which he did mid-week. "Wednesday is a mystical day," Cornell announced when his guest arrived. "Mother died on a Wednesday." Wood was fascinated by his host, later recalling, "For lunch he served pumpkin seeds and warm pineapple soda and then he brought out Oreo cookies. I thought he was a genius."

It was clear to Cornell's young friends that he saw himself at a great remove from them, an aged creature whose life would not overlap with theirs for long. "He seemed to be giving a lot of thought to leaving this world," Wood said. "He told me he wanted his house to go to a drug treatment center," perhaps remembering the troubled Joyce Hunter. Cornell also told him that he dreamed of living in different hotels. He imagined going around from one hotel to the next, while returning home when he pleased. He proposed to Wood: "Perhaps you could take over my house."

Of all his young friends and helpers, probably none was more devoted than Harry Roseman, a good-natured artist in his twenties who worked as Cornell's assistant beginning in 1969. He lived in Jamaica, Queens, with his wife, Catherine Murphy, a highly esteemed realist painter who was studying at Queens College. Cornell greatly enjoyed Roseman's company and would take him along on his local outings. Together they would ride the bus to downtown Flushing and shop for household goods. They might stop for lunch at the International House of Pancakes, or Woolworth's, where Cornell liked to sit at the counter and order the special of the day.

Some of Roseman's time was taken up helping the artist with his philanthropic projects. Roseman was astonished one day when Cornell asked him to take the subway to The Lighthouse, the rehabilitation center for the blind in Manhattan, with a shopping bag full of his boxes, then worth about $7,000 each. Cornell also gave away more modest objects, namely toys, which he accumulated by the dozens for local hospital drives and stored on his front porch. From time to time he would ask Roseman to replenish

Cornell's basement workshop, March 12, 1970 (photograph by Harry Roseman)

Cornell's workshop, October 18, 1971 (photograph by Harry Roseman)

his supply, instructing him to get "boys' and girls' toys: some toys that boys would like, and some that girls would like," as if there could be no overlap between the two.

While working at Utopia Parkway, Roseman, who was also a photographer, took dozens of pictures. Cornell had no interest in posing, but did not object to having Roseman photograph his house. The photos, most of them black-and-white, have not been published (with two exceptions) but certainly deserve to be. They offer a portrait of the artist as seen through the rooms of his house, themselves an image of his interior life, with their astonishing profusion of books, files, beloved objects, and his own artwork. Cornell, the writer Brian O'Doherty once observed, was "a kind of curator of culture, and his house on Utopia Parkway a bureau of which he was trustee, director and staff."

Some of the photographs were taken outdoors, in Cornell's back-yard garden, which can be surprising to see. It looks scruffier than one had imagined: an empty patch of grass enclosed by a chain-link fence, with an ugly apartment complex rising up behind it. Tacky garden statues—a squirrel, a frog, and a rabbit accompanied by four little bunnies—rest on the lawn. How many hours had Cornell spent here daydreaming? We see the quince tree beneath which he loved to sit. We see a lone chair with no one in it. In one affecting photograph [frontispiece], Cornell makes an appearance, sitting with his back toward the viewer, an old man reading a book in a chair that seems strangely small, more suitable perhaps for a child.

But it is Roseman's photos of the interior of the house that are surely the more arresting. We see the bedroom that for decades belonged to Mrs. Cornell, empty now, but still unmistakably a woman's bedroom, with faded floral wallpaper and treetops visible just outside the window. So, too, we see Cornell's bedroom—prim, uncluttered, virginal. He slept on a narrow metal cot that looked as if it belonged in an army hospital; there was no bedspread, just a white sheet pulled up to the headboard. Venetian blinds hung on one window, a vinyl shade on the other. On top of Cornell's dresser, combs, nail scissors, and two tins of Pond's talcum powder were arranged neatly on a fabric coverlet. His dresser mirror was adorned with snapshots of the past and movie stills of actresses. It was a bedroom for a star-struck monk.

• • •

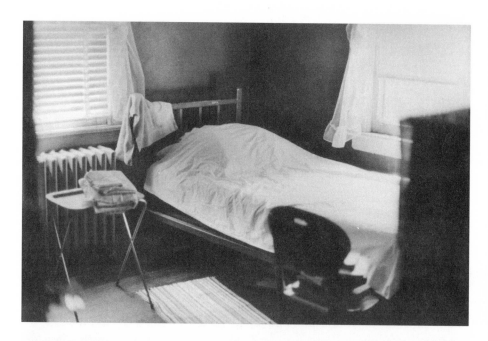

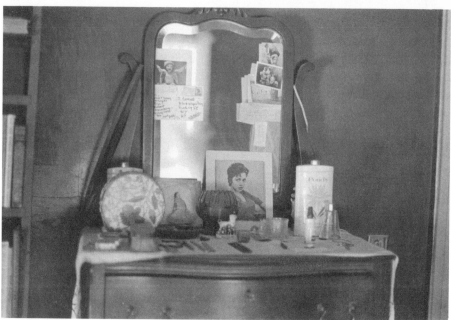

Cornell's bed and dresser, March 1, 1972 (photographs by Harry Roseman)

Not all of Cornell's new young acquaintances arrived on his doorstep simply to pay their respects. Judy Richheimer was a twenty-two-year-old film student at New York University when she first visited Cornell in August 1971, and she did so as part of a bet. An artist friend of hers who had heard that Cornell often gave away boxes to good-looking girls dared her to go to Utopia Parkway and charm a work of art out of him. So one day Richheimer, a native of Flushing, knocked on Cornell's door and said, "You don't know me but I used to ride my bicycle here when I was a little girl." Cornell was delighted. He invited her in, served tea, and, by the end of the afternoon, was offering her a collage with a photo of Christine Kaufman (Tony Curtis's ex-wife) in it. Not pleased by his selection, Richheimer asked, "Do you mind if I pick another?" Cornell laughed at her brazenness and allowed her to pick out her own collage.

Richheimer returned to Utopia Parkway several times and, at Cornell's request, once brought along her mother, who lived nearby on Crocheron Avenue. "My mother didn't like the experience," Richheimer said. "She found him too wacky and non-linear and didn't want to go back." But Cornell fared better with the young lady's father, Leonard Richheimer, an internist who practiced out of his house and who would now become Cornell's physician. Though Cornell never ventured to the doctor's office, Richheimer would drop in from time to time to check on him. It was obvious that Cornell was in poor health, though his meetings with the doctor, as with his previous physician, tended to sound more like therapy sessions. "In conversation he would fantasize about his ability to have sex with pretty young girls," Dr. Richheimer said, "and how he would like to fondle them and caress them and have them without anything on. He was horribly frustrated in the era I saw him, and horribly depressed. I remember looking in his refrigerator and seeing nothing and wondering whether he ate. He was like a homeless person with a roof over his head."

As Cornell reached the end of his life, he gave great thought to the cessation of his life. He brooded about death with composure and equanimity, worrying less about his own end than the uncertain fate of his work. Obviously, he had no children, no loyal kin to protect his interests once he could no longer do so himself. Nor would he leave behind a widow, an ancient female warrior to cling to his memory and battle the powers of the art world on his behalf. What would happen to his work in the future? He imagined his

boxes and collages traveling out from his studio to a hundred different cities, and the thought distressed him. He wished there was a way to keep them together, to link them into a kind of family—a family of objects—that could live together under the same roof forever.

This, really, had been the aim of even his individual boxes: to bring cast-off objects and images into a kind of domestic harmony. Each box, in a way, was its own family, an assemblage of connected others, its fragments relating to one another with a graceful dependency. If the curving shapes of his corks and springs rhymed with one another, the simple repetition of various elements again affirmed some basic connection among them. Cornell's sense of family security had always been precarious, yet with each new box he reconstructed a new family, as enchanting and self-contained as royalty.

And over the years, the sheer volume of his production seemed to offer another level of fortification. Now he thought often about Duchamp's *Valise* and told several friends he wished he could do something similar—create miniature versions of his boxes to put inside a traveler's suitcase as a way of keeping his work together.

In the years since his mother's death, Cornell had actively tried to find a "sanctuary" for his work. Already he had made overtures to several museums, offering them custody of his work. But he acted with his usual indecision, declining donations of his work in favor of long-terms loans. He had sent a group of his boxes to the Pasadena Art Museum, and a group of collages to the Rose Art Museum at Brandeis. In 1968, he lent sixteen collages and sixteen boxes to Cornell University's Andrew Dickson White Museum of Art (later the Herbert F. Johnson Museum of Art). He selected Cornell University because, he told several friends, he was intrigued by the coincidence of sharing his surname with the Ivy League university.

Thinking he wanted to make a will, he met with a Manhattan attorney, Harry Torczyner (pronounced Torch-ner), who was also an art collector and the future author of *Magritte, Ideas and Images* (1977). In July 1971, Torczyner paid a visit to Utopia Parkway; he took notes as Cornell told him, "I would like to create a foundation which would circulate my oeuvre from museum to museum and from college campus to college campus." Cornell also mentioned a desire to have some of his work sold, saying that the proceeds should be given to a charity "interested in the fate of the victims of drug addiction."

In the next few months, telephoning Torczyner when, as he said, "the

stars were right for a talk between us," Cornell spoke of his deteriorating health and the need to plan his estate. But he made little progress in that direction. True, he did manage to obtain through Torczyner a photograph of Magritte's wife, Georgette, as a young girl, and he donated a collage (*The Torchbearer*, whose title is a pun on the lawyer's name) to the United Jewish Appeal in Torczyner's honor. But he could not bring himself to complete the will. While Torczyner drew one up, Cornell, he said, "was afraid to sign it. He was so afraid of death." Thus the document remained unsigned.

Cornell was no less ambivalent about his plan to undertake an inventory of his work, a project conceived with the best intentions. His last assistant, David Boyce, was hired in 1971 for the express purpose of cataloguing the dozens of boxes scattered throughout the artist's house. Boyce was then a twenty-two-year-old dropout from the University of Massachusetts at Amherst who had moved to New York to paint, and he relished the chance to work for Cornell. On the days he came to Utopia Parkway, Cornell would shepherd the young artist through the house, addressing him formally as "Mr. Boyce" and pointing out the boxes in each room. There were boxes everywhere, it seemed—boxes crammed into closets, boxes stacked on tables, boxes resting precariously on the stairs.

"My job," Boyce said, "was to produce a written list, but whenever I started writing, Cornell would interrupt and show me more work, so I never got the inventory done." Cornell's conflicting instructions were not surprising. He no more cared to complete the list than he cared to acknowledge that his work was in fact finished and his life nearing its end. As much as he loved the lost past, he had no wish to disappear into it, and now found himself siding unequivocally with life.

22

"Sunshine Breaking Through . . ."

1972

Cornell had always dreamed of doing a show expressly for children, and in 1972 his dream came true. While on two previous occasions he had lent his boxes to the Children's Room of the New York Public Library, his latest show was held in an adult setting—a gallery at the Cooper Union, the tuition-free college for art, architecture, and engineering on Astor Place in Greenwich Village. The show was arranged by Dore Ashton, a distinguished art historian and longtime friend of the artist who taught at the school. For all of Ashton's scholarly credentials, "A Joseph Cornell Exhibition for Children" (February 10–March 2) had an antic charm. The works on view— twenty-six boxes and collages—were displayed at child's-eye level, no more than three feet off the ground.

Making a rare public appearance, Cornell attended the opening reception on the afternoon of February 10. Instead of champagne, the guests sipped cherry soda, and instead of canapes, they nibbled on brownies. Nearly all the guests were under fourteen, arriving from neighborhood schools to attend what was probably the first avant-garde exhibition in New York for children only. Cornell happily mingled among the small viewers and, after giving a tour of the show, agreed to take questions.

The New York Times sent arts reporter Grace Glueck to cover the event. Cornell was interviewed after the children left, sitting down to refresh himself with a brownie and a glass of cherry soda. Asked if he liked the soda, the sixty-eight-year-old artist told the *Times*: "In a very mystical way. They have them in the underground [subway] in those big conveying machines—it brings back memories." Overall, Cornell seemed gratified by the exhibition. "I'd like to do lots more for kids . . . This has been terrific—a very agreeable experience."

A month after the show came down, Cornell had another exhibition, this one at the Albright-Knox Art Gallery in Buffalo, New York. Organized by curator James N. Wood, the show (April 18–June 17) brought together a nice selection of Cornell's work—again, with children in mind. At Cornell's request, the opening reception was a highly exclusive affair. As the invitation made clear, this was to be a "CHILDREN'S PREVIEW of the exhibition JOSEPH CORNELL—COLLAGES and BOXES." And striking a tone more appropriate for a children's birthday party than a serious art show, the invitation promised refreshments and favors: "A poster will be given to those at the opening."

While Cornell did not travel to Buffalo to see the show, he was grateful for the chance to exhibit at the Albright-Knox, one of the country's oldest and most prestigious museums. In a letter to Wood of May 23, 1972, Cornell thanked the curator for his interest and assistance, and "in particular, the photograph of your daughter."

As Cornell got older, his audience got younger. The Albright-Knox show—the last to be held during his lifetime—was his first museum show dedicated to children. At sixty-eight years old, Cornell seemed uninterested in reaching anyone besides viewers at least fifty years younger than he. Of course, he had never cared for exhibiting in the first place, acting as if there was something indecent about sharing the things he loved. But with children, he felt differently, seeing them as uniquely qualified to understand the spirit of his work. Moreover, children can't buy anything! Children could bring him neither public acclaim nor financial gain, only personal fulfillment, but that was enough, and his desire to have them see his work perhaps also touched on the recent loss of his childlike brother, Robert, as if it were possible to make work and show it for his eyes only.

Cornell still thought about Robert incessantly, and he spoke of him with exaggerated reverence. His friends didn't know if he was joking or not when he described his brother as a great artist. "He talked about his brother a good deal," David Boyce said, "and said several times that he thought his brother was a better artist than he was." Leila Hadley was told something similar, later remarking, "Joseph said that Robert was the genius, not him." And Judy Richheimer remembered her surprise when, after telling her about Robert's "brilliance and great creativity," Cornell on one occasion showed her a selection of his brother's drawings, beaming with pride. "They looked like children's art," she noted, "and I said something polite."

Finally completing a will, Cornell outlined plans for the creation of the

Joseph and Robert Cornell Memorial Foundation, under whose terms proceeds from the sale of his house and his artwork would be used to help
handicapped children. The last book Cornell mentioned reading was *Dear
Theo*, the collection of Van Gogh's letters to his brother.

Cornell acted on behalf of children again when he was asked in the winter
of 1972 to contribute a print to a charity project for Phoenix House, a
nationwide program for drug treatment and prevention. Henry Geldzahler
had approached him about the project, knowing Cornell's sympathy for
"people who are wounded." Cornell was moved when Geldzahler came out
to Utopia Parkway with two teenage addicts—a boy and a girl—from the
Phoenix House program; he entertained his guests beneath the quince tree
in his yard. "Cornell was delighted," Geldzahler remarked, "and said he
would be glad to make prints even though he had never done them before."
 The prints were for a portfolio that would also include work by James
Rosenquist, David Hockney, R. B. Kitaj, and Ellsworth Kelly. While the
other artists made their lithographs in ateliers or printers' studios, Cornell
completed the entire project at Utopia Parkway. This was accomplished
with the help of Brooke Alexander, a dapper and dedicated young art dealer
in charge of producing the portfolio. Cornell gave him four collages, and
Alexander helped turn them into limited-edition prints by shuttling them
between Utopia Parkway and a printer's studio at various stages of completion.
 Cornell usually entertained the art dealer at his kitchen table. He would
serve Lipton tea and what Alexander described as "industrial-strength glazed
doughnuts from the supermarket." The doughnuts were offered straight
from the box, with Cornell insisting that his guest eat "more and more."
In spite of his graciousness, anyone could see that he was suffering from
severe depression. One day Cornell greeted Alexander in his pajamas. "I
got the sense," the art dealer said, "that if he didn't have plans to go out
on a particular day, he might just shuffle around in his pajamas and slippers
all day."
 Plagued by migraines, neck pain, and what he referred to as "eye pressure," Cornell now rarely left his house. Yet he sustained his many relationships by telephone. His phone calls were not like anyone else's, each
its own mélange of gossip, reminiscence, and revelation. Friends remember
marathon communications that could easily last an entire evening as Cornell

rambled on—his voice high, deliberate, and without variation—about everything from Coney Island to Mallarmé to his encounters with ballerinas. Frequent silences and a rustling in the background revealed to his listeners that Cornell was taking notes on their comments. "He prefaced his conversation with a formal announcement, like a visiting card, and then, free of urgencies, would converse for hours," the critic Brian O'Doherty has written. "So one had to cancel immediate plans and make preparations for a voyage."

Toward the end of Cornell's life, a rumor spread in the New York art world that he had stopped working. He had not exhibited any new boxes or collages since 1967, the year of his last appearance at the Schoelkopf Gallery; it was natural to assume that he had nothing new to show. This was not quite true. Up until the end, Cornell kept working, mostly tinkering with earlier boxes and continuing his memorial collages for his brother. Thinking he might want to make some new boxes, he asked his assistants to saw and nail wooden shells for him, having given up carpentry years earlier. Harry Roseman, who fabricated a few shells, recalls watching Cornell place one on the floor, "jumping up and down on it to make sure it was strong enough." The box withstood his test. Still, he didn't seem to be making new boxes. Cornell was the first to admit that he was no longer as prolific as he had been once. When friends asked him about his work, he often replied that he was "semi-retired."

Cornell's day-to-day routine was interrupted in the summer of 1972, when he began to suffer from prostate problems. According to his physician, Leonard Richheimer, "he was having trouble with urination, which is common among men his age." Cornell was admitted to Flushing Hospital on June 3 and remained hospitalized for three weeks. While the rules of Christian Science prohibit the use of medication, they do allow for surgery, and Cornell stoically submitted to a procedure requiring a penile insertion. He opted for local anesthesia and remained awake throughout the surgery, later noting of the insert that he "didn't mind it."

During his stay at the hospital, Cornell was noticeably appreciative of the nurses who cared for him. He liked having them in his room to take his pulse and his temperature. In a letter to Allegra Kent, Cornell cryptically referred to "a beautiful 'touch' experience with the Oriental nurse."

It was enough, though, to simply watch them, those shining women in their white uniforms. "He was darling with the nurses," said Leila Hadley, a frequent visitor to his bedside. "He talked to the nurses about themselves

and wanted to make them feel happy instead of expecting them to make *him* happy. The nurses adored him, and of course they had no idea who he was. They didn't know he was an artist. They just thought he was a nice elderly gentleman."

Cornell could also count on regular visits from his niece Helen Batcheller. While busy with her own three children in Northport, on Long Island, she took it upon herself to care for her uncle during his hospitalization and temporarily moved into his house to be that much closer to Flushing Hospital. Cornell, she said, was a model patient "who never complained about anything." While he could have afforded a private or semi-private room, he put himself in a four-bed ward, insisting to his niece that "other people need the space more than I do."

Cornell enlisted his niece's assistance in providing the nurses with gifts. One afternoon he sent her to the five-and-dime, instructing her to purchase an assortment of change purses, mirrors, combs, and candy. Cornell wrapped the gifts himself, tied them with ribbon, and displayed them on the table beside his bed. "Whenever a nurse or maid came into the room," Batcheller said, "he insisted that they help themselves to a little package. And when I was checking him out, I had to bring great big boxes of cookies for the nurses. That was the kind of person he was."

After his release from the hospital, Cornell convalesced at the homes of various relatives on Long Island. At first he stayed with Helen Batcheller in her newly built ranch house in Northport. It was a quiet, uneventful time for Cornell, and on most days he passed the hours reading the newspaper or listening to classical music on the radio. He wrote letters to friends and jotted down thoughts in a notebook. Still suffering from insomnia, he hoped for what he called a "sleep-through," but it rarely happened. Instead, he catnapped during the day.

There were occasional outings. His niece drove him into downtown Northport and on longer trips to nearby Huntington or Cold Spring Harbor, where he liked to browse in the antique shops and snack at the bakeries. She worried about his eating habits. "He kept a stash of baked goods beside his bed," she remembered. "He seldom sat down for meals, and had no appetite, except for sweets."

Cornell developed a mild infection after surgery, and his doctor prescribed antibiotics. Breaking with Christian Science, Cornell agreed to take the drug—but in fact was so medically naïve that he did not know how to. One day his niece walked into the kitchen and saw him open up a capsule,

pour the powdered contents into a glass of water, and drink the mixture. "He thought that's the way you do it," she later said. "He had never taken pills before."

Later that summer, Cornell paid an extended visit to Westhampton, staying at the home of his sister Helen Jagger, where their mother had passed her final years. He liked being near the ocean and, though he seldom bothered to get dressed, managed to stroll the shore nonetheless. "Quiet day on the dune in bathrobe," he noted in his diary on July 29.

At least one person from the Manhattan art world came out to see him during his convalescence. Yayoi Kusama, the Japanese artist with whom he had had a brief affair in 1964, had recently returned to New York after a stint abroad. Her "love happenings" had brought her notoriety but little money, and she was hoping Cornell might once again give her some boxes. Or perhaps, she thought, she could become his dealer; she imagined going into business with him. When she mentioned the idea to Cornell in Westhampton, he was momentarily sympathetic, writing her a check for a few hundred dollars to confirm his interest. In a snapshot taken that day on the grass, Yayoi leans tenderly against Cornell, who is neatly dressed in a shirt, tie, and cardigan. He stares down solemnly, resting his right hand on her head. It's a chilling photograph, an old man embracing his little angel, the white skin of his hand glowing above her head like a halo. He looks like a blind man healing her with his touch.

It was only a matter of days before Cornell rethought his conversation with Kusama and decided he had been overly generous. In a "Memo" to her on October 4, "re: 'business deal,' " Cornell advised: "I suggest you make that money go as far as possible . . . I shall probably be in a kind of retirement [when I return to Flushing] and not doing much in business." By the end of the month, he was requesting that Kusama not bother him further. "Yayoi," he wrote on October 30, "No mail please until I go to a new resting place for my health. I will try to write but do not know when. I am not seeing people. Need rest, quiet. I miss NYC very much. Say 'hello' for me."

In a letter to Allegra Kent the same day, Cornell voiced more practical concerns: "Do you remember the old pop tune: 'Everybody's Making Money But Tchaikovsky'? I feel that way so isolated and the prices dealers get for my things." Someday, he added, he would feel an "upsurge of inspiration" and "do something special" for her family.

• • •

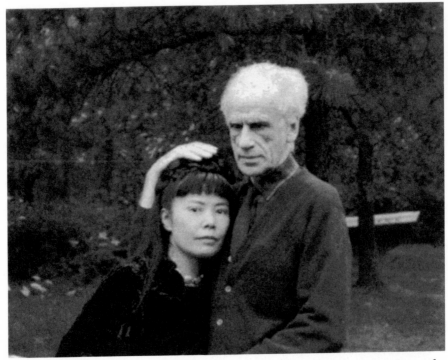

Cornell with Yayoi Kusama in Westhampton, 1972 (photograph courtesy Center for International Contemporary Arts)

On November 6, after five months away from home, Cornell returned to Utopia Parkway. While still in a debilitated condition, he hoped to resume ordinary life as much as possible. But whatever plans he had soon evaporated. Like a character in a Beckett play, he sat in his junk-encrusted house, an unshaven man in a stained bathrobe shuffling in his slippers from room to room. Autumn had arrived and the house was chilly. His thoughts turned toward "all these morbid images of winter approaching," he noted in his diary four days after his return.

He dreamed of venturing beyond his house, if only to ride the local bus into downtown Flushing. But he barely had the strength for even a limited outing. On December 6, he made his first trip to Main Street in Flushing since his hospitalization six months earlier. The rainy-day excursion brought him little pleasure, and he was astonished to realize that three of his favorite restaurants—the Merit Lunchroom, Chock Full O'Nuts, and Bickford's—had shut down. "Gone, gone, closed," he noted tersely in his diary.

He continued to correspond with his many friends, but there could be no pretending that he had much news to report. Cornell's last letter to Donald Windham was mailed in a translucent envelope, on which he wrote, "No need to open."

His circle of acquaintances, however, was still expanding. Frederick Morgan, a poet and the editor of the literary quarterly *Hudson Review*, had recently sent Cornell his new collection, *A Book of Change*, one of whose poems was conceived in homage to Cornell. Pleased by the gesture, Cornell, who had never met Morgan, called to thank him, complimenting "some poems that have to do with Christmas" and inviting him to visit. On December 20, Morgan drove out to Utopia Parkway with his wife, the writer Paula Deitz. Cornell entertained them on his front porch, sitting in a rocking chair and conversing, according to Morgan, about "New York City, penny arcades, Marie Taglioni, and his brother, who he said he missed very much." When the couple left, Cornell gave them a collage.

Later that evening, Cornell attended the mid-week service at the Bayside Christian Science Church. In his four decades of churchgoing, he had never attempted to offer a testimonial, content to just listen as others described their healing experiences. Now, however, he finally tried it, surprising the congregants by rising from his chair and saying a few words about how much Christian Science had meant to him. Writing in his diary the next day, Cornell noted with satisfaction that he was "able to get up on my feet for a single sentence testimonial but merely getting up was a testimony in itself." He felt moved, he added, "by the lovely hearty sincere greetings from the individual members. Thank you, Mrs. Eddy."

As Christmas approached, Cornell's two sisters on Long Island insisted that he pass the holiday with them. But he told them that he wasn't feeling well and would prefer to stay home by himself. On Christmas Eve, 1972, Cornell turned sixty-nine years old. He did not bother to write anything in his diary.

Four days later, however, he jotted down a few paragraphs. Sitting at the kitchen table at four in the morning, the oven door open for heat, he recorded his final entry. He reported a dream from which he "woke up in tears about not being introduced to a man in films." Then, slipping even deeper into remorse, he mentioned a friend who once "destroyed a novel that hadn't seemed worthwhile," a sentiment he could understand ("how similar a feeling") as he contemplated a lifetime's worth of "diary pages like this." Now, as always, Cornell doubted the worth of his undertakings and

wasn't sure at all what they amounted to. And yet, however skeptical he felt about the value of his work, he would hardly argue that life was without rewards. Looking out the window later that morning, he noticed that the sky was clearing. "Sunshine breaking through going on 12 noon."

December 29, 1972, was a Friday. Early that morning, Cornell spoke to his sister Betty by telephone. He asked her what she recommended for indigestion. She suggested soda and water. Before they hung up, Cornell confided ruefully, "You know, I was thinking, I wish I hadn't been so reserved."

When Helen Batcheller called later that morning, there was no answer. Concerned that something was wrong, she sent her husband, Ed, to Utopia Parkway. He knocked on the door. No one answered. He peered through a window and saw Cornell recumbent on the couch in the living room, his eyes closed. Batcheller climbed through a window to get into the house. He shook Cornell in an attempt to rouse him, but to no avail.

Dr. Richheimer was summoned. He arrived at Utopia Parkway within minutes. He was surprised by what he saw. He had come by only three days earlier and at the time Cornell had seemed fine. The doctor believed that Cornell died of a heart attack. "There was no sign of any agony," he later noted. "He looked like he was sleeping. He had his coat on, and a blanket pulled up to his chin."

A private service was held on January 8, 1973, at the Oak Hill Cemetery in Nyack. Cornell had requested that his body be cremated. His remains were interred in a grassy hill overlooking the Hudson River, near the graves of his mother, his father, and his brother, Robert. It was a bitter cold day, with the temperature hovering just above zero; the ground was glazed with snow. Instead of a church funeral, there was only a brief graveside service, at which the artist's sister Betty read a passage from Mary Baker Eddy's *Science and Health*. Later, Cornell's name would be added to an already existing granite tombstone that lists him merely as "Joseph 1903–1972," beneath the names and dates of his parents. Robert's grave was marked with a separate stone, a final rejection by his mother.

About fifty people turned out for the service. Some made the trip from

Manhattan, and most were professional acquaintances—art dealers who had sold his work (Richard Feigen, Brooke Alexander, Xavier Fourcade) or curators who had organized his shows (Diane Waldman and Henry Geldzahler). Sadly, there were no artists in attendance, nor were there many friends, and people later remarked that the service was strikingly underattended.

But then, Cornell had always been wary of the living, keeping his acquaintances at a safe remove. The dead—that was another story. For years he had found both artistic inspiration and everyday consolation in the lives of the departed, from Fanny Cerrito to Stéphane Mallarmé to Emily Dickinson, and had brought them to glowing life in the realm of his imagination. The mourners clustered around his grave on that gusty winter day did not reflect the true breadth of his day-to-day experiences, and yet their small numbers conveyed some basic truth about Cornell—his fantasy world was always more alive to him than the world in which he woke up every day and tended to the mundane details of living.

Not that Cornell was a stranger to reality. From the beginning he had responded to the avant-garde developments of his time with admirable swiftness and sureness. It is hard to think of another American artist who was receptive to so many different art movements or who managed to win the admiration of everyone from the Surrealists in the 1940s to the Abstract Expressionists in the 1950s to the Pop artists in the 1960s. Artists who agreed on little else agreed on Cornell.

They agreed, that is, on his originality. He found his epiphanies in the banal—in marbles and metal springs and other frugal objects, mingling the visionary aims of French Symbolism with a literalism that is distinctly American. In an exquisite conjunction between fantasy and the real, Cornell found the sublime at the five-and-dime. He transported Woolworth's reality into Cornellian unreality, which to him was as real as the objects in his boxes. The many critics who persist in pegging Cornell as a belated French Symbolist unwittingly slight him, stripping his work of its essentially American character. His precise arrangements of everyday objects belong at least partly to the vein of American realism that looks back to Peto's homely still lifes and forward to Warhol's brightly labeled soup cans.

True, Cornell was not the first artist to work in assemblage. His art belongs to an honorable modern tradition that began with Duchamp's readymades, Schwitters's use of common discards, and Picasso's recycling of newsprint. But Cornell *was* the first artist of any note to stake his entire

career on the media of collage and assemblage. It was Cornell who carried the tradition of assemblage from thirties Paris to fifties New York, and who kept it alive for a new generation of American artists (most notably Rauschenberg) during the heyday of abstract painting. Today, when so many contemporary artists are dedicated to creating "installations" from photos, video monitors, and objects-that-look-nothing-like-art, Cornell deserves credit for mixing up media decades before American culture became a culture of mix masters.

Did Cornell realize how great his influence would be over time? Probably not. Modesty might have led him to insist that he was simply the odd man out of his generation, and that his life, moreover, had been uneventful, no match in drama for the lives of the performers who filled his daydreams. Yet who could deny that his life had been heroic in its own quiet way? It certainly had not lacked for valor. The most selfless of artists, Cornell had cared for his handicapped brother and lived under the eye of his demanding mother until the age of sixty-one, a stubborn celibate. Yet in spite of his desperately lonely life, he created some of the most romantic objects ever to exist in three dimensions.

Cornell's last box, it might be said, was the one in which his ashes were buried, an irony not lost on the mourners at his funeral. "I remember my astonishment when Joseph's coffin was brought out," Donald Windham later noted. "It was so small." Indeed, it was no bigger than a Cornell box, and it seemed strange indeed that the artist should end up in a container so reminiscent of his own creations.

No artist was ever more death-haunted than Cornell, who found redemption by listening to messages from the illustrious dead and believing in life beyond the grave. Cornell can make believers of us, too. For we don't have to worship anything except art to know that Cornell is still very much with us. Through the example of his melancholy life and the sublime achievement of his art, he haunts us as vigorously as the dead once haunted him.

Acknowledgments

Don't believe the doomsayers: It's not true that we're born alone, and we may or may not die alone. We certainly do write alone, but in my own solitary pursuits I've been aided immeasurably by my friends (so maybe we don't write alone after all).

Daphne Merkin read all of this manuscript, bringing to the task equal parts acuity and affection. Mark Stevens and Peter Plagens were kind enough to read sizable chunks and offer advice informed by their considerable writing expertise. Jonathan Galassi and Paul Elie, my editors at Farrar, Straus & Giroux, provided crucial suggestions and sympathy. Kathy Robbins, my agent, has been there since day one. I owe an enduring debt to Raymond Sokolov, my editor at *The Wall Street Journal*, whose wisdom is matched only by his kindness. Many others have supported me in various ways, but I am particularly grateful to James Atlas, Sean Scully, Karen Marder, Celia Dugger, Alexis Gelber, Beatrice and Kent Gordis, my sisters, Lisa and Cherise, and Melissa Meyer, who accompanied me through the wilds of Queens on a trip to Utopia Parkway.

Through the years I have been sustained beyond measure by the faith and encouragement of my parents, Jerry and Sally Solomon. Every writer could use a set just like them.

This book is dedicated to my husband, Kent Sepkowitz, to whom I owe a debt that a string of words cannot begin to repay. Our sons, Eli and Leo, were born after I began work on this book and have allowed me to understand firsthand Cornell's belief that children are the royalty of the universe.

I owe an enormous debt to Cornell's devoted and delightful family: his sisters, Betty Benton and Helen Jagger, and his niece Helen Batcheller.

They provided me with access to all the right papers and patiently answered my endless queries over the past seven years.

My book, though the first biography of Cornell, is certainly not the first consideration of his work. I owe a debt to a man I never met—the late, great critic Henry McBride, who reviewed Cornell's first exhibition in *The Sun*. Diane Waldman wrote the first museum catalogue on Cornell in 1967. Lynda Roscoe Hartigan has done a marvel of research in the years since and was kind enough to make available to me pertinent archival material at the National Museum of American Art in Washington, D.C.

In general, the writing on Cornell has been top-notch, thanks largely but not exclusively to Sandra Leonard Starr, Dore Ashton, Hilton Kramer, Carter Ratcliff, Charles Simic, Kynaston McShine, Jed Perl, John Ashbery, Robert Hughes, Dick Tashjian, Kirk Varnedoe, and Adam Gopnik.

David Bourdon generously shared with me his unpublished notes from an interview with Cornell, as did Phyllis Tuchman. James Corcoran and Jennifer Vorbach at C&M Arts, the gallery that currently represents the Cornell estate, have been unfailingly helpful. Valerie Fletcher of the Hirshhorn Museum introduced me to Robert Lehrman, who gave me a memorable tour of his art collection and became a much-valued encourager of this book. This book has also benefited from the copy editing of Lynn Warshow and the design skills of Jonathan Lippincott.

For their varied and indispensable participation in this book, I also offer my gratitude to the following individuals: Richard M. Ader, Arman, Dore Ashton, Lauren Bacall, Timothy Baum, Joella Bayer, the late Ernst Beadle, Lindy Bergman, Robert Bergman, Avis Berman, the late Charles Boultenhouse, Ruth Bowman, David Boyce, Paul Brach, Stan Brakhage, Robert Delford Brown, Jeanne Bultman, Rudy Burckhardt, Leo Castelli, Tony Curtis, James T. Demetrion, Paula Dietz, Virginia Dorazio, the late Teeny Duchamp, Theresa Egan, Lawrence Fane, Richard Feigen, Louis Finkelstein, Charles Henri Ford, Mary Frank, Allan Frumkin, Betsy von Furstenberg, the late Henry Geldzahler, Creighton Gilbert, Trudy Goodman, Eugene C. Goossen, the late Clement Greenberg, Mimi Gross, Jodi Hauptman, Deborah Hay, Walter Hopps, Robert Indiana, Pat Johanson, Jasper Johns, the late Ray Johnson, Tobi Kahn, Allegra Kent, the late Lincoln Kirstein, Hilton Kramer, Yayoi Kusama, Alvin S. Lane, the late Leo Lerman, Samuel Lerman, Jean Levy, Sol LeWitt, Alexander Liberman, Leila Hadley Luce, Mark Mehler, the late Mary Grace Menaker, the late Joan Mitchell, Frederick Morgan, Florence and Donald Morris, the late Robert Motherwell, Catherine

Murphy, Catrina Neiman, Yoko Ono, Barry Paris, Beverly Pepper, Jean Plitt, Anne Porter, Robert Rauschenberg, Judy Richheimer, Leonard Richheimer, Harry Roseman, James Rosenquist, William Rubin, Irving Sandler, David Saunders, the late Jeffrey Schaire, David Schapiro, the late Meyer Schapiro, Peter Schjeldahl, Carolee Schneeman, Jane Schoelkopf, the late Robert Schoelkopf, June Schuster, Jeff Seroy, Gwen Van Dam Smiley, Lois Smith, the late David Solinger, Ileana Sonnabend, Susan Sontag, Alexandra Anderson-Spivy, Saul Steinberg, Bert Stern, Hedda Sterne, Allan Stone, Gwen Thomas, Yvonne Thomas, Calvin Tomkins, Harry Torczyner, Helen Tworkov, Susan Weil, Robert Whitman, Donald Windham, and Steve Wood.

For furnishing me with crucial documents, I am indebted to the following people and institutions: Rona Roob, the indefatigable archivist of the Museum of Modern Art; Ruth Quattlebaum and Jock Reynolds of Phillips Academy; G. Thomas Tanselle of the John Simon Guggenheim Memorial Foundation; Robert Haller, the director of Anthology Film Archives; Courtney Donnell of the Art Institute of Chicago; Liz Armstrong, formerly of the Walker Art Center; Susan Cross of the Solomon R. Guggenheim Museum; Kari E. Horowicz of the Albright-Knox Art Gallery; Lisa M. Leary of the Rose Art Museum, Brandeis University; Lee Klune of the Nyack Public Schools; Eugene R. Gaddis of the Wadsworth Atheneum; Thomas Sokolowski, formerly of the Grey Art Gallery and Study Center, New York University; Thomas W. Leavitt, formerly of the Herbert F. Johnson Museum of Art at Cornell University; Nancy Johnson of the American Academy and Institute of Arts and Letters; Marianne Craig Moore, the literary executor for the Estate of Marianne Moore; the Rosenbach Museum & Library; Virginia Krumholz of the Cleveland Museum of Art; Charles Ellis and Sergeant William J. Matusiak of the New York City Police Department; Maureen Haskell of the Queens County Criminal Court; Freda Leight of the First Church of Christ, Scientist in Great Neck; and Nathan A. Talbot, manager of the publication committees for the Christian Science Mother Church in Boston.

I owe a particular debt to Judy Throm, Nancy Malloy, Arleen Pancza-Graham, and the rest of the staff of the Archives of American Art, Smithsonian Institution, which contains the most important collection of Cornell's papers.

I am indebted to the anonymous librarians who answer the phones at the telephone reference desk of the New York Public Library. They seem to have every fact in the world at their fingertips.

Finally, I owe a debt to Steve Hanoka, the current owner of 3708 Utopia

Parkway, the house in Flushing where Cornell lived for forty-three years. Mr. Hanoka took the time one Sunday to give me a tour of his home and provide me with measurements of the rooms. The house, by the way, has changed quite a bit since Cornell lived there. His basement workshop has been redone as a paneled den. The quince tree in the back yard, his favorite site for reading and daydreaming, has since died. Nonetheless, one suspects that Cornell would have been delighted to hear that the house's current owner shares at least some of his love of childhood enchantments: Mr. Hanoka earns his living planning birthday parties for children.

Notes

Key to the main abbreviations:

AAA = Joseph Cornell Papers, Archives of American Art, Smithsonian Institution, Washington, D.C.

BB = Betty Benton, the artist's sister.

Getty Center = Special Collections, the Getty Center for the History of Art and the Humanities, Los Angeles, California.

Hartigan = Lynda Roscoe Hartigan, "Joseph Cornell: A Biography," an essay included in Kynaston McShine's *Joseph Cornell*, an exhibition catalogue (New York: The Museum of Modern Art, 1981).

HC = Helen Cornell, the artist's mother.

JC = Joseph Cornell

NMAA = The Joseph Cornell Study Center at the National Museum of American Art, Smithsonian Institution, Washington, D.C.

UT = The Harry Ransom Humanities Research Center, University of Texas at Austin.

I

3 with a Dr. Toms in attendance: JC, certificate and record of birth, State of New York, Bureau of Vital Statistics, #48751.

4 it never occurred to the Cornell family to visit . . . the Metropolitan Museum: Interview on May 12, 1989, with "Betty" Benton, the artist's sister, who supplied most of the material pertaining to the Cornell family in this chapter. Also, interview with Helen Jagger, the artist's other sister, on October 21, 1989.

4 he saw Buffalo Bill: JC jotted down recollections of this performance in a note inside the back jacket of his copy of Ben Hecht's *A Child of the Century*; the book is in the collection of the NMAA.

4 Harry Houdini: JC, letter to Richard Feigen, April 9, 1963, courtesy Feigen. Also, JC, letter to Marianne Moore, October 17, 1944, Moore Papers, the Rosenbach Museum & Library.

5 "entranced by the magic of the lights": JC, diary entry, April 6, 1967, AAA, roll 1062.

6 the youngest of three boys: He is incorrectly identified as one of four children in the MoMA catalogue, p. 92.

6 "caught cold walking up the hill": Jagger, interview with author, October 21, 1989.

6 died of typhoid fever: According to a death certificate supplied to the author by the New Jersey State Archives in Trenton (Volume BC, p. 25), JC's paternal grandfather—also Joseph I. Cornell—died on May 29, 1876, in Closter, N.J. He was thirty-four, and his occupation was listed as "Employed in U.S. Ex." The certificate further reveals that he was born in Seneca County, N.Y., the son of Joseph I. Cornell and Mary Laylor.

7 according to her gift log: This document is owned by the artist's niece, Helen Batcheller.

7 Helen was born, on February 15, 1906: This date is given incorrectly in the MoMA catalogue, p. 92.

8 "You have always had top place": HC, letter to JC, April 25, 1965, AAA, roll 1057.

8 "delight at the never-failing souvenirs": JC, diary entry, June 26, 1967, AAA, roll 1062.

8 he often described his father to his friends as a "magician": Leila Hadley Luce, interview with author, May 9, 1990.

9 "Dady gave me this post-card to send to you": The postcard is owned by BB.

9 a nearby wax museum: Rudy Burckhardt, interview with author, May 4, 1990.

10 "the big house on the hill": According to a land deed filed with the Rockland County Clerk, the house was purchased from Lillie B. Cornish on December 23, 1911.

11 One of them was done by James Bard: Robert Schoelkopf, interview with author, December 2, 1989. The painting is now owned by Helen Batcheller, as are others of the Commodore's heirlooms.

12 "Get your nose out of that book": BB, interview with author, May 12, 1989.

12 Joseph had been baptized six months after his birth: Excerpts from the registers of the (now-defunct) First Presbyterian Church in Nyack state that JC was baptized there on June 12, 1904. His parents had joined the church the previous year, on December 6, 1903. Former church member Harriet M. Hasbrouck located this information for me.

13 One of her specialties was a Jack Horner pie: Jagger, interview with author, October 21, 1989.

13 there were frequent stomachaches: Ibid.

13 "one of my most cherished, precious memories": JC, diary entry, February 2, 1966, AAA, roll 1062.

13 attended the Liberty Street School: According to records provided to the author by Nyack High School, JC never graduated from grade school.

16 "She expected him to do everything": BB, interview with author, May 12, 1989.

17 "unable to lift himself": Jagger, interview with author, October 21, 1989.

17 a nurse named Valentine Peake: BB, interview with author, May 12, 1989.

17 "Joseph I. Cornell . . . died yesterday": *Nyack Evening Journal* (April 30, 1917), 1. The obituary also mentioned that he had been a member of Rockland Lodge, No. 723.

18 The funeral took place: *Nyack Evening Journal* (May 1, 1917), p. 1.

18 Price of admission: one pin: Jagger, interview with author, October 21, 1989.

18 "COMBINATION TICKET ENTITLES BEARER TO": Hartigan, 93.

2

21 "an attack of German measles": Letter from school nurse to HC, January 26, 1918, courtesy Andover. Ruth Quattlebaum, Andover's archivist, kindly provided me with copies of pertinent records and correspondence in the school's files.

22 "your son's illness": Ibid., January 28, 1918.

22 "Feelings at Andover at age 13–17": JC, letter to Bartlett H. Hayes, Jr., May 18, 1969, courtesy Andover.

22 "the boxes might find a 'home' ": JC, letter to Hayes, c. 1969, courtesy Andover.

23 ended up as a Gaul: Various references in *The Phillipian*, see following note.

23 A smattering of items in *The Phillipian*: References to JC's athletic activities can be found in the school newspaper on May 11, May 14, May 18, May 21, and May 25, 1921.

23 installed at the Pease House: School records, courtesy Andover.

23 "He was an inconspicuous loner": Alexander Preston, conversation with author, December 22, 1991.

23 "He was just a quiet Joe": James Bunting, Jr., conversation with author, December 22, 1991.

23 Cornell took four years of Latin: School transcript, courtesy Andover.

24 Hugo's *Les Misérables*: Andover course catalogue, 1920–21.

24 the school honor roll: JC's name could be found on the honor roll published in *The Phillipian* on December 6, 1919, January 14, 1920, May 8, 1920, November 10, 1920, February 19, 1921, and April 27, 1921.

24 "More good news!": JC, letter to HC, undated, AAA, roll 1056A.

24 "Dear Robbie": JC, letter to Robert Cornell, undated, AAA, roll 1956A.

25 "Please don't spend your money": JC, letter to HC, undated, AAA, roll 1056A.

25 had fallen on hard times: BB and Jagger, interviews with author.

26 "Dear Mr. Bancroft": HC, letter to Cecil K. Bancroft, registrar, August 9, 1918, courtesy Andover.

26 $600 a year: *Phillips Academy Catalogue*, 1917–18, p. 23.

26 "Guardian's Name": JC's school transcript, courtesy Andover.

27 "working for his scholarship": Edward Skillin, conversation with author, December 22, 1991.

27 "The Greatest Magician in the World": JC, school paper, AAA, roll 1056A.

28 "I am going to give a speech": Undated letter from JC to Helen Cornell, AAA, roll 1056A.

28 "rugged, German types": Unpublished notes, David Bourdon of *Life*.

28 "Your card brought back": JC, postcard to Parker Tyler, postmarked August 25, 1939, UT.

29 "At your suggestion I brought to the attention of the faculty": Letter from Alfred E. Stearns to George Kunhardt, courtesy Andover.

29 "unusually sensitive" youth: Jagger, interview with author, October 21, 1989.

30 "He didn't go to college": BB, interview with author, May 12, 1989.

3

32 a picturesque town of about 7,000: 1921 Chamber of Commerce guide to Queens, courtesy Queens Borough Public Library, central library, Jamaica, N.Y., Long Island Division.

33 Bridal Row: Jagger, interview with author, October 21, 1989. Also noted by BB in an interview published in *The Bayside Times* (January 16, 1975), 1.

33 twelve dollars a week: Jagger, interview with author, October 21, 1989.

33 "the nightmare alley of lower Broadway": JC, undated diary entry, AAA, roll 1958. Also cited in Hartigan, 97.

34 "the teeming life of the metropolis": JC, in a draft of a letter to a Yale undergraduate, Leslie John Schreyer, c. 1968, courtesy BB. Cited in Sandra Leonard Starr's *Joseph Cornell*, exhibition catalogue (Tokyo: Japan Association of Art Museums, 1992), 50.

35 "a sanctuary and retreat of infinite pleasures": JC, undated diary entry on verso of letter dated January 15, 1941, AAA, roll 1076. Also cited in Hartigan, 96.

35 "The salesmen's desks were clustered": Jagger, interview with author, October 21, 1989.

35 "He was just different that way": Jagger, interview with author, October 21, 1989.

35 he never forgot his embarrassment: Phyllis Tuchman interviewed JC in the summer of 1971 and graciously shared her unpublished notes with me.

36 French recordings he had picked up in the city: Jagger, interview with author, October 21, 1989.

36 Robert *"felt so* for him": Jagger, letter to author, April 19, 1991.

36 Queens city directory: *1933 Queens City Directory*, courtesy Queens Borough Public Library.

37 "The Misses Helen and Betty Cornell are spending three weeks": "Society News," *The Flushing Evening Journal* (July 21, 1921).

37 "I'm so glad Joe enjoyed his visit": Letter from Howard Storms to HC, July 12, 1923, courtesy Helen Batcheller.

38 a "yellow brick brewery": The building was once criticized as such by James H. Mapleson, impresario at the Academy of Music. Cited in *The Encyclopedia of New York City*, edited by Kenneth T. Jackson (New Haven: Yale University Press, 1995), 757.

38 to approach her backstage": Jagger, interview with author, October 21, 1989.

38 the 1922 *Rain*: Jagger and BB, interviews with author.

39 "I have a treasured memory of her": JC, in a draft of a letter to a "Miss Palmer," February 17, 1953, AAA, roll 1059.

39 Anna Pavlova: Jagger and BB, interviews with author.

39 "Raquel Meller": Unsent draft of a letter from JC to Hans Huth, research curator of the Art Institute of Chicago, July 20, 1953, AAA, roll 1059.

40 "a vanished golden age of gallery trotting": Ibid.

40 "In a single room": Ibid.

40 He purchased a drawing by Brook's wife: Avis Berman, *Rebels on Eighth Street: Juliana Force and the Whitney Museum of American Art* (New York: Atheneum, 1990), 235.

40 "the superb folios of *Ganymede*": JC to Huth, July 20, 1953.

41 "it was too live": Donald Windham, interview with author, April 12, 1990.

41 "interviewed by David Bourdon of *Life*": David Bourdon graciously shared his unpublished notes (hereafter "Bourdon notes") with me.

42 Robert . . . was ecstatic when Griffith: Jagger, letter to author, April 22, 1991.

42 "the profound and suggestive power": JC, " 'Enchanted Wanderer': Excerpt from a Journey Album for Hedy Lamarr," *View* (December 1941–January 1942), 3.

43 "a cashier at the Bayside Motion Picture Theatre": This story was later repeated by many of JC's acquaintances, including Robert Motherwell, Marcel Duchamp, and Alexander Iolas. And Frank O'Hara told it to Irving Sandler.

44 a "luxury shelf": JC, letter to his sisters, September 11, 1928, AAA, roll 1056A.

45 "the natural, wholesome, healing . . .": JC, diary entry, July 29, 1953, AAA, roll 1059. Also cited in Hartigan, 97–98.

45 "accessibility from place of residence": Freda Leight, the clerk of the Great Neck Christian Science Church, supplied all material pertaining to JC's involvement with the church on February 20, 1991. JC was a member of this church from 1926 until 1952, when he became a founding member of a new church in Bayside, N.Y. Church rolls indicate that he had been interested in Christian Science "for two years" before he formally joined the Great Neck church.

45 "I only know Mr. Cornell": Ibid.

45 "Mr. Cornell is most sincere": Ibid.

45 "he applied for membership in . . . Eddy's Mother Church": Nathan A. Talbot, manager, Committees on Publication, The First Church of Christ, Scientist, in a letter to the author, February 7, 1990. According to church records, Cornell applied for membership in the Mother Church on September 8, 1926. He was formally admitted that November. His application indicates that he was already a member of the Great Neck Christian Science Church, and was formerly a Methodist. He remained a member of the Mother Church until his death.

46 "My mother was very jealous": BB, interview with author, May 12, 1989.

47 left an estate: Will 38–531, Probate file of Emma V. Storms, date of probate November 28, 1926, Rockland County Surrogate's Court.

47 "Dear Sis": JC, letter to sister Helen, October 27, 1924, AAA, roll 1056A.

47 "Dear Girls": JC, letter to his sisters, September 11, 1928, AAA, roll 1056A.

49 "wandering in search of everything": André Breton, *L'Amour fou* (Paris: Gallimard, 1936), 24.

4

50 "the Cornell family bought a house": Land deed, May 9, 1929, Queens County Court (Liber 3296, p. 187). Mrs. Cornell purchased the house from Oscar and Aina Pettersson of 3702 Utopia Parkway, Russian immigrants who had built the strip of four identical houses on the block. The Cornells were the first occupants of their house.

50 "which cost $14,000": Ibid.

51 "Utopia Parkway . . . was conceived as a singularly commercial enterprise": Assorted notes in folder on Utopia Parkway, Queens Borough Public Library, Jamaica, N.Y., Long Island Room.

51 "These suburbs are dumps": JC, diary entry, July 10, 1948, AAA, roll 1059.

52 "sense of Americana": Ibid.

52 "Helen was married": Jagger, interview with author, October 21, 1989.

54 "I need the funny papers": Ibid.

54 "They'd sit and watch": BB, interview with author, May 12, 1989.

54 tossing peanuts to the blue jays: Ibid. Also, Donald Windham, "Joseph Cornell," a catalogue accompanying a 1996 exhibition of the same name at C&M Arts, unpaginated.

54 "When he got to the city": BB, interview with author, May 12, 1989.

55 When Levy married Joella in Paris: Julien Levy, *Memoir of an Art Gallery* (New York: G. P. Putnam's Sons, 1977), 46.

56 "I never had any real sympathy": JC, draft of a letter to Hans Huth, July 20, 1953, AAA, roll 1059.

56 "has healthier possibilities": JC, letter to Alfred H. Barr, Jr., November 13, 1936, Archives of the Museum of Modern Art.

57 The curator and art historian William Rubin: William S. Rubin, *Dada, Surrealism and Their Heritage* (New York: The Museum of Modern Art, 1968), 143.

60 "You wouldn't mistake one of mine": Levy, 77.

60 "He was scared of Julien": Joella Loy Bayer, interview with the author, March 5, 1992.

62 "Joseph had a total identification with Robert": Henry Geldzahler, interview with author, December 5, 1989.

63 "resented a gallery": Levy, 137.

63 "a cake decorator's tube": JC, letter to Hans Huth, June 21, 1953, Archives of the Chicago Art Institute.

65 "a ship that is mostly cobweb": Edward Alden Jewell, review, *The New York Times* (January 13, 1932), 27.

65 "I always *re-visited* every show": HC, letter to Robert Schoelkopf, c. 1966, Archives of the Schoelkopf Gallery.

66 first prospered . . . during World War I: Jagger, interview with author, October 21, 1989.

66 selling refrigerators door-to-door: Jagger and BB, interviews with author.

66 "wells of blood": BB, interview with author, May 12, 1989.

66 "a swell piece of my own cake": JC, letter to his sisters, October 14, 1943, AAA, roll 1956A.

66 "amusingly clever bibelots": Edward Alden Jewell, review, *The New York Times* (December 1, 1932), 19.

67 "glittering ornaments": "Art Notes and Comment," *Herald Tribune* (November 27, 1932), section VII, 8.

67 "very simple, very strange": "Attractions in Various Galleries," *The Sun* (December 3, 1932), 11.

5

69 "literature distribution committee": Freda Leight, clerk, First Church of Christ, Scientist, Great Neck, provided me with information pertaining to JC's church activities.

69 an attendant in the Reading Room: Ibid.

70 "He was so embarrassingly shy": Dore Ashton, *A Joseph Cornell Album* (New York: The Viking Press, 1974), xi.

70 "He made for the WC": Ibid.

70 "a collector of Dali": In a letter to Hans Huth on June 21, 1953, JC wrote: "One thing is certain and that is that I was never influenced by Dali in spite of coming in direct contact with him and at one time owning the first picture sold of his in the first group Surrealist exhibition in NYC, 1932," Archives of the Chicago Art Institute.

70 "he made the first surrealist purchase in America": Stephanie Terenzio, ed., *The Collected Writings of Robert Motherwell* (New York: Oxford University Press, 1992), 223.

71 *Myself at the Age of Ten*: A letter from the registrar of the Museum of Modern Art (November 22, 1938) thanks JC for lending this Dali painting to the circulating exhibition of "Fantastic Art, Dada and Surrealism," Archives of the Museum of Modern Art.

71 "He never took the painting home": Rose Fried, interview with David Bourdon, 1969; Bourdon notes.

72 "a pitiful little lunatic": Antony Penrose, *The Lives of Lee Miller* (London: Thames and Hudson, 1985), 54.

72 "Thank you so much for your cordial letter": Fay Wray, letter to JC, AAA, roll 1056.

74 "She had been fired": Russell Lynes, *Good Old Modern: An Intimate Portrait of the Museum of Modern Art* (Kingsport, Tenn.: Kingsport Press, 1973), 108.

76 "one of excessive politeness": "Monsieur Phot (Scenario)," included in Julien Levy, *Surrealism* (New York: Black Sun Press, 1936), 77.

76 some 2,500 pictures: JC, letter to Jay Leyda, April 17, 1935, Archives of the Anthology Film Archives.

77 asked to teach a Sunday-school class: Records of the First Church of Christ, Scientist, Great Neck, as provided to the author by its current clerk, Freda Leight.

77 "guiding, protecting and directing": Freda Leight, interview with author, January 23, 1996.

77 A pioneer in the field of design: "Ethel Traphagen Leigh Is Dead; Founded Fashion School in '23" (obituary), *The New York Times* (May 1, 1963).

78 His salary was paltry: According to a résumé JC filed with his application for a Guggenheim grant in 1945, he earned $15 a week at Traphagen's and $3,000 a year at Whitman's.

78 "hack work": BB, interview with author, May 12, 1989.

78 "countless days seemed like eternities": JC, letter to Parker Tyler, February 3, 1941, Harry Ransom Humanities Research Center, UT.

78 "This gray morning marks a milestone": JC, undated letter to BB, AAA, roll 1056A.

79 "I don't find any Cornell about": Julien Levy, undated letter to Barr. Archives of the Museum of Modern Art.

80 Carl Backman: Hartigan, 100.

80 his "real first-born": Ashton, 91.

80 "I applied at least six coats": JC, letter to the Wadsworth Atheneum, July 5, 1938, Archives of the Wadsworth Atheneum.

82 he referred art historians to *Illumined Pleasures*: JC, interview with P. Tuchman, 1971.

82 "everything can be used in a lifetime": Bourdon notes.

83 "this is an emergency number": JC, letter to Eleanor Howland, Barr's secretary, November 20, 1936, Archives of the Museum of Modern Art.

83 "One sure thing": "The Surrealists," *Harper's Bazaar* (November 1936), 126.

84 "I have never been an official Surrealist:" JC, letter to Barr, November 13, 1936, Archives of the Museum of Modern Art.

84 "American constructivist": Alfred H. Barr, Jr., ed., *Fantastic Art, Dada and Surrealism*, exhibition catalogue (New York: The Museum of Modern Art), 266. Cited in Dickran Tashjian, *A Boatload of Madmen: Surrealism and the American Avant-Garde, 1920–1950* (New York: Thames and Hudson, 1995), 248.

84 "Surrealism would never have attracted": *Time* (December 14, 1936).

84 "That's the only brilliant intuition": Dali, quoted in Mark Polizzotti, *Revolution of the Mind: The Life of André Breton* (New York: Farrar, Straus & Giroux, 1995), 471.

85 "discovered a warehouse in New Jersey": Levy, *Memoir of an Art Gallery*, 229.

86 "When one owns a print": P. Adams Sitney, "The Cinematic Gaze of Joseph Cornell," essay in 1981 MoMA exhibition catalogue, 75.

86 "If you love watching movies from the middle on": Charles Simic, *Dime-Store Alchemy: The Art of Joseph Cornell* (Hopewell, N.J.: Ecco Press, 1992), 59.

87 "incomplete experiment": Levy, *Memoir of an Art Gallery*, 230.

89 "Salaud!": Ibid.

89 "My idea for a film": Ibid., 231.

6

91 "I have a vision of him now": JC, diary entry, July 1954, AAA, roll 1059, reference to Edmund Gosse, *French Profiles* (New York: Dodd Mead & Co., 1905).

92 "complete happiness": JC, diary entry, July 10, 1948, AAA, roll 1059.

92 "I have just completed": JC, letter to Leyda, November 15, 1938, Archives of the Anthology Film Archives.

92 "identified on the exhibition checklist": Bruce Altshuler, *The Avant-Garde in Exhibition: New Art in the 20th Century* (New York: Harry N. Abrams, 1994), 132. Altshuler kindly helped me locate a checklist for the exhibition (which is mysteriously missing from the MoMA library) at the Ubu Gallery in Manhattan.

93 "Cornell is very cut up": Julien Levy, undated letter to Chick Austin, Archives of the Wadsworth Atheneum.

94 "confused the aim of painting": Lincoln Kirstein, *Tchelitchev* (Santa Fe: Twelvetrees Press, 1994), 40. Also quoted in David Bourdon, "Alchemist at Large: The Return of Tchelitchev," *Art in America* (July 1995), 64.

95 "three hundred more than Dali": Parker Tyler, *The Divine Comedy of Pavel Tchelitchew* (New York: Fleet Publishing Corp., 1967), 443.

95 "the first candid, gloves-off account": Quoted in Steven Watson's introduction, Charles Henri Ford and Parker Tyler, *The Young and Evil* (New York: A Sea Horse Book, Gay Presses of New York, 1988), xxv.

95 "my total lack of interest in psycho-analysis": JC, letter to Charles Henri Ford, July 8, 1939, Getty Center.

96 "Joseph, These were written for you": Ford, inscription in JC's copy of *Seven Gothic Tales*, October 29, 1942, NMAA.

96 "I have been going by the old garbage dumping grounds": JC, letter to Ford, September 27, 1939, Getty Center.

96 "I found something last week": Ibid., January 30, 1939, Getty Center.

96 "He was a day prowler": Charles Henri Ford, interview with author.

97 "completely disgusted him": Quoted in Polizzotti, 88.

97 "Wayne Koestenbaum": Wayne Koestenbaum, *The Queen's Throat: Opera, Homosexuality and the Mystery of Desire* (New York: Poseidon Press, 1993), 64.

99 "If his name had been easier to pronounce": Tyler, 3.

99 eyebrow pencil and mascara: Watson's introduction, *The Young and Evil*, xv.

99 "Because Tyler's vision": Gore Vidal, *Myra Breckinridge* and *Myron* (New York: Vintage Contemporaries, 1987), 13.

99 "I did for Parker Tyler": Watson's introduction, *The Young and Evil*, xxx.

100 To "the Benvenuto Cellini": The inscription is on the inside cover of JC's copy of Tyler's *The Metaphor in the Jungle, and other poems*, January 18, 1941, NMAA. Cited in Dickran Tashjian, *Joseph Cornell: Gifts of Desire* (Miami Beach: Grassfield Press, 1992), 15.

100 "my first visit to you": JC, letter to Tyler, February 22, 1948, UT.

100 "Cornell's reflexes were always slow": Parker Tyler, letter to Edwin Bergman, Archives of the Art Institute of Chicago.

100 "By a rather curious coincidence": JC, letter to Tyler, June 11, 1939, UT.

100 "At present writing Garbo": JC, postcard to Tyler, postmarked July 25, 1939, UT.

100 "There is a miracle going on": JC, letter to Ford, July 8, 1939, Getty Center.

102 "a step up": Levy, *Memoir of an Art Gallery*, 203.

102 "one of my favorite objects": JC, letter to Monroe Wheeler, August 31, 1942, Archives of the Museum of Modern Art.

103 "It looks nothing like me": Donald Windham heard this story after the box was exhibited at MoMA in 1942.

103 "Cornell was crushed by her appraisal": Windham, interview with the author, April 12, 1990.

103 Cornell used a photostat: Richard Benson, the photographer and printer, kindly provided me with technical information on the photostat.

106 "The only truly surrealist work": Julien Levy, press release, Archives of the Museum of Modern Art.

106 "It appears that only dreamers": Henry McBride, "Varied Gallery Attractions," *The Sun* (December 9, 1939), 19.

107 "It is impossible to describe the show in a few words": Carlyle Burrows, "Notes and Comments on Events in Arts: Playful Objects," New York *Herald Tribune* (December 10, 1939), sections 6, 8.

107 "the more exotically minded": Howard Devree, "Here, There, Elsewhere," *The New York Times* (December 10, 1939), sections 10, 12.

7

108 "an extremely gifted and subtle artist": Lincoln Kirstein, October 30, 1945, letter of recommendation to the John Simon Guggenheim Memorial Foundation, courtesy Guggenheim Foundation.

108 "a clumsy decorator": Kirstein in his memoir *Quarry* (Santa Fe: Twelve Trees Press); quoted in his *New York Times* obituary (January 6, 1996), 26.

109 "not for the first time, ruined a ballet": Richard Buckle, with John Taras, *George Balanchine, Ballet Master* (New York: Random House, 1988), 125. Quoted by Bourdon, "Alchemist at Large," 65. Also, for further information on Kirstein and Balanchine, I am indebted to Joan Acocella, "Heroes and Hero Worship," *The New York Review of Books* (November 16, 1995).

109 dressed only in leotards: Acocella, 33.

109 "If I don't see you at the rehearsals": JC to Tyler, May 25, 1941, UT.

110 "He was always full of fascinating tips": Quoted in Sandra Leonard Starr, *Joseph Cornell and the Ballet*, an exhibition catalogue for a show of the same name at Castelli, Feigen, Corcoran (November 2 to December 18, 1983) in New York.

111 "little proposition": JC, letter to Ford, July 27, 1940, Getty Center.

111 "The figure of the young danseuse": JC, undated diary entry, AAA, roll 1066. Quoted in Starr, 20.

112 a uniformed guard: JC, diary entry, January 4, 1944, AAA, roll 1958. Cited in Starr, 31.

112 "The gracious and elusive figure": JC, letter to Tyler, September 24, 1942, UT.

113 "On a moonlight night": JC, Inscription on *Taglioni's Jewel Casket*, Permanent Collection, Museum of Modern Art.

115 "dilettante manner of working": JC, letter to Tyler, September 25, 1940, UT.

115 "Soon there appears": Quoted in Catrina Neiman, "View Magazine: Transatlantic Pact," introduction to Charles Henri Ford, ed., *View: Parade of the Avant-Garde, 1940–1947* (New York: Thunder's Mouth Press, 1991), xvi.

116 "As we go to press": Editor's note, *View* (October 1940), vol. 1, nos. 2, 4.

116 "an actress who more than anyone": Edwin Denby, "The Original Ballet Russe," included in *Dance Writings* (New York: Alfred A. Knopf, 1986), 70.

116 "like a Pierrot": Starr, 59.

116 "I want you to meet a genius": Ibid., 59.

116 "He was already an elderly man": Ibid., 60.

117 "water and tea bags": Ibid.

118 Henry McBride: McBride, "Attractions in the Galleries," *The Sun* (December 14, 1940), 11.

118 "Carlyle Burrows": Burrows, "Notes and Comments on Events in Art," New York *Herald Tribune* (December 15, 1940), sections 6, 8.

119 "Edward Alden Jewell": Jewell, review, *The New York Times* (December 15, 1940), section X, 11.

120 "round fur hat": JC, diary entry, n.d., AAA, roll 1958.

120 "wrote a letter to my mother": BB, interview with author, May 12, 1989.

120 "freelance commercial artist": JC, résumé, Archives of the Museum of Modern Art.

121 He "never seemed content": Cecil Beaton, quoted in Ashton, x.

121 "My collection of old films": JC, letter to Ford, October 2, 1939, Getty Center.

121 "I've just snapped out of it": JC, letter to Tyler, February 3, 1941, UT.

122 "Unfortunately I wasn't near enough": Ibid., January 10, 1941, UT.

122 "watched her watching": Ibid., February 3, 1941, UT.

122 "I got soaked": JC, letter to Tchelitchew, July 1941, UT.

123 "When she dances": Edwin Denby, "Kurt Jooss: The Monte Carlo Ballet," in *Dance Writings*, 81.

124 "Who takes you home?": Starr, 68.

124 "I've seen 'Come Live With Me' ": JC, letter to Tyler, May 25, 1941, UT.

124 "about a story of stars": JC, letter to Tchelitchew, July 1941, UT.

124 "Yesterday I was trying": JC, diary entry, July 15, 1941, AAA, roll 1058.

125 "starched shirt": JC, letter to Tyler, July 2, 1941, UT.

125 "ENCHANTED WANDERER": JC, " 'Enchanted Wanderer': Excerpt from a Journey Album for Hedy Lamarr," *View* (December 1941–January 1942), 3.

125 "attracted a good deal of attention": The collage is reproduced or discussed in Ashton, 150; Marjorie Keller, *The Untutored Eye* (Cranbury, N.J.: Associated University Presses, 1986), 105; and Tashjian, 46.

125 "She has carried a masculine name": "Enchanted Wanderer," 3.

127 "Saw Marlene Dietrich": JC, diary entry, spring 1944, AAA, roll 1058.

127 "a royal purple shirt": JC, undated diary entry, c. 1950, AAA, roll 1059; pointed out to the author by Jodi Hauptman.

127 "my Toumanovas I guarantee": JC, letter to Tyler, September 24, 1942, UT.

8

128 "I did not want to live in sin": Peggy Guggenheim, *Confessions of an Art Addict* (New York: Macmillan, 1968), 91.

128 grumbled endlessly about the New World: Deborah Solomon, "Good-bye, Dali: How Surrealism Turned into Abstract Expressionism," *The New York Times Book Review* (October 8, 1995), 39.

129 riding the Madison Avenue bus: JC, diary entry, summer 1941 ("typed from memory"), AAA, roll 1058.

129 "His art was more memorable than he was": Meyer Schapiro, interview with the author, May 10, 1994.

130 "had evolved an experiment": André Breton, "Genesis and Perspective of Surrealism, in Peggy Guggenheim, *Art of This Century* (New York: Arno Press, 1968), 26.

130 "came off quite well": JC, letter to James Thrall Soby, April 7, 1942, Archives of the Museum of Modern Art.

130 "Dear Mrs. Ernst": JC, letter to Peggy Guggenheim, March 12, 1942, Guggenheim Papers, AAA, roll ITVEI.

131 *"Story Without a Name"*: JC, *View* (April 1942), 23.

131 "I could hardly hear myself think": JC, letter to James Thrall Soby, April 7, 1942, Archives of the Museum of Modern Art.

132 *Joseph Cornell's Theater of the Mind: Selected Diaries, Letters and Files*, Mary Ann Caws, ed. (New York: Thames and Hudson, 1993).

133 "The first thing he showed me": Quoted in Hartigan, 105.

133 "ballet, Mallarmé, small hotels": Robert Motherwell, letter to Lynda Hartigan, November 15, 1977, in *The Collected Writings of Robert Motherwell*, 222.

134 "He just watched her and watched her": Motherwell, conversation with author, September 1989.

134 "a tall stack of Danish": Hedda Sterne, interview with author, January 13, 1992.

134 "It was his desire to have a limited relationship": Saul Steinberg, interview with author, February 20, 1992.

134 pushcarts on Orchard Street: Sawin, *Surrealism in Exile and the Beginning of the New York School*, 222.

135 Duchamp answered the phone: JC, diary entry, April 28, 1942, AAA, roll 1058. (This entry must have been typed from memory as it bears an incorrect date; Duchamp did not return to New York until July of that year.)

135 "At Duchamp's 11 to 1": JC, diary entry, December 21, 1942, AAA, roll 1058.

137 "As time went on": Carl Backman, quoted in Hartigan, 100.

139 "that might be encountered in a penny arcade in a dream": JC, undated note filed in his "Night Voyage" folder, AAA, roll 1066.

139 "Sofonisba Anguissola": Creighton Gilbert, the Renaissance scholar and professor of art history at Yale, kindly provided me with information on Anguissola. Gilbert befriended Cornell in the sixties and recalls that he "was fascinated by women artists of the Renaissance."

140 One of the few portraits of an adolescent: Gilbert interview, November 8, 1993.

140 "the artist's self-image": Harold Rosenberg, "The Art World: Object Poems," *The New Yorker* (June 3, 1967), 112.

142 "dog shit": John Bernard Myers, *Tracking the Marvelous: A Life in the New York Art World* (New York: Random House, 1981), 22.

142 Duchamp wanted to own the piece: Teeny Duchamp, undated letter to the author.

144 ISMS RAMPANT: *Newsweek* (November 2, 1942), quoted in Jacqueline Bograd Weld, *Peggy: The Wayward Guggenheim* (New York: E. P. Dutton, 1986), 290.

145 "surrealist, pretentious": Emily Genauer, *New York World-Telegram* (December 19, 1942), quoted in Weld, 293.

145 "greatly gifted": Clement Greenberg, "Review of a Joint Exhibition of Joseph Cornell and Laurence Vail," *The Nation* (December 26, 1942), in John O'Brian, ed., *Clement Greenberg: The Collected Essays and Criticism*, Volume I, Perceptions and Judgments 1939–1944 (Chicago: The University of Chicago Press, 1986), 131–32.

145 "Other things took precedence": Greenberg, conversation with author, May 1990.

145 in her revised memoirs: Peggy Guggenheim, *Out of This Century: Confessions of an Art Addict* (New York: Universe Books, 1979).

146 "I had sent him a beautiful Cornell object": Ibid., 293.

146 suggesting he play with it: Weld, 427.

146 "ever-smiling, gentle": Tyler, 379.

146 "Julien Levy suggested": JC, letter to Monroe Wheeler, August 31, 1942, Archives of the Museum of Modern Art.

146 "It is being refinished": Ibid., September 8, 1942.

146 "Please phone him": Wheeler scribbled this comment on the upper left corner of a letter from JC, October 10, 1942, Archives of the Museum of Modern Art.

9

147 "He would suddenly stop": Jimmy Ernst, *A Not-So-Still Life* (New York: St. Martin's, 1984), 151.

148 he worked at the Allied Control Company: JC, application for a grant from the John Simon Guggenheim Memorial Foundation, September 19, 1945, Archives of the Guggenheim Foundation.

148 55 cents an hour: Ibid.

148 "he wanted some kind of involvement": BB, interview with author, May 12, 1989.

148 "overwhelmed with mental fatigue": JC, undated diary fragment in "Defense Work 1943" folder, AAA, roll 1066.

149 "her pleasant expression": JC, ibid., June 14, 1943.

149 "Anne (tester) (Allied)": The card can be found in his "Defense Work" folder, AAA, roll 1066.

150 "visual possession": The author is grateful to Dr. Mark Mahler, a professor of neurology at the Albert Einstein College of Medicine, for helping to coin this phrase.

150 black top coat: JC, ibid., August 10, 1943.

150 "Have not forgotten you": JC, letter to Frederick Kiesler, August 22, 1943, in *Film Culture* 70–71 (1983), 141.

151 "*The Crystal Cage*": JC, "The Crystal Cage (portrait of Berenice)," in the "American Fantastica" issue of *View* (January 1943), 10–16.

153 "He had a hard time when I got married": BB, interview with author, May 12, 1989. Also, similar comment in BB interview with Paul Cummings, AAA.

153 Cornell initially found the doll: BB, interview with author, May 12, 1989. Also, Leila Hadley Luce, interview with author, May 9, 1990.

153 "He wanted a picture of the doll": Ernst Beadle, interview with author, April 7, 1990.

155 run by . . . Kirk Askew: Levy, *Memoir of an Art Gallery*, 265.

156 "Cornell's art I shall have to leave altogether": Edward Alden Jewell, "Maestro Julien Levy," *The New York Times* (December 12, 1943), section II, 8.

157 "accept a little Christmas tree": JC, letter to Tilly Losch, Christmas 1943, in Starr, 71.

159 "She was always the most glamorous person": HC, letter to JC, May 26, 1965, AAA, roll 1057.

159 "When I introduced myself": HC, letter to JC, May 24, 1965, AAA, roll 1057.

159 "this mad, distant suitor": *The Collected Writings of Robert Motherwell*, 222.

160 "You can't help making beautiful things": Cornell scribbled this comment from Mina Loy on a scrap of paper in 1945, AAA, roll 1058.

160 "Could there be any doubt": Walter de la Mare, *Memoirs of a Midget* (New York: Readers Club Edition, 1941), 184, NMAA.

160 "the superlative effects": JC, undated diary entry, c. 1944, Garden Center folder, AAA, roll 1072.

160 "resentment and persecution": Ibid.

160 "the fantastic aspect of arriving home": Ibid.

161 "inevitably produces fatigue": Ibid.

161 "A flower shop": Windham, interview with author, April 1, 1990.

161 "his taste and erudition": Lincoln Kirstein, letter of recommendation to the Guggenheim Foundation, October 30, 1945, Archives of the Guggenheim Foundation.

161 "a gaunt face": Donald Windham, *Tanaquil* (New York: Holt, Rinehart and Winston, 1972), 133.

161 a close friend of Tennessee Williams: Windham, interview with author, April 12, 1990.

162 "stimulated by a class": JC, undated letter to Windham, courtesy Windham.

162 "sitting in the corner": Windham, interview with author, April 12, 1990.

162 "He thought this was a practical idea": Ibid.

163 "I cannot dance upon my toes": See JC, "Le Quatuor danse a Londres par Taglione, Grisi, Cerrito et Fanny Elsler," *Dance Index*, Vol. 3, no. 7/8 (July–August 1944), 104.

163 "In the letters written between 1910 and 1914": JC's copy of this book can be found at the NMAA.

165 "she was to meet her mother": Parker Tyler, "Marianne Moore's Views on Writing and Editing," *View* (November 1940), in Charles Henri Ford, ed., *View: Parade of the Avant-Garde 1940–1947* (New York: Thunder's Mouth Press, 1991), 11.

165 "the only concrete reaction": JC, letter to Marianne Moore, March 23, 1943, Moore Archives, Rosenbach Museum & Library, Philadelphia.

166 "any kind of censorship": Moore, letter to *View*; reprinted in *View: Parade of the Avant-Garde*, 81–82.

166 "I have meant to write before": JC, letter to Moore, April 9, 1944, Moore Archives, Rosenbach Museum.

166 "recent sheaf of poems": JC, letter to Moore, October 17, 1944, Moore Archives, Rosenbach Museum.

166 "ever grateful wonder": Moore, letter to JC, March 26, 1943, AAA, roll 1056.

10

167 The art director would leaf through the material: Alexander Liberman, interview with author, May 22, 1989.

168 "There was something very severe": Ibid.

168 "the largest amount": JC, diary entry, February 20, 1945, AAA, roll 1058.

168 including the box's current owner: Francine du Plessix Gray, Liberman's step-daughter, now owns the box; telephone conversation with author.

168 "celestial blue heavens": JC, diary entry, December 9, 1948, AAA, roll 1059.

169 listed in Ayer's records: Elizabeth Draper kindly provided me with material from the ad agency's archives.

169 "Upon awakening worked in cellar": JC, diary entry, February 15, 1945, AAA, roll 1058.

169 "a series of monographs": JC, application for a Guggenheim grant, September 12, 1945, Archives of the Guggenheim Memorial Foundation.

169 "has a very eccentric": Kirstein, letter of recommendation to the Guggenheim Memorial Foundation.

170 "virtuoso": Moore, letter of recommendation to the Guggenheim Memorial Foundation, September 19, 1945, Archives of the Guggenheim Memorial Foundation.

170 "nonsensical": Wheeler, letter of recommendation to the Guggenheim Memorial

Foundation, September 24, 1945, Archives of the Guggenheim Memorial Foundation.

170 would permit only the three women: Ashton, 73.

171 "a feeling that I sold nothing": Levy, letter to Dorothy Miller, March 13, 1956, Archives of the Museum of Modern Art.

171 "most of the florists in town": Edward Alden Jewell, "Fantastic in Art at Hugo Gallery," *The New York Times* (November 16, 1945).

171 "from the humblest worker": Ibid.

172 "Met Dali 1st time in years": JC, diary entry, November 30, 1945, AAA, roll 1058.

172 "Cornell was such a genuinely poetic person": Iolas, quoted in Laura de Coppet and Alan Jones, *The Art Dealers* (New York: Clarkson N. Potter, 1984), 55.

174 "pure Hollywood hokum": JC, diary entry, February 26, 1945, AAA, roll 1058.

174 "interesting Javanese modeling": JC, note in Bacall source file, courtesy Lindy Bergman.

174 "underneath all this cheesecake": Ibid.

175 "I love it and wish I had it": Lauren Bacall made this comment to the author through her assistant, Bonnie Kurt, March 4, 1996.

175 "an abstract ideal of feminine beauty": JC, "Romantic Museum" exhibition catalogue, 1946, n.p.

176 "Elsewhere in the gallery": Howard Devree, "Many, New, Diverse," *The New York Times* (December 15, 1946), section II, 9.

176 For his birthday: JC, diary entry, December 1946, AAA, roll 1059.

176 "The invitation still holds": JC, letter to Windham, December 11, 1946, courtesy Windham.

176 "Cornell had asthma": Ernst Beadle, interview with author, April 7, 1990.

176 "a young slight blonde Scandinavian girl": JC, diary entry, November 21, 1947, AAA, roll 1059.

178 "girl in pink dress": JC, diary entry, November 27, 1948, AAA, roll 1059.

178 "watching the activities": JC, diary entry, October 19, 1945, AAA, roll 1058.

178 " 'Indian' drum majorette leader": Ibid.

179 "a Shirley Temple movie mag": JC, diary entry, July 10, 1947, AAA, roll 1059.

179 "a gaunt, cadaverous, Charles Addams–like character": William N. Copley, "Portrait of the Artist as a Young Art Dealer," an essay in *CPLY: Reflection on a Past Life* (Houston: Institute for the Arts, Rice University, 1979).

179 "He asked if he could have an ice cream soda": Ibid.

179 "made lamps out of hers": Ibid.

180 "He said we had loused it up": Ibid.

180 "light laugh": JC, diary fragment, "Zizi Jeanmaire" source file, AAA, roll 1075.

180 *"Pour Joseph"*: Ibid.

180 *"Pour Robert"*: Ibid.

181 "a sense of aloneness": Ibid.

181 was surprised to learn: Starr, 74.

182 racked by disappointment: Ashton, 32.

182 "JACKSON POLLOCK": "Jackson Pollock—Is he the greatest living painter in the United States?" *Life* (August 8, 1949), 42.

11

184 he would often get bored: John Bernard Myers, *Tracking the Marvelous: A Life in the New York Art World* (New York: Random House, 1983), 169.

185 a working-class Philadelphia family: Theresa Egan kindly supplied me with biographical information on her late husband.

186 a "drip" painting of sorts: At least two other boxes by JC, *Habitat Group for a Shooting Gallery* (1943) and *Untitled (The Hotel Eden)*, made use of dripped or splashed paint in the years before Pollock began his drip paintings. But it is *Object 1941* whose dripped paint bears the closest resemblance to Pollock's own technique, and it seems plausible that Pollock could have seen the box when it was shown in a "Collage" exhibition at Peggy Guggenheim's Art of This Century in April 1943, an exhibition in which Pollock also participated.

186 "clean and abstract": JC, undated note in his Aviary source file, AAA, roll 1066.

187 "A room": JC, diary entry,

192 "fun, surprise and beauty": Stuart Preston, "Aviary," *The New York Times* (December 18, 1949), section II, 9.

193 "Joseph Cornell has taken the surrealist construction": T.B.H.[Hess], "Joseph Cornell," *Art News* (January 1950), 45.

194 akin to the nineteenth-century Symbolists: Ashton argues this view in her *Joseph Cornell Album*, 111.

195 he "gives his subjects": Sanford Schwartz, "The Rookie," an essay included in *Artists and Writers* (New York: Yarrow Press, 1990), 87.

195 "At evening an unexpected burst": JC, diary entry, January 3, 1950, AAA, roll 1059.

196 "de Kooning's *mot*": JC, note from 1964 filed in his "How a Box Is Constructed" source file, AAA, roll 1066.

196 "Dear Willem de Kooning": JC, draft of a letter to de Kooning, October 15, 1951, AAA, roll 1059.

197 "My wife and children": Hermine Tworkov, letter to JC, December 15, 1951, AAA, roll 1056.

197 "I want to thank you": Ibid., January 13, 1952, AAA, roll 1056.

198 "Love, Joseph": Helen Tworkov, interview with author, June 9, 1995.

198 "Won't sell museums": JC, diary entry, August 7, 1953, AAA, roll 1059.

198 "Kate is very thrilled": Mell Rothko, undated letter to JC, ca. 1957, AAA, roll 1056.

198 "I wish I could approach": Rothko, letter to JC, date indecipherable, AAA, roll 1056.

199 "I am one of the few": Motherwell, letter to JC, July 1948, Motherwell file, AAA, roll 1074.

199 Cornell presented Motherwell: *The Collected Writings of Robert Motherwell*, 223.

199 "the only known example": Ibid, 222.

199 "the pleasure of hearing from him": JC, letter to James Card, May 5, 1949, courtesy Card.

200 "appropriated the liveliest part": Ibid., June 24, 1951, courtesy Card.

200 "lean-faced fellow": James Card, *Seductive Cinema: The Art of Silent Film* (New York: Alfred A. Knopf, 1994), 271–72.

200 "Her mystified parents": James Card, interview with author, August 10, 1993.

201 "At the soirees": JC, undated draft of a letter to Motherwell, Motherwell file, AAA, roll 1074.

202 "The audience laughed": Ileana Sonnabend, interview with author, January 24, 1992.

202 "the Egan period": Ashton, 82.

202 "Charlie told marvelous stories": Rauschenberg, interview with author, June 28, 1995.

12

204 "He was long and thin": Maria Cimino, interview with author, June 5, 1989.

204 "He offered to turn the room into a fairyland": Maria Cimino, "Annual Report of Exhibitions in the Central Children's Room (July 1–June 30, 1951)," Archives of the New York Public Library.

205 "a long, drawn-out affair": JC, letter to Cimino, June 13, 1950, Archives of the New York Public Library.

205 "They must be seen": Stuart Preston, "Giacometti and Others," *The New York Times* (December 17, 1950), section II, 8.

206 "subtle sense of placement": Henry McBride, "Joseph Cornell maquettes," *Art News* (January 1951), 50.

206 electrical fire: In a 1951 questionnaire on file with the Museum of Modern Art, Cornell indicated that the work was inspired by "the burning of the carousel in Central Park."

206 "a complete environment": JC, letter to Dorothy Miller, Archives of the Museum of Modern Art.

207 "It was strange": Susan Weil, interview with author, June 1995.

208 "Went over to Gimbels": HC, letter to her sons, May 1956, AAA, roll 1057.

208 "I'm sick and tired": JC, letter to BB, July 28, 1955, AAA, roll 1057.

209 "I await the proper moment": JC, diary entry, first week of February 1951, AAA, roll 1059.

209 "Only five years late": JC, letter to BB, January 4, 1957, AAA, roll 1057.

210 "my packed days here": JC, diary entry, September 24, 1951, AAA, roll 1059.

210 "after a lunch of pistachio ice cream": Ibid.

211 "warm aftermath of the vacation": JC, ibid., October 3, 1951.

211 "saw de Koonings for first time": JC, ibid., June 16, 1951.

211 "I lost complete interest": JC, draft of a letter to Willem de Kooning, October 15, 1951, AAA, roll 1059.

211 "Einstein, time, space, etc.": JC, diary entry, November 8, 1951, AAA, roll 1059.

212 "your family would be welcome to join you": JC, draft of a letter to Harold Rosenberg, February 8, 1952, AAA, roll 1059.

214 took out two biographies of Emily Dickinson: JC, diary entry, September 9, 1952, AAA, roll 1059. Additional discussions of Cornell's interest in Dickinson can be found in Sandra Leonard Starr, *Joseph Cornell: Art and Metaphysics*, an exhibition catalogue (New York: Castelli, Feigen, Corcoran, 1982), 79–83; and Tashjian, 77–93.

214 "I'm Nobody! Who are you?": Emily Dickinson, No. 288, c. 1861.

214 "she had given up hoping for love": JC's copy of *The Riddle of Emily Dickinson* (Boston: Houghton Mifflin, 1951) can be found at the NMAA. Cited by Starr, *Joseph Cornell: Art and Metaphysics*, 82.

215 "torturous seclusion": JC, diary entry, October 10, 1052, AAA, roll 1059.

215 stumble upon a daguerreotype: Ibid.

217 "appreciation for Edward Hopper's world": JC, diary entry, May 27, 1967, AAA, roll 1062.

217 "beautiful, shallow, glass-faced boxes": S.G. [Sidney Geist], "Joseph Cornell," *Art Digest* (March 15, 1953), 18.

217 "each box is like a stop on the railroad line": Fairfield Porter, "Reviews and Previews: Joseph Cornell," *Art News* (April 1953), 40.

218 "Mr. Egan had a head injury": JC, letter to BB, August 30, 1951, AAA, roll 1056A.

219 "Cornell was very possessive": Alan Frumkin, interview with author, January 30, 1992.

220 "His work forces you": Robert Motherwell, "Preface to a Joseph Cornell Exhibition," included in *Joseph Cornell: Portfolio Catalogue* (Leo Castelli Gallery, Richard L. Feigen and Co., and James Corcoran Gallery, 1976), unpaginated.

220 the *Everyday Art Quarterly*: Huldah Curl, assistant curator, letter to JC, July 24, 1953, Archives of the Walker Art Center.

221 "When I have made": JC, draft of a letter to Robert Motherwell, March 21, 1954, Motherwell folder, AAA, roll 1074.

221 "incurred a local expense of $8.00": JC, letter to Huldah Curl of the Walker Art Center, September 15, 1953, Archives of the Walker Art Center.

13

222 "the hush of early morning": JC, diary entry, June 9, 1954, AAA, roll 1059.

223 "deeply hurt": JC made this comment to his friend Gwen (Van Dam) Smiley. Interview with author, February 15, 1992.

223 "incident of gashed hand": JC, diary entry, January 6, 1954, AAA, roll 1059.

224 I should still like to travel around on the El: Rudy Burckhardt, letter to JC, May 6, 1953, AAA, roll 1056.

225 just one suit: Stan Brakhage, interview with author, February 1, 1993.

225 "He loved to stand on the platforms": Ibid.

226 "the archetypical Flushing mother": Ibid.

226 "I know this will sound preposterous": Ibid.
227 "my little Swiss friend": Quoted in William MacKay's introduction to Denby, *Dance Writings* 23.
227 "His face was almost a tragic face": Burckhardt, interview with author, May 4, 1990.
228 "Shooting at Union Square": JC, diary entry, November 13, 1955, AAA, roll 1059.
228 "Get that": Burckhardt, interview with author, May 4, 1990.
230 "I sat there for what seemed like an eternity": Jean Jagger, interview with author, May 1994.
230 "love of humanity": JC, diary entry, December 2, 1955, AAA, roll 1059.
230 "make up gift packages for children": JC, diary entry, August 19, 1954, AAA, roll 1059.
230 "I'm tired of this one": Brakhage, interview with author, February 1, 1993.
232 "Reading from Malibran file": JC, diary entry, August 22, 1954, AAA, roll 1059.
233 "with his hands over his eyes": Windham, interview with author, April 12, 1990.
233 an affectionate friendship: Lois Smith, interview with author, December 21, 1993.
233 "I didn't know he was a famous artist": Gwen (Van Dam) Smiley, interview with author, February 15, 1992.
234 "He was very Victorian": Ibid.
234 "too discouraged": Ibid.
234 "the feeling of creation": JC, diary entry, February 20, 1945, AAA, roll 1058.
234 "I would tell him": Burckhardt, interview with author, May 4, 1990.

14

235 "When the Annual was over": Eleanor Ward, interview with Paul Cummings for the Archives of American Art, February 8, 1972, AAA, oral history project.
236 "Cornell would come in": Rauschenberg, interview with author, June 28, 1995.
237 "The only difference between me and Cornell": Ibid.
237 "one of the great originals": Quoted in Paul Gardner, "The Stable wasn't 'just another gallery,' " *Art News* (May 1982), 113.
237 "an entirely different batch": Ibid.
237 "a risky and unfeeling act": Mark Rothko, "Personal Statement," *Tiger's Eye* (December 1947), 44.
238 "Twombly here": JC, diary entry, June 14, 1955, AAA, roll 1059.
238 "He wanted to know about Versailles": Joan Mitchell, interview with author, August 15, 1991.
238 "so pure and uncompromising a spirit": F.O.'H. [Frank O'Hara], "Joseph Cornell and Landes Lewitin," *Art News* (September 1955), 50.
240 "first glimpse of Andromeda": JC, diary entry, c. 1956, AAA, roll 1059.
240 "elation of star gazing": JC, diary entry, January 7, 1956, AAA, roll 1059.
240 "beckon the spectator": *The New York Times* (December 17, 1955), 20.
241 "intense pleasure and satisfaction," JC, letter to Mrs. Barr, February 16, 1956, Archives of the Museum of Modern Art.

241 "He and I mutually agreed": Dorothy Miller, letter to Julien Levy, c. 1956, Archives of the Museum of Modern Art.

241 "I should appreciate": JC, letter to John I.H. Baur, May 4, 1957, Archives of the Whitney Museum of American Art.

242 "acquiring Van Gogh's letters": JC, diary entry, March 29, 1956, AAA, roll 1059.

242 "Suzanne's first visit": JC, diary entry, January 7, 1956, AAA, roll 1059.

242 "Cornell was captivated": Smiley, interview with author, February 15, 1992.

243 he did very little cutting: Burckhardt, interview with author, May 4, 1990.

243 "It took me a long time to realize": Ibid.

243 "Everything would be arranged": Carolee Schneeman, interview with author, August 22, 1991.

244 "We both hope": JC, letter to Tyler, May 22, 1956, UT.

244 "Please don't speak too glowingly": JC, letter to Schneeman, June 13, 1956, courtesy Schneeman.

244 "He was terribly thin": Allegra Kent, interview with author, January 19, 1995.

245 "tempting and still possible": JC, draft of a letter to Allegra Kent, August 18, 1956, AAA, roll 1059.

245 "unauthorized biography": See press release for "Exhibition of Dance and Theatre Design" at the Museum of Modern Art (November 25, 1945–February 17, 1946), Archives of the Museum of Modern Art.

246 "He leaves the door ajar": L.C. [Lawrence Campbell], "Joseph Cornell," *Art News* (November 1956), 6–7.

247 "Cornell wanted the movie": Gwen Thomas, interview with author, April 1994.

247 "Just recently I asked": JC, letter to Ford, November 19, 1957, Getty Center.

249 "chipped enamel table": Howard Griffin, "Auriga, Andromeda, Cameoleopardalis," *Art News* (December 1957), 64.

249 "Two things have changed my life": Ibid.

15

251 "Joan Collins in new Esquire": JC, diary entry, March 18, 1958, AAA, roll 1060.

251 "Ringside seat by window": JC, diary entry, July 28, 1959.

252 "June Dairy truck": JC, diary entry, April 1959.

252 "teener fixing her white kerchief": JC, diary entry, September 15, 1958.

252 "teener with red scarf": JC, diary entry, March 24, 1958.

252 "Chinese teener": JC, diary entry, June 15, 1959.

252 "teeners in doorway": JC, diary entry, May 1958.

252 "teener on bench": JC, diary entry, August 10, 1959.

252 "girl in white blouse": JC, diary entry, September 15, 1958.

252 "gal in pink linen skirt": JC, diary entry, July 11, 1959.

253 appreciation of the young people: JC, diary entry, January 1958.

254 "apprehensive about space": Jacques Derrida, *Memoirs of the Blind* (Chicago: University of Chicago Press, 1993), 5.

254 "strange shop that had cream horns": JC, diary entry, July 19, 1959.

254 "They were thick as horns": Dr. Samuel B. Lerman, interview with author, April 11, 1990.

254 "scary kook": Ibid.

254 "He would discuss them": Ibid.

255 "Dr. L. for Robert's toe nails": JC, diary entry, January 14, 1959, AAA, roll 1060.

255 "lunch with mother": JC, diary entry, November 25, 1959.

255 "Just steering clear": JC, diary entry, May 21, 1958.

256 "Joseph Cornell called to say": "PW," memo to "JB," November 3, 1959, Archives of the Whitney Museum of American Art.

257 "Whenever I mentioned": Richard L. Feigen, interview with author, April 11, 1990.

257 a hot dog wrapper: Walter Hopps, *Kienholz: A Retrospective* (New York: Whitney Museum of American Art, 1996), 30.

257 "What do you do, Mr. Blum": Irving Blum, interview with author, August 4, 1995.

257 "I couldn't tell him enough stories": Ibid.

258 the daughter of a Cincinnati eye surgeon: Calvin Tomkins, "The Art World: Dada and Mama," *The New Yorker* (January 15, 1996), 56.

258 "very old movies": Teeny Duchamp, undated letter to the author, postmarked June 14, 1991.

258 "What period of sculpture": JC, diary entry, March 1959, AAA, roll 1060.

258 "saw a beauty": Julien Levy, letter to Dorothy Miller, March 13, 1956, Archives of the Museum of Modern Art.

258 owned only one of his boxes: Ibid.

258 refused his request: Julien Levy, letter to JC, 1958, AAA, roll 1056.

259 "He could no longer expect": Donald Windham, "Joseph Cornell: 'No Need to Open,' " an essay in the exhibition catalogue published in conjunction with "Joseph Cornell: Box Constructions & Collages (New York: C & M Arts, 1996).

259 hatched a clever plot: Edwin Bergman, interview with the American Jewish Committee (of Chicago) Oral History Project, August 21, 1981, AAA. Also, Lindy Bergman provided me with information on her husband's relationship with Cornell in an interview on July 13, 1994.

260 "stale sweets": Robert Bergman, the collector's son, in an interview with the author, March 1, 1996.

260 "bringing me the fairy tokens": JC, letter to Edwin Bergman, September 20, 1959, Archives of the Art Institute of Chicago.

260 "Yes, I should enjoy 'corresponding' ": Ibid., November 8, 1959, Archives of the Art Institute of Chicago.

260 "your nice visit": HC, letter to Bergman, December 11, 1962, Archives of the Art Institute of Chicago.

261 "He spoke English, of course": Bergman, interview with the American Jewish Committee.

261 "I regret": JC, letter to Bergman, January 7, 1963, Archives of the Art Institute of Chicago.

261 "I brought pictures": Ibid.

261 "too many good boxes": Copley, "Portrait of the Artist as a Young Art Dealer."

261 "You're Bergman from Chicago": The art dealer Robert Schoelkopf made this comment according to Bergman, interview with the American Jewish Committee.

262 "He kept asking": E. C. Goossen, interview with author, January 5, 1994.

262 "The Bennington thing": JC, letter to Feigen, December 22, 1959, courtesy Feigen.

266 "this image of the teener in the library": Ibid., December 24, 1959.

16

268 "the ferocious barking of the art dealer's dachshund": Calvin Tomkins, *Off the Wall: Robert Rauschenberg and the Art World of Our Time* (New York: Penguin Books, 1982), 140.

268 "I don't want my work": Quoted in Deborah Solomon, "The Unflagging Artistry of Jasper Johns," *The New York Times Magazine* (June 19, 1988), 20.

269 "I asked him what his name was": Jasper Johns, conversation with author, November 13, 1990.

269 "extraordinary creature": JC, diary entry, January 14, 1962, AAA, roll 1061.

269 "He was reluctant to sell": Leo Castelli, interview with author, January 22, 1992.

269 "We receive constant requests": Eleanor Ward, letter to JC, December 8, 1961, AAA, roll 1056.

270 "KINDLY FREEZE ALL UNSOLD WORK": JC, telegram to Feigen, January 17, 1961, courtesy Feigen.

270 "KINDLY KEEP UNSOLD WORK FROZEN": Ibid., March 17, 1961.

270 "SORRY BUT MUST REQUEST": Ibid., March 19, 1961.

270 "the radical simplicity": John Ashbery, "Joseph Cornell," *Art News* (Summer 1967); reprinted in Ashbery, *Reported Sightings, Art Chronicles 1957–1987*, edited by David Bergman (New York: Knopf, 1989), 17.

271 "I think Cornell was ahead of his time": Sol Lewitt, conversation with author, February 1994.

271 "The MoMA is giving me a section": JC, letter to BB, September 11, 1961, AAA, roll 1057.

272 "What I remember most": David Solinger, conversation with author, December 30, 1993.

272 "I thought of his mother": Dore Ashton, conversation with author, March 23, 1994.

272 "She was resentful": Jean Levy, conversation with author, November 6, 1989.

273 "I found 2 little rolls": Hans Richter, letter to JC, October 9, 1961, AAA, roll 1056.

273 "Girl Over 16": Cited in Hartigan, 111.

273 "Put it back": Schneeman, interview with author, August 22, 1991.

274 "When you saw the man *in situ*": Pat Johanson, interview with author, January 4, 1994.

274 "Dear Miss Duke": JC, draft of a letter to Patty Duke, March 25, 1962, AAA, roll 1061.

275 "Dear Mr. Cornell": Patty Duke, letter to JC, in Patty Duke celebrity file, AAA, roll 1065.

275 "The willingness to risk excess": JC noted that the Updike quotation was from an article on J. D. Salinger in *Harper's*, though Mary McCarthy in fact wrote the piece on Salinger in the October 1962 issue of the magazine (and it does not contain the pertinent quote). It's unclear where JC spotted the Updike line.

275 "sliced off his thumb": Samuel Lerman, interview with author, April 11, 1990.

279 "thinking he could help us": Robert Whitman, interview with author, August 1, 1995.

279 "He was very taken with Princess Summer-Fall-Winter-Spring": Ibid.

279 "Susanne de Maria yesterday": JC, diary entry, April 10, 1963, AAA, roll 1061.

280 piled into Rosenquist's car: Ford, interview with author, May 22, 1991.

280 "The boxes were wrapped up in newspaper": Robert Indiana, interview with author, February 21, 1992.

280 "Such a sweet young man!": Quoted by BB, interview with author, May 12, 1989.

280 "When I visited her": James Rosenquist, conversation with author, September 21, 1994.

280 "Cornell couldn't receive us": Arman, conversation with author, April 29, 1994.

281 "seven assemblage boxes": N.Y.U. press release, December 1, 1963, Archives of New York University.

281 "He made Howard stay on the front porch": Ruth Bowman, conversation with author, August 3, 1995.

282 under Cornell's direct influence: Feigen, interview with author, April 11, 1990.

282 "What I loved about his work": Tony Curtis, interview with author, August 4, 1995.

282 "I'm just not up to seeing anyone": Feigen, interview with author, April 11, 1990.

282 "a big box of marzipan fruits": Ibid.

283 "a very intelligent guy": Curtis, interview with author, August 4, 1995.

283 "Whenever I arrived by plane": Ibid.

283 "And then I'd come out": Ibid.

284 "horrified by Curtis's copies": Geldzahler, interview with author, December 5, 1989.

17

285 "It was nicely wrapped": Burckhardt, interview with author, May 4, 1990.

285 eighteen-year-old: According to records on file with the New York City Police Department (UF61 complaint), she was born on July 2, 1943.

287 "the kind of 'theater' ": JC, undated letter, private collection; quoted in Hartigan, 112.

287 "in case of Tina showing up": JC, diary entry, March 2, 1962, AAA, roll 1961.

287 "adorable earnestness": JC, diary entry, March 8, 1962, AAA, roll 1061.

287 a borrowed black Chevy: New York City Police Department records (UF61 complaint).

287 It drove her crazy: BB, interview with the author, May 12, 1989.

287 tied to a drug habit: Ibid.

288 "the kiss": JC, diary entry, March 12, 1965, AAA, roll 1061.

288 "I don't go there anymore": JC, diary entry, May 23, 1962, AAA roll 1061.

288 "gone up in smoke": Ibid.

290 "Tina gone (for good?)": JC, "memo," February 4, 1963, AAA, roll 1061.

290 "the guise was thin": JC, diary entry, April 1, 1963, AAA, roll 1061.

290 "the nightmare futility of doing things for her": JC, diary entry, April 20, 1965, AAA, roll 1061.

290 "*Meat Joy* was ecstatic to do": Schneeman, interview with author, August 22, 1991.

291 "*Nymph en vacances*": JC, enclosure in an undated letter to Schneeman, courtesy Schneeman.

291 "Should you be able": JC, letter to Schneeman, postmarked January 16, 1964, courtesy Schneeman.

291 "to practice drawing the figure": Schneeman, interview with author, August 22, 1991.

291 "I heard from a mutual friend": JC, letter to Schneeman, June 1964, courtesy Schneeman.

292 "task movement": See Tomkins, 226.

292 "spark rich associative images": Schneeman, interview with author, August 22, 1991.

292 "a Russian princess": Ibid.

292 "sounded so darling": JC, letter to Schneeman, May 1964, courtesy Schneeman.

292 "During my spring vacation": Pauline (last name deleted to protect her privacy), letter to JC, 1964, AAA, roll 1056.

293 "He used to tell me": Gertrude Stein, interview with the author, November 30, 1989.

293 "I believe it was love at first sight": Yayoi Kusama, undated letter to author, postmarked June 14, 1991.

293 "The birds are waiting": JC, undated letter to Kusama, courtesy Kusama.

293 "Because of Cornell's almost obsessional love": Kusama, undated letter to author, postmarked June 14, 1991.

294 "soixante-neuf": Judy Richheimer, interview with author, February 18, 1990.

294 "Cornell was deeply impotent": Kusama, undated letter to author, postmarked June 14, 1991.

294 "to sterilize them": Kusama, undated letter to author, postmarked June 14, 1991.

295 "two teen-aged girls": Feigen, interview with author, April 11, 1990.

295 "The police told me": Ibid.

295 "3 SEIZED IN THEFT OF ART IN FLUSHING:" *The New York Times* (September 18, 1964). While the article reported that Joyce was charged with abetting a crime, she was charged with grand larceny, according to Queens County Criminal Court.

295 "Cornell came to me": Allan Stone, interview with author, January 29, 1992.

296 "Dear Joe": HC, letter to JC, November 24, 1964, AAA, roll 1057.

297 reading aloud to Robert: Alexandra Anderson, interview with author, July 20, 1994.

297 "He was very concerned about her": Ibid.

297 was murdered by an acquaintance: Homicide report, New York City Police Department (UF 61, #10726). Also, arrest report, Lawrence French, criminal record #442039.

297 As he packed up: Ibid.

298 "He called me up": Solomon Ethe, interview with the author, January 5, 1994.

299 "father of the deceased": New York City Police Department records (UF61 complaint).

299 Cornell who arranged for her funeral: Records of the Flushing Cemetery Association.

299 wasn't buried until December 30: Ibid.

299 "Wooden Box": Ibid.

18

300 "Cornell was full of praise": Steinberg, interview with author, February 20, 1992.

300 "He loved his brother": Alexander Iolas, quoted in Coppet and Jones, 55.

300 "They had this intense closeness": Schneeman, interview with author, August 22, 1991.

300 give Robert a shave: Windham, interview with author,

300 "The locomotive": RC, letter to Feigen, July 7, 1964, courtesy Feigen.

301 "just enough body": Ethe, interview with author, January 5, 1994.

301 "He was so happy": Jagger, interview with author, October 21, 1989.

302 "He went peacefully": JC, letter to Irving Blum, March 12, 1965, Archives of the Pasadena Museum.

302 "I am certain": JC, letter to HC, May 25, 1965.

302 "I pen in a state of prolonged bewilderment": JC, letter to E. B. Henning, March 17, 1965, Archives of the Cleveland Museum of Art.

302 Letters of condolence: Each of these letters can be found in JC's papers, AAA, roll 1056.

302 "in her baby blue dress": JC, diary entry, September 12, 1965, AAA, roll 1062.

302 "shopping for food": JC, diary entry, August 24, 1965, AAA, roll 1061.

303 "golden moment": JC, diary entry, March 2, 1965, AAA, roll 1061.

305 "never had lessons": JC, undated letter to John Ashbery, c. 1966, reprinted in Caws, 234.

307 "I totally understood his mind": Trudy Goodman, interview with author.

307 "her sweetness is a natural thing": JC, diary entry, April 4, 1965, AAA, roll 1061.

307 "working at the dining room table": JC, diary entry, March 4, 1965, AAA, roll 1061.

307 "He was so strange": Goodman, interview with author.

308 "looking for someone to sleep in": JC, letter to Ford, April 4, 1965, Getty Center.

308 "I worried": Anderson, interview with author, July 20, 1994.

308 "He was interested in adolescent girls": Ibid.

309 "He talked as if in ecstasy": Larry Jordan, interview with author.

309 "He was shy: Ibid.

309 "The month I was there": Ibid.

310 "poetic documentary": JC, letter to Wayne Andrews, February 26, 1966, in Caws, 335.

310 They both declined: Feigen, interview with author, April 11, 1990; Stone, interview with author, January 29, 1992.

311 a fan of his work: Robert Schoelkopf, interview with author, December 2, 1989.

311 "Robert Cornell is the putative subject": Jay Jacobs, "In the Galleries: Robert Cornell," *Arts* (March 1966), 64.

311 "Robert died recently": L.C. [Lawrence Campbell], "Joseph Cornell and Robert Cornell," *Art News* (February 1966), 14.

312 "After it was published": Hilton Kramer, interview with Peter Plagens, January 1995; Plagens graciously shared his unpublished notes with the author.

312 "His fantasy seems closer": Hilton Kramer, "The Enigmatic Collages of Joseph Cornell," *The New York Times* (January 23, 1966), section II, 15.

312 "I almost threw it away": Hilton Kramer, conversation with author, January 9, 1995.

312 only two sold: Schoelkopf Gallery sales records, courtesy Schoelkopf.

313 "I have taken so long": Schoelkopf, letter to S. Lane Faison, Jr., January 22, 1966, Robert Schoelkopf.

313 "He was jubilant": Howard Hussey, "Collaging the Moment," in *Joseph Cornell: Collages, 1931–72,* exhibition catalogue (New York: Castelli, Feigen, Corcoran, 1978), 15.

313 "deploring the educational system": JC, diary entry, July 25, 1964, AAA, roll 1061.

314 nine different head shots: Cornell's copy of *Against Interpretation* can be found at the NMAA.

314 "Dear Mr. Cornell": Susan Sontag, letter to JC, December 12, 1965, AAA, roll 1056.

314 "image of Jeanne Moreau": JC, diary entry, January 20, 1966, AAA, roll 1062.

314 "A week ago this evening": JC, diary entry, January 26, 1966, AAA, roll 1062.

314 "Cornell seemed to be": Sontag, interview with author, July 11, 1994.

314 "Sontag is *life*": JC, diary entry, January 11, 1966, AAA, roll 1062.

314 "I had not been au courant": JC, letter to Andrews, February 26, 1966, in Caws, 335.

315 "wanderlusting around": JC, draft of a letter to Sontag, January 14, 1966, AAA, roll 1062.

315 "It was a great privilege": Sontag, interview with author, July 11, 1994.

316 "I'm sorry you had to wait": Malitte Matta, letter to JC, AAA, roll 1056.

319 "His heart was broken and mended": Rauschenberg, quoted in Brian O'Doherty, "Joseph Cornell" (New York: Pace Publications, 1986), 9.

319 Sontag was astonished: Sontag, interview with author, July 11, 1994.

19

320 "loves the ocean": BB, interview with author, May 12, 1989.

320 "may not be interesting": HC, letter to JC, June 11, 1965, AAA, roll 1057.

321 "I hear glowing accounts": HC, letter to Vivienne, AAA, roll 1057.

321 "I miss Joe very much": HC, letter to Feigen, March 18, 1965, courtesy Feigen.

321 "How I envy you": HC, to JC, October 28, 1965, AAA, roll 1057.

321 "Sometimes I feel no one Mother": HC, letter to Tilly Losch, January 2, 1966, reprinted in Caws, 327.

321 "Haven't had one word from Mrs. Duchamp": HC, letter to JC, December 8, 1965, AAA, roll 1057.

321 "I wrote you a long letter": Ibid., April 1965.

322 "beautiful and heartfelt letters": JC, diary entry, August 28, 1967, AAA, roll 1062.

323 "I was so critical so many times": HC, letter to JC, April 25, 1965, AAA, roll 1057.

323 "Joe dear . . . Thank you": Ibid., March 23, 1965.

324 "Joe Dear, I would so love": Ibid., April 13, 1965.

324 "Thank you for coming": Ibid., April 23, 1965.

324 "I never feel adequate": Ibid., May 25, 1965.

325 "one bright spot": Ibid., July 1965.

325 "I never stop using": Ibid., March 21, 1965, AAA, roll 1057.

326 "Could you find out": Ibid., September 22, 1966.

326 "The fact that Patricia Neal had survived": Helen Batcheller, interview with author, June 6, 1989.

327 "Dearest Mother": JC, diary entry, October 13, 1966, AAA, roll 1062.

327 "the stone floors": JC, diary entry, October 20, 1966.

327 "surprise at the absence of deep grief": Ibid.

328 "French fries only": JC, letter to his deceased mother (unsent), November 24, 1966, AAA, roll 1062.

328 "Sitting by kitchen stove in bathrobe": Ibid.

20

329 "the nightmare of my empty house": JC, diary entry, May 19, 1967, AAA, roll 1062.

329 "one of four artists": Unsigned, "Artists: The Compulsive Cabinetmaker," *Time* (July 8, 1966).

330 "Schwitters' greatest successor": Walter Hopps, "Joseph Cornell: 1950s and 1960s," an exhibition catalogue (Monterrey, Mexico: Museo de arte contemporaneo de Monterrey, 1992), 20.

330 Hopps was fired: Calvin Tomkins, "Profile" (Walter Hopps), *The New Yorker* (July 29, 1991), 46.

331 not to be "maudlin": James Demetrion, interview with author, April 16, 1993.

331 "Because they are three-dimensional": Fairfield Porter, "Joseph Cornell," *Art and Literature* (Spring 1966), 121.

331 "the most dramatic example": Philip Leider, "Extravagant Liberties Within Circumscribed Aims," *The New York Times* (January 15, 1967).

331 "Cornell knew she was in Hollywood Land": Demetrion, interview with author, April 16, 1993.

331 "about five and a half people": Hopps, interview with author, October 26, 1994.

332 "He told me that he admired the nude": Diane Waldman, interview with author, May 8, 1990.

332 "Cornell concluded in his dreamy mind": Thomas Messer, interview with author, October 12, 1994.

333 "The negotiations": Ibid.

333 when students might have a better chance: Bourdon, interview with author, March 11, 1991.

333 "These are not the terms": M.B. [Mel Bochner], "In the Museums: Joseph Cornell," *Arts* (Summer 1967), 54.

333 "an exhibition of unforgettable beauty": Hilton Kramer, "The Poetic Shadow-Box World of Joseph Cornell," *The New York Times* (May 6, 1967), 27.

333 "are primarily descendants of the slot machine": Harold Rosenberg, "The Art World: Object Poems," *The New Yorker* (June 3, 1967), 112.

334 "extremely knowing": Max Kozloff, "Joseph Cornell," *The Nation* (May 29, 1967), 701.

334 "a historic event": John Ashbery, "Cornell: The Cube Root of Dreams," *Art News* (Summer 1967), 57.

334 "Cornell is a major American artist": Bourdon, interview with author, March 11, 1991.

334 "a black button": David Bourdon, "Enigmatic Bachelor of Utopia Parkway," *Life* (December 15, 1967), 63.

335 "Cornell freezes": Ibid., 64.

335 "abortive": JC, diary entry, December 13, 1967, AAA, roll 1062.

335 "It was the first time": Bourdon, interview with author, March 11, 1991.

335 "Little is known": Diane Waldman, *Joseph Cornell*, exhibition catalogue (New York: Solomon R. Guggenheim Museum, 1967), 11.

336 "if I'd ever known": JC, diary entry, June 5, 1967, AAA, roll 1062. Also, diary entry, April 21, 1968, in which JC offered further thoughts on the catalogue, concluding that the preface "is an unhappy business."

336 "analytical detailing": Bourdon, interview with author, March 11, 1991.

336 "the Times man": JC, diary entry, April 10, 1967, AAA, roll 1062.

336 "I'll not be there": JC, letter to BB, AAA, roll 1057.

336 "Enchantment dwelt": Elizabeth Thode, letter to JC, May 6, 1967, AAA, roll 1056.

337 "original Van Gogh letters": JC, diary entry, June 1, 1967, AAA, roll 1062.

337 "Mother joined with Robert": Ibid., April 11, 1967.

337 "quince tree, birds": JC, "April 4 into April 5," 1967.

338 "NO WORDS TO EXPRESS": Tamara Toumanova, telegram to JC, December 24, 1967, AAA, roll 1056.

338 "Pleased to see the beautiful layout": Windham, letter to JC, December 17, 1967, AAA, roll 1056.

339 a fourth-grade class: Their letters to JC can be found at the AAA, roll 1056.

339 "Met Caroline and her friends": JC, diary entry, October 21, 1967, AAA, roll 1062.

339 "Caroline just by": Ibid., October 26, 1967.

339 "late summer costume": Ibid., November 6, 1967.

340 "irritating, uneven and depressing": Peter Schjeldahl, "Marilyn: Still Being Exploited?" *The New York Times* (December 17, 1967), section II, 40.

340 "I was completely wowed": Peter Schjeldahl, conversation with author, September 1995.

341 "a very charming gentleman": Paulette Diamond, interview with author, November 28, 1989.

341 "He was one of the darlingest persons": Ruth Van Dyne, interview with author, November 29, 1989.

341 "Why are we going to such lengths": Edna Canarelli, interview with author, November 28, 1989.

21

342 "We were quite excited": Alvin Lane, conversation with author, October 27, 1994.

342 "Anxious to receive response": Felicia Geffen, letter to JC, January 17, 1968, Archives of the American Academy and Institute of Arts and Letters.

342 "If there is a Mrs. Cornell": Felicia Geffen, letter to JC, January 5, 1968, Archives of the American Academy and Institute of Arts and Letters.

343 "is unfortunately unable to be with us": Minutes of the award ceremony, Archives of the American Academy and Institute of Arts and Letters.

343 accept the medal for him: Windham, interview with author, November 7, 1989.

343 "Naturally . . . I am eager": William Seitz, letter to JC, August 1, 1967, Archives of Rose Art Museum, Brandeis University.

344 "do not show this artist at his best": Jerrold Lanes, "Current and Forthcoming Exhibitions: Rose Art Museum," *Burlington Magazine* (July 1968), 425.

346 "In an inspired bit of installation": Thomas Hess, editorial, *Art News* (December 1969), 5.

346 "a series of precious Tiffany displays": James R. Mellow, "The Met Goes Modern," *The New Leader* (December 22, 1969).

346 "failed rather badly": Philip Leider, "Modern American Art at the Met," *Artforum* (December 1969), 62.

347 "Cornell particularly liked the Olitskis": Geldzahler, interview with author, December 5, 1989.

347 "executed in the past eight years": Metropolitan Museum of Art press release, December 1970, Archives of the Metropolitan Museum.

347 "executed in the past five years": Geldzahler, "Collage by Joseph Cornell," *Metropolitan Museum of Art Bulletin* (December 1970).

347 "these collages represent": Stephen Spector, "Joseph Cornell at the Metropolitan Museum of Art," *Arts* (December 1970–January 1971), 53.

348 "He was very accepting": David Saunders, interview with author, November 9, 1989.

348 He told Mrs. Schiavo: Lawrence Fane (interview with author, December 19, 1994) supplied me with background information on the late Helen Schiavo.

349 "Is it all right": Creighton Gilbert, interview with author, November 18, 1993.

349 "They looked at him": Fane, interview with author, December 19, 1994.

349 "He didn't want to be introduced": Louis Finkelstein, conversation with author, December 1994.

349 "I couldn't imagine him": Mary Frank, interview with author, February 20, 1990.

350 "The students went blank": Ibid.

351 "just someone else I knew then": Yoko Ono, conversation with author, July 14, 1993.

351 "Cornell said they could have": Ray Johnson, interview with author, March 9, 1991.

351 "I worried about": Kent, interview with author, January 19, 1995.

353 "There was obviously a fantasy romance": Betsy von Furstenberg, interview with author, April 19, 1990.

353 "Everyone would use the same tea bag": Ibid.

353 "I went out to you": JC, note to von Furstenberg, ca. December 1970, courtesy von Furstenberg.

353 "A jay is screeching now": JC, letter to Caroline von Furstenberg, November 19, 1969, courtesy von Furstenberg.

354 "He wrote me a check for $5,000": Luce, interview with author, May 9, 1990.

356 "I'd start a school for young artists": David Saunders, interview with author, November 9, 1989.

357 "Wednesday is a mystical day": Steve Wood, interview with author, December 1, 1991.

359 "boys' and girls' toys": Harry Roseman, interview with author, April 5, 1991.

359 "a kind of curator of culture": Brian O'Doherty, "Joseph Cornell," an exhibition catalogue (New York: Pace Gallery, December 5, 1986–January 31, 1987), 4.

361 "You don't know me": Judy Richheimer, interview with author, February 18, 1990.

361 "In conversation he would fantasize": Leonard Richheimer, interview with the author, February 26, 1990.

362 he thought often about Duchamp's *Valise*: Wood, interview with author, December 1, 1991.

362 "I would like to create a foundation": Harry Torczyner, letter to author, October 16, 1995.

362 "the victims of drug addiction": Ibid.

363 "afraid to sign it": Ibid.

363 "My job . . . was to produce a written list": David Boyce, interview with author, January 25, 1992.

<center>22</center>

364 Cornell attended the opening reception: Grace Glueck, "Youths Laud Cooper Union 'Adult' Art," *The New York Times* (February 11, 1972), 22.

364 "In a very mystical way": Ibid.

365 "CHILDREN'S PREVIEW": Invitation for JC exhibition, Archives of the Albright-Knox Art Gallery.

365 "in particular, the photograph of your daughter": JC, letter to James Wood, May 23, 1972, Archives of the Albright-Knox Art Gallery.

365 "He talked about his brother": David Boyce, interview with author, January 25, 1992.

365 "Joseph said that Robert": Luce, interview with author, May 9, 1990.

365 "brilliance and great creativity": Judy Richheimer, interview with author, February 18, 1990.

366 "*Dear Theo*": JC's copy of the book (at the NMAA) is inscribed "May 1972 Main Street Flushing."

366 "people who are wounded": Geldzahler, interview with author, December 5, 1989.

366 "Cornell was delighted": Ibid.

366 "industrial-strength glazed doughnuts": Brooke Alexander, interview with author, May 17, 1989.

367 "He prefaced his conversation": O'Doherty, 9.

367 "jumping up and down on it": Roseman, interview with author, April 5, 1991.

367 "semi-retired": Ibid.

367 "he was having trouble with urination": Leonard Richheimer, interview with author, February 26, 1990.

367 admitted . . . on June 3: According to the Patient Archives of Flushing Hospital, JC was hospitalized from June 3 to June 23, 1972.

367 stoically submitted: Leonard Richheimer, interview with author, February 26, 1990.

367 "a beautiful 'touch' experience": JC, letter to Allegra Kent, October 30, 1972, courtesy Kent.

367 "He was darling with the nurses": Hadley, interview with author, May 9, 1990.

368 "who never complained": Helen Batcheller, interview with author, June 6, 1989.

368 "Whenever a nurse": Ibid.

368 "He kept a stash": Ibid.

369 "He thought that's the way": Ibid.

369 "Quiet day on the dune": JC, diary entry, July 29, 1972, AAA, roll 1064.

369 Memo . . . "re: 'business deal' ": JC, letter to Yayoi Kusama, October 4, 1972, courtesy Kusama.

369 "No mail please": Ibid., October 30, 1972, courtesy Kusama.

369 "Do you remember": JC, letter to Allegra Kent, October 30, 1972, courtesy Kent.

370 "all these morbid images": JC, diary entry, November 10, 1972, AAA, roll 1064.

370 "Gone, gone, closed": Ibid., December 6, 1972.

371 "No need to open": Windham, *Joseph Cornell*, an exhibition catalogue (New York: C&M Arts, 1996), n.p.

371 "some poems that have to do with Christmas": Frederick Morgan, conversation with author, May 8, 1996.

371 "able to get up on my feet": JC, diary entry, December 21, 1972, AAA, roll 1064.

371 he wasn't feeling well: BB, interview with author, May 12, 1989.

371 "woke up in tears": JC, diary entry, December 28, 1972, AAA, roll 1064.

372 "You know, I was thinking": BB, interview with author, May 12, 1989. Also Hartigan, 115.

372 recumbent on the couch: Ed Batcheller, interview with author, June 6, 1989.

372 died of a heart attack: JC's death certificate, on file with the New York City Department of Health (#156 72 4017522), says he died at 8 a.m.

372 "There was no sign of any agony": Leonard Richheimer, interview with author, February 26, 1990.

372 About fifty people: Interviews with Henry Geldzahler, Brooke Alexander, and Richard Feigen.

374 "I remember my astonishment": Windham, interview with author, April 12, 1990.

Index

NOTE: Works cited are by Joseph Cornell unless otherwise identified.

N
6537
C66
S64
1997

Solomon, Deborah.

Utopia Parkway.

$30.00

DATE			